Inventing Marcel **Duchamp**

THE DYNAMICS OF PORTRAITURE

NATIONAL PORTRAIT GALLERY
SMITHSONIAN INSTITUTION
WASHINGTON, D.C.

THE MIT PRESS
CAMBRIDGE, MASSACHUSETTS
LONDON, ENGLAND

EDITED BY
ANNE COLLINS GOODYEAR
JAMES W. MCMANUS

WITH ADDITIONAL ESSAYS BY
JANINE A. MILEAF
FRANCIS M. NAUMANN
MICHAEL R. TAYLOR

Contents

Foreword

Many Americans know of Marcel Duchamp, if they recognize his name at all, as the French-born artist who scandalized New York with his *Nude Descending a Staircase (No. 2)*, exhibited in the Armory Show of 1913.

This book and the exhibition it accompanies place Marcel Duchamp in a much fuller and more meaningful context. The Smithsonian's National Portrait Gallery is a natural choice as the organizer of "Inventing Marcel Duchamp: The Dynamics of Portraiture," as Duchamp was both a profound influence on the art of portraiture in the twentieth century, as well as—in later life—a naturalized U.S. citizen with an extensive network of colleagues, critics, emulators, and admirers in this country.

Co-curators Anne Collins Goodyear and James W. McManus remind us that Duchamp was especially ingenious in employing portraiture as a device of self-invention. Thus, it is entirely fitting that this exhibition is mounted in the magnificent structure formerly known as the nation's "Temple of Invention," the early nineteenth-century Patent Office Building in Washington, D.C., now home to the National Portrait Gallery and the Smithsonian American Art Museum.

Museums, like temples, both reveal and conceal. They display objects deliberately arranged to convey messages about identity, meaning, and value. They conceal, to a large extent, the processes or performances that shape those displays, as well as the "behind the scenes" collections of objects consciously withheld from public view. So it was with Duchamp's approach to the art of portraiture: he strove simultaneously to reveal dimensions of an invented identity and to conceal, at some shadowy distance, aspects of his inner persona that he held back from the viewer.

Marcel Duchamp died in the midst of the tumultuous and memorable events of 1968. Forty years on, his contributions to modern art—notably though not exclusively in his innovations of self-portrayal—seem even more remarkable than during his lifetime. As with other thoroughly researched exhibitions, this project has yielded surprising finds, such as the rediscovery of Daniel MacMorris's 1937 portrait and study sketches of Duchamp, which are seen here for the first time in seven decades. Like Duchamp himself, the project has been both audacious in its scope and provocative in its insights. We feel it presents a truly enduring assessment of singular achievements in portraiture.

Enormous credit goes to Anne Collins Goodyear and guest curator James W. McManus, who together conceptualized the project, identified its content, and orchestrated its production. Many colleagues on the staff of the National Portrait Gallery, too many to list each by name, have played instrumental roles in bringing the objects together from many sources, designing and installing the show, and producing this volume. A generous grant from the Smithsonian Institution's Scholarly Studies Program, together with funding from the Henry Luce Foundation, the Florence Gould Foundation, and the Marc Pachter Exhibition Fund, provided essential support. We also thank Mary McMorris and Leonard Santoro and Aaron and Barbara Levine for their support. We are grateful to the many museums and individuals who lent to the exhibition, as well as to the contributors whose essays appear here.

Martin E. Sullivan
Director
National Portrait Gallery, Smithsonian Institution

Abbreviations

AAA Archives of American Art, Smithsonian Institution

Cabanne, *Dialogues with Marcel Duchamp* Pierre Cabanne, *Dialogues with Marcel Duchamp*. Translated by Ron Padgett. 1967. Reprint, New York: Viking, 1971.

d'Harnoncourt and McShine, *Marcel Duchamp* Anne d'Harnoncourt and Kynaston McShine, eds., *Marcel Duchamp*. New York and Philadelphia: Museum of Modern Art and Philadelphia Museum of Art, 1973.

Henderson, *Duchamp in Context* Linda Dalrymple Henderson, *Duchamp in Context: Science and Technology in the Large Glass and Related Works*. Princeton, NJ: Princeton University Press, 1998.

Jones, *En-Gendering* Amelia Jones, *Postmodernism and the En-Gendering of Marcel Duchamp*. Cambridge: Cambridge University Press, 1994.

Lebel, *Duchamp* Robert Lebel, *Marcel Duchamp*. Translated by George Heard Hamilton. New York: Grove Press, 1959. Originally published as *Sur Marcel Duchamp*. Paris: Trianon Press, 1959.

Naumann, *Art of Making Art* Francis M. Naumann, *Marcel Duchamp: The Art of Making Art in the Age of Mechanical Reproduction*. Ghent: Ludion Press; New York: distributed by Harry N. Abrams, 1999.

Naumann, *New York Dada* Francis M. Naumann, *New York Dada, 1915–23*. New York: Harry N. Abrams, 1994.

Naumann and Obalk, *Affectionately, Marcel* Francis M. Naumann and Hector Obalk, eds. *Affectionately, Marcel: The Selected Correspondence of Marcel Duchamp*. Translated by Jill Taylor. Ghent: Ludion Press, 2000.

Schwarz, *Complete Works* Arturo Schwarz, *The Complete Works of Marcel Duchamp*, 2 vols. 3rd rev. ed. New York: Delano Greenridge Editions, 1997.

Tomkins, *Duchamp* Calvin Tomkins, *Duchamp: A Biography*. New York: Henry Holt, 1996.

WMD *Salt Seller: The Writings of Marcel Duchamp*. Edited by Michel Sanouillet and Elmer Peterson. New York: Oxford University Press, 1973.

List of Authors

ACG Anne Collins Goodyear
JWM James W. McManus
JEQ Jennifer E. Quick
AK Aubrie Koenig
KD Kate Erin Dempsey

INVENTING
MARCEL DUCHAMP

The Dynamics of Portraiture

Anne Collins Goodyear
and James W. McManus

A Portrait of Duchamp

A portrait of Duchamp, a photograph, stares at me
from my desk. His gaze speaks out to everyone,
but above all to the young.
 "Who are you, and what do you bring to us?"
 "You can't fool me, so let's be frank."
 "Answer me, using simple words, not hollow ones."
 "Seek, find, be yourself."
 "Don't follow things that others are running after."
 "Don't follow the herd."
 "Don't repeat, in spite of the 'encore's'."
 "Don't digest bits of other people; it digests badly
 and gets noticed."
 "Have fun. If not, you'll bore us."

The portrait falls silent.

—Henri-Pierre Roché[1]

Ruminating on his diverse impressions of Marcel Duchamp (1887–1968), Henri-Pierre Roché (1870–1959) instinctively turned to a photographic portrait to recapture the artist's voice. The gesture both provides testament to Roché's regard for his absent friend and also reveals something of the peculiar authority bound up with Duchamp's likeness. Words directed toward a new generation seem to flow from the silent lips, Roché informs us, admonishing the young not to emulate but to invent anew. And it is here that Roché captures something of the magic of Duchamp's image, providing a critical clue to the sway it continues to hold four decades after Duchamp's death. Through portraiture Duchamp continues to speak, uttering ever-shifting lessons perpetually directed toward the future. Through portraiture the invention of Marcel Duchamp continues apace, dynamically reshaping a legacy that continues to inform both the practice and the interpretation of modern and contemporary art.

"Inventing Marcel Duchamp: The Dynamics of Portraiture" unites for the first time more than one hundred portraits and self-portraits—photographs, prints, drawings, collage, paintings, sculpture, and film, ranging from 1911 to 2007—of one of the most influential artists of the twentieth century. A master of self-invention, Duchamp throughout his career skillfully developed his public persona through a combination of self-representation and collaborations with those who portrayed him. With the exception of his well-known aliases—featured in such works as photographs of Rrose Sélavy, *Wanted: $2,000 Reward,* the *Monte Carlo Bond,* and his *Compensation Portrait*—portrayals of Duchamp, particularly by other artists, have largely been overlooked by scholars and often treated as transparent markers of the artist's appearance rather than as an integral aspect of Duchamp's body of work. For if Duchamp used portraiture actively, he did so not to close down avenues of interpretation, but as a means to encourage others to portray him, courting their diverse interpretations as part of his own legacy and inspiring a dynamic interchange that continues to the present. This dynamic was largely shaped and abetted by the artist himself, who teasingly both revealed and disguised himself before the public. "Not Seen and/or Less Seen of/by Marcel Duchamp/Rrose Selavy, 1904–64," ran the title of an exhibition of previously unknown works by Duchamp at the Cordier & Ekstrom Gallery in 1965.[2] The words apply just as fluidly to the artist himself. His tantalizing dance of exposure and withdrawal plays out in the selection of portraits gathered here in the first exhibition devoted to the art of depicting Marcel Duchamp.

As will rapidly become evident to the readers of this catalogue and viewers of the exhibition, we interpret "portraiture" broadly, taking into account both works that create iconic likenesses of Duchamp and those that are abstract, thus deliberately expanding the terrain of portraiture. These depictions include not only Duchamp's own experimental self-representations in various guises and his *Boîte-en-valise* (pl. 37), but also nontraditional portrayals of Duchamp by Baroness Elsa von Freytag-Loringhoven (pl. 13), Katherine Dreier (pl. 10), Joseph Cornell (pl. 84), Mel Bochner (pl. 81), and Brian O'Doherty, who used his medical training to make a portrait of Duchamp based on an electrocardiogram (pls. 75, 76, 77). Even when Duchamp is not directly portrayed, such as in later responses to his 1923 self-depiction in *Wanted: $2,000 Reward* by Richard Pettibone (pl. 72), Sturtevant

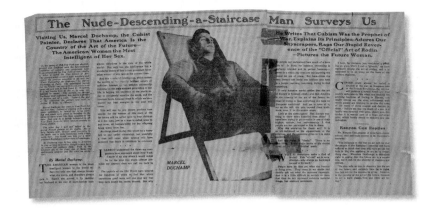

(pls. 93, 94), and Gavin Turk (pl. 101); Yasumasa Morimura's self-stylization as Rrose Sélavy (pl. 89); Douglas Gordon's *Proposition for a Posthumous Portrait* (pl. 100); and Ray Beldner's *Avec Ma Langue Dans Ma Joue, or With My Language in My Game* (pl. 103), his unseen presence endures. The conflation of self-portrayal by artists of later generations with the deliberate evocation of Duchamp demonstrates just how powerfully he has affected the very (self) definition of recent and contemporary art and artists.

Duchamp's complex involvement with the enterprise of portrayal, and the response of others to his practice, is expanded on at length in the essays included in this volume. As if responding to Henri-Pierre Roché's meditation on the likeness of his close friend, Duchamp, Francis M. Naumann provides a valuable overview of portrayals of Duchamp from early in his career to the present day, addressing the extraordinary popularity and power of Duchamp as subject. Michael R. Taylor explores Duchamp's activities as a portraitist in his own right, describing how portraiture influenced other projects. Janine A. Mileaf, examining the implications of Duchamp's self-portrayal in the guise of the female persona Rrose Sélavy, looks at the way in which several women artists responded through the enterprise of portraiture to the conceptual demands of Duchamp's work. James W. McManus looks closely at his use of photography as a means for constructing Rrose Sélavy. Anne Collins Goodyear focuses on Duchamp's use of self-portrayal, particularly late in his career, to ensure the survival of his legacy. As the combination of these essays makes clear, together with detailed discussions of each of the works included in this exhibition, Duchamp has meant different things to many individuals. Each generation and each artist has interpreted anew the impact of Duchamp's presence and legacy.

Throughout his career Duchamp frustrated the attempts of critics, scholars, and even his friends to feel secure in their attempts to explain his motivations, to describe the "meaning" of his work—in short, to know him fully. The perception of mystery was cultivated by the artist himself, who at the end of his life told one scholar, "I don't want to be pinned down to any position. My position is the lack of a position, but, of course, you can't even talk about it, the minute you talk you spoil the whole game."[3] Duchamp's unwillingness to "explain" himself reflects a larger strategy of selective silence on his part. But as Amelia Jones has noted, that silence did not prevent Duchamp from making himself known and is largely belied by the numerous interviews and public talks Duchamp agreed to give in the final decade of his life.[4]

Paradoxically then, Duchamp used the technique of public exposure to cultivate an aura of mystery and withdrawal. It is one of the goals of this project to indicate some of the channels through which the artist disseminated his likeness. These include numerous newspaper articles incorporating his picture, published on the occasion of his arrival in the United States, such as "The Nude-Descending-a-Staircase Man Surveys Us," which appeared in the *New York Tribune* in September 1915 (fig. 1.1), *Vanity Fair*'s September 1914 "Marcel Duchamp Visits New York," and the playful depiction of him in the *Literary Digest*'s "The European Art Invasion" of November 1915. But aside from such early examples of his exotic appeal as a European "other," another wave of publications featuring Duchamp's

fig. 1.1 "The Nude-Descending-a-Staircase Man Surveys Us," *New York Tribune*, September 12, 1915. Yale Collection of American Literature, Beinecke Rare Book and Manuscript Library, New Haven, Connecticut

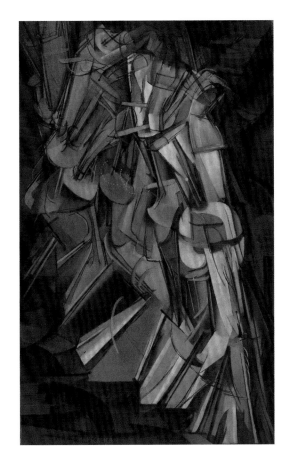

fig. 1.2

Nude Descending a Staircase (No. 2) by Marcel Duchamp, oil on canvas, 1912. Philadelphia Museum of Art, Pennsylvania; The Louise and Walter Arensberg Collection, 1950

likeness appeared in the years after World War II, following his return to the United States, and include a 1945 issue of *View* magazine dedicated to him (pl. 42a and b), a major article entitled "Dada's Daddy," included in *Life* magazine in 1952 (pl. 51), and, most prominently, Robert Lebel's 1959 monograph *Sur Marcel Duchamp* (pl. 62), in which the artist played an active role. The success of Duchamp's efforts, particularly in the 1940s and 1950s, can be gauged in part by the numerous publications, exhibitions, and new editions of his work that appeared in the late 1950s and 1960s. These included a French collection of his writings; an English translation of Lebel's monograph and *The Green Box;* important exhibitions in Pasadena, New York, London, and Stockholm; and new editions of the readymades and the *Boîte-en-valise* (pl. 37).[5]

Duchamp's willingness to use depictions of himself in the press to tweak public associations with his work plays out in fascinating fashion where *Nude Descending a Staircase (No. 2)* (fig. 1.2) is concerned. As Duchamp's friend Robert Parker later noted, "a pre-fabricated fame awaited him" upon his arrival in the United States in 1915 because of the explosive response to his *Nude Descending a Staircase (No. 2)* in the 1913 Armory Show.[6] Outraged but intrigued, American audiences delighted in vilifying the painting, which generated numerous spoofing responses, such as a cartoon depicting rush hour in New York entitled "The Rude Descending a Staircase."[7] As Duchamp would complain in the mid-1930s, he had become "only a shadowy figure behind the reality of that painting." His dissatisfaction would become the excuse for a 1937 portrait by Daniel MacMorris (pl. 34). "To rectify the situation," a contemporary news account explains, "[MacMorris] painted a portrait of Duchamp, strong and clear, and in the background, he placed a detail of the haunting picture, making it the 'shadowy figure.'"[8] Following his return to the United States in the midst of World War II, however, Duchamp was more than willing to exploit his famous canvas to once again raise his public profile. Thus, in 1946 Duchamp staged a photograph of himself descending a staircase, employing George Karger to create the image (fig. 1.3). Only a few years later, a time-lapse picture of Duchamp moving down a flight of stairs by Eliot Elisofon would be juxtaposed with a reproduction of his well-known painting in the pages of *Life* (pl. 51). The picture would later be reproduced on the cover of the 1967 edition of Lebel's monograph.[9]

Duchamp did not restrict his entrepreneurial approach to disseminating his likeness to publications. Indeed, a number of the images included in this exhibition were previously shown in elaborate store window displays. Copies or variants of Man Ray's 1930 photograph of Duchamp from the side (pl. 29), of a 1942 photograph by André Gomès of Duchamp (see pl. 39 for a variant), and of an unidentified photographer's rendition of Duchamp and Mary Reynolds with a tape measure (pl. 36) all appeared, in concert with additional pictures by Man Ray and Carl Van Vechten, in the window of La Hune bookstore during the 1946 exhibition "Tracts et Papillons Surréalistes," curated by André Breton at the bookstore (fig. 1.4).[10] Later, in 1960, Victor Obsatz's double-exposure photograph of Duchamp turning his head (pl. 54), featured on the cover of the English translation of Lebel's monograph, would have a prominent place in the window of Bamberger's Department Store in Newark, New Jersey, together with an installation re-creating *Nude*

Descending a Staircase (No. 2) (see fig. 5.7).[11] These elaborate constructions, which also functioned as self-portraits in aggregate, suggest that the impression Du-champ later emanated, as Calvin Tomkins would have it, "of an amused and toler-ant spectator . . . [who] views with serene detachment the cult that is made up of his own posterity," may have been an artistic illusion all its own.[12]

The exhibition captures long-standing trends in the portrayal of Duchamp, revealing modes of capturing him that persist in the work of several artists. Per-haps most evident is the profile that emerges consistently both in portraits of Duchamp and in his self-portraiture. This trope, with a long history in portrai-ture, appears early in Duchamp's career in photographs by Alfred Stieglitz (pl. 23), Edward Steichen (pl. 9), and Man Ray (pl. 29), and in drawings by Joseph Stella (pl. 12), Francis Picabia (pl. 8), and Jean Crotti (pls. 4, 5). The device was later picked up by Duchamp in 1957 when he began a series known as *Self-Portrait in Profile* (pl. 58), prompted by the publication of Robert Lebel's monograph on the art-ist, *Sur Marcel Duchamp,* which was rapidly translated into English.[13] If the black silhouette spoke to Duchamp's interest in shadows and negative space, it may also have had another resonance, given his advancing age.[14] "When a clock is seen from the side (in profile) it no longer tells the time," explained Duchamp in 1958—the year after he completed an edition of 130 (later 137) torn self-portrait profiles—in reference to a note from *The Green Box.*[15] The image later became the basis for works by Jasper Johns (pls. 66, 67), Ray Johnson (pl. 88), Andrew Lord (pl. 99), and Ray Beldner (pl. 103).

Indeed, not only self-portraits but also portraits *of* Marcel Duchamp resound with hidden references to theoretical concerns described in his writings or made manifest in his works of art. The creation of numerous photographs of Duchamp during the second half of his career, from the early 1940s forward, by different photographers showing him in multiple-exposure photographs, posing with his art, or smoking his cigar suggests that he subtly but carefully "directed" these sittings, ensuring that certain poses were recorded. These include Arnold New-man's 1942 photograph of Duchamp with his *Sixteen Miles of String* installation at the "First Papers of Surrealism" exhibition (pl. 41), which seemingly juxtaposed Duchamp with his 1914 *Network of Stoppages.* Newman's later *Portrait of Marcel Duchamp: Nine Malic Moulds and Cast Shadows* (pl. 74) similarly hints at Duchamp's active involvement in the composition, although Newman was not cognizant of his subtle influence.[16] One of André Gomès's 1942 photographs of Duchamp at the Villa Air-Bel in Marseille portrays the artist morphing himself into his bottle rack, the first of his recorded readymades.[17] Another (pl. 39) shows Duchamp with an expansive tree branching out above his head, suggestive of the "arbor-type" of the Bride in *The Large Glass,* while Ugo Mulas's photograph *Marcel Duchamp Look-ing at Hat Rack* (pl. 68) similarly produces an analogue of *The Large Glass,* with "the bachelor" looking longingly at the Bride, known as "Pendu femelle," or hanging female.[18] Meanwhile, photographs of Duchamp in motion reflect *Nude Descending a Staircase (No. 2),* while images of cigar smoke instantly conjure up references to the "infra-thin," an allusion set up by Duchamp's words on the back cover of the 1945 issue of *View* (pl. 42a and b) devoted to him: "When the tobacco smoke smells like the mouth that exhales it, the two odors marry through infra-thin."[19]

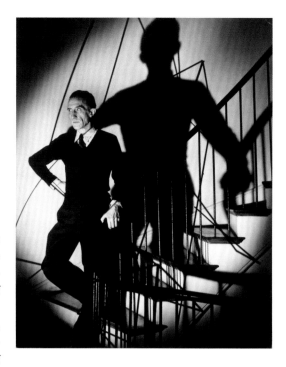

fig. 1.3 | *Duchamp Descending a Staircase* by George Karger, gelatin silver print, 1946. Philadelphia Museum of Art, Pennsylvania; gift of Jacqueline, Paul, and Peter Matisse in memory of their mother, Alexina Duchamp

fig. 1.4 | "Tracts et Papillons Surréalistes" (window display, La Hune bookstore), gelatin silver print, 1948. Philadel-phia Museum of Art, Pennsylvania, Marcel Duchamp Archive; gift of Jacqueline, Paul, and Peter Matisse in memory of their mother, Alexina Duchamp

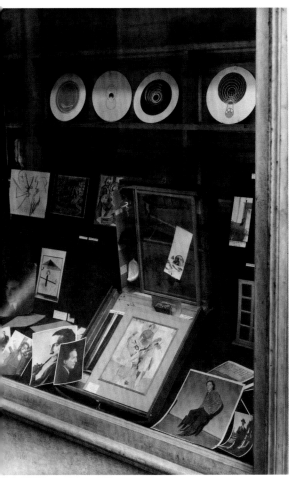

The words referred directly to the cover—designed by Duchamp—which features a wine bottle bearing Duchamp's military record spewing smoke into the night sky, an image also evocative of the Milky Way of *The Large Glass.* The complex work clearly functions as a symbolic self-portrait. Visitors to the exhibition and readers of the catalogue are certain to discover many more such interconnections.

Yet despite the abundance of portraits depicting Duchamp during his lifetime and following it, as well as the evidence of Duchamp's active participation in the development of this work, relatively few of these images are well known. Indeed, in the course of organizing this exhibition, it has become evident that the present attempt to unite some of the most interesting self-portraits and portrayals of Duchamp must, of necessity, be only partial. The range and depth of the portraiture we have encountered in the course of our research has been staggering. Yet surprisingly, given the huge interest in Duchamp's career, this marks the first attempt to bring together a selection of the best of these works, although it is precisely by assembling them that Duchamp's deep commitment to the genre becomes apparent.

As noted earlier, better known are projects in which Duchamp adopted various aliases, including submitting portraits of others to represent him. Most famous is the collaboration with Man Ray that produced the persona of Rrose Sélavy (pls. 14a, 15, 16, 17), a multitiered pun meaning "Eros is life." In a series of photographs by Man Ray, Duchamp operates as a sultry, bejeweled lady wearing a large hat and a fur stole or pearl necklace. The character of "Rrose" appears in many other guises, including as the most prominent alias on a "Wanted" poster featuring "mug shots" of Duchamp (pl. 25) and as a cosignatory on Duchamp's *Monte Carlo Bond,* featuring yet another spoofing image of the artist, this time in the guise of Mercury (pl. 27).[20] Another photograph, featuring Duchamp with a star (or is it a comet?) cut into his hair (pls. 18, 19, 20), dramatically merges the identity of the male artist with that of his female alter ego through the addition by Duchamp of the dramatic inscription: "Voici rrose sélavy."[21] Two decades later, in the issue of *View* devoted to the artist, Duchamp would artificially age himself, appearing in a mug shot as *Marcel Duchamp at the Age of Eighty-Five* (pl. 43), a picture he placed beside one of Stieglitz's 1923 photographs of him (pl. 23).[22]

In addition to transforming himself by resorting to theatrical methods, Duchamp on at least two occasions accomplished similar ends by identifying himself through appropriated photographs of others. On the cover of a 1924 issue of 391, Francis Picabia substituted Duchamp with a "look alike" photograph of the French boxer Georges Carpentier (pl. 26). In 1942, as scholar David Hopkins has discussed, Duchamp used Ben Shahn's photograph of a migrant mother victimized by the Dust Bowl to represent himself in the 1942 *First Papers of Surrealism* catalogue (pl. 40).[23] Duchamp's choices reflect both his sense of humor and his sensitivity to the political and social codes implicit in portraiture.

Why portraiture should provide such a novel approach to exploring the legacy of Duchamp points to another scholarly dimension of our exhibition: the reexamination of the role of portraiture during the twentieth century. After enjoying a "golden age" during the late nineteenth century in the hands of such erudite artists as John Singer Sargent, James McNeill Whistler, Cecilia Beaux, and

Mary Cassatt, portraiture was largely cast aside during the twentieth century, or so the histories tell us. Given its traditional associations, conventional portraiture did not seem compatible with the aims of the avant-garde. However, as isolated studies have indicated, a number of avant-garde artists were actively involved in recasting portraiture during the early part of the twentieth century, including, importantly, Marius de Zayas, Marsden Hartley, and Francis Picabia. The work of Caroline Jones on the machine portraits of Picabia, as well as research by Bruce Robertson on Marsden Hartley and Wendy Wick Reaves on Marius de Zayas, helps establish the backdrop against which Duchamp was operating, particularly given his contact with Alfred Stieglitz and artists close to him during the 1910s.[24] In fact, as Reaves has demonstrated, portraiture never really disappeared during the twentieth century, even in the hands of advanced artists.[25] The critical prejudice against portraiture has begun to reverse itself in recent years, helping make possible this new examination of a large, previously untapped, source of information about Duchamp.

An unanticipated lesson of this exhibition has been a common lack of familiarity with Duchamp's career among members of the general public, despite an enormous interest among artists and scholars. The detailed chronology in this catalogue, prepared by Hannah Wong, provides information about major events in Duchamp's life and helps to contextualize the portraiture presented here. What accounts for the striking discrepancy between scholarly fascination with Duchamp and his obscurity among those not well versed in the arts? Perhaps the single most important factor is the sheer elusiveness of the persona he constructed coupled with the unconventional nature of his artwork, which did not stress the fetishization of the artist's hand, but instead emphasized the importance of intellect, a much more challenging quality to pin down. Taught to equate artistic accomplishment with the production of unique artifacts bearing evidence of the artist's hand, even well-educated individuals have difficulty placing Duchamp, known for his construction of playful aliases, "readymade" multiples, and masterworks such as *The Large Glass* and *Étant donnés* that cannot be transported among the pantheon of "great" twentieth-century artists.

Yet many of the artists included here for their depictions of Duchamp have become household names, such as Alfred Stieglitz, Edward Steichen, Andy Warhol, and Jasper Johns. Their responses to Duchamp reveal the formative stamp he left upon their artwork, lending support to Roger Shattuck's observation that "after Duchamp it was no longer possible to be an artist in the way that it was before."[26] Perhaps most important, precisely by upending and dismantling critical and aesthetic categories that had long held force, challenging the sway of the easel painting and disrupting adherence to Kantian notions of universal taste, Duchamp carved out new space for intellectual and personal expression that radically reshaped approaches to representing the self and other.[27]

As this exhibition contends, portraiture provides a powerful opportunity to document the extensive impact he had on his contemporaries, both in his youth and his maturity. The inclusion of recent posthumous portrayals of Duchamp by such recent artists as Ray Beldner (pls. 102, 103), David Hammons (pl. 98), Douglas Gordon (pl. 100), Andrew Lord (pl. 99), Jonathan Santlofer (pls. 95, 96), Gavin Turk

(pl. 101), and Douglas Vogel (pl. 100) demonstrates that his importance continues unabated, manifesting itself still further with each passing generation. Like the objects he created, Duchamp as subject serves as a marker for opening fields of inquiry.

Notes

1. H. P. Roché, "Souvenirs of Marcel Duchamp," trans. William N. Copley, in Lebel, *Duchamp*, 87. A picture of Roché gazing at a photograph of Duchamp is reproduced in "Portfolio: Photographs of or about Marcel Duchamp," *Étant donné Marcel Duchamp 7* (2006): 228–29.

2. *Not Seen and/or Less Seen of/by Marcel Duchamp/Rrose Selavy, 1904–64*, foreword and catalogue texts by Richard Hamilton (New York: Cordier & Ekstrom, 1964). The show ran from January 14 to February 13, 1965.

3. Marcel Duchamp, quoted by Arturo Schwarz, "Marcel Duchamp, the Man, Even," in *Marcel Duchamp: Artist of the Century*, ed. Rudolf E. Kuenzli and Francis M. Naumann (1989; Cambridge, MA: MIT Press, 1996), 229, caption p. 227.

4. Jones, *En-Gendering*, 63–109, especially 99–103.

5. The publications include *Marchand du Sel*, écrits de Marcel Duchamp, réunis et présentées par Michel Sanouillet; bibliographie de Poupard-Lieussou (Paris: Le Terrain Vague, 1958); Lebel, *Duchamp*; and *Marcel Duchamp, The Bride Stripped Bare by Her Bachelors, Even: A Typographic Version by Richard Hamilton of Marcel Duchamp's Green Box*, trans. George Heard Hamilton (London: Percy Lund, Humphries, 1960). See Hannah Wong's chronology in this volume for more information on the exhibitions featuring Duchamp's work and the editioning of his readymades. For more information on the various editions of the *Boîte-en-valise*, see Ecke Bonk, *Marcel Duchamp: The Portable Museum*, trans. David Britt (London: Thames & Hudson, 1989) and pl. 37.

6. Robert A. Parker, "America Discovers Marcel," *View* 5, no. 1 (March 1945): 32.

7. "The Rude Descending a Staircase," *New York Evening Sun*, March 20, 1913, reproduced in d'Harnoncourt and McShine, *Marcel Duchamp*, 14.

8. Daniel MacMorris, "Marcel Duchamp's 'Frankenstein,'" *Art Digest* 12 (January 1938): 22.

9. This was the cover of Lebel, *Duchamp*.

10. Although André Breton organized the exhibition, it is likely that Duchamp contributed "documents, photographs, and artworks" to the window display, which, in addition to photographic portraits of Duchamp, featured Rotoreliefs and selections from *Boîte-en-valise*. Paul B. Franklin, "1959: Headline, Duchamp," *Étant donné Marcel Duchamp* 7 (2006): 158; a copy of the photograph of Duchamp by Gomès featured in the window is reproduced in Robert Lebel, "Last Evening with Duchamp," *Étant donné Marcel Duchamp* 7 (2006): 180.

11. This installation is discussed at length in Anne Collins Goodyear's essay in this volume.

12. Calvin Tomkins, "Not Seen and/or Less Seen: Marcel Duchamp," *New Yorker*, February 6, 1965, 39.

13. See n. 7.

14. See *WMD* for more on Duchamp's interest in shadows and negative space.

15. This comment was made by Duchamp in reference to a note from *The Green Box* reading: "The Clock in profile./and the Inspector of Space" (emphasis Duchamp's); it is published in *Marcel Duchamp, The Bride Stripped Bare by Her Bachelors, Even: A Typographic Version by Richard Hamilton of Marcel Duchamp's Green Box*, trans. George Heard Hamilton, np. The 1957 date of the edition of self-portraits has been established by Paul B. Franklin's documentation of correspondence between Duchamp, Lebel, and publisher Arnold Fawcus; see Franklin, "1959: Headline, Duchamp," 145–46.

16. Anne Collins Goodyear and James W. McManus, conversation with Arnold Newman, December 22, 2005.

17. According to Robert Lebel, it was St. Sebastian "the patron saint of artists whose pose [Duchamp] ironically assumed in a photograph of 1942; [unlike this model] he refuses to be the dolorous target of the arrows that the 'regardeurs' (beholders) voluptuously shoot, and his replies are return shots that deliberately miss their target." See Lebel, *Duchamp*, 179; the photograph is reproduced on p. 180 of his essay.

18. On the figure of the Bride as an "arbor-type," see *The Green Box, WMD*, 42–44; on the figure of the Bride as the "Pendu femelle," see *The Green Box, WMD*, 27, 45, and 48. While Gomès's photograph was taken in February, before the tree was in a state of "blossoming," Duchamp certainly was aware that the blossoming would soon come. On the dating of the photograph, see Paul B. Franklin, "Notes," n. 3, for Lebel, "Last Evening with Duchamp," 180. Regarding Mulas's photograph, we thank Linda D. Henderson for her insight; personal conversation with Anne Collins Goodyear, August 18, 2007. For an overview of the narrative of *The Bride Stripped Bare by Her Bachelors, Even (The Large Glass)*, see Tomkins, *Duchamp*, 1–14.

19. Marcel Duchamp, *View* 5, no. 1 (March 1945), back cover; translation by the author; the original French reads: "QUANd/la FuMÉe de tABAC/SeNT ausSi/de La bouche/qui l'EXHALE, les DEUX ODEURS/S'ÉpouSeNt par INFRA-mINce" [sic]. According to Duchamp, the elusive concept of "infra-thin" could not be directly described, only illustrated through example. The evocation of infra-thin given on the back of *View* also appeared among a series of notes devoted to the concept that Duchamp preserved in an envelope. Composed between approximately 1935 and 1945, the notes on infra-thin concern the nearly imperceptible barriers between things, or the liminal space between them, a concept that fascinated Duchamp. The notes on infra-thin are included in *Marcel Duchamp, Notes*, ed. Paul Matisse (Boston: G. K. Hall, 1983); although the book is unpaginated, the notes are numbered. The note published on the back of *View* appears as no. 33; a related note appears as no. 11, verso. On the "liminal moments" captured in Duchamp's notes on infra-thin, see Henderson, *Duchamp in Context*, 213–14.

20. For a persuasive argument that Duchamp is emulating Mercury in the *Monte Carlo Bond*, see James W. McManus, "Rrose Sélavy, Machinist/Erotaton," in *Marcel Duchamp and Eroticism*, ed. Marc Decimo (Newcastle, Eng.: Cambridge Scholars Publishing, 2007), 66–70.

21. See James W. McManus's essay in this volume for a detailed discussion of this image.

22. Please see the discussion for pl. 43 for more information on this work.

23. David Hopkins, "The Politics of Equivocation: Sherrie Levine, Duchamp's *Compensation Portrait*, and Surrealism in the USA, 1942–45," *Oxford Art Journal* 26, no. 1 (2003): 45–68.

24. Caroline A. Jones, "The Sex of the Machine: Mechanomorphic Art, New Women, and Francis Picabia's Neurasthenic Cure," in *Picturing Science/Producing Art*, ed. Caroline A. Jones and Peter Galison (New York and London: Routledge, 1998), 145–80; on Marius de Zayas, see Wendy Wick Reaves, *Celebrity Caricature in America* (New Haven, CT: Yale University Press for the National Portrait Gallery, 1998), 72–102; Bruce Robertson, "Marsden Hartley and Self-Portraiture," in *Marsden Hartley*, ed. Elizabeth Mankin Kornhauser (New Haven, CT: Yale University Press, 2002), 153–64.

25. Wendy Wick Reaves, *Eye Contact: Modern American Portrait Drawings from the National Portrait Gallery* (Seattle and London: University of Washington Press for the National Portrait Gallery), 11–31.

26. Roger Shattuck, "Dada-Surrealist Expedition," pt. 2, *New York Review of Books*, June 1, 1972, 20. Thierry de Duve makes a similar argument, specifically with regard to Duchamp's impact on the enterprise of painting, in *Kant after Duchamp* (Cambridge, MA: MIT Press, 1996), 167.

27. On Duchamp's challenge to Kantian judgments of taste, see Thomas McEvilley, "empyrrhical thinking (and why kant [sic] can't)," *Artforum* 27, no. 2 (October 1988): 120–27. A somewhat revised version of this essay appears as "Duchamp, Pyrronianism, and the Overthrow of the Kantian Tradition," in McEvilley's *Sculpture in the Age of Doubt* (New York: Allworth Press, 1999), 49–68. See also "Kant, Duchamp, and Dada: The Background," in McEvilley, *The Triumph of Anti-Art, Conceptual and Performance Art in the Formation of Post-Modernism* (Kingston, NY: Documentext, 2005), 15–35. See also de Duve, *Kant after Duchamp*, especially 301–25.

THE RECURRENT,

HAUNTING GHOST

Depictions of Marcel Duchamp by His Contemporaries and Ours

Francis M. Naumann

Marcel Duchamp's reputation as an artistic iconoclast—combined with his legendary good looks, genial character, and accessibility—have made him the subject of numerous portraits. Indeed, if we combine the number of portraits made by his contemporaries with those made posthumously, Duchamp has been depicted more often than any other major artist of the modern era. While Picasso and Matisse unquestionably enjoyed greater public recognition (and, as a result, may have been photographed more often), they were portrayed in paintings and sculptures less frequently than Duchamp. To this day, artists continue to render him as a living presence, as if he were still walking, talking, and thinking among us. His art and ideas continue to reverberate as sources of inspiration in the world of contemporary art, far overshadowing the influence of either Matisse or Picasso. While these artists are still influential, they are seldom depicted as still-living entities by contemporary artists because the nature of their influence is different. Whereas the complexity of Picasso's line is still carefully studied by artists, and Matisse's vibrant, intense, and harmonious colors never cease to inspire, these qualities are essentially products of vision ("retinal" in Duchamp's terminology) and are, therefore, subject to evolving changes in taste. The ideas Duchamp introduced avoid fluctuations of style by inhabiting the mind, thereby forcing an intense and rigorous engagement with the process of thought.

This very point is succinctly expressed in the first portrait of Duchamp made by another artist: Jean Crotti's *Portrait de Marcel Duchamp sur mésure* (pl. 3). Crotti (1878–1958), a Swiss painter who lived in New York during World War I, shared a studio with Duchamp in the spring of 1916. His portrait of Duchamp consists of essentially two elements: a cast made from a human forehead (probably Duchamp's), from which are suspended a pair of glass eyes. The eyes are symbols of vision, while the forehead contains the brain and represents the process of thought. This dichotomy—between an art meant to be purely visual and appeal to the eyes and an art that is more intellectual and meant to appeal to the cerebral qualities of the mind—preoccupied Duchamp in these years. He would later say that one of his goals as an artist was to defy the French adage *d'être bête comme un peintre* (to be as stupid as a painter), which presumed that painting was essentially a mindless activity. Crotti would have found this goal admirable, for as he told a reporter in 1915, "It is not with nature [that] I am concerned, but with ideas."[1]

Before leaving Paris, Duchamp met and befriended the artist Francis Picabia (1879–1953), with whom he shared a distaste for the veneration of the art of the past. Picabia would go on to establish a reputation as one of the major abstract painters of his day while continuing to draw in a deftly naturalistic style. It was probably during his last sojourn to New York in 1917 that he made a quick sketch of Duchamp, capturing at once the artist's handsome Norman features and love for the game of chess (pl. 8). Three chess pieces—a black rook, a white knight, and a black pawn—are visible behind Duchamp's head, while Picabia has given his friend a shirt collar with a checkerboard pattern, as if to acknowledge that the game has physically enveloped Duchamp (and, to a certain degree, during these years, it had). Picabia has emblazoned the name of the city they temporarily shared across Duchamp's forehead, implying, perhaps, that only in a metropolitan center like New York, far removed from the conflict plaguing the

fig. 2.1 | *Marcel Duchamp Triangles* by Katherine S. Dreier, oil on canvas, c. 1918 (lost or destroyed). Photograph courtesy of Yale Collection of American Literature, Beinecke Rare Book and Manuscript Library, New Haven, Connecticut

The title of this essay comes from a comment made by Kirk Varnedoe (1946–2003) when he was reinstalling the permanent collection of the Museum of Modern Art in 1993. He made the point that in the new installation of the galleries, Picasso was "a little less prominent," while Duchamp was "the recurrent, haunting ghost." Robin Cembalest, "The Ghost in the Installation," *ARTnews* (November 1993): 141. I am grateful to Kathleen Tunney, assistant to the Library and Museum Archives at the Museum of Modern Art, for having located a copy of this article for me, and to Kirk Varnedoe for having given me permission to use these words as the title of an exhibition I organized for Francis M. Naumann Fine Art, New York, in the fall of 2003, as well as the title for a book of my collected essays on Duchamp (in preparation).

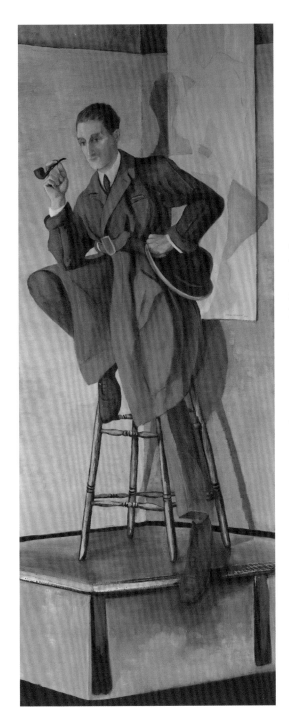

cities of Europe, could they momentarily avoid thinking about the atrocities of war and instead enjoy a leisurely game of chess.

Duchamp's interest in chess intensified during his early years in New York. He played often with the various guests who attended the nearly nightly soirées held at the West 67th Street apartment of Walter and Louise Arensberg, wealthy collectors of modern art who, as their friends often observed, collected not only art but artists as well. It was likely at the Arensberg apartment that Duchamp met and befriended Katherine S. Dreier (1877–1952), a painter and dedicated patron of the arts who was immediately attracted to his profound intellect (and possibly even more), but who never really understood what his work was all about. A devoted theosophist, she believed in the power of art to be spiritually uplifting and transformative, characteristics that she sensed were innate components of Duchamp's personality. Soon after they met, she wrote to tell him that she admired his originality as well as his "strength of character and spiritual sensitiveness."[2] Dreier probably conflated Duchamp's naturally quiet and reserved temperament—and his disavowal of material wealth—with her notion of spiritual sensitivity. In 1918 she made two portraits of Duchamp, each of which expresses these aspects of his personality to a varying degree. The first is a straightforward portrait of the artist wearing a long trench coat, smoking a pipe, seated on a tall kitchen stool (fig. 2.1). The stool is an appropriate support for the maker of *Bicycle Wheel,* the first readymade of 1913 (remade in New York in 1915), which features a stool as its base. Directly behind the artist are multiple impressions of his cast shadow, one of which appears to occupy a tall, thin vertical support, which perceptive viewers will see is signed and dated in its lower-right corner, "Marcel Duchamp 1916." This suggests that Duchamp himself painted the cast shadows. Mirrors, reflections, and shadows were an interest of Duchamp's for a variety of projects he was working on at the time. (They were used to explain the fourth dimension and figure prominently in notes he was compiling for his most elaborate and ambitious work from these years, *The Large Glass.*) Whereas Duchamp would have seen these shadows as a product of science, Dreier probably considered them projections of the artist's inner self, a physical record of, as she put it, his "spiritual sensitiveness."

Although Dreier gave this portrait the title *Triangles,* it is hard to find any in the image, whereas they are the predominant geometric element in her *Abstract Portrait of Marcel Duchamp* (pl. 10). Theosophists used triangles to explain the path followed in the attainment of a higher spiritual state, claiming that those who stand at the apex of this triangle are geniuses. This is precisely what Wassily Kandinsky wrote in *Concerning the Spiritual in Art,* a book surely read by Dreier (either in the original German edition of 1912 or the English translation of 1914). In Dreier's *Abstract Portrait of Marcel Duchamp,* two triangles flank a large golden-yellow orb in the center of the composition that is overlapped by a thin, tapering, conelike shape, its apex culminating at some point off the canvas at the upper left, where the genius (in this case, presumably Duchamp) resides. Committed though Dreier certainly was to the principles of abstraction, she retained certain figurative elements (as did Kandinsky), and one becomes immediately apparent when the canvas is turned upside down: overlapping the conelike shape in the

center of the painting is Duchamp's pipe, the very object he holds in his hand in the representational portrait. Once this element is identified, the white pigment that surrounds it can be interpreted as smoke emerging from the bowl, but at this point, other elements in this composition defy a similar analytical reading and remain essentially abstract. In her book *Western Art and the New Era*, Dreier was the first to reproduce this portrait and the first to explain how its abstract components convey the subject: "Thus through the balance of curves, angles and squares, through broken or straight lines, or harmoniously flowing ones, through color harmony or discord, through vibrant or subdued tones, cold or warm, there arises a representation of the character which suggests clearly the person in question, and brings more pleasure to those who understand, than would an ordinary portrait representing only the figure and face."[3]

When Duchamp returned to Paris in 1919, he had already begun to establish the reputation of an artist who had abandoned painting in order to devote his life to chess. Indeed, in a letter written to Walter Arensberg from Buenos Aires a few months earlier, he had described himself as a "chess maniac," so it is no surprise that when Georges de Zayas (1898–1967) made a caricature of Duchamp—for a book featuring interviews with ten artists and a musician in Paris—he is shown playing the game to which he was so intensely devoted and, as in Dreier's figurative portrait, smoking a pipe and seated on a tall stool (fig. 2.2).[4] In all caricatures, select features are exaggerated to emphasize the most revealing and identifiable characteristics of a subject's physiognomy. In this case, de Zayas has exaggerated Duchamp's angular chin and lower jaw, reducing them to the bottom half of a rectangle, a geometric shape that has its counterpart in the semicircle that defines his nearly bald skull. (Duchamp had shaved his head as part of a cure for a scalp infection contracted in Buenos Aires.) Duchamp's arching back is so exaggerated as to resemble the letter *D*, referring, in this case, to the first initial of the artist's last name (although this may be a product more of happenstance than intent).

Caricature artists will use everything at their disposal to facilitate the identification of their subject; not only will they freely accentuate a person's physical appearance, but they will incorporate into their images whatever other elements are knowingly associated with the person being depicted. In the case of Georges de Zayas's portrait *Marcel Duchamp*, the pipe, chess pieces, and stool serve this purpose. These same three elements appear again—but rearranged and in a more compressed format—in a collage portrait of Duchamp by Baroness Elsa von Freytag-Loringhoven (1874–1927), an eccentric German poet and collage artist who resided in New York during the years of World War I.[5] Duchamp's face is rendered in a stylized version of cubism but colored with the palette of German expressionist painting. His long pipe dangles from his smiling lips, while the spokes and rim of his *Bicycle Wheel* touch the side of his head, its shape distorted to fit within the irregular format of the composition.[6] The chess piece below them resembles the shape of a bottle, likely a reference to Duchamp's *Belle Haleine: Eau de Voilette* perfume bottle, to which is attached a portrait of his female alter ego, Rrose Sélavy (see pls. 14a, 15, 16, 17). The allusion to chess continues in the repeated geometric forms at the bottom of the composition, where, at the far

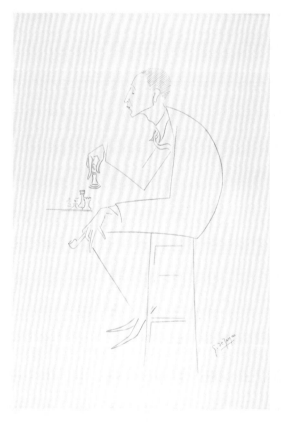

fig. 2.2 | *Marcel Duchamp* by Georges de Zayas, lithograph, 1919. Philadelphia Museum of Art, Pennsylvania; The Louise and Walter Arensberg Collection, 1950

right, a form resembles a chess queen similar to the one Duchamp designed for a rubber stamp set that he made in Buenos Aires in 1918.

Like Dreier, with her figurative and abstract portraits of Duchamp (see fig. 2.1 and pl. 10), Baroness Elsa followed her relatively straightforward depiction of the artist with one decidedly more symbolic than naturalistic (pl. 13). Composed of a wine glass filled with a variety of elements that she found on the streets or pilfered from department stores (after her husband returned to Germany in 1914, she was left penniless), this object was probably conceived as a trophy for Marcel Duchamp, an artist who unleashed the potential of everyday objects for artistic expression (although that was not Duchamp's intent when he conceived of the readymades). As the Baroness's biographer observed, the use of a wine glass may have been a reference to Duchamp's *Large Glass,* but this glass is filled with objects that Elsa used to adorn her own body: exotic bird feathers, coiled and distended springs, a tassel, shards of fabric, cheap costume jewelry, and, at the summit, what appears to be a fishing lure.[7] If the last element is in fact a lure, it could have been designed to ensnare Duchamp, for whom Baroness Elsa harbored a romantic infatuation (which to her great disappointment was never reciprocated). Whatever the interpretation, the work has an unquestionable historical significance, as it is the very first assemblage (a sculpture made entirely of found objects) in the history of Western art.

Baroness Elsa's portrait was made after Duchamp's return to the United States in 1920, where, with the exception of a six-month sojourn to Paris in 1921, he remained for over two years, a period of intense activity that coincided with the most public manifestation of the Dada movement in New York. During this period several of Duchamp's friends and colleagues requested that he serve as the subject of portraits, beginning with an elegant drawing on paper made by the Italian-American futurist painter Joseph Stella (1877–1946) (pl. 12). Stella likely met Duchamp as early as 1916, when their work was shown together in a group exhibition at Bourgeois Gallery in New York, but they got to know one another better in 1920 and 1921, as a result of their association with the Société Anonyme, the museum of modern art founded by Katherine Dreier, Duchamp, and Man Ray. Stella was a remarkable draftsman, possessed of a natural talent that he put to use for years working as a magazine illustrator. His profile portrait of Duchamp was probably made from life, for the precision and subtlety of execution reveals nuances that a photographic print captures only with difficulty. The technique used is silverpoint, a medium developed in the Renaissance that is exceedingly difficult to use, since mistakes are difficult to correct. (Stella called it an "unbending inexorable" medium.) He exploited the ability of this technique to produce remarkably precise renderings. Stella sought aesthetic affiliation with the great Tuscan artists of the fifteenth century: "I dedicate my ardent wish to draw with all the precision possible, using the inflexible media of silverpoint and goldpoint that reveal instantly the clearest graphic eloquence."[8] Duchamp—who had renounced an art that was personally expressive in favor of one that was more precise and mechanical—would have admired these goals.

When Duchamp returned to the United States in 1920, his head was still shaved—as is documented in Stella's portrait—probably in a continued effort to

rid himself of the scalp infection he had contracted in Buenos Aires. His appearance shocked some friends. Ettie Stettheimer, for example, one of three sisters to whom Duchamp had given French lessons, was particularly dismayed: "His head shorn of its most vital, fluid and adventurous feature, the long hair he brushed firmly back," she wrote, "now his almost naked skull, though in itself correct enough, revealed with brutal frankness the structural bony materiality of the whole." She was most distressed by the fact that it caused him to appear too exposed, too revealing. "Samson, you know, lost his strength with his hair," she told him. "You seem to be in danger of losing your mystery!"[9] Ettie's sister Florine (1871–1944) was a painter, and she made two portraits of Duchamp in this period, both of which show him with closely cropped hair. In the first (see fig. 3.4), only his head appears in the center of a square-shaped canvas, while an aura seems to emanate from behind it to the periphery of the picture. The hovering effigy gives the appearance of an apparition, like the head of St. John the Baptist in paintings by Gustave Moreau, or as in the detached, floating heads of Odilon Redon. Sources in symbolist paintings were probably not far from Florine Stettheimer's mind when she painted this picture, for, as if inspired by a black-and-white reproduction from a book, it is rendered nearly entirely in grisaille, its only coloration provided in the subtle orange tonality given to the lips.[10]

Stettheimer followed this portrait with a far more ambitious and complex portrayal of Duchamp in the company of his female persona, Rrose Sélavy (pl. 22), an unusual depiction of both personages in the same image. Here Duchamp sits with legs crossed in an upholstered chair labeled with his initials as he works a crank that elevates the effeminate Rrose, dressed, appropriately (considering the meaning of *rose* in French), entirely in pink. Above Duchamp floats the image of a detached horse's head, derived from a chess piece that the artist designed a few years earlier. This head is encased between two translucent panels inscribed with rectilinear divisions to resemble Duchamp's *Fresh Widow* (Museum of Modern Art, New York), a work from 1920 signed by Rose Sélavy.[11] Between the two figures a clock appears, perhaps a reference to a chess clock or, as I have suggested elsewhere, to the fourth dimension, the passage of time necessary to comprehend the transformation from one persona to the other.[12] Even though this painting was made in 1923—by which time Duchamp had cured his scalp problem—both figures in this painting are depicted with little hair. In her pictures Stettheimer chose to present her memory of reality, or at least her interpretation of it. It is this freedom from verisimilitude that allows her paintings to be infused with potent symbolism, as in the case of this portrait, in which a fictional character convincingly makes an appearance.

In the same year that Stettheimer envisioned Rrose Sélavy in New York, Man Ray painted her portrait in Paris, where he had followed Duchamp and would live for the next twenty years. Man Ray (1890–1976) had dedicated his previous ten years in America to painting, but by the time he met Duchamp, he had already come to realize that traditional modes of artistic expression were of little consequence in his effort to ally himself with the avant-garde. Some years earlier Man Ray had purchased a camera with the intention of taking pictures of his paintings, and it was in his capacity as a skilled photographer that, in 1920–21,

Duchamp enlisted his services to document several projects on which he was working: dust accumulating on the surface of *The Large Glass;* the movement of a motorized optical device that he had constructed; and the physical manifestation of his female alter ego. As indicated above, in addition to the well-known photographs that Man Ray took of Rrose (pls. 14a, 17), he made at least one formal painted portrait of her (see pl. 21), but she is curiously not depicted as a woman, but as Duchamp himself in a straightforward frontal pose. The only reference to her name comes in the lower-right corner of the composition, where the rendering of a single rose is inscribed with a French-Latin word play that provides her last name: "Cela vit."

After moving to Paris in 1923, Duchamp devoted more time to playing chess than to becoming an integral figure in the French art scene. Although he was photographed on numerous occasions, he was not the subject of any painted portraits. That would change in 1936, when he made a return visit to the United States and was asked to pose for a formal portrait by the American realist painter Daniel MacMorris (1893–1981). MacMorris had a studio in the Carnegie Hall Building on West 57th Street, next door to Katherine Dreier, whose guest Duchamp would be during this trip. (He came to repair *The Large Glass,* which Dreier owned and which had been damaged in transit after its first showing at the Brooklyn Museum ten years earlier.) MacMorris was a muralist and an accomplished portrait painter, primarily of civic leaders in his hometown of Kansas City, Missouri. Realizing that painting Duchamp would expand his repertoire internationally, he asked Dreier if she would intercede on his behalf. Duchamp agreed, but only if MacMorris could accommodate his constrained schedule. After completing work on the glass, Duchamp went to California to see the Arensbergs. On his way back he stopped in Cleveland to see his *Nude Descending a Staircase,* on loan for an exhibition celebrating the Cleveland Museum's twentieth anniversary. Duchamp wrote to MacMorris from Hollywood (in English; pl. 31) and again from Cleveland (in French; pl. 33), letting him know that he was willing to pose for his portrait but could only spare about an hour between trains. In the end, Duchamp showed up at MacMorris's studio at the appointed hour and gave more time than they had agreed on, enough for MacMorris to produce a vibrant and exceptionally life-like sketch (pl. 30). He asked if Duchamp could return for another session before returning to Europe, and Duchamp willingly obliged. Two days later, Duchamp was back in MacMorris's studio, where he sat for another portrait study (pl. 32) and, after lunch, posed for two more hours as MacMorris sketched out the final composition in oil (pl. 34).

The finished canvas—which MacMorris completed in Duchamp's absence a year later—portrays the forty-nine-year-old artist in a formal suit and tie, not customary attire for a portrait of an artist in this era. His ubiquitous pipe in hand, Duchamp looks directly into the eyes of the viewer, his features dramatically lit from below by a bright light that also serves to illuminate a portion of his infamous *Nude,* which hangs directly behind him on the wall. While Duchamp posed, MacMorris seized the opportunity to ask the Frenchman about this painting, which had created such a sensation when it was shown in the Armory Show some twenty-three years earlier. A few days before this second meeting

in MacMorris's studio, *Time* magazine published a report on Duchamp's visit to Hollywood. The journalist asked some general questions about painting, whereupon Duchamp quipped: "My attitude towards Art is that of an atheist towards religion. I would rather be shot, kill myself or kill someone than paint again."[13] It is hard to imagine that MacMorris would have missed this shocking statement, for he began his questioning of Duchamp by asking whether he considered his *Nude* a painting. "No," he surprisingly responded, "it is an organization of kinetic elements, an expression of time and space through the abstract expression of motion. A painting is necessarily a juxtaposition of two or more colors on a surface. I purposely restricted *The Nude* to wood colorings so that the question of painting, per se, might not be raised."[14]

The notoriety of this picture overshadowed the identity of its author. When Duchamp stopped in Cleveland to see his *Nude*, museum officials were shocked to see him, for they had assumed he was dead. (In fact, a museum label inexplicably gave the years of birth and death as 1889–1933). "I have often meditated on that incident," Duchamp told MacMorris, "about the reality of life in inert things and the ghostly unreality of human existence itself. Insofar as the public was concerned, I was dead; but here this creation, this child of mine, was continuing on and persistently gossiping its cryptic message to the world."[15]

Duchamp's anonymity was legendary, which partly accounts for the fact that he was rarely portrayed by other artists in the 1930s and 1940s, a situation that would change dramatically in the 1950s and 1960s. In these years he became increasingly well known in Europe, not just for his painting of a descending nude but as a profound intellect whose ideas had changed the very nature of art. Among the first to immortalize Duchamp in this way was Marcel Gromaire (1872–1971), a minor French artist whose early work was influenced by fauvism and expressionism, but who later developed a stylized graphic technique derived from Fernand Léger. Gromaire's *Portrait of Marcel Duchamp* (private collection) shows the artist surrounded by skyscrapers, an environment associated more with New York than Paris. This may have been precisely what Gromaire intended, because by the early 1950s, when this print was made, few Parisians thought of Duchamp as part of the French art scene, knowing that after World War II he had moved permanently to the United States.

Gromaire was a product of what is now known as the School of Paris, an international group of painters and sculptors who came of age between the wars but whose work lacks the stylistic coherence to be identified as part of a unified movement. Among these artists were two of Duchamp's siblings: his sister Suzanne (1889–1963) and his older brother Jacques Villon (1875–1963). Suzanne—who in 1921 married Duchamp's former studiomate from New York, Jean Crotti (and with him founded Tabu, an offshoot of Dada)—depicted her brother Marcel in an etching made in 1953, when he was sixty-six years old (pl. 53). The likeness is a good one. She depicts her older brother with arms folded, seated in a chair, most likely in the apartment she shared with her husband in Neuilly (a studio that Duchamp himself had once occupied). In the background can be seen canvasses stacked against the wall, probably paintings by Suzanne and Crotti. The inclusion of this detail may not have been entirely incidental, for by that time

fig. 2.3 *Portrait of Marcel Duchamp* by Isabelle Waldberg, cast bronze on stone base, 1958. Private collection

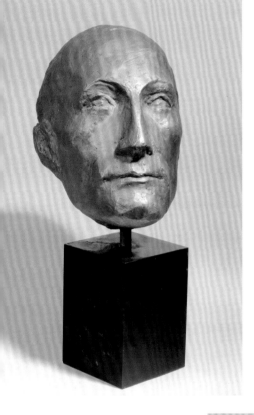

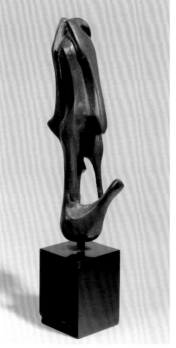

Duchamp was infamous among artists for having abandoned painting. This does not mean, however, as many have mistakenly concluded, that he had abandoned painters. To the end of his life, he steadfastly supported and encouraged the activities of other artists, especially the efforts of his sister and brother-in-law, offering advice whenever requested, facilitating sales, and helping to organize exhibitions of their work in Paris and New York.

Jacques Villon devoted his life to painting and printmaking, never wholly abandoning the cubist style that had informed his earlier work. This is evident in his *Marcel Duchamp* (pl. 52), an etching that shows his younger brother seated in an armchair and supporting his head with one hand, the tight angular features given to his face seemingly amplified to define the fragmented space that envelops him (as if his thoughts had the transformative power to control the structure of his surroundings). This reading is supported by an analysis of the artist's right hand, which, as it advances toward the viewer (and away from the arm of the chair), becomes increasingly part of the picture's angular structure, its linear construction used more to define cubist space than to articulate the intricacies of human anatomy. It is unlikely that Duchamp posed for this work, although he may have done so for Villon's *Marcel Duchamp,* a late but colorful cubist composition painted in 1952 that served to illustrate an important article about Duchamp in *Life* magazine (pl. 51). The picture was reproduced full-page and in color, although editors of the magazine were quick to inform their readers that it was a comparatively traditional picture, which stood in sharp contrast to the more innovative work of the younger brother. "Though cubist in itself," a caption read, "this portrait seems conservative next to the work of Dadaist Duchamp."[16]

Although Duchamp had made New York his home, he returned to Paris often to visit friends and relatives and to help with the organization and installation of several International Surrealist exhibitions. He kept his small studio on the rue Larrey until 1946. In that year he turned his keys over to Isabelle Waldberg (1911–1990), a young French sculptor whom he had befriended when she lived in New York in the early 1940s. Although married to Patrick Waldberg, a well-known writer on surrealism, she maintained an intimate relationship with Robert Lebel, author of the first monograph on Duchamp. In 1958, a year before Lebel's book appeared, Waldberg made several sculpted portraits of Duchamp, the first a crude rendering of his facial features in clay, subsequently cast in bronze (fig. 2.3). Although the work is rough in execution, Waldberg nevertheless managed to accurately record the structure of Duchamp's head, resulting in a reasonable likeness of the artist.[17] In the same year this portrait was made, Waldberg made an essentially abstract sculpture that was also curiously entitled *Portrait of Marcel Duchamp* (fig. 2.4); only when its subtitle is known—*The Smoke from His Cigar*—can we come to understand how the undulating, amorphic, Arp-like shapes have anything to do with Duchamp.

fig. 2.4 *Portrait of Marcel Duchamp: The Smoke from His Cigar* by Isabelle Waldberg, cast bronze on stone base, 1958. Private collection

After Lebel's monograph appeared in 1959, Duchamp's life changed. Not only did he become better known as a result of its publication, but he was seemingly resuscitated from the oblivion of history by artists and critics from around the world who realized that the ideas he introduced—particularly as they pertained to the readymades—anticipated advances in contemporary art by nearly half a century. In the 1960s his ideas were so widely accepted that some wondered if painting had a future, a conclusion not entirely dissimilar from one Duchamp had reached regarding his own work as early as 1918. Whereas some championed his precedence, others blamed him for having destroyed the future of painting. This was never his intention. When pressed, Duchamp always emphasized that his ideas were not meant to apply to others. "I don't want to destroy art of any-body else," he told an audience at the Museum of Modern Art in 1961, "but for myself, that's all."[18] Many did not see it that way. Indeed, it was probably in reaction to the myth that Duchamp had contributed to the death of painting that three young artists living in Paris in the mid-1960s—the Spaniard Eduardo Arroyo (b. 1937), the Frenchman Gilles Aillaud (1928–2005), and the Italian Antonio Recalcati (b. 1938)—were inspired to create a series of pictures that depicted the tragic death—by murder!—of Marcel Duchamp.

Given the provocative title *Live and Let Die, or the Tragic End of Marcel Duchamp,* the eight paintings in this series were placed on public display in Paris in the fall of 1965, as part of an exhibition called "La figuration narrative dans l'art contemporain," organized by the Galerie Creuze. The sequence begins innocently enough with a straightforward replica of Duchamp's *Nude Descending a Staircase,* but the next panel shows a man seen from the back ascending a staircase in a typically Parisian hallway. In the next scene the man's identity is revealed, as the three artists are shown murdering Duchamp: Aillaud, wearing sunglasses, looks on in complicity; Recalcati, cigarette in mouth, restrains the artist, while Arroyo, his back to viewers, pulls aggressively at Duchamp's necktie. The next picture shows Duchamp's *Fountain,* which the three artists probably regarded as the object most responsible for the death of painting (since it had forced the public to confront issues raised by the readymades). The next panel presents the first evidence that Duchamp is dead: he sits lifeless in a chair, his head slumped down, a reproduction of his *Fluttering Heart* nearby, as if to suggest that his heart has given out or, conversely, that sadness permeates the scene. That the artists felt anything but regretful of their actions is revealed in the canvases that follow: after a replica of *The Large Glass,* the artists are shown throwing Duchamp's disrobed corpse down the very staircase he ascended earlier in the series (an obvious visual parody with the painting that begins the series, *Nude Descending a Staircase*). The final canvas depicts Duchamp's funeral, his coffin draped in an American flag and held by pall bearers made up of the leading figures of the Nouveau Réaliste group in Paris and the pop art movement in New York: Robert Rauschenberg, Claes Oldenburg, Andy Warhol, Martial Raysse, Pierre Restany, and Arman. If there were any doubts as to their intentions, Arroyo, Recalcati, and Aillaud later composed a statement that read in part: "Thus Marcel Duchamp can be seen to be a particularly successful defender of bourgeois culture. He endorses all the falsehoods for which culture

anaesthetizes lively energies and makes it live in illusion, thus condoning trust in the future."[19]

As it happened, Duchamp was in Paris when the exhibition went on view. A few days before the opening, he was coerced by the owner of the gallery to stop by and see these pictures. From all reports, Duchamp was amused, and he graciously signed the guest book. However, some fifty of his friends—including André Breton, Robert Lebel, and Arturo Schwarz—were so angry that they signed a statement, called "The Third Degree of Painting," that condemned the series as "a loathsome crime disguised as a ritual assassination."[20] One visitor to the gallery pulled out a pocket knife and attacked the third painting in the series, which shows Arroyo choking Duchamp. When asked later for his reaction to the display of these pictures, Duchamp thought that it was something better left ignored. As he explained, "these people want to get noticed, that's all." Although Duchamp was not customarily critical, in an ironic statement that was directed at the artists of the series, he could not resist saying, "It was awful as painting."[21]

* * *

The influence of Marcel Duchamp on contemporary art is a matter of public record. In 2004, over five hundred British art professionals nominated Duchamp's *Fountain* "The Most Influential Artwork of the 20th Century," and two years later, British art students named Duchamp the most influential artist in history.[22] Although the polls were conducted in England, it is likely that the outcome would have been the same if they had been taken in the United States. Since the mid-1950s, when paintings by Jasper Johns took on the appearance of flags, targets, and numbers, and Robert Rauschenberg's collages and assemblages incorporated actual tires, stuffed animals, and other sundry materials, the precedence of the readymade has been widely acknowledged. The importance of Duchamp's contribution would be confirmed in the 1960s, when subjects like soup cans, advertisements, and comic books established a new movement in American art, one that was at first called neo-Dada, soon to be replaced by the term *pop*.

The first artists from this period to depict Duchamp in their work were Rauschenberg and Johns. In 1960, Rauschenberg made an elaborate combine painting (the name he used for assemblages combining various found objects and materials) that he dedicated to Duchamp and his wife Alexina (known as Teeny). In terms of traditional portraiture, the painting contains no obvious reference to Duchamp, although it has been suggested that the entire format of the picture may have been intended to reflect that of *The Large Glass*.[23] In *According to What,* an exceptionally large painting from 1964, Johns was far more direct in his reference to Duchamp: in a separate canvas hinged to the lower-left corner of the painting, he reproduced Duchamp's *Self-Portrait in Profile*—not a straightforward replication of the image, but the effect of a shadow created by it. He did this, he later explained, because he wanted to create a confusion of authorship, "a kind of play on whose work it is, whether mine or his."[24] In 1971, Johns, who often reworks imagery from earlier paintings in a variety of media, reproduced the hinged fragment of this painting in a lithograph (pl. 67). Next to the Duchamp

portrait, Johns has added a burst of paint, but in such quantity that it appears to have dripped before it had a chance to dry. The specific intent of this detail is unknown, although with Duchamp's well-known admonition against expressive painting, it is reasonable to assume that Johns intended the irony.

After his death in 1968, Duchamp was immortalized in America with a large-scale retrospective organized by the Philadelphia Museum of Art and the Museum of Modern Art in New York (1973), followed a few years later by his first major European museum exhibition, which marked the opening of the Musée National d'Art Moderne–Centre Georges Pompidou in Paris (1977). For this exhibition, director Pontus Hulten enlisted the assistance of Jennifer Gough-Cooper and Jacques Caumont, researchers who were in the process of gathering information for a detailed chronology of Duchamp's life. They proposed beginning the exhibition with a series of pictures illustrating the life of Duchamp. To create the series, they commissioned André Raffray, a French realist painter who had earlier worked as an animator for the cinema. An appropriate choice, Raffray not only grew up in a small Norman town (similar to the one in which Duchamp was raised) but was fascinated by the artist; in addition, he had already painted several narrative scenes based on the history of French cinema. Over a period of two years, he completed *La vie illustrée*, twelve gouache panels that reconstruct major events in Duchamp's life not otherwise recorded—from painting his first picture at age fifteen, to repairing *The Large Glass* (fig. 2.5), to standing next to his *Étant donnés* in the last year of his life. The informative and uplifting spirit of this series represents a fitting—albeit unintended—response to the negative message conveyed in the series of paintings by Arroyo, Aillaud, and Recalcati. For the Pompidou exhibition, Raffray's twelve gouaches were enlarged on sheets of transparent color film and displayed above the heads of visitors in a room designed to resemble the nave of a church. The intention was obvious: the series would have reminded viewers of scenes depicting the Life of Christ (or of some saint to whom a church was dedicated), narrative cycles that often fill the interior of churches, or, more specifically, it might have reminded viewers of the fourteen scenes that comprise the Stations of the Cross, which, to this day, line the interior of almost every Roman Catholic church.[25]

Curiously, the twelve panels in the series do not account for the eight years, from 1915 through 1923, during which Duchamp periodically spent time in New York, arguably the most important and productive period of his life. The omission, likely a consequence of the Francophile nature of the enterprise, was rectified when Raffray later added a thirteenth panel to the series, called *Chez Arensberg* (fig. 2.6), depicting a typical soirée at the apartment of Louise and Walter Arensberg. In this scene Duchamp is at the center of the composition, smoking a pipe and seated at a Shaker table (the type with a top that folds back and converts into

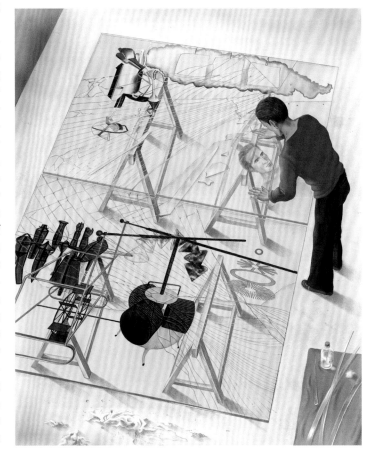

fig. 2.5 | *Marcel Duchamp: La vie illustrée: Marcel Duchamp repairing his large glass* The Bride Stripped Bare by Her Bachelors, Even, *after it was broken a few years earlier in transit, New Haven, 1936* by André Raffray, gouache and tempera on paper, 1977. Private collection

34

a chair). The image gives him the appearance of being enthroned, an appropriate allusion because he was often identified by visitors to these gatherings as the guest of honor. Beatrice Wood is seated in an upholstered armchair in the lower-left corner, the location where an artist often places his or her signature. (Wood provided a great deal of information about what went on at the Arensbergs.) Henri-Pierre Roché and Francis Picabia are playing chess, Picabia executing the last move in a game that determined whose magazine would continue publication, Roché's *The Blind Man* or Picabia's *391*. (Roché lost, so his magazine ceased publication after only two issues; Picabia's continued for seven more years.) In addition to Picabia, among those in this scene who made portraits of Duchamp are Joseph Stella (at left, with a guitar in hand), Man Ray (behind the chess players), and Baroness Elsa von Freytag-Loringhoven (the provocatively attired figure who saunters into the room from the right, smoking and drinking).

Many artists who portray other artists in their work do so with the intention of paying homage to an individual whom they considered a vital force in their own creative endeavors. This is what motivated Ray Johnson—who, for over forty years (until his untimely death in 1995), worked primarily in the medium of collage—to make hundreds of works dedicated to specific artists or writers, ranging from Gertrude Stein, Marianne Moore, and James Joyce to Duchamp, Piet Mondrian, Rene Magritte, Jackson Pollock, Barnett Newman, Joseph Cornell, Jim Rosenquist, Andy Warhol, Chuck Close, Joseph Kosuth, and many others.[26] In this group, Cornell and Duchamp figure prominently, since they were both such important early influences in his work. Johnson saw and admired Duchamp from afar at various art gatherings in New York in the 1960s; they were introduced on several occasions, but a closer friendship never developed. Duchamp appears in Johnson's work for the first time in a collage from 1968 (pl. 82), a reworking of the well-known photograph of Duchamp with his head shaved in the pattern of a comet (pls. 18, 19, 20). The figure that appears in the collage is Toby Spiselman, but it is too severely effaced to be easily identified. Spiselman wears a scarf that resembles the fur collar of Rrose Sélavy, while an upraised hand mimics her pose. The star at the top is not created by shaving but is a toy sheriff's badge, typical of the humor and irony that permeates much of Johnson's work (but which often goes unnoticed). Duchamp's name appears again in another collage, from 1971, entitled *The Frog in the Snake*. Here the connection with Duchamp is more verbal than visual, as printed words within the image—"The Snake is in the Fog"—generate an obvious wordplay with the title. Finally, in 1987 Johnson created what is perhaps his most complex and intellectually engaging depiction of the artist in a collage called *Duchamp with "Blue Eyes"* (pl. 88). Here, Duchamp's profile is filled with a sequence of fragmented images arranged in the pattern of a repeating staircase, clearly an allusion to his *Nude Descending a Staircase,* while at the very top of the image, a scientific diagram for lenses appears, a nod to Duchamp's interest in optics as well as to his admonition against retinal painting. This same line of reasoning may have caused Johnson to allow two patches

fig. 2.6 | *Chez Arensberg* by André Raffray, gouache and tempera on paper, 1984. Private collection

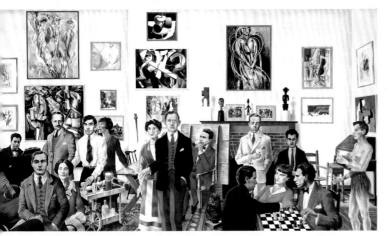

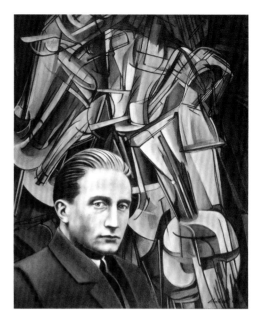

of blue—made with pastel rubbed into the surface of the paper—to indicate the color of Duchamp's eyes (emphasized in the title of the work). Duchamp's eyes were not blue, a fact surely known to Johnson. Of course, the image was not intended as an exercise in verisimilitude but as an attempt to elevate the status of his chosen subject to a romantic ideal, as Johnson had done previously in his depictions of various celebrities (James Dean, Elvis Presley, Shirley Temple, Marilyn Monroe, and so on).

Throughout the 1980s and 1990s artists continued to incorporate images of Duchamp in their work, or they created entirely new ones to suit their particular needs. Sarah Austin (1935–1994), daughter of museum director A. Everett "Chick" Austin (best known for having introduced surrealism to the United States), began her career by making shadow boxes, somewhat in the manner of Joseph Cornell. Many of the boxes were tributes to specific artists, composers, and literary figures she admired. Duchamp was the subject of at least four of these boxes, one of which (private collection) juxtaposes Irving Penn's photograph of Duchamp (see pl. 48) with a photograph of Albert Einstein. The images are reproduced on interlocking puzzle parts, portions of which have been interchanged, causing the identities of Duchamp and Einstein to fuse. The use of puzzle parts may have been intended as a commentary on the enigmatic personalities and accomplishments of Austin's respective subjects, or, more likely, she used them as a device to acknowledge the individual accomplishments of two great geniuses in history.[27]

Many contemporary artists who have used Duchamp as a subject in their work do so with the intention of acknowledging his genius, while others are attracted to his invention of a female alter ego. The Italian painter Carlo Maria Mariani has incorporated numerous references to Duchamp in his work since the mid-1980s. In large paintings that resemble works produced by the great masters of the Renaissance and baroque, Mariani has subtly interspersed works by Duchamp—*Fountain, With Hidden Noise, Bottle Rack,* and three erotic objects from the 1950s—within the context of predominantly classical settings. The results can often be disconcerting, and they are always provocative. In his *1919/1990* (pl. 90), Mariani has ingeniously fused Man Ray's photographic *Rrose Sélavy* (pl. 14a) with Leonardo da Vinci's *Mona Lisa* (the folded hands resemble those in the famous Renaissance painting). But Mariani has taken the reference one step further: by adding a mustache and goatee to Duchamp's face, he has amusingly combined the identity of Rrose Sélavy with that of *L.H.O.O.Q.,* Duchamp's infamous defacement of the *Mona Lisa,* where he added—graffiti-style—the same two elements of facial hair.

As our culture changes, Rrose Sélavy seems to be making ever-more frequent appearances in the paintings and drawings of contemporary artists. She is rendered in the form of an apparition, for example, in Mark Tansey's *The Enunciation* (pl. 92), a painting that shows Duchamp seated in a train compartment and smoking a cigarette as he looks casually out the window and catches a glimpse of Rrose Sélavy as she passes by in the window of a train heading in the opposite direction. The fictional event that Tansey reconstructs is a train ride from Paris, one of many that Duchamp took to visit his parents in Rouen. We might imagine that this trip took place in December 1911, the date of Duchamp's painting *Sad*

fig. 2.7 | *Marcel Duchamp* by Jacques Moitoret, oil on canvas, 2004. Private collection

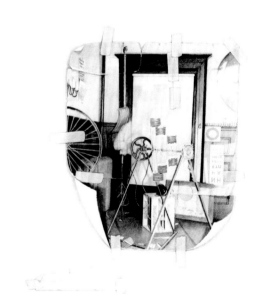

fig. 2.8 | *The Recurrent, Haunting Ghost* by Jonathan Santlofer, pencil on paper, 2005. Private collection

Young Man on a Train (Peggy Guggenheim Collection, Venice), which, in a cubo-futurist style, renders the artist in multiple views, as if to capture the effect of a moving train. This painting was infamously described by an art historian as a depiction of the artist "masturbating . . . on a jouncing train," an interpretation that did not elude Tansey, who shows the artist with his left hand nestled in his crotch, an appropriate sexual reference, perhaps, to record the moment when Duchamp foresaw the birth of his female identity.[28] The title Tansey gave to his painting—*The Enunciation*—was intended as a pun on *The Annunciation,* for Rrose appears to Duchamp like the Archangel Gabriel to Mary, informing him of a momentous future event: the birth of Rrose. Just as medieval scholars of Christianity believed that Mary became impregnated upon hearing the angel's voice, in Tansey's painting, Rrose is born upon enunciating her name. The name itself is specifically referred to in the overall rose-violet coloration that Tansey gave to the picture.[29]

A profound respect for what Duchamp accomplished can be found in virtually every portrait made of him by contemporary artists. Seattle painter Jacques Moitoret included his *Marcel Duchamp* (fig. 2.7) in a series of sixteen paintings commemorating painters whom he believes made the most lasting contributions to the development of modern art. Moitoret placed a photographic likeness of Duchamp against the backdrop of *Nude Descending a Staircase,* unwittingly presenting Duchamp in a position similar to that in the portrait made more than half a century earlier by MacMorris (pl. 34). Unlike the earlier portrait, Moitoret depicts Duchamp as a young man, at the approximate age when he painted *Nude Descending.* The artist feels that Duchamp's *Nude* is one of the great icons of the twentieth century, "right up there," he explains, "with the female robot in Fritz Lang's *Metropolis.*"[30] Duchamp's *Fountain* attains a similar iconic status in Jonathan Santlofer's *Portrait of Richard Mutt* (pl. 95), although the close juxtaposition of Duchamp's face with the urinal is meant to be comically uncomfortable. The portrait is made with hydrocal, a material like plaster that Santlofer cuts into, creating the effect of bas-relief, a technique also used in making his *Portrait of Marcel Duchamp and Rrose Sélavy* (pl. 96). Santlofer recently turned his talents to writing detective novels, a series of very successful books that are all based on crimes that take place in the New York art world. The same sense of admiration that he engenders for the heroine of these novels can be found in his various portraits of Duchamp, including one drawn in a trompe l'oeil manner (fig. 2.8) and executed with a deft illusionism matched only by the intriguing fictional narratives he masterfully creates in his writing.

Most artists who have made portraits of Duchamp rely on extant photographs of the artist. Rob Wynne, for example, based his portrait of Duchamp (fig. 2.9) on Alfred Stieglitz's 1923 photographic portrait of the artist (pl. 24). The Wynne portrait is executed entirely with black thread sewn through vellum (the excess visible through the translucent material), an oblique reference, perhaps, to Duchamp's *Three Standard Stoppages,* 1913–14 (Museum of Modern Art, New York), in which

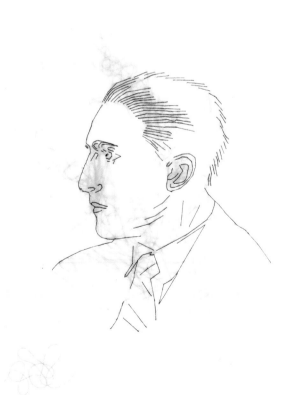

fig. 2.9 | *Marcel Duchamp* by Rob Wynne, string on paper, 2004. Private collection

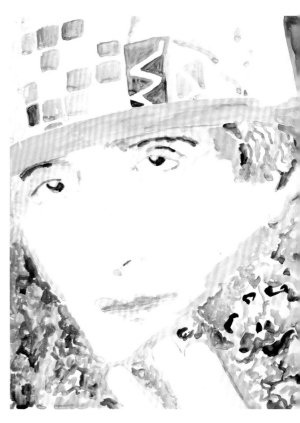

the artist dropped three sections of thread onto a canvas surface to create a new unit of measurement based on the laws of chance. What attracts Wynne to Duchamp is what he calls the artist's "invisible reality"—that is to say, the things Duchamp created that cannot be seen but only really understood and appreciated as products of pure thought. Wynne's friend and colleague Jane Kaplowitz based her *Portrait of Rrose Sélavy* (fig. 2.10) on Man Ray's photograph from 1921 (pl. 17). She used a closely focused view of Rrose's face to create a delicate watercolor portrait, rendered with a delicacy and sensitivity reminiscent of Florine Stettheimer (whom she has also portrayed, and for whom she has professed admiration). Finally, Nancy Becker's portrait of Duchamp (fig. 2.11) is appropriated from Man Ray's painted portrait of Rrose Sélavy (see pl. 21). Executed at the same size as the lost original, Becker has elected to change the medium from oil to pencil, tracing multiple images of the artist on translucent paper, causing him to appear as a ghostly apparition. Like her husband, the artist Richard Pettibone (see pls. 72, 73), Becker has long admired Duchamp, and through their work they have both paid homage to this important influence on their lives as artists.

Whereas most artists have relied on photographs or work by other artists in creating their depictions of Duchamp, some—as we have seen with Jasper Johns (pls. 66, 67) and Ray Johnson (pl. 88)—have used his *Self-Portrait in Profile*. The English artist Andrew Lord, for example, has shaped the contours of large ceramic vessels into a shape mimicking Duchamp's profile portrait (a technique he has also used with the profiles of Johns, Picasso, and Gauguin) (pl. 99). Like diagrams used by cognitive psychologists in figure-ground experiments, the portrait only becomes visible when the viewer concentrates on the negative space that surrounds the vessel. Similarly, Tom Shannon's *Mon Key*—a title that puns on the word "monkey" and the Franglais combination of "*mon*" (my) and "key" (*klee*)—also makes use of Duchamp's *Self-Portrait in Profile*, but Shannon has replicated Duchamp's profile on the side of an ordinary house key, as if to suggest that this object could offer a key to understanding Duchamp. Shannon, both an artist and inventor (with several patents to his name), knows only too well that no single key of this type can exist, though he readily concedes that for him, the example of Duchamp has unlocked many doors.

There can be no question that Marcel Duchamp continues to inhabit the creative imagination of contemporary artists worldwide and that his influence will continue long into the future. This situation is no comfort to conservative art critics, many of whom, in their angst-ridden despair, blame Duchamp for everything they feel is wrong with the world of contemporary art. To view the situation in a more positive light, it would be more accurate and productive to blame Duchamp for everything that is right with contemporary art, for he can—and, for that matter, should—be held responsible for having moved the process of making art from the eyes to the brain. Just as his readymades elevated the status of ordinary objects, he has forced us to ask questions about the very nature of art, an inquiry that seems every bit as vital today as it was a century ago. It is perhaps for this reason above all others that artists continue to embrace Duchamp as a still-living presence, a "recurrent, haunting ghost," whose ideas have—as Jasper Johns once so eloquently expressed it—"changed the condition of being here."[31]

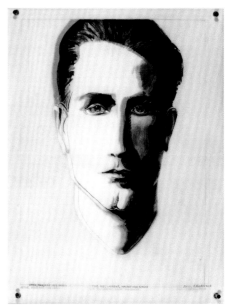

fig. 2.10 | *Portrait of Rrose Sélavy* by Jane Kaplowitz, watercolor on paper, 2004. Private collection

fig. 2.11 | *Man Ray's Rrose Sélavy* by Nancy Becker, pencil on tracing paper, 2005. Private collection

Notes

1. "French Artists Spur on an American Art," *New York Tribune,* October 24, 1915, sec. 4. I have analyzed this sculpture in much the same terms on two previous occasions: see Naumann, *New York Dada,* 103; and preface to *Jean Crotti: L'Oeuvre Peint [1900–1958], Catalogue Raisonné,* ed. Jean Carlo Bertoli (Milan: 5 Continents, 2007), 14–15. Duchamp's comment about "being as stupid as a painter" is discussed in "Eleven Europeans in America," ed. James Johnson Sweeney, *Museum of Modern Art Bulletin* 13, no. 45 (1946): 20–21, and in Francis Roberts, "'I Propose to Strain the Laws of Physics,' Interview with Marcel Duchamp," *ARTnews* 67, no. 8 (December 1968): 63–64 (interview conducted in 1963).

2. Letter from Katherine S. Dreier to Marcel Duchamp, April 13, 1917 (Papers of Katherine S. Dreier, Beinecke Rare Book and Manuscript Library, Yale University, New Haven, Connecticut).

3. Katherine S. Dreier, *Western Art and the New Era* (New York: Brentano's, 1923), 112.

4. Georges de Zayas was the brother of Marius de Zayas (1880–1961), a caricaturist and art dealer who played a major role in the avant-garde in the early twentieth century. In their native Mexico, George, Marius, and a younger brother, Rafael, worked as caricature artists until moving to New York in 1907. Marius settled in New York, where he showed caricatures at Alfred Stieglitz's 291 Gallery and later opened galleries of his own (see Marius de Zayas, *How, When, and Why Modern Art Came to New York,* ed. Francis Naumann [Cambridge, MA: MIT Press, 1996]). Georges de Zayas studied art in Paris, where he met some of the most important artists of the day. His *Portrait of Duchamp* was part of the portfolio *Caricatures par Georges de Zayas: Huit Peintres, deux sculptures et un musician très modernes* (Paris, 1919), which also featured caricatures of the following artists: Albert Gleizes, Henri Matisse, Marie Laurencin, Jean Metzinger, Francis Picabia, Pablo Picasso, and Georges Ribemont-Dessignes; the sculptors Alexander Archipenko and Constantin Brancusi; and the musician Eric Satie. The text for this publication was written by Curnonsky, pseudonym of the French writer Maurice Edmond Sailland (1872–1956), who later became a well-known food critic in France. Georges de Zayas returned to the United States in 1926, where he resumed his career as a caricature artist, contributing to *Colliers, Harpers Bazaar,* and the magazine section of the *New York Herald Tribune.*

5. For a reproduction of this collage, see Naumann, *New York Dada,* 171.

6. Irene Gammel noticed that this pipe closely resembles the white clay calumet used by native North Americans for rituals, better known as a peace pipe; see Gammel, *Baroness Elsa: Gender, Dada, and Everyday Modernity* (Cambridge, MA: MIT Press, 2001), 302.

7. Gammel, *Baroness Elsa,* 12.

8. Joseph Stella, "Confession," undated manuscript published in Barbara Haskell,

Joseph Stella (New York: Whitney Museum of Art, distributed by Harry N. Abrams, New York), 120, 220. Haskell reproduces another silverpoint and an oil-on-paper portrait that she identifies as *Portrait of Marcel Duchamp* and dates to "ca. 1923–24" (her fig. 145). Although the subject bears a certain resemblance to the silverpoint drawing discussed here, I do not believe the similarities are sufficient to make this identification with certainty.

9. Henrie Waste [pseudonym for Ettie Stettheimer], *Love Days* (New York: Alfred A. Knopf, 1923), 108.

10. The picture is unsigned and undated; for this reason, dates have been suggested that range from 1920 through 1926. For the latter, see Barbara J. Bloemink, *The Life and Art of Florine Stettheimer* (New Haven, CT: Yale University Press, 1995), 146. Because of Duchamp's closely cropped hair, I have given it a beginning date of 1920 and, to coincide with the second portrait (pl. 22), a terminal date of 1923.

11. There is a distinction between the spelling "Rose"—as Duchamp originally conceived the first name of his female persona in New York—and "Rrose" (with a double *r*), as he later modified the spelling in Paris. Generally speaking, all photographs taken by Man Ray of Rose in New York use a single *r,* while those taken later in Paris use a double *r.* In the present text, whenever the name is referred to in a generic sense (when no distinction is necessary), it is given as Rrose. For a more detailed explanation of the differences between these spellings and the New York versus Paris photo sessions, see Naumann, *New York Dada,* 228, n. 59. Please also see James W. McManus's essay in this volume for detailed information on the development of the persona of Rrose Sélavy.

12. Naumann, *New York Dada,* 153; see also Parker Tyler, *Florine Stettheimer: A Life in Art* (New York: Farrar, Straus and Company, 1963), 41.

13. "Cubism to Cynicism," *Time,* August 31, 1936, 22. This issue carries the same date—August 31, 1936—as Duchamp's second visit to MacMorris's studio (see the inscription in the lower-left corner of pl. 32). The magazine usually appeared on newsstands two or three days before the posted date.

14. "Marcel Duchamp's 'Frankenstein,'" *Art Digest* 12, no. 7 (January 1, 1938): 22.

15. Quoted in Daniel MacMorris, *MacMorris: 60 Years* (Mission, KS: Intercollegiate Press, 1974), 32–33. Duchamp told Pierre Cabanne: "The funniest thing is that for at least thirty or forty years the painting was known, but I wasn't." Cabanne, *Dialogues with Marcel Duchamp,* 45. See also Jennifer Gough-Cooper and Jacques Caumont, "Ephemerides on and about Marcel Duchamp and Rrose Sélavy, 1887–1968," in *Marcel Duchamp: Work and Life,* ed. Pontus Hulten (Cambridge, MA: MIT Press, 1993), entry for August 26, 1936.

16. Winthrop Sargeant, "Dada's Daddy," *Life,* April 28, 1952, 101. Villon made several other paintings of his brother in this period, as well as a number of drawings and etchings; see, for example, Daniel Robbins, ed., *Jacques Villon* (Cambridge, MA: Fogg Art Museum, 1976), 177–78; Dora Vallier, *Jacques Villon: Oeuvres de 1897 à 1956* (Paris: Éditions Cahiers d'Art, 1957), 91; and Colette de Ginestet and Catherine Pouillon, *Jacques Villon: Les Estampes et les illustrations: catalogue raisonné* (Paris: Arts et Métiers Graphiques, 1979), 356–57, 378–79.

17. In 1978, Waldberg mounted another cast of this portrait on a wood chessboard (Fonds national d'art contemporain, Paris) and a variant on another chessboard in a more elaborate assemblage (Kunstmuseum Berne). These two works are reproduced in *Étant donné Marcel Duchamp* 7 (2006): 41 and 98, in a special issue of the magazine devoted to Robert Lebel, Isabelle Waldberg, and Patrick Waldberg. For more on the Lebel-Waldberg relationship, see Paul Franklin's interviews with Jean-Jacques Lebel and Michael Waldberg in this same issue of *Étant donné.*

18. Duchamp's remark was made in response to a question posed by William C. Seitz, "The Art of Assemblage," a symposium held at the Museum of Modern Art, New York, October 19, 1961. Transcribed in John Elderfield, ed., *Essays on Assemblage* (New York: Museum of Modern Art, 1992), 150.

19. François Parent and Raymond Perrot, *Le Salon de la Jeune peinture: Une histoire, 1950–1983* (Montreal, 1983), 46; quoted in Eric de Chassey, "Paris–New York: Rivalry and Denial," in Sarah Wilson, ed., *Paris: Capital of the Arts, 1900–1968* (London: Royal Academy of Art, 2002), 349. All eight of the paintings in this series are reproduced in this publication (pl. no. 280, 402–3).

20. Quoted in Gough-Cooper and Caumont, "Ephemerides," entry for October 6, 1965.

21. Interview in Cabanne, *Dialogues with Marcel Duchamp,* 102–3.

22. The conservative English press had a field day with the identification of a urinal to such an elevated artistic status; see Nigel Reynolds, "'Shocking' Urinal Better Than Picasso Because They Say So," *The Daily Telegraph* (London), December 2, 2004; Waldemar Januszczak, "Font of All Modern Art," *The Sunday Times* (London), December 5, 2004; and Joanne Allen, "Marcel Duchamp Is Art Students' Favourite," *The Art Newspaper,* no. 170 (June 2006): 9.

23. The painting, *Trophy II (for Teeny & Marcel Duchamp),* is in the collection of the Walker Art Center, Minneapolis. For a comparison with Duchamp's *The Large Glass,* see Francis M. Naumann, "The Legacy of Marcel Duchamp," *Burlington Magazine* (February 1995): 138.

24. Quoted in John Coplans, "Fragments According to Johns: An Interview with Jasper

Johns," *The Print Collector's Newsletter* 3, no. 2 (May–June 1972): 31. My own analysis of the hinged canvas in this painting can be found in Francis M. Naumann, *Jasper Johns According to What & Watchman* (New York: Gagosian Gallery, 1992), 21–27.

25. The twelve panels in this series were also published in the form of a children's book, Jennifer Gough-Cooper and Jacques Caumont, *La vie illustrée de Marcel Duchamp* (Paris: Centre National d'Art et de Culture Georges Pompidou, 1977), trans. Anthony Melville and reprinted as *Marcel Duchamp: A Life in Pictures* (London: Atlas Press, 1999). For a reproduction of their display in the Duchamp exhibition at the Pompidou, see *André Raffray ou la peinture recommencée* (Paris: La Différence, 2005), 77.

26. These individuals and more were the subject of the exhibition *Ray Johnson En Rapport,* Feigen Contemporary, New York, November 2–December 23, 2006 (catalogue with an introduction by William S. Wilson).

27. For more on this artist, see Mary Ann Caws, "The Modernist Art of Sarah G. Austin," in *Sarah G. Austin: Meditations on Modernism* (Hartford, CT: Wadsworth Atheneum Museum of Art, 2000), 6–11.

28. Joseph Masheck, introduction to *Marcel Duchamp in Perspective* (Englewood Cliffs, NJ: Prentice-Hall, 1975), 5.

29. In an interview with Judi Freeman, Tansey indicated that the inspiration for this picture came from his reading of Thierry de Duve, wherein Duchamp's moment of revelation is discussed. See Freeman, "Metaphor and Inquiry in Mark Tansey's 'Chain of Solutions,'" in *Mark Tansey* (Los Angeles County Museum of Art; San Francisco: Chronicle Books, 1993), 67, n. 63. Freeman specifically identifies this book as *The Definitively Unfinished Writings of Marcel Duchamp,* published by MIT Press in 1991 [underscore added]. No book by this title is known, although de Duve did serve as editor of *The Definitively Unfinished Marcel Duchamp* (Cambridge, MA: MIT Press, 1991), where this moment of revelation is not discussed. De Duve does analyze Duchamp's *Sad Young Man on a Train* in his book *Pictorial Nominalism: On Marcel Duchamp's Passage from Painting to the Readymade* (Minneapolis: University of Minnesota Press, 1991), 39, in which he imagines that in this painting, Duchamp envisions himself moving on a train and simultaneously fixed on the station platform. "This Duchamp is imaginary," he writes, "supported by the phantasm of a subject of *enunciation* capable of situating himself outside history and able to comment on historical relativities from an absolute point of view, that of the 'oculist witness'" (emphasis added).

30. E-mail message to the author, August 11, 2007.

31. Jasper Johns, "Marcel Duchamp (1887–1968)," *Artforum* 7, no. 3 (November 1968): 6.

#3

BACHELORETTES

Janine A. Mileaf

Marcel Duchamp's female coconspirators collaborated with him to produce a mode of portraiture perfectly keyed to his oeuvre. The collection of paintings and objects defined here as portraits of Duchamp, by such fellow artists as Beatrice Wood, the Baroness Elsa von Freytag-Loringhoven, Florine Stettheimer, his sister Suzanne Duchamp, and Mary Reynolds, clearly escape preoccupations with natural likeness or interior consciousness characteristic of traditional portraiture.[1] Some of the works take surprising formats not easily recognizable as portraits. Yet rather than fully rejecting the genre, these artists share a focus on interchange, a necessary feature of portrait sittings. In so doing, they realize a series of works that explore Duchamp in terms of his métier and through a dialogue that highlights the gender relations embedded in these artistic interactions. This essay does not attempt a broad survey; instead it isolates a particular group of artworks from the interwar years to explore how Duchamp worked with women and how they, in turn, responded to him. In some cases the artists included here specifically chose to render a portrait in a nontraditional medium. In other instances the artists under discussion created works that, while not necessarily conceived as portraits, in fact function as portrayals because of the way they reflect and capture the persona of Duchamp in terms of his working methods. The resulting study surprisingly suggests that gender play, as emblematized by the character of Rrose Sélavy, fosters productivity. In collaboration with both real and invented women, Duchamp repeatedly spoke "of or by" female figures to forge a new kind of identity in portraiture.

In its denial of traditional notions of identity and self-expression, Duchamp's oeuvre stands against conventional goals of portraiture. It is therefore not surprising that portraits of him by his close companions also depart from these aims. Such strategies as the readymade or the adoption of multiple personae defy the notion that a subject's personality could at once be deeply inscribed within his or her consciousness and be revealed through physiognomy and/or symbolic ornamentation. As his friends took on the project of portraying Duchamp, they often turned away from his visage and toward his artistic production. That Duchamp's character would best be captured through an engagement with his practice, rather than his person, makes sense and indeed does not stray far from the portrait's goal to define a person's public stature. What marks a departure in these works, beyond frequent use of unconventional mediums, is the degree to which the boundaries between sitter and artist become blurred. Building on that interface, these works emphasize the collaborative nature of portraiture while referring to the artistic idioms of both their makers and their subject. In the end these portrayals of Duchamp by his female friends seem to argue that any attempt at defining another will turn back upon the self. They become as revealing of the artists' self-conceptions as they do of their ostensible subject, Marcel Duchamp.

Women feature equivocally in Duchamp's art and life. The recurring motif of the bride, who is pitted against her frustrated suitors in the celebrated *Large Glass,* establishes the feminine as an oppositional and elusive force in Duchamp's oeuvre. At the same time, Duchamp's alter ego, the character Rrose Sélavy, invites the feminine into the realm of productivity.[2] While Rrose is not an easily embraceable emissary of femininity, wearing as she does a name considered "awful" and a

fig. 3.1 *Fountain* by Marcel Duchamp, porcelain urinal, 1950 (replica of 1917 original). Philadelphia Museum of Art, Pennsylvania; gift (by exchange) of Mrs. Herbert Cameron Morris, 1998

I would like to thank Anne Collins Goodyear and James W. McManus for their thoughtful responses to this text, as well as Matthew Witkovsky for his unwavering eye.

gruff visage, she is credited with generating important aspects of Duchamp's oeuvre.[3] The drama enacted between the bride and her bachelors in *The Large Glass* registers at once as indicative of sexual relations in the historic past and as an allegory of the creative process. Through invented methods and vocabularies, Duchamp sets up a male-identified bachelor apparatus in the lower half of this work on glass and a flourishing figure of femininity in the upper region. One is not sure whether to read the sexual encounter here as a metaphor of artmaking, or to see the attempt to avoid all conventional pleasure in the sensuality of paint as symbolic of Duchamp's rejection of conventional family life. The unattainable bride, upon whom the bachelors set their desires, may be seen at once as a figure of sexuality and as a surrogate for the work of art—an equally elusive aim for the aspiring male painter. In either case the feminine term jams the works, making neither consummation nor construction possible. Rrose, on the other hand, acts as a functioning partner to Duchamp's lackadaisical self. She produces puns, readymades, and products for sale, satisfying the desire for completion.

These contradictory feminine tropes leave open questions as to Duchamp's artistic assessment of the value of his female counterparts. No doubt his lived relations are equally inconclusive. While an investigation of Duchamp's biography—and specifically his sexual relations with women—would indicate his ambivalence regarding romantic attachments (at least in the early years of his career), I want to focus instead on how he interacted artistically with women who were his friends, relations, or lovers—and what the work they produced together indicates about the surprising gendering of production in his oeuvre. What stands out plainly in a study of these works is Duchamp's penchant for collaboration *tout court*.[4] We find in focusing on images made of him that he frequently has some say in their formation. While an initial response to this trend might be to criticize Duchamp's authorial interference in his female friends' production, I argue that Duchamp found it fruitful to work with women, and at the same time that he was not overly eager to name himself as agent. Indeed, these exchanges suggest that creativity itself was enhanced through gender play that specifically relinquished the ownership of ideas.

One of the most enigmatic statements in Duchamp's extremely contradictory corpus regards the creative efforts of a woman. With respect to the controversy surrounding *Fountain* (fig. 3.1), the urinal that was submitted to the "First Exhibition of the Society of Independent Artists" in New York in 1917, Duchamp wrote a letter to his sister Suzanne in which he attributed the original idea to a "female friend under a masculine pseudonym."[5] He explained that she had sent in a urinal and then defended its decency. In a letter to Georgia O'Keeffe, Alfred Stieglitz suggested that he had been given a similar impression.[6] William Camfield has surmised that these mentions refer to Louise Norton, estranged wife of the publisher of the journal *Rogue,* because her telephone number was cited in a letter from Charles Demuth to the critic Henry McBride as a contact for Richard Mutt.[7] Although Norton's precise role in these events remains unclear, some have conjectured that she or another woman submitted the urinal to the committee to keep Duchamp's identity a secret.[8] Others entertain the idea that someone else actually did conceive of *Fountain,* since it makes little sense for Duchamp to have

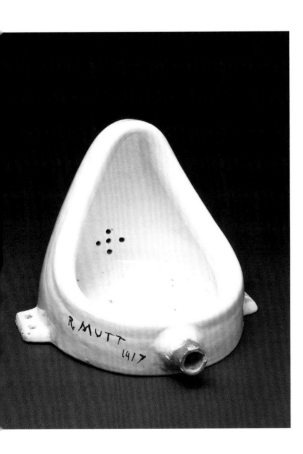

kept up a ruse in a letter to his sister, who was far away in France.[9] What is certain is that Norton, in addition to offering to serve as a contact for critics, participated in the production of the second issue of *The Blind Man,* the journal in which the submission of *Fountain* was both publicized and defended. Her essay, "Buddha of the Bathroom," launches a defense of the urinal, comparing the "jurors" of the ostensibly unjuried Independents exhibition to atavistic monkeys for associating the porcelain fixture "with a certain natural function of a secretive sort."[10] Norton's authoritative voice suggests intimate awareness of the motivations that generated the character of R. Mutt, regardless of her precise relation to him.

While history has consolidated the genius of *Fountain* within the person of Duchamp, there nonetheless remains a lingering doubt as to this attribution. Thus, one of the fundamental gestures of modern art, one that helped to establish not only Duchamp's reputation but also his oppositional stance toward the institutions of art, may or may not have been executed or originated by a "female friend." Duchamp's career is thus built on a confusion of gender that credits a woman with a watershed idea. As *Fountain* has become increasingly identified with Duchamp, this ambiguity has faded. Yet it was a fundamental aspect of the original presentation of the idea that was acknowledged by Duchamp's peers.

One such witness to the gender confusion of *Fountain* was Beatrice Wood. A significant contributor to *The Blind Man* and a protagonist in these events, Wood was the journal's nominal publisher and coeditor, as well as an aspiring actress and artist who became a mainstay at the salon of Walter and Louise Arensberg.[11] By her own assessment, Wood was very much in thrall with her two coeditors, Duchamp and Henri-Pierre Roché, in those years, and through her romantic attachments became an essential player in the organization, publication, and celebration of the Independents exhibition. Despite her guise of naïveté, Wood produced the submission that ended up fielding the harshest responses from critics.[12] In the absence of *Fountain,* Wood's painting entitled *Un peut* [sic] *d'eau dans du savon* (A Little Water in Some Soap) (fig. 3.2) acted as a gauge for public outrage. Depicting a headless, nude female torso molded into the space of a bathtub (as reconstructed by Wood in the 1970s), the painting sports a sort of three-dimensional fig leaf in the form of a shell-shaped morsel of soap.[13] As Wood explained in her memoir, the work was the result of collaboration, or was at least embellished with the help of Duchamp. It was Duchamp, she said, who prodded her to use a real piece of soap instead of painting an image of a seashell on top of the nude's genitalia, and it was also he who encouraged her to title the work with its inverted logic: she had mistakenly written (in French) "A little water in some soap," rather than the intended "A little soap in some water." When the work garnered "more attention than any other entry" at the Independents exhibition, receiving unequaled negative criticism, Wood credited the success to Duchamp's "prankishness."[14]

fig. 3.2 *Un peut* [sic] *d'eau dans du savon* by Beatrice Wood, graphite, colored pencil, and soap on cardboard, 1977 (replica of 1917 original). Whitney Museum of American Art, New York City; gift of Francis M. Naumann

Wood's bathtub nude may be read as a transgendered portrait of Duchamp because it works with the absent urinal to stand in for their makers. Though likely understood by Wood as more of a flirtation than a portrait, this painting offers an interpretation of Duchamp through surrogacy. Even though it was not immediately attributed to Duchamp, *Fountain* quickly became a stand-in for the artist—demanding of the Independents the respect accorded to the person.[15] Wood answered its profoundly provocative gesture through a figure/object combination that enacted a similar displacement. In producing her female plumbing fixture, Wood was looking for a feminized version of the urinal—a double for herself, as well as for Duchamp's invention and the man himself. The hypermasculinized connotations of the original object were remarked on by Wood when she pronounced it "a man's urinal, turned on its back."[16] In the way that Duchamp would later play with the feminine identity of Rrose Sélavy, this painting pairs with the urinal to express multiple identities.

In her painting, Wood recalls Botticelli's *Birth of Venus,* with the combination of watery foreground, seashell, and female nude. This Venus finds her home not in the generative context of nature, but in the domestic realm of plumbing. Eroticized in combination with the decapitated nude, the bathtub makes oblique reference to its suppressed male counterpart. Like *Fountain,* Wood's painting speaks about the relationship between seemingly sanitized porcelain bathroom fixtures and the bodily functions they are designed to conduct. And the strategic inclusion of the piece of real soap echoes the readymade strategy that *Fountain* would have pronounced publicly had it made it to the exhibition. Yet Wood's shell-shaped soap also breaks away from the most radical tenets of the readymade since this three-dimensional, manufactured object acts both iconographically as a fig leaf and associatively in terms of its functional location in the bathroom. That is, the piece of soap makes sense in the picture as a seashell and as a piece of soap, while readymades more often resisted such pictorial logic. As a portrayal of Duchamp, Wood's painting enacts the sort of gender inversion that will be realized in the person of Rrose Sélavy a few years later—the urinal is displaced by a feminized bathroom fixture whose very presence asserts the precedence of its absent partner.

Wood's memoirs characterize the beginning of her artistic life and the conception of this work in terms that considerably diminish her agency. She is young, enthusiastic about literature, disdainful of modern art, and distracted by romance: "I did not care about being an artist," she wrote, "I was only interested in love."[17] She begins drawing seriously at Duchamp's suggestion and continues by using his studio while allowing his informal critiques to shape her aesthetic sensibility.[18] She sees herself as formed by the combination of Roché and Duchamp: "The two of them agreed about everything concerning me and conspired to see that my education took the course they approved."[19] And yet *Un peut d'eau . . . ,* one of the most significant artworks to result from those interchanges, resists such a characterization by making clear the masculine connotations of the urinal while carving a space for Wood's own playful eroticism. Her rendition of a plumbing fixture also brings out the urinal's own ambiguity. In stressing how the female body fits within it, it recalls the womblike implications of the urinal's shape as photographed for *The Blind Man.*

The Venus inscribed in Wood's bathtub presages Rrose Sélavy as a female rejoinder to *Fountain,* while it makes oblique reference to another of Duchamp's ongoing considerations regarding the formation of masculinity. The *Nine Malic Moulds* (fig. 3.3), which were conceived in combination with the bachelor apparatus of Duchamp's *Large Glass,* encase the forms of nine different male types within their shells. These "molds" were just that—forms that were meant to help contain and shape the bachelors' generative substance within. Wood's Venus is similarly enclosed within the walls of her bathtub. Her body presses against the hardened walls of the tub, reminding the viewer that the tub was designed in relation to human scale and shape. As in the *Malic Moulds,* the malleability of the human body here works against its own containment. The give-and-take established between mold and molded in both works figures the process of portrayal itself. Similarly, Wood constructs an alternative to Duchamp's *Fountain* as a feminized nude even as she narrates her own artistic formation in his hands. Duchamp will later theorize such a relation as "infra-thin," a term that he describes as "the warmth of a seat (which has just/been left)" or the "difference between the contact of water and that of molten lead for ex. or cream with the walls of its own container."[20] While Wood could not have predicted this trajectory of Duchamp's thought, the counterpart she invented for *Fountain* (either in 1917 or at the time of its reconstruction) encapsulates the pairing of self and other examined by Duchamp and thus acts as a displaced, or unintentional, form of portraiture.

Another of Duchamp's self-professed admirers to have dabbled in portrayal of him was the Baroness Elsa von Freytag-Loringhoven, a German émigré to New York who was an artist's model, a poet, and an artist. In every way the complement to Wood's *jeune fille,* the Baroness was thirty-nine, daring, worldly, and self-defined when she arrived in New York in 1913. As recent feminist scholarship by Irene Gammel and Amelia Jones has maintained, the Baroness lived out many of the precepts suggested by the artistic strategies of the interwar avant-gardes, and in some ways she exceeded even the boundaries set by these groups of mostly male artists.[21] She not only resisted conventional lifestyles by engaging in extreme behaviors like stealing and dueling, but she also used her body as the material for artworks that transgressed the boundaries between art and life.[22] A consummate *flâneuse,* the Baroness made herself one with Greenwich Village

fig. 3.3 *Nine Malic Moulds* by Marcel Duchamp, steel and varnish, 1914–15. Musée National d'Art Moderne, Centre Georges Pompidou, Paris, France

street and party life as both source for and realization of her self as art. Descriptions of her self-fashioning, along with her writing, suggest a character bordering on manic, but one also brilliantly able to channel her energies at essential moments. George Biddle, an artist who was considering her as a model, remembers asking to see her nude:

> With a royal gesture she swept apart the folds of a scarlet raincoat. She stood before me quite naked—or nearly so. Over the nipples of her breasts were two tin tomato cans, fastened with a green string about her back. Between the tomato cans hung a very small birdcage and within it a crestfallen canary. One arm was covered from wrists to shoulder with celluloid curtain rings, which later she admitted to have pilfered from Wanamaker's. She removed her hat, which had been tastefully but inconspicuously trimmed with gilded carrots, beets and other vegetables. Her hair was close cropped and dyed vermillion.[23]

As described by Biddle, the Baroness unveiled her femininity in an aggressive, unconventional, and disconcerting manner—the opened folds of the scarlet raincoat noted by the artist may be an intentional metaphor for a vulval display, but his description may also inadvertently register his anxiety in response to her flamboyant disrobing. Indeed, the Baroness seems to have inspired unease in many of her male observers.[24] The now famous 1915 studio photographs of her dramatically posed in skin-tight striped capris and patterned bustier, an aviator hat adorned with a feather and strapped around her chin, bangle bracelets, and ankle-tied slippers capture only a shade of the charisma—and extremity—that eyewitnesses consistently note.[25]

The most celebrated portrait that the Baroness constructed of Duchamp extends this self-performance, acting as a perfect cipher between the artistic persona cultivated by the Baroness and the character and creative inventions of Duchamp.[26] Unlike Wood's bathtub painting, the Baroness's tribute to Duchamp was purposely conceived as a portrait, yet it too is slyly subversive. An assemblage composed within a wine glass, this work has not survived but is remembered in an evocative photograph by Charles Sheeler (pl. 13), which casts the airy assemblage in a warm light as it focuses attention on the details of its composition. Once again, this work draws on the precedent of the readymade while altering its operation. Using such ephemeral materials as feathers, streamers, ribbon, and other celebratory debris, the Baroness manages to characterize Duchamp in a festive manner, even as she references her own penchant for exotic dress. Though seemingly taking up the strategy of the readymade, the Baroness employs found materials to connotatively portray Duchamp and their shared lifestyle in the manner of symbolic portraiture. The wine glass may reference the material structure of *The Large Glass,* but it also acts in dialogue with a readymade like *Bottle Rack,* which is similarly linked by function to the wine bottle. Excesses of drink and socializing in these circles have been remarked on by many chroniclers of the times. Among them, Gabrielle Buffet, critic and wife of the artist Francis Picabia, remembered how in New York, Duchamp had "flung

himself into orgies of drunkenness and every other excess."[27] As a stuffed drinking glass, Duchamp comes off not only as the originator of the readymade but as a kind of after-party—the spent debris from a celebration gone too far. While the glass is certainly full of party paraphernalia, I also identify the implication of a fuse running up its center—an elongated line of wire and feathers that if lit would travel quickly through the body of the work, causing a catastrophic explosion.[28]

This characterization of Duchamp as ignitable in some ways does not match the Baroness's estimation of him. The specific relationship between the two is captured explicitly, if ironically, in her own words: "Marcel, Marcel, I love you like Hell, Marcel."[29] Briefly holding studios in the same Broadway building, they had a friendship that was at once unsatisfying to her for its lack of intimacy and rewarding in terms of mutual respect.[30] As she wrote to editor Jane Heap, Marcel "likes my society—my seriousness—my honesty—my trouble—since I have learned not to touch him nor suffer from restraint."[31] Duchamp apparently gratified the Baroness's desire to be understood as an artist, while defusing what she herself made sure to characterize as a voracious sexuality. For his part, Duchamp, along with Man Ray, employed the Baroness as a model of eccentricity, even as he showed her respect in private contexts. She appears, not unlike her portrait of Duchamp, decorated with a feather headdress in a photograph by Man Ray in the single issue of the journal *New York Dada* and elsewhere, often nude, as a demonstration of Dada extremes.[32] The fate of the Baroness, portrayed in her day as a walking example of Dada in America and embraced fully as an artist and poet only in the recent past, perhaps speaks further to the excesses captured in this wine glass. Her sense of herself as outside even the more advanced circles of her time echoes in the overstuffed glass. The Baroness's portrait of Duchamp therefore resembles herself, festooned with debris and baubles, more than it does the debonair, even reserved, comportment for which Duchamp is famous. And at the same time, the work insists that he be understood within that volatile and also destructive culture of excess.

The Baroness's construction of Duchamp thus acts as a doubled portrait of the artist and sitter. This conflation of maker and subject emphasizes another aspect of their shared personae. As will be discussed further below, Duchamp concocted an outrageous alternative for himself in the posed photographs of Rrose Sélavy by Man Ray (pls. 14a, 17), while the Baroness, in addition to wearing the fantastic costumes mentioned earlier, also participated in the cross-dressing that was practiced by many women artists in bohemian circles of the time as part of their claim for artistic freedom.[33] The affinity between these two figures does indeed seem to be characterized by a form of complementarity. She was outrageous, while he was controlled, but they both performed their identities against the constraints of bourgeois culture. The plumed wineglass seems able to implicate each figure in its portrayal without reducing their very clear differences.

In addition to these behavioral parities, the Baroness and Duchamp have been associated in the naming of objects like the wineglass as art. The Baroness's biographer, Irene Gammel, even believes that it was the Baroness to whom Duchamp referred in his letter regarding the authorship of *Fountain*. She bases this argument on the Baroness's fabrication of *God,* an equally scatological

assemblage fashioned out of a cast-iron plumbing trap and a miter box, coupled with Richard Mutt's Philadelphia domicile and testimony that the Baroness had been in that city in the spring of 1917.[34] The implications of this hypothesis are intriguing for a consideration of the gendering of productivity in Duchamp's oeuvre. As discussed earlier, Duchamp stressed that his female friend had taken a "masculine pseudonym" when he wrote to Suzanne Duchamp about *Fountain*. Whether the stated female friend was Norton, the Baroness, or an invented ruse, Duchamp clearly credited the conception to a feminine figure draped in masculine guise. When Duchamp conceived of Rrose Sélavy, this equation was reversed, but the necessity to change roles or identities as part of the process of creative invention was preserved.

The character of Rose Sélavy first appeared in 1920 as the copyright holder to *Fresh Widow,* a readymade of a darkened, miniature French window. She then materialized in 1921 in various photographs by Man Ray, as her name evolved to assume the double *r* required to pronounce her name "Eros."[35] This posed studio portrait series shows Duchamp in drag, wearing make-up, hats, jewelry, rich fabrics, and other accoutrements of femininity. The first group of images was destined for the label of the readymade *Belle Haleine: Eau de Voilette* (pl. 15), an altered perfume bottle that was reproduced on the cover of *New York Dada* (pl. 16). Another set of photographs casts Rrose in a second costume (pl. 17). Here, a real woman's hands (those of Francis Picabia's girlfriend Germaine Everling) caress a sumptuous fur collar, while a sly, slit-eyed glance enticingly meets the viewer's gaze from beneath a scarf-tied hat. As Duchamp recounted to Pierre Cabanne, Rrose emerged because he had wanted to devise an alter ego and at first considered switching religions:

> In effect, I wanted to change my identity, and the first idea that came to me was to take a Jewish name. I was Catholic, and it was a change to go from one religion to another! I didn't find a Jewish name that I especially liked, or that tempted me, and suddenly I had an idea: why not change sex? It was much simpler. So the name Rrose Sélavy came from that. Nowadays, this may be all very well—names change with the times—but Rrose was an awful name in 1920.[36]

This often-quoted explanation for the decision to take on a feminine counterpart in fact says very little about the original impulse to invent an alias, or about Duchamp's comfort at being received as feminine. As described by such contempories as Stieglitz, Duchamp came across as comfortably bi-gendered: "Duchamp is a very fine simple fellow.—Of today. Modest—clean cut—as spiritual & clean as Duncan—Very clear—not dogmatic—broad—gentle as a woman—still masculine."[37] As Susan Fillin-Yeh and others have argued, the practice of cross-dressing was not especially rare at the time—the gaiety of many events and the flexibility of these social circles made experimentation and disguise a common feature of avant-garde culture.[38] Rrose is distinctive in her apotheosis, not for her appearance but for her productive contribution to Duchamp's oeuvre. She signed letters and artworks, published *The Green Box,* founded a fabric-dyeing business

and a putative fashion shop, authored journal essays and a book of puns, and was suggested as a marriage partner for the surrealist poet Robert Desnos.[39] Rather than merely playing at dressing-up, Duchamp seems to have needed an alternative character to take up some of the artistic activity that he wanted to generate, but not author. That he chose to do so in the guise of a woman is not a random choice but one that is sustained throughout Duchamp's oeuvre and, as I have been arguing, within the portraits by women with whom he collaborated.

It is in a painting by the artist Florine Stettheimer, a rival salon host who entertained guests from the Arensberg set, that Rrose received her due in a full-fledged oil portrait. Stettheimer's highly autobiographical oeuvre captures not only intimates of her close-knit family but also scenes of group association and festivity. Stettheimer, along with her sisters Ettie and Carrie, with whom she lived together with their mother, befriended Duchamp in 1916. As a French tutor to the sisters, he linked them to their abandoned European lifestyle following their repatriation at the outbreak of war. Feminized to the point of near parody, Stettheimer's paintings are punctuated by hot pinks and lurid reds, yellows, and oranges. They feature swathes of lace fabric, outsized bunches of flowers, details of fashion and interior decor, stylized figures, and the dry, thick brushwork of folk art. Portraits—and especially self-portraits—comprise a mainstay of Stettheimer's output. She dedicated at least two oil portraits, as well as many group scenes, to the artist she recorded as "Duche"—a punning nickname used among the three sisters—in the title of a poem. Like the portraits she made, Stettheimer's poem portrays Duchamp as an energy source, but one that ultimately negates intense sensation:

> A silver-tin thin spiral
> Revolving from cool twilight—
> To as far as link dawn
> A Steely negation of lightning
> That strikes—
> A solid lambswool mountain
> Reared into the hot night
> And ended the spinning spirals
> Love flight—[40]

Here Duchamp dampens emotion—a "Steely negation of lightning" that strikes muffling lambswool, a revolving spiral that ends in "love flight." Stettheimer's earliest portrait of Duchamp makes a similar point (fig. 3.4). This odd, iconlike depiction shows Duchamp's detached head rendered in grisaille and emitting rays like a sun. His eyes are downcast and his reddened lips are pursed; yet his face reads as elegant, almost feminine. As in the poem, Duchamp appears in this portrait as an energy source that for all its power remains isolated.

This characterization uncannily matches that made by the Baroness in another portrait of Duchamp, which did not survive in any visible form. Described by George Biddle, the painter who also remembered the Baroness's disrobing, it was painted on a piece of celluloid: "His face was indicated by an electric bulb

shedding icicles, with large pendulous ears and other symbols." In response to a prompt from Biddle, the Baroness explained the lightbulb: "Because he is so frightfully cold. You see all his heat flows into his art. For that reason, although he loves me, he would never touch the hem of my red oilskin slicker. Something of his dynamic warmth—electrically—would be dissipated through contact."[41] The sense of Duchamp as a light-emitting source that would be deadened through touch confirms these women's experience of him as participating positively in their artistic lives despite his detachment.

A second portrait of Duchamp by Stettheimer, more detailed than the first, also includes the motif of the spiral, but in this case it is cast as a mechanism by which Duchamp manipulates himself in the guise of Rrose Sélavy (pl. 22). A double portrait, Stettheimer's painting features the paired figures of Duchamp and Rrose sitting across from each other in the implied space of a room. The background is flat and monochrome but features a wall clock and an open window through which the head of one of Duchamp's chess knights appears. The male Duchamp, wearing a sober costume of gray and black, sits in a pale pink armchair that is decorated with a pair of crossed flags, the inscription "Marcel Duchamp by Florine Stettheimer," and, like the work's silver-painted wooden frame, the repeating initials "MD MD MD." From his cross-legged position in the chair, Duchamp extends one arm to turn a crank that controls a sort of spring-loaded stool upon which is perched Rrose Sélavy as a form of jack-in-the-box. In Stettheimer's hands, Rrose becomes a fashionable character, sporting a rose-colored jumpsuit with oversized shoulder pads, lace anklet socks, chic close-cropped reddish hair (as opposed to the male Duchamp's brown hair), and bangle bracelets. Her pose is conversational, as she raises one shoulder and puts out her opposite hand. Her legs are entwined with one ankle behind the calf of the other. In an earlier painting of a party for Duchamp, Stettheimer had uncannily prefigured the coloring of this shadow figure.[42] Here, Duchamp appears in a pink jacket with close-cropped red hair that seems closer to the Baroness's famous vermillion lacquered top than Duchamp's occasionally shaven skull.

The contemporary critic Henry McBride, who was a friend of Stettheimer, praised the Duchamp/Rrose portrait, making an interesting comment about its ability to capture Duchamp as one imagines he would be. Noting that Stettheimer never worked from life, he saw in her portrayal of Duchamp a "whimsy" that matched his persona:

> Marcel in real life is pure fantasy. If you were to study his paintings, and particularly his art constructions, and were then to try to conjure up his physical appearance, you could not fail to guess him, for he is his own best creation, and exactly what you thought. . . . The most complicated character in the whole contemporary range of modern art has been reduced to one transparent equation.[43]

McBride praises Stettheimer for matching the fantastic element that Duchamp projects in daily life and for the simplicity of her painting. The "transparent equation" is for McBride a positive attribute that suggests she has

fig. 3.4 | *Portrait of Marcel Duchamp* by Florine Stettheimer, oil on canvas, c. 1923–26. Museum of Fine Arts, Springfield, Massachusetts; gift of the Estate of Ettie and Florine Stettheimer

captured the character of the sitter in his most apparent terms. McBride's sense that Duchamp was himself already "his own best creation" coincides with Stettheimer's portrayal of Duchamp manipulating the figure of Rrose Sélavy.

That this is a double portrait of Duchamp and his alter ego suggests the significance of this guise among the Stettheimer trio. In a letter to Ettie Stettheimer, Duchamp tellingly signed himself "Rose-Mar Cel," playing on his dual identity even within personal correspondence.[44] The unmarried status of these three sisters makes their household a space for gender innovation. Without the presence of a male figure, the three women fashioned different roles for themselves that both exaggerated and exceeded their femininity, breaking through strictures of behavior for the time. That Duchamp would have been intrigued with these women during the years that he himself was working out the frustrations of sexual relations—and the passage from virgin to bride to wife—in *The Large Glass* is not surprising.

Stettheimer further seems to have envisioned herself in exotic and transformative ways that match her portrayal of Duchamp as a doubled ego. In *Portrait of Myself* (fig. 3.5), Stettheimer fashions herself as a sort of flame, a fantastic ethereal figure who, despite her bright coloration, seems to float off the canvas. She outlines her eyes with heavy red lashes, and seats herself on a blood-red form that echoes the flowers and garlands she holds in her hands but also recalls an inverted flame or a suspended, fringed afghan hung over an invisible chair. She is wearing a black beret that caps off her pink-tinged face and a small, elegant black watch around her wrist. Her white lace dress is deep-cut in the front and transparent where the shape of her legs shows through. She wears a cape around her shoulders, which is tied at the neck with a black ribbon. Her white high-heeled shoes, as well as the feet that fit within them, are miniaturized, as all of her limbs seem to taper off at the extremities. In the upper right corner of the painting, there is a hot yellow sun toward which an elongated red firefly is drawn, and across the upper region Stettheimer has inscribed her name, "Florine S," in white cursive lettering on a white dappled background. The otherworldliness of this self-portrayal mirrors the imaginary nature of the admittedly more studied portrait

fig. 3.5 *Portrait of Myself* by Florine Stettheimer, oil on canvas, 1923. Columbia University in the City of New York; gift of the Estate of Ettie Stettheimer, 1967

of Duchamp. But what most insistently ties Stettheimer's self-image to her portrayal of Duchamp is their shared fascination with variations on the drama of femininity.

The closest Duchamp probably came to having an actual female double was in his relationship with his sister Suzanne. It was she who received letters announcing the invention of the readymade and the enigmatic news of his female friend's cover under the pseudonym Richard Mutt.[45] A well-chosen interlocutor, Suzanne quickly synthesized the tenets of mechanomorphism and the readymade and became one of the earliest proponents of Dada in Paris.[46] Her first work in this style, *Un et une menacés* [He and She Threatened], not only employs real objects in the mode of Wood's *Un peut d'eau . . .*, but it also questions the topic of sexual relations along the lines of *The Large Glass*.

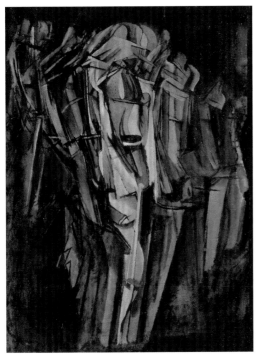

Suzanne's earliest portrayal of her brother Marcel derives from a compli-cated set of exchanges (she would later make a figurative etching of him in 1952). When Suzanne married the artist Jean Crotti, Marcel, who was in Buenos Aires at the time (with Yvonne Chastel, Crotti's ex-wife), sent them a wedding gift that consisted of instructions for a *Readymade malheureux* (Unhappy Readymade). The newlyweds were to suspend a geometry textbook from the balcony of their apart-ment and let the wind and rain destroy the pages. As evidence of their execu-tion of his plan and as a permanent marker of the ephemeral work, Suzanne both photographed (fig. 3.6) and painted the book as it hung in the wind. The photograph was sent to Duchamp, who later repro-duced an altered version, with geometrical illustrations enhanced, in his *Boîte-en-valise* (Box in a Valise).

Suzanne pointedly titled her painting *Le readymade malheureux de Marcel* (Marcel Duchamp's Unhappy Readymade), 1920, and inscribed the words onto the canvas. The title allows the paint-ing to refer simultaneously to Marcel and to his peculiar wedding gift. Indeed, by affirming the association of unhappiness with her brother rather than herself—*Marcel's* unhappiness, not mine—Suzanne seems to counter the implication that he intended to mark her wedding with regret. In typical manner, Duchamp dis-missed any deeper reading of the work by attributing the sadness to the book whose pages would be destroyed: "It amused me to bring the idea of happy and unhappy into the readymades, and then the rain, the wind, the pages flying, it was an amusing idea."[47] Yet biographers have indeed suspected that Duchamp's stay in Buenos Aires was the impetus for the tribute to unhappiness, or more likely, it was in response to the news of the death of his brother Raymond.[48] Duchamp had, in one of his earliest self-portraits (fig. 3.7), already identified himself as a *Sad Young Man on a Train*, although he used the word "triste" here rather than "malheureux." An inscription on the verso of this painting in the style of *Nude Descending a Staircase*, which reads "Marcel Duchamp nude [sketch]," affirms its association with him.[49] Having been painted after a visit to his family in their hometown of Rouen, where Suzanne had just married her first husband, it would likely have made a rather formative impression on Suzanne, who a decade later memorialized her brother in this second painting about sadness.

As Suzanne recorded the ephemeral exchange between herself, her brother, and her new husband, she also altered the meaning of the readymade. In her painting, the book is largely unrecognizable—an abstracted trapezoid shape that feels more solid and unyielding than the pages of a book flapping in the wind. In addition, she omits reference to the subject of the book, leaving the pages a blank surface of wrinkles and creases. Suzanne further obscures the image by inverting the scene so that it reads upside down. The vertical lines that indicate the ironwork on a balcony extend into the upper region of the painting rather than toward the ground, and the string that seems to have been used to suspend the book falls against gravity into the sky. These distortions may merely signify

fig. 3.6 | *Marcel Duchamp's Unhappy Ready-made* by Suzanne Duchamp, gelatin silver print, c. 1919–20. Philadel-phia Museum of Art, Pennsylvania; gift of Virginia and William Camfield, 1983

fig. 3.7 | *Nude* [Study]—*Sad Young Man on a Train* by Marcel Duchamp, oil on cardboard, 1911–12. Peggy Guggen-heim Collection, Venice (Solomon R. Guggenheim Foundation, New York)

a Dadaist prank—the artist's attempt to make strange what would otherwise be a rather conventional (if awkward) painting of a more radical idea. At the same time, Suzanne's obfuscation seems in line with her likely vague awareness of her brother's well-being at that moment in time, when he had traveled so far and had sent to her what might have been a rather blatant message about his own preoccupation with unhappiness, even, or perhaps especially, on the occasion of her marriage.

When Duchamp eventually settled back in Paris, he gradually established an ongoing, though not exclusive, relationship with the American expatriate Mary Reynolds, a war widow who, friends with Peggy Guggenheim, found herself in the center of the most advanced avant-garde circles.[50] This discreet partnership lasted from 1924 until the Second World War forced both Duchamp and Reynolds back to the United States—she a bit later than he and under harrowing circumstances.[51] In the late 1920s, following a fashionable trend, Reynolds had trained in the studio of master artisan Pierre Legrain to become a bookbinder. Although not a métier that sustained her financially, bookbinding was a fulfilling avocation for Reynolds, who produced a selection of diverse encasements for such classic surrealist and avant-garde texts as Man Ray and Paul Éluard's *Les mains libres,* William Seabrook's *Secrets of the Jungle,* and Raymond Queneau's *Un rude hiver,* many of which contain personal inscriptions to Reynolds from the authors.

Reynolds's oeuvre, indeed her medium, offers a particular opportunity for consideration of the question of collaboration between Duchamp and his female intimates. Her practice of bookbinding reflected a deep engagement with the texts, and thereby with the authors whose works she was to embellish. Furthermore, Reynolds, who did not demonstrate a strong desire to identify herself as an artist, was apparently quite open to working with and even executing Duchamp's ideas. Her most celebrated bookbinding, for Alfred Jarry's *Ubu Roi,* for example, was made after a design by Duchamp, as is known through the testimony of Henri-Pierre Roché.[52] A strange photograph of the two of them posing as Salome and John the Baptist (pl. 36), Reynolds outfitted in a white robe and Duchamp as a detached head upon a table, probably registers the result of a similar interaction with Duchamp instigating and Reynolds executing, as Sheldon Nodelman has recently argued.[53] Yet once again, the enactment puts Reynolds in the position of power, while Duchamp takes up the ultimate role of passivity—that is, death.

Little is known about the inception of the idea for Reynolds's binding for Duchamp's 1939 book of puns entitled *Rrose Sélavy,* a circumstance that leaves open the possibility for imagining the set of interactions that might have led to the work's final form (fig. 3.8). Undoubtedly the result of some form of exchange, the design includes a tricolored leather binding upon which are attached rectangular gray cards on both front and back covers. The interior endpapers are decorated with leaf silhouettes and enigmatic ink drawings of two crawling bugs. Rough string frames the gray cards, which are embossed with block letters that form the French phrase "of or by Marcel Duchamp or Rrose Sélavy." This phrase, along with the letterpress stamp from which Reynolds certainly obtained the imprint, derives from the title cards for the edition of Duchamp's *Boîte-en-valise* (pl. 37), a retrospective miniature collection of his oeuvre that was housed in a

fig. 3.8

Rrose Sélavy by Marcel Duchamp, bookbinding by Mary Reynolds. Paris: G.L.M., 1939. Mary Reynolds Collection no. 246, Ryerson and Burnham Libraries, The Art Institute of Chicago, Illinois

suitcase.[54] The examples that Reynolds used for the book have multiple strikes, suggesting that they were perhaps cast-offs from the original project.[55] Her incorporation of recycled materials from a work of art that was meant to commemorate, and even displace, Duchamp's entire oeuvre overwhelmingly marks this object as a form of portrait. The *Boîte* itself may be taken autobiographically, while Reynolds's quotation from it resonates with Duchamp's effort to control his legacy through a process of reproduction. The circumstance of the book having been titled after Duchamp's alter ego adds an additional layer of meaning to the object produced by Reynolds. Duchamp emphasizes the possibilities of productive, if indeterminate, interaction by labeling his work as either "of" or "by" himself or Rrose Sélavy.

In these multilayered references to Duchamp's self-invention, there is little room to imagine that Reynolds held an important place in the conception of gender that Duchamp was working out in this object and others over the course of his career. And at the same time, his notes on the idea of "infra-thin," as mentioned earlier, from the latter part of his life suggest that he was indeed quite conscious of a need for a paired form of creativity. Beyond the playful gender swapping of Rrose Sélavy, Duchamp sought a term that would imply the exchange of male and female operations: "infra-thin separation—better than screen, because it indicates interval (taken in one sense) and screen (taken in another sense)—separation has the two senses male and female."[56] An infra-thin *separation* would thus indicate the necessity of the give-and-take that Duchamp recognized as an essential aspect of his creativity—once again the relationship between mold and molded that had been indicated in Wood's bathtub painting. Duchamp was careful to stress that infra-thin was an adjective and thus modified a relationship, rather than being in and of itself a static entity. This working relationship between complementary parts seems to be precisely what was put in place by Duchamp and his female friends in terms of portraiture.

Duchamp's most important statement in his early career about sexual relations, *The Large Glass,* made an allegory of the creative process within a drama of failed copulation. The independent bachelors worked fruitlessly to gain the favor of the bride, who in her own domain was being "stripped bare" by their attentions. In his move to the invention of Rrose Sélavy, Duchamp posed in the guise of the feminine in order to accomplish various tasks. Duchamp's female companions responded to and recorded these maneuvers in a number of inventive portrayals that both counter and continue his assertions. Duchamp's identity merges with his working methods in these works, which are furthermore the products of collaboration between the artists and their subject. These portraits promote the idea that one should identify strongly outside oneself in order to generate new ideas—and they specifically mark that identification as crossing gender lines. Thus the very idea of a stable identity that could be depicted in a traditional portrait is made obsolete in this practice that not only stresses the exchanges that occur within the process of portraiture but also insists that one play across the lines of masculinity and femininity to produce works of art. If the bachelors signify a form of halted production, Duchamp's indeterminate bachelorettes suffer no such frustration.

Notes

1. Conspicuously absent from this list is Katherine Dreier who, despite her active collaborations with Duchamp vis-à-vis the Société Anonyme, did not engage with the fundamental challenges to art and identity introduced by Duchamp's practice in the two portraits she made of him, one abstract (pl. 10) and one figurative (see fig. 2.1). Dreier famously opposed *Fountain* at its initial appearance, and she subsequently held on to her beliefs in the transformative powers of art. Her portraits of Duchamp, not surprisingly therefore, do not subvert notions of identity, gender and otherwise, or the integrity of painting in the manner discussed here.

2. Helen Molesworth has stressed Rrose Sélavy's contributions of a commercial nature. See "Rrose Sélavy Goes Shopping," in Leah Dickerman, with Matthew S. Witkovsky, eds., *The Dada Seminars* (Washington, DC: Center for Advanced Study in the Visual Arts at the National Gallery of Art, 2005), 173–89.

3. Cabanne, *Dialogues with Marcel Duchamp*, 64.

4. This collaborative impulse also manifests itself in Duchamp's friendships with men. Man Ray and Francis Picabia are important examples, but he also took on projects requested by André Breton in later years. Nonetheless, I find that the specific intersection of portraiture and collaboration is especially highlighted in his relations with women.

5. "Une de mes amies sous un pseudonym masculin, Richard Mutt, avait envoyé un pissotière en porcelaine comme sculpture; ce n'était pas du tout indecent aucune raison pour la refuser." Marcel Duchamp to Suzanne Duchamp, April 11, 1917, reprinted in Naumann and Obalk, *Affectionately, Marcel*, 47.

6. An unpublished letter from Alfred Stieglitz to Georgia O'Keeffe suggests that Stieglitz was under a similar impression. See William A. Camfield, "Marcel Duchamp's *Fountain*: Its History and Aesthetics in the Context of 1917," in Rudolf Kuenzli and Francis M. Naumann, eds., *Marcel Duchamp: Artist of the Century* (Cambridge, MA: MIT Press, 1989), 91, n. 39; and Alfred Stieglitz to Georgia O'Keeffe, April 19, 1917, Beinecke Rare Book and Manuscript Library, Yale University, New Haven, Connecticut.

7. Charles Demuth to Henry McBride, undated, Archives of Henry McBride, Beinecke Rare Book and Manuscript Library, Yale University, cited in Camfield, "Marcel Duchamp's *Fountain*" [1989], 72. Camfield, who first supplied the information that the telephone number given for R. Mutt belonged to Louise Norton, states that Norton "has not provided additional information about her role," while Beatrice Wood "has always insisted that Duchamp was the artist" (Camfield, "Marcel Duchamp's

Fountain" [1989], 90, n. 29). In a later essay, he again associates Norton with the events, but maintains that the reference to a "female friend" was a "white lie" (Camfield, "Marcel Duchamp's *Fountain*: Aesthetic Object, Icon, or Anti-Art?," in Thierry de Duve, ed., *The Definitively Unfinished Marcel Duchamp* [Cambridge, MA: MIT Press, 1991], 139–41).

8. See discussion of the Baroness and *Fountain* later in this essay.

9. Camfield, for example, says, "I see no reason to doubt the sincerity of Duchamp's earliest known statement on *Fountain*," but goes on to acknowledge the quandary posed by the letter (Camfield, "Marcel Duchamp's *Fountain*" [1989], 72). He repeats a similar assessment that the "white lie" either refers to Rrose Sélavy or that a woman actually did send in the object in Camfield, "Marcel Duchamp's *Fountain*" [1991], 139. Others, like Thierry de Duve and Francis Naumann imply that the letter was intentionally misleading. See de Duve, *Kant after Duchamp* (Cambridge, MA: MIT Press, 1996), 104–5, and Naumann, *New York Dada*, 185.

10. Louise Norton, "Buddha of the Bathroom," *The Blind Man* 2 (1917): 5–6, reprinted in Joseph Masheck, ed., *Marcel Duchamp in Perspective* (Englewood Cliffs, NJ: Prentice Hall, 1975), 70–72.

11. Wood explains that she was asked to serve as publisher among the three editors because she was the only American in the group. See Beatrice Wood, *I Shock Myself: The Autobiography of Beatrice Wood* (San Francisco: Chronicle Books, 1985), 31.

12. For more on the reviews of this work and a reading of its autobiographical nature, see Paul B. Franklin, "Beatrice Wood, Her Dada . . . and Her Mama," in Naomi Sawelson-Gorse, ed., *Women in Dada: Essays on Sex, Gender, and Identity* (Cambridge, MA: MIT Press), 113–17.

13. Although Wood reconstructed the image as a graphite and pencil drawing, she refers to the original as an oil painting. Furthermore, we cannot know how faithfully the reconstructed version represents the original. For example, it is interesting to speculate about whether the 1969 unveiling of the headless figure in *Étant donnés* could have influenced Wood's memory of her lost work.

14. Wood, *I Shock Myself*, 32.

15. Barbara Zabel has argued that *Fountain* may even be taken as a self-portrait, thus supporting a related reading of Wood's rejoinder. See "The Constructed Self: Gender and Portraiture in Machine-Age America," in Sawelson-Gorse, *Women in Dada*, 35.

16. Ibid., 29.

17. Ibid., 20.

18. Ibid., 23–25, 32.

19. Ibid., 25.

20. Paul Matisse, ed., *Marcel Duchamp, Notes*, trans. Anne d'Harnoncourt (Boston: G.K. Hall, 1983), nn. 4 and 14 (unpaginated).

21. Irene Gammel, *Baroness Elsa: Gender, Dada, and Everyday Modernity* (Cambridge, MA: MIT Press, 2002); and Amelia Jones, "The Baroness and Neurasthenic Art History," in *Irrational Modernism: A Neurasthenic History of New York Dada* (Cambridge, MA: MIT Press, 2004), 2–33. Also see Paul Hjartarson and Tracy Kulba, eds., *The Politics of Cultural Mediation: Baroness Elsa von Freytag-Loringhoven and Felix Paul Greve* (Edmonton: University of Alberta Press, 2003). Jones, in particular, argues that the Baroness "can be viewed as embodying the cacophonous clash of races, sexes, sexualities, and classes of people that constituted the population of New York City in the World War I era and that accompanied the massive cultural shifts to which Dada responded and which it helped to promote" (Jones, "The Baroness and Neurasthenic Art History," 9).

22. The Baroness is famous for having challenged William Carlos Williams to a boxing match, among other outrageous acts of gendered provocation (Rudolf E. Kuenzli, "Elsa von Freytag-Loringhoven and New York Dada," in Sawelson-Gorse, *Women in Dada*, 451–52).

23. George Biddle, *An American Artist's Story* (Boston: Little, Brown, 1939), 137, quoted in Gammel, *Baroness Elsa*, 201–2.

24. William Carlos Williams's account of his encounters with the Baroness are often cited in this regard. See "Sample Prose Piece: The Three Letters," *Contact* 4 (Summer 1921), cited in Jones, "The Baroness and Neurasthenic Art History," 7–8, and Gammel, *Baroness Elsa*, 267–68, where she notes that Williams listed all of the men who feared the Baroness in his *Autobiography*.

25. Textual accounts of the Baroness's attire are plentiful. See Jones, "The Baroness and Neurasthenic Art History," and Gammel, *Baroness Elsa*, throughout.

26. A second portrait of Duchamp by the Baroness combines collage and pastel to form a more caricatured portrayal of his visage in combination with varied motifs. See Francis M. Naumann, ed., *Making Mischief: Dada Invades New York* (New York: Whitney Museum of American Art, 1996), 124.

27. Gabrielle Buffet-Picabia, "Some Memories of Pre-Dada: Picabia and Duchamp," 1949, reprinted in Robert Motherwell, ed., *The Dada Painters and Poets: An Anthology* (Boston: G. K. Hall, 1981), 260.

28. Gammel reads the portrait literally as a kind of bird, whose plumes refer to Duchamp's penchant for cross-dressing and whose phallic form asserts his unwillingness to engage in

sexual relations with the Baroness. Gammel, *Baroness Elsa,* 12.

29. Louis Bouché, *Autobiography,* Louis Bouché Papers, Archives of American Art, roll 688, frame 701, quoted in Gammel, *Baroness Elsa,* 173.

30. Ibid., 171.

31. Elsa von Freytag-Loringhoven to Jane Heap, c. winter 1922 (*The Little Review* Papers, Golda Meir Library, University of Wisconsin, Milwaukee), quoted in ibid., 171.

32. *New York Dada* (New York: 1921), 4, reproduced in Naumann, *New York Dada,* 206. Both Gammel and Jones have stressed the Baroness's nude appearance in a 1921 letter from Man Ray to Tristan Tzara captioned with the scatological joke "delamerdelamerde." The daring image is a still from a lost film in which she was to shave her pubic hair. Gammel, *Baroness Elsa,* 290–94; Jones, "The Baroness and Neurasthenic Art History," 3–5, 308 n. 135.

33. "The Baronness's performative (rather than biological) penis/phallus, along with Duchamp's erotically invested *garçonne-esque* Rrose (eros, in the feminine, as commodity) were, I am suggesting, the ultimate weapons against the bourgeois norms that Dada in general thought of itself as radically antagonizing. This is so even though (or perhaps precisely because) these performances surface and exaggerate the commodified, feminized subject rather than repress the demasculinizing effects of modern life on the conventional, ironclad figures of the artist (itself an exaggerated version of the mythical, Cartesian, modernist subject)." From Amelia Jones, "'Women' in Dada: Elsa, Rrose, and Charlie," in Sawelson-Gorse, *Women in Dada,* 159. On cross-dressing, see Susan Fillin-Yeh, "Dandies, Marginality, and Modernism: Georgia O'Keeffe, Marcel Duchamp, and Other Cross-Dressers," reprinted in Sawelson-Gorse, *Women in Dada,* 174–203.

34. Gammel, *Baroness Elsa,* 222–25.

35. Please see James W. McManus's essay in this volume for more on the development of Rose/Rrose Sélavy.

36. Cabanne, *Dialogues with Marcel Duchamp,* 64.

37. Alfred Stieglitz to Georgia O'Keeffe, December 14, 1916, Beinecke Rare Book and Manuscript Library, Yale University.

38. Fillin-Yeh, "Dandies, Marginality, and Modernism."

39. See Jennifer Gough-Cooper and Jacques Caumont, "Ephemerides on and about Marcel Duchamp and Rrose Sélavy, 1887–1968," in *Marcel Duchamp: Work and Life,* ed. Pontus Hulten (Cambridge, MA: MIT Press, 1993).

40. Florine Stettheimer, *Crystal Flowers* (privately printed, 1949), 55, quoted in

Barbara J. Bloemink, *The Art and Life of Florine Stettheimer* (New Haven, CT, and London: Yale University Press, 1995), 146.

41. Biddle, *American Artist's Story,* 138, cited in Gammel, *Baroness Elsa,* 176.

42. Florine Stettheimer's *La fête à Duchamp* is reproduced in color in Naumann, *Making Mischief,* 83, and in Bloemink, *Art and Life of Florine Stettheimer,* 83.

43. Henry McBride, "Florine Stettheimer: A Reminiscence," *View* 5 no. 3 (October 1945): 13–14, quoted in Bloemink, *Art and Life of Florine Stettheimer,* 143–44.

44. Gough-Cooper and Caumont, "Ephemerides," entry for July 6, 1921.

45. MD to SD, January 15, 1916, reprinted in Naumann and Obalk, *Affectionately, Marcel,* 43; MD to SD, April 11, 1917, ibid.

46. William Camfield has stressed Suzanne's early adherence to the mechanomorphic style. See Camfield, "Suzanne Duchamp and Dada in Paris," in Sawelson-Gorse, *Women in Dada,* 82.

47. Cabanne, *Dialogues with Marcel Duchamp,* 61.

48. Tomkins, *Duchamp,* 212–14.

49. Joseph Masheck, introduction to Masheck, *Duchamp in Perspective,* 5.

50. Their relationship spanned Duchamp's brief marriage in 1927 to Lydie Sarazin-Levassor. The most valuable reference on Mary Reynolds is Susan Glover Godlewski, "Warm Ashes: The Life and Career of Mary Reynolds," *The Art Institute of Chicago Museum Studies* 22, no. 2 (1996): 102–15. Unless otherwise noted, details provided for Reynolds's life are from this source.

51. See Godlewski, "Warm Ashes," 111–13; and Janet Flanner, "The Escape of Mrs. Jeffries," *New Yorker,* May 22, May 29, and June 5, 1943. Also see Calvin Tomkins's account in Tomkins, *Duchamp,* 317–28.

52. Gough-Cooper and Caumont, "Ephemerides," entry for November 26, 1934.

53. Nodelman further sees the decollation of the Saint as a sign of his ascension and "glorious liberation," which is undertaken after the Saint refuses the sexual advances of Salome. He reads this as a possible metaphor for a relationship in which Duchamp refused Reynolds a satisfying union, but it might rather be taken as evidence of Duchamp's willingness to stage his own emasculation in favor of a more fruitful interchange. See Sheldon Nodelman, "The Decollation of Saint Marcel," *Art in America* 94, no. 9 (October 2006): 107–19.

54. For a reproduction of the stamp, see Ecke Bonk, "Delay Included," in *Joseph Cornell/ Marcel Duchamp* (Houston and Philadelphia: Menil Collection and Philadelphia Museum of Art, 1998), 103.

55. Elsewhere I have argued that Reynolds may have had a part in designing the structure for the *Boîte-en-valise.* Her use here of rejected materials from that project supports this thesis further. "Boxes, Books, and the *Boîte-en-valise,*" in Sophie Levy, ed., *A Transatlantic Avant-Garde* (Chicago and Giverny: Terra Museum of American Art, 2003), 33–42.

56. Matisse, *Marcel Duchamp, Notes,* n. 9, unpaginated.

NOT SEEN AND/OR LESS SEEN

Hiding in Front of the Camera

James W. McManus

. . . known also under [the] name RROSE SÉLAVY.

—from *Wanted, $2,000 Reward,* Marcel Duchamp, 1923[1]

In a 1964 interview with his biographer Calvin Tomkins, Marcel Duchamp offered, in a moment of self-reflection, "I'm a pseudo all in all, that's my characteristic."[2] His direct reference in that conversation was to his acceptance of pseudo-science, rejecting what he sensed to be the closed-circuit system of the laws of science. It is possible and reasonable to infer another reading from his choice of the word "pseudo," namely pseudonym—the fabrication of fictitious names, especially those assumed by an author. As subject, coauthor, or author of portraits of himself, Duchamp, self-defined as an "an-artist" (a deliberate pun on anarchy), confounds our expectations of portraiture.[3] Our efforts at grafting an identity onto him lead us not to but away from that goal. Many times the subject of the camera's eye, the shadowy and elusive Marcel Duchamp, *bricoleur,* proved a master of self-invention, recasting his image and shuffling identities via the means of invented personae. (The most important was Rrose Sélavy, whose shadowy image, captured by the camera, comes to us in the form of the photograph.) Inviting us into this shadowy realm, Duchamp adroitly draws us into confrontations with our notions of meaning and identity and constructs a sense of mystery, keeping us off track and off balance. He remains in the end "wanted."

In this study I will consider Duchamp's fabrication of his Janus-figured, mediumistic alter ego Rrose Sélavy (spelled Rose prior to July 1921, after that date Rrose), demonstrating how her image operates as an amalgam of two entities he designed: the MARiée (bride) and the CELibat (bachelor). Between 1919 and 1921 Duchamp assumed the pseudo-identity of the *célibat* and was photographed on at least four occasions sporting variations of a tonsure. In 1921 he was photographed on three occasions (twice in New York and once in Paris), in collaboration with Man Ray, in the guise of Rose/Rrose.[4] To date, the tonsure photographs— unlike those of Rrose Sélavy—have not been discussed collectively, nor have they been considered in relationship to the photographs of Rose made during the same time. Comparing the dates of the two groups of photographs, it seems likely that Duchamp was wearing his hair in a tonsure at the time when each of the photographs of Rose/Rrose was made.[5] This leads me to consider that Duchamp had "veiled" himself beneath the mask of the *célibat* who, working in concert with the *mariée,* operates behind the feminine masquerade of Rrose. Such a move would bring to life T. J. Demos's "formation of the self within a perpetual state of exile—an abolition of identity from within identity."[6] By drawing the two groups of photographs into one discussion, I hope to shed light on those of Rrose Sélavy, which engender a synthetic relationship between the bride (*mariée*), who veils the physical presence of Duchamp, and Duchamp in the guise of the bachelor (*célibat*), resulting in an androgynous union revealing both the female and male components visible in the image of her. This relationship is opposite the dialectical relationship, discussed below, in *The Bride Stripped Bare by Her Bachelors,*

fig. 4.1 Sketch of *Large Glass* with "MARiée/
CEL," from *The Bride Stripped Bare
by Her Bachelors, Even (The Green
Box)* by Marcel Duchamp, 1934.
Philadelphia Museum of Art, Penn-
sylvania; The Louise and Walter
Arensberg Collection, 1950

Even (hereafter referred to as *The Large Glass*).[7] Together with Duchamp, Rrose shared the psychological traits of distancing, mystery, and moral indifference that were essential to operations they would mastermind and execute over the next decades.

> The possible implying the becoming—the passage
> from one to the other takes place in the infra thin.
> —Marcel Duchamp[8]

A sketch accompanying one of the notes in *The Green Box* (fig. 4.1) provides two interesting clues to the changes in relationship I have suggested. The first is the isolated positions of the bride (MARiée) in *The Large Glass*'s upper register, and those of her bachelors (CELibats) in the lower register. The second is given by the graphic design of the two names—the first three letters of each capitalized. Amelia Jones has stated that "the signature—evidence of the authorial body—is itself split, broken into two halves, in which difference or 'separation has two senses male and female.'"[9] In the photographs of Rrose Sélavy, the *célibat* is relo-cated behind the *mariée*. The transparent image of the *mariée*, as a mask or veil placed over the image of the *célibat*, does not hide his underlying presence. With this arrangement I would suggest that his careful representation of "MAR" and "CEL" signals his intended joining of the female and male senses into one being— MARCEL. Together they mobilize a transitive field, activating an in-between that can be read as multivalent in playing out gender and sexual identities. And this "in-between" is, I believe, the intended focal point set up by what Duchamp called "infrathin separation. . . . Separation has 2 senses male and female." The union of opposites is called for in another note: "When the tobacco smoke smells also of the mouth from which it comes, the 2 smells marry by infra thin."[10] By analogy, this model serves to illustrate the union of the male and female—Marcel becom-ing Rrose.

Three other notes, written between 1912 and 1920 and published later in *A l'infinitif,* are significant as well. One titled "Theory" describes the random selec-tion of two sets of words taken from the dictionary. Duchamp asked himself to consider "the same difference of 'personality'" of each word set as if they "had been written by A and by B." He concluded the note by saying that "there would be cases where this 'personality' could disappear in A and B. That is the best case and the most difficult."[11] Here, too, another of his notes on the infra-thin is sugges-tive: "The possible/implying the becoming—the passage from one/to the other takes place/in the infra thin."[12] In this model, A could be either the mariée or the célibat, with B being the other, the disappearance of each signaling their loss of identity and emergence as Rrose. The third note, on "appearance/apparition," refers to the molds as the apparition (their ghostlike images).[13] The two images, the MARiée and the CELibat, make the two halves of the mold, together making a surface apparition, a kind of mirror image used for the making of the object.

June Singer's description of such a union and its operation provides a model for understanding a relationship between the alchemical androgyne and the Pyrrhonian model of establishing polar opposites as a means to activate an

in-between space. She states: "Only when the Two have become established as separate entities can they move apart and then join together in a new way to create the many and to disperse them. In time, the pairs of opposites tend to polarize. . . . The alchemists of old understood that in their opus they were dealing with complementary principles that had to undergo a continual serial process of unification and separation."[14]

> I am a regular movie actor. . . . I had absolutely
> no idea of becoming any Marcel Duchamp at all.
> —Marcel Duchamp, 1963[15]

During the course of his career, Duchamp employed various tools and tricks to fabricate a number of identities for the "parade of personae" performing in his stead.[16] Unpacking this *bricoleur*'s kit, we encounter a curious array of devices and a collection of cryptic notes readable only by the *bricoleur* himself—many dealing with photography, shadows (see fig. 1.3), mirrors (pl. 7), and infra-thin (pl. 79). Rummaging further among the clutter, we encounter an odd assortment of wigs, barber's shears, shaving cream, and hinges. And tucked under all of this are the writings of two philosophers, Pyrrho of Elis and Max Stirner, whom Duchamp identified as important influences.[17]

Both Pyrrho and Stirner proposed alternatives to fixed notions of "being" that would serve Duchamp in shaping his attitude of indifference. He encountered both at a very formative period early in his career. While they cannot be described as exclusive in their influence, together they read as significant, informing important patterns observable in Duchamp's overall strategy—one seen in his readymades and images of the deliberately destabilized self.

All the props or conceptual means I have mentioned served as aids that contributed to the construction of images of a deliberately destabilized self. Duchamp, though not a photographer, possessed a sophisticated understanding of photography's capabilities for conceptualizing many of the ideas that animate his work, especially the construction of carefully orchestrated, shifting images of the self seen through a variety of guises. As Dawn Ades has pointed out, "there is a high degree of connivance between Duchamp and the photographer. Duchamp was clearly instrumental in the conception of the photographs and stage-managed their effects."[18] With the photograph it appears that Duchamp sensed an intriguing dichotomy, one through which he could explore the verity of resemblances and question the representation of being.

> I don't believe in the word "being." The idea is a
> human invention. . . . It's an essential concept, which
> doesn't exist at all, and which I don't believe in.
> —Marcel Duchamp, interview with Pierre Cabanne[19]

It appears that Duchamp encountered Max Stirner before learning about Pyrrho of Elis. Francis Picabia likely introduced him to Stirner's book, *Der Einzige und sein Eigentum,* around 1911.[20] An obscure mid-nineteenth century German philosopher,

Stirner was enjoying something of a revival and following among anarchists in the first decades of the twentieth century. (The book had been translated into French, *Le moi et sa propriété,* in 1900, and into English, *The Ego and Its Own,* in 1907.)[21] His single idea, elaborated throughout the book, concerns the autonomy of the individual. Duchamp emphasized the book's importance on his thinking, referring to it as "a remarkable book . . . which advances no formal theories, but just keeps saying that the ego is always there in everything."[22]

Stirner devoted a considerable number of pages to questions of ownership and their relationship to the model of egoism he was constructing, arguing that what the individual holds in her or his power is the individual's own.[23] Stirnerian egoism may be best thought of not in terms of the pursuit of self-interest but as a variety of individual self-government or autonomy.[24] What Stirner offered likely contributed to Duchamp's strategy of appropriation, important both to the readymades and the fabrication of personae. According to Allan Antliff, Duchamp was as early as 1913 "inspired by Stirner's condemnation of the ego's subservience to metaphysical concepts and social norms [and]. . . became increasingly preoccupied with conceptual productions that subordinated social conventions, including the idea of 'art' to the caprice of his personality."[25]

Duchamp's treatment of language as an oppressive force factors into our equation as an important part of his repertoire. The same is true for Stirner. This point is amplified in an assessment made in the *Stanford Encyclopedia of Philosophy* regarding Stirner's rejection of conventional forms of intellectual discussion linked to his substantive views about language and rationality. Stirner claimed that "accepted meanings and traditional standards of argumentation are underpinned by a conception of truth as a privileged realm beyond individual control."[26] In his analysis of *The Ego and His Own,* R.W.K. Paterson observes that Stirner "commandeered" the German language as "an instrument in his own hands and for his own purposes."[27] Like Stirner, Duchamp would commandeer language.

The friendships Duchamp formed with Picabia (in 1911) and Apollinaire (in 1912), both enthusiasts of Stirner and engaged in the playful use of language in their own works, would contribute importantly to Duchamp's design and use of what Jerold Seigel has labeled his "private language."[28] His bricolage constructed by a private language can be found in notes published in *The Green Box, A l'infinitif,* and *Marcel Duchamp, Notes,* as well as in comments he made in various interviews. In his 1963 *Vogue* magazine interview with William Seitz, Duchamp described his point of view as one that doubted everything. Belief in truth and being itself were the main targets of his skepticism. In that interview he let loose a torrent of negative feelings regarding language, making the point that "words are tools of 'to be'—of expression. They are completely built on the fact that you 'are.'"[29] His alternative seems to have been, Seigel argues, to create a new tripartite language; one aspect eliminating references to concrete objects in the world, a second giving expression only to its own universe, and the third a private language made up of symbols whose meanings are established by and only known by the author.[30] All contribute in undermining the assumption that the world has a stable manner of "being." What Seigel makes clear is that Duchamp rejects determinism, replacing it with a strategy of indifference.

Sometime between late 1912 and the middle of 1915, when he was working as a librarian at the Bibliotheque Ste. Genevieve, Duchamp, as Arturo Schwarz has pointed out, had "the opportunity to read through the works of Greek scholars and found that he most appreciated the attitude of Pyrrho as closest to his own."[31] Thomas McEvilley gives considerable weight to Pyrrho's effect on Duchamp and argues that "he seems to have awakened from a kind of dogmatic slumber during his investigation of Pyrrhonism, and the way of thinking he constructed for himself thereafter, and stuck with for the rest of his life, must stand on its own as a thought-out position."[32]

Little survives of Pyrrho's writings. What Duchamp most likely read were the works of other Greek philosophers who refer to Pyrrho in their own writings. Writing in 1992, Paul O. Kristeller, citing Timon (a student of Pyrrho), distilled his skepticism into three questions: "1. of what kind things are; 2. what must be our attitude toward them; 3. what the result of this attitude will be." The answer to the first is that "all things are indifferent, uncertain, and unjudgeable," and to the second, "neither our perceptions nor our opinions are either true or false." Finally, "everything can be affirmed with equal validity, that it is, that it is not, that it is and is not at the same time, and that it neither is nor is not at the same time."[33] When applied by Duchamp, this system, paired with Stirnerian egoism, joins in refuting beliefs in truth and being—a refutation essential to the establishment of his notion of the beauty of indifference.

> Call it a little game between "I" and "me."
> —Marcel Duchamp, 1961

In a 1961 interview, broadcast on the BBC program *Monitor,* Katharine Kuh asked Duchamp, "Why were you so anxious to avoid the traditional?"[34] Significant within his response were these observations: "I was really trying to invent, instead of merely expressing myself. I was never interested in looking at myself in an aesthetic mirror. My intention was to get away from myself, though I knew perfectly well I was using myself. Call it a little game between 'I' and 'me.'"[35] Duchamp's remark echoes Pyrrho's uncertainty along with Stirner's decentered "I," forming a perpetual pattern of flux—shuffling identities. It is in this arena of flux where we make our discoveries, not of "being," but of an ongoing state of "becoming."[36] Addressing Duchamp's remarks within the context of the construction and operation of image, T. J. Demos concludes that "Duchamp's game unleashes a self-differing force that produced a gap between 'I' and 'me,' between subject and object, which would fundamentally estrange the self from identity . . . corrode the unity and integrity of individuality, and insistently place being in proximity with difference . . . Duchamp proposed a radical formation of the self within a state of perpetual exile—an abolition of identity from within identity."[37] Within Duchamp's collection of personae, the "appearance" of each contributes to the division of the whole, resulting in a Duchamp whose presence is felt through an absence masked by the projection of fabricated personae serving in his stead.

I am not going to New York. I am leaving Paris.
—Marcel Duchamp to Walter Pach, April 27, 1915[38]

Duchamp's arrival in New York in June 1915 represented the culmination of events extending back nearly three years. The year 1912 was critical, putting into motion a practice of withdrawal and disengagement that would serve to shape his life-long strategy of indifference. That spring in Paris he submitted his recently completed *Nude Descending a Staircase (No. 2)* to the Salon des Indépendants. Albert Gleizes and Jean Metzinger, leaders of the Puteaux cubist group, pressed for its removal on the grounds that the work violated "reasonable Cubism" and veered toward futurist tendencies.[39] The incident probably brought to a head an inevitable collision between Duchamp and those within the Puteaux cubist group—a true test of Stirnerian egoism. Duchamp withdrew the painting and himself from the group, thereby asserting himself as the proprietor of self-governance.

In June of that year he left Paris for Munich, where he would spend the next four months. Considerable mystery surrounds Duchamp's time there. However, judging from the drawings, paintings, and notes from that time, he was undergoing a radical transformation. While there he received a request from Guillaume Apollinaire that he have a portrait photograph taken for inclusion in Apollinaire's upcoming book, *Les peintres cubistes*. The result is the well-known and iconic portrait by the German photographer Hans Hoffmann (pl. 1) that accompanied Apollinaire's brief entry regarding Duchamp in his book. In 1923 Man Ray used Hoffmann's photograph as the basis for his portrait of Duchamp, *Cela Vit* (pl. 21), and again in 1936 in his *Portrait of Marcel Duchamp Overlaid with a Photogram of the Glissière* (pl. 35).[40]

Returning to Paris in the fall of 1912, Duchamp distanced himself physically and emotionally from the Paris art world. He was not present when his painting *Nude Descending a Staircase (No. 2)* was selected for inclusion in the Armory Show that opened in New York in February of 1913. The exhibition was a scandal and a huge success. *Nude Descending* became the focal work in the American press, and Duchamp, in absentia, became a celebrity. He would later confront this public renown upon his arrival in New York in June of 1915.[41]

War broke out in 1914. Although he had completed his compulsory military service eight years earlier, Duchamp was summoned before the draft board in January of 1915 and exempted for medical reasons. Subjected to daily abuse for not being in the trenches, Duchamp sensed it was time to leave Paris.[42] On June 15 he arrived in New York. Bundled up with his belongings was something intangible but critical: the already formulated persona of dandy/*flâneur*—one which would serve him well. Taken by Walter Pach to the apartment of Walter and Louise Arensberg, Duchamp, the "readymade" hero, was ensconced as the centerpiece in one of the important circles of New York's burgeoning modernist movement. Treated to celebrity status, Duchamp was the subject of an article that appeared in the September issue of *Vanity Fair*—a posh magazine devoted equally to the glorification of celebrities and promoting products to an affluent audience. The accompanying photograph depicts Duchamp as refined and well-dressed, transformed into a brand of modernism.[43] Much less puffery was offered in the article

"The European Art Invasion," published in the November 27, 1915, issue of the *Literary Digest*. Following its introduction of Duchamp as the man who painted *The Nude Descending a Staircase (No. 2)*, he is quoted: "So far as painting goes—it is a matter of indifference to me where I am."[44]

Exposed to considerable attention and revered, he became a subject for photographers, painters, and sculptors alike. Photographers like Man Ray (pl. 14a) and Edward Steichen (pl. 9) added to his growing mystique through their enigmatic portraits. Jean Crotti (pl. 3) and Katherine Dreier (pl. 10) contributed to Duchamp's expanding *gloire* with interpretive and abstract portrayals. Duchamp was being drawn into an art world, one from which he sought detachment in Paris. But, he was no moth to the flame. He would rely on the cunning and skill of his dandyish indifference to keep him from harm's way. Situating himself on the edge of this "world," his already formulated strategy of indifference/disinterest would serve him well.

Around 1913, while still in Paris, he had begun a series of experiments that in 1915 he would identify as "readymades." Displaced and relocated, objects such as the bicycle wheel and the snow shovel were experiments that functioned as elements of what now can be read as part of Duchamp's larger inquiry into engagement/disengagement. Chrissie Iles reminds us that Duchamp described the readymades as having a "snapshot effect."[45] She points to the argument made by Rosalind Krauss and Dalia Judovitz that "the readymade and the photograph both point towards the object, but remain distanced from it, thus defining themselves, ultimately, in terms of indexical immateriality."[46] Initially conceived as private exercises not intended for display, in New York the readymades assumed a new role, and in 1916, at the Bourgeois Galleries, he displayed two unnamed items that he later described as "readymades."[47] They appear to have aroused little, if any, interest, and their shadowy selves remain unknown. By challenging each object's identity, and that of art and artist more generally, he tested an idea that would come to full bloom the next year.

In 1917, the newly formed Society of Independent Artists, of which Duchamp was a director, proposed holding an exhibition open to all dues-paying members. The terms of the exhibition were generally left open: there was no jury, and all submissions were to be displayed. He must have smelled a rat. Reminiscent of events five years earlier, when he was asked to withdraw *Nude Descending a Staircase (No. 2)*, Duchamp immediately recognized the limits of such an "open" policy. He set about testing them immediately. Collaborating with friends, Duchamp purchased a urinal from a local manufacturer, signed it "R. MUTT, 1917," and submitted it under the title *Fountain* (see fig. 3.1). Situated on a pedestal and rotated ninety degrees from its normal upright position, *Fountain* suggests an early experiment with the theme of gender inversion and possibly serves as a precursor to *L.H.O.O.Q.* and Rrose Sélavy.[48] It was rejected, and so Duchamp and others resigned in protest. Photographed by Alfred Stieglitz, *Fountain* (the original object was soon lost) appeared in *The Blind Man,* accompanied by two essays, "The Richard Mutt Case" and "Buddha in the Bathroom."[49] The first appeared without a signature. The second was signed by Louise Norton, whose signature may have been a front, the real author possibly Duchamp.[50] The pseudonym Richard

Mutt, along with the questionable identities of those writing in *The Blind Man,* had already contributed to the destabilization of the self. Duchamp contributed further to this process when, in a letter to his sister Suzanne, he added more confusion to the question of the identity and authorship by shifting responsibility for *Fountain* to "a female friend of mine, using a male pseudonym Richard Mutt."[51]

The day following the opening of the Society of Independent Artists exhibition, the United States entered the Great War. Duchamp, like other aliens, faced the prospect of being drafted into the American army. Duchamp was nervous about his situation, and disengagement and withdrawal were viable options, as they had been in 1912 and again in 1915. Finally, on August 14, 1918, he boarded the S.S. *Crofton* with Yvonne Chastel and set sail for Buenos Aires, arriving on September 19.[52] Duchamp's choice of Buenos Aires remains something of a mystery. Aside from time spent playing chess and working on his notes for *The Large Glass,* Duchamp did only a modest amount of work during his stay. However, one important photograph credited to this time and place does exist. It is the portrait *Duchamp with Partial Tonsure,* 1919 (pl. 11). This photograph gives us our first glimpse of Duchamp in the role of the *célibat,* a key figure in the eventual conjunction with the *mariée* forming the image of his alter ego, Rrose Sélavy.

> I was losing my hair some time ago but a powerful treatment
> of Yvonne's and a crew cut seem to have saved it for a while.
> —Marcel Duchamp[53]

On March 9, 1919, writing from Buenos Aires to his soon-to-be brother-in-law, Jean Crotti, in Paris, Duchamp informed him that Yvonne Chastel (Crotti's former wife) had cut his hair and applied a potent remedy to his head in an effort to restore his hair.[54] The photograph taken at the time, and possibly by Chastel, gives the appearance that Duchamp's head was entirely shaved. Instead, the haircut, which approximates the Flemish style of the tonsure and was not a fully shaved head, suggests additional possible meanings.[55]

Historically, the tonsure served as an outward signal of a *célibat's* withdrawal from the secular world—an image that Duchamp would appropriate as if putting on a mask, heightening the distance between himself and others. Through this image, which argues for a high degree of connivance between the sitter and the photographer, we read the dandy/*flâneur* arming himself with yet another layer of protection. But protection from what? The tonsure, as pointed out by Giovanna Zapperi, symbolizes the young *célibat's* death to the world and his birth into a new life.[56] For Duchamp this symbolism has an important implication—his appropriation of the identity of the *célibat,* specifically that of a secular *célibat.* Death was also a timely topic surrounding Duchamp at that time. He had recently been informed of the deaths of his brother Raymond and his close friend Guillaume Apollinaire.

On June 22 Duchamp boarded a ship and arrived in France in late July.[57] He spent his time in France mostly visiting family and friends, many of whom he had not seen for four years, and making a few new acquaintances. He received comments about his close-cropped hair, his younger sisters disliking it, and it

is likely that he offered no reason beyond what had been stated in the letter to Crotti. He was reunited with the Picabias, with whom he stayed. Missing was Apollinaire, and Apollinaire was, no doubt, weighing on his mind. Duchamp did little work while in France. One piece, however, is of great significance: the rectified readymade *L.H.O.O.Q.* (1919)—made using a cheap print of Leonardo's *Mona Lisa* to which he added a moustache, goatee, and the coarse phrase "L.H.O.O.Q." (Duchamp's loose translation was "There is a fire down below.")[58] Like *Fountain* before it, *L.H.O.O.Q.* demonstrates Duchamp's playful approach to questions of gender identity through inversion and disruption. Both can be read as important prefigurations of Rrose Sélavy.

During the 1960s Duchamp was repeatedly asked to explain his motive for *L.H.O.O.Q.*[59] His most direct response came in a 1961 radio interview with Herbert Crehan: "In 1919 when Dada was in full blast, and we were demolishing many things, the *Mona Lisa* became a prime victim. I put a moustache and a goatee on her face simply with the idea of desecrating it."[60] In a later interview with Calvin Tomkins he offered, "The curious thing about that moustache and goatee is that when you look at the *Mona Lisa* she becomes a man. It is not a woman disguised as a man; it is a real man, and that was my discovery, without realizing it at the time."[61] Not one to offer explanations, Duchamp's "clipped" accountings have stood both for and in the way of understanding, serving largely as framing devices used when discussing the work. I would like to suggest other considerations that could also contribute to the work's puzzling complexity, important among them Duchamp's sense of Apollinaire's absence.

Duchamp first met Apollinaire in 1912, not long after the latter had been held as a suspect in the 1911 theft of the *Mona Lisa* from the Louvre, an incident that scarred Apollinaire emotionally. In 1917 Duchamp, while in New York, completed the rectified readymade *Apolinère Enameled.*[62] This work shares a number of interesting qualities with *L.H.O.O.Q.* In both rectified readymades Duchamp engages us in an interplay between a modified image and the altered or added cryptic text, creating tension-filled relationships between image and word, thereby obfuscating meaning. Functioning as homophones, both texts set up a linguistic game assailing language in its social function, suggesting, as Rosalind Krauss has proposed, two entirely different meanings: one as a title, and another as a sentence.[63]

Attention must also be paid to Apollinaire's play *Les mamelles de Tirésias,* which was performed in Paris during the summer of 1917: echoes of its impact still reverberated in 1919. Addressing questions of gender identity, the play contains a number of interesting elements that connect it with *L.H.O.O.Q.* and that anticipate the arrival of Rrose Sélavy. Principally an antiwar farce, the play contained a serious and timely theme: the low French birthrate and the need to procreate *pour la patrie*—a theme spoofed by Duchamp's inscription "L.H.O.O.Q." Early in the first act, Thérèse, a self-avowed feminist and anarchist, exchanges her female sexual identity, assuming that of the male figure Tirésias by growing a beard and moustache while letting her breasts (helium-filled balloons) fly away. A few scenes later Tirésias strips both herself and her husband, donning his male attire and he hers. The gender identities of both are transformed,

she parroting the struttings of a military general, and he producing machine-made children.[64]

The climate of postwar Paris was another likely contributor to the creation of *L.H.O.O.Q.* Although France was victorious, the war had been costly. Most citizens seemed anxious to restore a sense of serenity wrapped in a veil of national unity and pride that nurtured a jingoist political conservatism reflected in the "call to order."[65] Importantly, in 1919, Parisian Dada was in its preliminary phase. Led by Francis Picabia and André Breton, Dada mounted a stand against advocates of "purity in painting."[66] Duchamp's comment to Herbert Crehan that the *Mona Lisa* was ripe for a Dadaist assault may be read within the context of this situation. The inscription "L.H.O.O.Q." applied at the bottom of the print, along with the moustache and goatee Duchamp drew, highjacked the painting's purity. Duchamp, the "an-artist," had denounced the purely visual, reinstating the relationship between words and images, establishing a conflict that energizes both, and accomplishing the desired effect of the rebus—reminding us of the important influence Pyrrho and Stirner had on his thinking.

Two days after Christmas, Duchamp departed Paris for New York, arriving on January 6, 1920. Back in New York, Duchamp seemed to pick up steam, and 1920 was a very productive year. He returned to work on his *Large Glass* and rekindled his friendship with Man Ray, who had recently committed himself to portrait and documentary photography on a full-time basis.[67] The two undertook a number of important collaborations.

> I just wanted two identities, that's all.
> —Marcel Duchamp, 1965

The New York to which Duchamp returned that year was far different from the one he left in 1918. Teased out of the complex character of the period are certain issues that led to the creation of his alter ego Rose (later Rrose) Sélavy sometime during 1920. Other factors helped pave the way for her emergence. These include a new Puritanism, based on fear of radicals and foreigners, that demanded adherence to clearly defined gender identities and roles. Also significant were conflicts between feminism and fashion and between social classes in asserting fashion leadership. Drawing from popular culture, a fascination grew with icons of fame and figures from high society, the stage, and the motion picture screen. Rose's (aka Duchamp's) responses to all this are given character through an outburst of sardonic humor that infected New York and Paris Dada.

When asked the reasons for Rose's creation, Duchamp responded, "I wanted to create two identities, that's all," quickly shifting the conversation by describing the etymology of her name.[68] In interviews he told Calvin Tomkins and later Pierre Cabanne that Rose was a common and ugly name. He also stated that he had considered changing his religion and selecting a Jewish name, but he claimed he could not find one to his liking so he adopted the female name Rose and, as he put it, changed his sex instead.[69]

My own sense is that his answers are incomplete and designed to derail us. Drawing in part on Lois W. Banner's history of the U.S. cosmetic industry, Nancy

Ring builds a compelling argument that the name "Rose" was not viewed as common or ugly at the time Duchamp conceived Rrose Sélavy.[70] Instead, during the 1910s and 1920s, manufacturers of beauty products and advertising copywriters combined the names of flowers (such as rose and violet) with French phrases to create elegant-sounding names that enhanced the mystique of their products. The pages of *Vanity Fair* magazine from this period are populated with advertisements for products with names like "Rose d'Orsay," "Jardin de Rose," and "Quelques Violettes." The magazine also published ads for a fashion designer named "Madame Rose," who promised to "bring Paris to your door."[71]

Not disputing the theme of gender change, I would add another dialectic—that of a Catholic/Jewish, religious/cultural dynamic, both in his native France and in New York. As Duchamp indicated, Rose was indeed a popular first name for women during the early part of the twentieth century. It seems that it was not only popular within the Catholic community but used in an anglicized version in the Jewish community as well. Duchamp's collaborator in the creation of the photographic portraits of Rose was Man Ray, a Jew from Brooklyn who had already changed his name from Emmanuel Radnitzky. It seems reasonable to think that he could have assisted in the selection of Rose as a name. We also discover that in modern Hebrew the name "Shoshana" means "rose" or "my rose." Additionally, it is the biblical root of the Old Testament name Susanna—which is Susan in English and Suzanne in French—the implications of which might merit further exploration.[72]

The subsequent addition of the second *r* to Rrose's name transforms its function along with her identity, effecting her passage from virgin to earthly bride to femme fatale. Rrose's last name, Sélavy, Duchamp described as a word play on the French phrase *c'est la vie,* recalling his attitude of indifference.[73] Together, the two names function to create what Rosalind Krauss describes as a homophone suggesting two entirely different meanings: a proper name, Rrose Sélavy, and a sentence, *eros c'est la vie.*[74]

> Make a painting or sculpture as one winds up a reel of cine-film.
> —Marcel Duchamp, c. 1920?

Duchamp's experiments with photography, film, and optics contributed in important ways to the construction of images of Rrose that are unstable: they oscillate between the maleness of the *célibat* and the femininity of the *mariée* to establish a continual process of unification and separation. Around 1920, Duchamp (using an early handheld motion-picture camera given him by Katherine Dreier) began exploring the potential of cinematography with Man Ray.[75] An enthusiast of motion pictures, Duchamp was curious about cinema techniques, an interest that would prove far-reaching.[76] In a note from this time period, he provided a conceptual sketch regarding making "a painting or sculpture as one winds up a reel of cine-film." He defined the desired effect as " a new 'take' continuing the preceding turn and linking it to the next."[77] The lessons learned from their experiments as filmmakers proved useful to Duchamp and Man Ray, especially the technique of montage, which recalls the language of another of his notes

fig. 4.2 | *Portrait of Marcel Duchamp* by Man Ray, gelatin silver print, 1920–21. Yale University Art Gallery, New Haven, Connecticut; gift from the Estate of Katherine S. Dreier

cited earlier: "The possible/implying the becoming—the passage from one/to the other takes place/in the infra thin." Unlike photo collage and photomontage, which at that time were becoming staple parts of the Dadaists' visual vocabulary, the editorial effect of montage in cinematography produces a multiple sense of action—where images are superimposed, they become simultaneously temporal and spatial, in constant flux, broken down, and reassembled again.

Important as cinemaphotography might be as an agent guiding the construction of images in flux, for Duchamp it cannot be considered the only probable source and needs to be seen as part of a larger constellation of sources including chronophotography and optics. The chronophotographic images produced by Etienne-Jules Marey and Eadweard Muybridge, known to have informed Duchamp's works, provide a sequential record of movement within a single picture frame.[78] Our eye is drawn not to the individual pose but to the transition from the previous pose to the next.

Duchamp, who had an interest in optics and optical devices, was likely aware of photographic methods such as "Parallax Stereogram," developed by Frederick E. Ives, or Gabriel M. Lippman's system using a series of lenses.[79] Both produced what *Scientific American* called "Novel Changeable Photographs." These featured alternating strips from two different pictures attached to a panel over which was placed an optical barrier allowing one image to be viewed from the right side and the other from the left.[80] In one of the notes included in *The Green Box,* labeled "mirrorical return," Duchamp describes the design and function of a similar optical device, the "Wilson-Lincoln system," intended to be part of *The Large Glass* (it was never executed).[81] The note is accompanied by an ideagram (see fig. 5.1) in the form of an accordion-folded plane, illustrating how he thought the "system" would operate "like the portraits which seen from the left show Wilson [and] seen from the right show Lincoln."[82] Employing this model when considering the photographs of Rrose Sélavy, we can imagine that when seen from the left it reveals the MARiée, and from the right the CELibat. Viewed from directly in front, both images become visible—the amalgam of the two creating a state, like that in the motion picture, where the image is broken down and then assembled again.

> Man and Marcel were very much a team, afflicted with the
> same mischievous inventive spirit, and compatible humor.
> —Herbert R. Lottman, 2001[83]

In early February of 1920, not long after Duchamp returned to New York from Paris, Gabrielle Buffet-Picabia (the estranged wife of Francis Picabia) arrived. She was on a mission to sell high-fashion dresses designed by the sister of the Paris couturier Paul Poiret.[84] During the three months that she stayed with Duchamp, it seems likely that she introduced him to the world of high fashion, a theme that, as I suggested earlier, had important implications for Duchamp and Man Ray in their concoction of Rose Sélavy.

Later that year (or possibly in early 1921) Duchamp sat for Joseph Stella, who produced the silverpoint drawing of his head in profile (pl. 12). Around the same time he was the subject of a photograph taken by Man Ray (fig. 4.2) that,

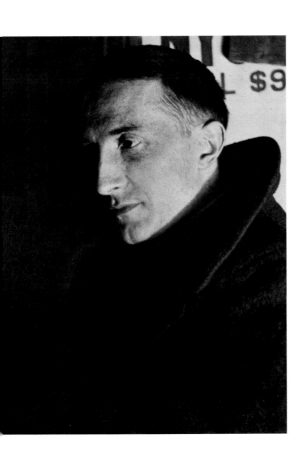

like the Stella, shows Duchamp in profile, again sporting a close-cropped haircut. The manner of the cut approximates that of a Celtic-type tonsure and suggests another exercise in Duchamp's conscious effort to portray himself as the *célibat*. Some years later Katherine Dreier referred to this photograph as "her photo of him 'as a monk.'"[85]

Early in 1921, Duchamp and Man Ray produced the first "appearance" of Rose Sélavy, a persona made visible only through Man Ray's camera. Roland Barthes wrote that a "photograph's essence is to ratify what it represents."[86] If so, I would propose that Duchamp, fronted by the newly created persona of Rose and coolly maintaining distance, took Stirnerian aim, poking fun at moral, beauty, and fashion arbiters. Inserted into the conversation as a pseudocelebrity, Rose rubs up against images of celebrities and fashion models that populated the pages of *Vanity Fair* magazine, images that provided codes to class-conscious audiences identifying correct behavior, dress, and standards of beauty.[87] Rose mimics the subtly erotically charged images of female celebrities and fashion models whose portrayals in the pages of fashion magazines and in department store display windows waver between those of consumer and product to be consumed.

The photograph, like the display window, establishes an ambivalent topography—both drawing the observer into a gaze through a transparent surface and separating them from the object of desire. Sequestered behind the "pane," the subject of the photograph, like the objects in the display window, reveals itself as a reference to something absent. In the note titled "Speculations," dated 1913, Duchamp spelled out the terms establishing an absence that mobilizes seduction and activates the erotic:

The question of shop windows ∴
To undergo the interrogation of shop windows ∴
The exigency of the shop window ∴
The shop window proof of the existence of the outside world ∴

When one undergoes the examination of the shop window, one also pronounces one's own sentence. In fact, one's choice is "round trip." From the demands of the shop windows, from the inevitable response to shop windows, my choice is determined. No obstinacy, ad absurdum, of hiding the coition through a glass pane with one or many objects of the shop window. The penalty consists in cutting the pane and in feeling regret as soon as possession is consummated. Q.E.D.[88]

Roland Barthes reminds us that the "photograph belongs to that class of laminated objects whose two leaves cannot be separated without destroying them both: the windowpane and the landscape . . . desire and its object."[89] For Rose the pane is never cut. She never leaves that ambivalent topography from which her interrogation of us mirrors ours of her.

By the 1920s to be beautiful meant the adoption of artificial means: clothing, hairstyle, and makeup (which had recently assumed legitimacy) added up to the

construction of the "feminine mystique."[90] Rose, in the photograph, invites us to interrogate that "feminine mystique." Her shadowy image "appears" in female attire with a stylish hat pulled down over her head. Her face seems heavily made up, and her lips are sharply defined by lipstick. Little attention is given to her eyes or brows in this photograph, providing the opportunity for the *célibat* to interrogate us by peering out through the masquerade at her audience. Unlike photographs of highly effective female impersonators, the underlying male figure is not hidden. We move back and forth between the image of the *célibat* and the feminine masquerade. Deception, I believe, was not the goal. The visible *célibat*, necessary in the construction of the desired dialectic, recalls Pyrrho's "it both is and is not." And, far from being benign, I see the *célibat* operating as an advocate of a secular asceticism (informed by Stirner), poking fun at the establishment, undermining social convention, and creating identity and gender confusion. Rose was quickly earning her stripes as an anarchist.

Sometime before April 1921, Rose made her second "appearance" before Man Ray's camera (pl. 16).[91] The pseudocelebrity had turned entrepreneur, establishing herself as a brand name/trademark by underwriting a pseudoproduct, the perfume labeled *Belle Haleine: Eau de Voilette* (pl. 15).[92] Designedly fetishized and more feminized, the image produced in this photograph shows Duchamp crossdressed as Rose, who sports women's clothing and a veiled hat, along with jewelry and makeup. She is veiled behind Belle Haleine, who veils the *célibat,* who veils Duchamp, creating the desired disruption of identity. As with the balance of opposites seen in alchemical emblems of the androgyne, the photograph recalls the effects of cinematographic montage and Pyrrho's skepticism, existing in constant flux—disassembly and reassembly.

Just as with the first "appearance" of Rose, one gets the impression that Duchamp and Man Ray are sticking a pin into the balloon of high fashion. Described as an assisted readymade, *Belle Haleine: Eau de Voilette* consists of an appropriated *Un Air Embaume* perfume bottle and case by Rigaud. The original label on the bottle was replaced by one designed by Man Ray that features Rose's photograph along with typography renaming the product "Belle Haleine/Eau de Voilette/RS/New York/Paris."[93] Playfully structured, the brand name reads "Belle Haleine," which translates as "beautiful breath." The second part twists the phrase "*eau de violette*" to read "*Eau de Voilette.*" By inverting the i and the o, the reference is shifted from the name of a flower to the French word that means veil or a hat-veil. A homophone, the title can be read both as a name and as a sentence—"Beautiful Breath, Veil Water." It operates as a linguistic game that assails language in its social function.

That June, Duchamp, along with Rose, left New York for Paris, arriving around June 20.[94] There he quickly renewed his friendship with Francis Picabia, who drew him into what was increasingly becoming the volatile Paris Dada circle. The following month, in the July 10 special issue of *391,* Picabia made public for the first time the not-so-subtle alteration of Rose Sélavy's first name.[95] Adding a second *r,* it now read Rrose, the spelling that Duchamp would continue to use, in effect transforming her name into "Eros C'est la vie." Prior to his exhibition of *L'oeil cacodylate* at the Salon d'Autumne, which opened in October, Picabia had invited

about fifty of his friends (and enemies) to his apartment, where they signed the piece.[96]

Man Ray arrived in Paris on July 22. Picabia quickly introduced him to the members of the Paris Dada circle. Shortly after that, Gabrielle Buffet-Picabia provided him another important introduction—to the couturier Paul Poiret. By August he had received an assignment to photograph the season's offerings for the dress designer; the photographs appeared in *Vanity Fair* and other important magazines.[97]

Within this timeframe is a group of photographs of Duchamp, his hair cut with a star/comet tonsure. These photographs have variously been attributed to Man Ray and Georges de Zayas. The photographs can be divided into different groups—those taken indoors (pls. 18, 19) and those showing Duchamp sitting on a park bench (pl. 20).[98] They can also be divided along a timeline: one taken before the tonsure was completed (not illustrated), those taken right after it was completed (not illustrated), and those done a few days later, showing stubble in the area defining the pathway of the cometlike swath crossing over the crown of his head toward his forehead (pls. 18, 19).

It is useful to recall that Duchamp was sharing an apartment at 22 rue de Condamine with Yvonne Chastel.[99] Two years earlier, she had administered his first tonsure while they were in Buenos Aires, and she was possibly the author of the photograph commemorating the event. Notable too is the fact that Man Ray was living in the same building. They, possibly along with de Zayas, could have participated in administering and photographing the tonsure sometime between August 9 and September 17, 1921.[100]

What was Duchamp up to? Interestingly, this tonsure offers an allusion to one of Duchamp's notes found in *The Green Box*. The note describes the "headlight child," whose configuration parallels that of the overall pattern of the haircut.[101] More to the point, perhaps, the tonsure cut offers a direct reference to Rrose herself. The pattern of the five-point star is also that of the five-petaled wild rose, thought to be a secret symbol revealing the feminine principle. From Roman times this symbol has been called the "Rose of Venus," its shape mimicking the pentagrammatic path traced by the planet Venus, making it a symbol of the goddess of love. *Eros c'est la vie*.[102]

One of the photographs taken outdoors (pl. 20) shows Duchamp leaning forward, the star quite visible. A cropped print of it, mounted on paper, is accompanied by the inscription "Voici Rrose Sélavy, 1921," in Duchamp's hand.[103] This photograph, along with the inscription, contributes importantly to my claim that Duchamp, in the guise of the *célibat* sporting the star/comet tonsure, situates himself behind the feminine masquerade—the *mariée*—their "wedding" composing the transitive image of the androgynous Rrose Sélavy. The inscription is another homophone working on two levels (title and sentence). The phrase translates "here is Rrose Sélavy."

Piecing together the events of late 1921, it seems plausible that Man Ray photographed Duchamp in the guise of Rrose Sélavy at this time, while he was still sharing an apartment with Duchamp and Yvonne Chastel.[104] Man Ray, who for the last year or so had devoted himself full-time to portrait and documentary

fig. 4.3 | *Duchamp Mannequin, Galerie Beaux-Arts, 1938* by Raoul Ubac, gelatin silver print, 1938. Research Library, The Getty Research Institute, Los Angeles, California (92.R.76)

photography, had recently undertaken the assignment of photographing the fall collection of the scion of Paris fashion design, Paul Poiret, who "believed adamantly that fashion should be 'the privilege of the elite.'"[105] With the third and last photographed appearance of Rrose Sélavy, the feminine masquerade is more fetishized than the previous two versions—she having experienced what is labeled in the beauty industry today "a complete makeover." Attention to makeup and retouching of the curls over the left ear and the eyebrows, along with careful lighting, work to soften Duchamp's features. A more feminine and erotic Rrose (playing against the veiled *célibat*) emerges, costumed with the aid of Germaine Everling's hat and fur-trimmed coat. Adding to the complexity of gender identity, this version of Rrose features an actual female presence, in the form of Everling's arms and hands (she is behind Duchamp in travesty, hidden from the camera's eye), physically embracing the *célibat*.[106]

From her initial appearance to this point, Rrose has been a figure in transit —rough-hewn to apparently refined. The mischievous, inventive spirit shared by Duchamp and Man Ray, and previously seen in the first two iterations of Rrose, surfaced again. Could it be that the two were spoofing not only the commercially fabricated "femme fatale" but Man Ray's role as fashion photographer? Taste and beauty, as they were being increasingly defined by the beauty and fashion industries, were the targets. And, as before, the weapon of irony was used to launch an assault. Hurling the androgyne Rrose into fray, the male authors mock the commercially marketed recipes for the construction of feminine identity. And Rrose, established not only as a persona but as a trademark/brand name, was ready to contribute to the fun. Settled in Paris, she affirmed her own identity and announced her professional presence with her business card reading:

> Precision Oculism
> RROSE SÉLAVY
> New York—Paris
> COMPLETE LINE OF WHISKERS AND KICKS

Like Duchamp's readymades, instruments for unloading ideas and then to be discarded or left behind, the image of Rrose Sélavy developed over the course of 1921 would not appear again. Duchamp expressed the importance of not repeating himself, and that concern likely applies here as elsewhere. To continue the appearance before Man Ray's camera in her guise would run that risk and, even worse, hazarded the transformation of Rrose into a caricature. Not seen and/or less seen, she moved into the shadows from which she would continue her partnership with Duchamp as author, publisher, and engineer over the next decades.

Although Rrose slipped into the shadows, not to be seen again, periodic references or allusions to her continuing presence can be recorded. In these cases, and with his collaborator Man Ray, Duchamp massages the equation, at times inverting the positional relationships between the MARiée and the CELibat that I have previously discussed.

In mid-1922, writing to Man Ray from New York, Duchamp playfully signed a letter to "Marcel à vie," suggesting his ongoing identification with Rrose.[107] The next year Man Ray painted the now-lost portrait of Duchamp, *Cela Vit* (pl. 21). Based on the 1912 Hans Hoffmann photograph of Duchamp (pl. 1), his representation, along with the rebuslike title appearing in the lower right corner of the canvas (an image of a rose next to the words "Cela Vit"), operates enigmatically. George Baker attaches considerable importance to this title, noting a shift in meaning from Duchamp's "c'est la vie" ("that is [just] life") to "cela vit ("that is [there] is living [alive]").[108] Like the phrase "Voici, Rrose Sélavy" accompanying the star/comet tonsure photograph of Duchamp, Man Ray's "cela vit," with its shift in wording (from "c'est la vie"), may be suggesting that the shadowy Rrose, not seen and/or less seen, is alive. The mask seems to have come off and the masquerade seems over. Duchamp appears revealed. Or are we being reminded that Duchamp continually marked his identity, like that of Rrose, as contingent, unfixed, ultimately fictive, becoming another alias?[109]

Writing in 1950, Duchamp concluded a letter to Fiske Kimball by referring to himself as "a prima donna in reverse" and signing it "Sarah Bernhardt alias Marcel Duchamp." Discussing this letter, Jennifer Blessing argues that "Duchamp performs textual cross-dressing in an unending circuit of identifications: he represents himself as a woman . . . the 'prima donna in reverse' makes him a man again, while recalling the artist's own prima donna—the bearded Mona Lisa."[110]

That letter seems to reflect on another glimpse of Rrose, surviving through Man Ray's photographs, and with it insight into his slippery play with the theme of identity. The event was the 1938 Exposition internationale du surréalisme held in Paris at the Gallerie Beaux-Arts. Lewis Kachur has described the layout for the exhibition as featuring an entry hall where sixteen mannequins, each dressed by a different artist, greeted the patrons. Important among the group was Duchamp's contribution, *Rrose Sélavy* (fig. 4.3).[111] Kachur assesses Duchamp's seemingly understated and simple contribution as anything but that. Clearly it represents a mirror, reversing what we have seen with the other renditions of Rrose. Here the image of the *célibat* operates in front of that of the *mariée*—she is peeking out from behind him. Like the other artists, he began with a full-size female wax mannequin, partially dressing it in men's attire and a curly blond wig. The jacket, waistcoat, shirt and tie, hat, and men's brogues have all been described as belonging to Duchamp, thereby reversing his earlier portrayal of Rrose in borrowed female clothing. While the mannequin's upper body is clothed in male attire, her lower torso and legs are bare, exposing her sex—except there is none. Rrose is stripped bare by her bachelor and found genderless. Written across the mannequin's pubic mound is the signature "Rrose Sélavy."[112] It seems to certify the Pyrrhonian notion "that it is, that it is not, that is and is not at the same time, and that it neither is nor is not at the same time."

fig. 4.4 | *Marcel Duchamp with Turkish Coin Necklace on Forehead, Hollywood* by Man Ray, gelatin silver print, 1949. Philadelphia Museum of Art, Pennsylvania; gift of Jacqueline, Paul, and Peter Matisse in memory of their mother, Alexina Duchamp, 1998

Two photographs from around 1950 indicate Duchamp's continuing engagement with an unending circuit of identifications. In 1949 Man Ray photographed Duchamp with a Turkish necklace placed over his head (fig. 4.4). Generally ignored, I think this photograph can be read as a witty and playful recall of Rrose. Traditional wedding costumes worn by Turkish women included a headdress festooned with gold coins that fall across the forehead—the MARiée.[113] The other is the mid-1950s Polaroid print of Duchamp, sitting wearing a coat and tie and holding his pipe. Perched on his head is a curly blond wig (pl. 55).[114] Viewing this photograph today, the image serves simultaneously as a mirror and a projector—reflecting on Rrose and signaling *Étant donnés* (the secret ongoing project that would not be revealed until after Duchamp's death). Situated in front of the camera, Duchamp appears to be hiding in front of the camera, secreted by allusions to work not yet seen.

I had no position.
—Marcel Duchamp, from an interview by Pierre Cabanne, 1966[115]

Informed by Pyrrhonian indifference and Stirner's mastering "ego," Marcel Duchamp authored a fascinating conundrum, a rebus that keeps us from fixing his identity. He has proved the master of self-invention, recasting his image and shuffling identities through the means of invented personae. The certainty of uncertainty proposed through Duchamp's fracturing of identity finds its "mirrorical return"—further shuffling identities. Recalling Roland Barthes's assessment that the photograph, like the window pane, separates desire and its object, we are left at an impasse—endgame. He remains wanted.

Notes

1. Marcel Duchamp, *Wanted: $2,000 Reward*, rectified readymade, 1923. See Schwarz, *Complete Works*, vol. 2, 699.

2. Tomkins, *Duchamp*, 445.

3. Joseph Masheck, ed., *Marcel Duchamp in Perspective* (Englewood Cliffs, NJ: Prentice-Hall, 1975), 19. For extended discussions regarding the expectations of portraiture, see Richard Brilliant, *Portraiture* (Cambridge, MA: Harvard University Press, 1991), and Shearer West, *Portraiture* (Oxford: Oxford University Press, 2004).

4. I am grateful to Francis M. Naumann who, on a number of occasions, has shared his insights regarding the order, dating, and locations where the photographs of Rrose Sélavy were made in collaboration with Man Ray. It was he who first proposed that the first two photographs where made in New York during the first part of 1921 and that the third version was made in Paris later that year.

5. Opinions vary greatly regarding the dates when many of these photographs were made. For example, dates of 1919 or 1921 are given for the photographs of Duchamp with the star/

comet tonsure (see nn. 98 and 100). The dates are often followed by an attribution, crediting the photographs to Man Ray. Assuming that Man Ray photographed Duchamp with the star/comet tonsure, 1919 does not work. Duchamp spent part of that year in Buenos Aires, the other in France. Man Ray was in New York. Similar problems occur with the photographs of Rrose Sélavy. Some authors date them as late as 1924. (See n. 4 above.) Duchamp may have contributed to the problem. In a note on the verso of one of the prints of the Paris version of Rrose, he gave the date 1924. Later, in a letter to Arturo Schwarz dated March 1968, he corrected the date—1921. Schwarz, *Complete Works*, vol. 2, 693.

6. T. J. Demos, *The Exiles of Marcel Duchamp* (Cambridge, MA: MIT Press, 2007), 89.

7. M. E. Warlick, *Max Ernst and Alchemy, A Magician in Search of a Myth* (Austin: University of Texas Press, 2001), 45–47; Marcel Duchamp, letter to Louis and Walter Arensberg, June 15 and 20, 1919, in Naumann and Obalk, *Affectionately, Marcel*, 85–87.

8. Marcel Duchamp, "Note 1," in *Marcel Duchamp, Notes*, arr. and trans. Paul Matisse (Paris: Centre National d'Art et de Culture Georges Pompidou, 1980), unpaginated.

9. Jones, *En-gendering*, 143.

10. Duchamp, "Note 9" (recto) and "Note 11" (verso), in *Notes*.

11. Marcel Duchamp, *in the infinitive: a typotranslation by Richard Hamilton and Ecke Bonk of Marcel Duchamp's White Box*, trans. from the French by Jackie Matisse, Richard Hamilton, and Ecke Bonk (Paris: Succession Marcel Duchamp, 1999), 22.

12. Duchamp, "Note 1," *Notes*. See also Octavio Paz, *Marcel Duchamp: Appearance Stripped Bare*, trans. Rachel Phillips and Donald Gardner (New York: Viking, 1978), 138–53.

13. *WMD*, 84–85.

14. June Singer, *Androgyny: A New Theory Toward Sexuality* (New York: Anchor Press, 1976), 20–21 and 246.

15. Jean-Marie Droit, "Marcel Duchamp: A Game of Chess," videocassette. Evanston, IL: Home Vision, 1987.

16. See Moira Roth, "Marcel Duchamp in America: A Self Ready-Made," in *Difference/Indifference: Musings on Postmodernism, Marcel Duchamp and John Cage*, introduction and text by Moira Roth, commentary by Jonathan D. Katz (Amsterdam: G + B Arts International, 1998), 17–32. This essay chronicles the development of Duchamp's many personae.

17. Tomkins, *Duchamp*, 122–23.

18. Dawn Ades, "Duchamp's Masquerades," in *The Portrait in Photography*, ed. Graham Clark (London: Reakton Books, 1992), 94.

19. Cabanne, *Dialogues with Marcel Duchamp*, 89–90.

20. Francis M. Naumann, "Aesthetic Anarchy: Self-Portraits and Related Works by Marcel Duchamp, Francis Picabia and Man Ray," in *Marcel Duchamp, Francis Picabia, and Man Ray* (London: Tate Gallery, 2008), 58–75.

21. Max Stirner, *The Ego and His Own*, selected and introduced by John Carroll (New York: Harper & Row, 1971), 27.

22. Tomkins, *Duchamp*, 123.

23. Max Stirner, *The Ego and His Own,* trans. from the German by Steven T. Byington (New York: E. C. Walker, 1913), 242–75.

24. William Seitz, "What Happened to Art? An interview with Marcel Duchamp on the present consequences of New York's Armory Show," in *Vogue,* February 15, 1963, 113.

25. Allan Antliff, *Anarchist Modernism: Art, Politics and the First American Avant-garde* (Chicago: University of Chicago Press, 2001), 76–77, 90.

26. "Max Stirner," *Stanford Encyclopedia of Philosophy,* http://plato.Stanford.edu/entries/max.stirner/ (November 16, 2007).

27. R.K.W. Paterson, *The Nihilistic Egoist: Max Stirner* (London: Oxford University Press for the University of Hull, 1971), 64.

28. Jerrold Seigel, *The Private Worlds of Marcel Duchamp: Desire, Liberation and the Self in Modern Culture* (Berkeley: University of California Press, 1995), 154.

29. Seitz, "What Happened to Art," 113

30. Seigel, *Private Worlds,* 151–54.

31. Henderson, *Duchamp in Context,* 250, n. 40; Schwarz, *Complete Works,* vol. 1, 33.

32. Thomas McEvilley, *The Triumph of Anti-Art: Conceptual and Performance Art in the Formation of Post-Modernism* (New York: McPherson & Company, 2005), 21.

33. Paul Oskar Kristeller, *Greek Philosophers of the Hellenistic Age* (New York: Columbia University Press, 1993), 43–44.

34. Katharine Kuh, "Marcel Duchamp," in *The Artist's Voice: Talks with Seventeen Artists* (New York: Harper & Row, 1962), 83.

35. Ibid.

36. Seitz, "What Happened to Art," 113. See also Cabanne, *Dialogues with Marcel Duchamp,* 89–90.

37. Demos, *Exiles,* 88–89.

38. Naumann and Obalk, *Affectionately, Marcel,* 35.

39. Tomkins, *Duchamp,* 81. See also Cabanne, *Dialogues with Marcel Duchamp,* 17.

40. In his autobiography (Man Ray, *Self Portrait,* 233) Man Ray claims that Duchamp sat for the painting *Cela Vit.* This is doubtful. A comparison of the image of Duchamp's decollated head floating across the painting's surface matches exactly that of Hoffmann's 1912 photograph. For a discussion of Man Ray's 1936 *Portrait of Marcel Duchamp Overlaid with a Photogram of the Glissière,* see Ecke Bonk, *Marcel Duchamp: The Box in a Valise,* trans. David Britt (New York: Rizzoli, 1989), 208. Man Ray is not the only artist to find the Hoffmann photograph useful for his purposes. The Munich-based artist Rudolf Herz recently used it as a central element in his installation *Zugzwang,* shown in the "Mirroring Evil" exhibition at New York's Jewish Museum in 2002. His interest in this part of Duchamp's career and the Hoffmann photograph continues. On June 8, 2008, Herz showed this author models for a new piece utilizing the photograph that is currently in the planning stages.

41. During his first months in New York, Duchamp was the subject of a number of newspaper and magazine interviews. See, for example, "The Nude Descending-a-Staircase Man Surveys Us," *New York Tribune,* September 12, 1915, in the Papers of Henry McBride, Yale Collection of American Literature, Beinecke Rare Book and Manuscript Library, Yale University, New Haven, Connecticut. See also Naomi Sawelson-Gorse, "On the Hot Seat: Mike Wallace interviews Marcel Duchamp," *Art History* 23, no. 1 (March 2000): 35–55. In this interview Duchamp stated clearly that the figure in *Nude Descending a Staircase (No. 2)* is "a woman."

42. Tomkins, *Duchamp,* 140.

43. "Marcel Duchamp Visits New York," *Vanity Fair,* September 1915, 57.

44. "The European Art-Invasion," *Literary Digest for November 27, 1915,* November 27, 1915, 1223–25.

45. *WMD,* 33.

46. Chrissie Iles, "Marcel Duchamp, Man Ray and the Desiring Machine," in *Marcel Duchamp–Man Ray: 50 Years of Alchemy* (New York: Sean Kelly Gallery, 2004), 35.

47. Tomkins, *Duchamp,* 156.

48. The terms "inversion" and "Uranian" were in vogue as references to gender issues during the later part of the nineteenth and early twentieth centuries. Duchamp's selection of a urinal and rotating its position ninety degrees suggests allusions to gender as a way for him to complicate questions of identity. Please see Janine A. Mileaf's essay in this volume for more on the gender inversion implicit in *Fountain.*

49. See William A. Camfield, *Marcel Duchamp/Fountain* (Houston: Menil Foundation, Houston Fine Art Press, 1989), 35–40. In the succeeding months, Beatrice Wood and Carl Van Vechten, referring to Stieglitz's photograph, expressed curiosity regarding *Fountain*'s gender identity, suggesting it be either an image of the Madonna or the Buddha.

50. Nancy N. Ring, "New York Dada and the Crisis of Masculinity: Man Ray, Francis Picabia, and Marcel Duchamp in the United States, 1913–1921," PhD diss., Northwestern University, 1991, 225–31.

51. Marcel Duchamp to Suzanne Duchamp, letter dated April 11, 1917, in Naumann and Obalk, *Affectionately, Marcel,* 47. See also Janine A. Mileaf's discussion regarding the authorship of *Fountain* in her essay in this volume.

52. Jennifer Gough-Cooper and Jacques Caumont, "Ephemerides on and about Marcel Duchamp and Rrose Sélavy," in *Marcel Duchamp: Work and Life,* ed. Pontus Hulten (Cambridge, MA: MIT Press, 1993), entry for September 19, 1918.

53. Schwarz, *Complete Works,* vol. 2, 673.

54. Ibid.

55. Conversation between this author and Sean Kelly, February 10, 2005. See also Wikipedia: "Tonsure." The term describes cutting the hair from the scalp of clerics, devotees, or holy people as a symbol of their renunciation of worldly fashion and esteem. While the origin of the tradition remains unclear, it can be traced back to the seventh or eighth centuries. Also, see "Lecture explores the history of a haircut," Megan Comerford, http://media.www.thecowl.com/media/storage/paper493/news/2004/11/11/News/Lecture.Explores.History.Of.A.Haircut-802256.shtml (August 21, 2007).

56. Giovanna Zapperi, "Marcel Duchamp's Tonsure: Towards an Alternative Masculinity," *Oxford Art Journal* 30, no.2 (2007): 291–303.

57. Tomkins, *Duchamp,* 214–15.

58. Herbert Crehan, "Dada," *Evidence,* no. 3 (Autumn 1961): 38.

59. Duchamp's responses to questions about his motives behind *L.H.O.O.Q.* are numerous, dating back at least to his 1953 conversations with Sidney, Harriet, and Caroll Janis. Still unedited, that conversation is referenced in Stewart Dickson's "Response to 'Female Molds,'" *Tout-fait: The Marcel Duchamp Studies Online Journal* (http:// www.toutfiait.com/duchamp.jsp?posted=46494 [August 15, 2007]. Other important interviews include Crehan, "Dada," 38; Calvin Tomkins, *The Bride and the Bachelors: Five Masters of the Avant-Garde* (New York: Viking Press, 1965), 45; and Cabanne, *Dialogues with Marcel Duchamp,* 62.

60. Crehan, "Dada," 38.

61. Tomkins, *Duchamp,* 222. See also Steven Dickson's discussion of this point in his aforementioned essay, "Response to 'Female Molds.'"

62. Schwarz, *Complete Works,* vol. 2, 647.

63. Rosalind E. Krauss, *The Originality of the Avant-Garde and Other Modernist Myths* (Cambridge, MA: MIT Press, 1985), 200.

64. Bibliotheque Augustina, Guillaume Apollinaire, *Les Mamelles de Tirésias,* http://www.fh-augsburg.de/~harsch/gallica/Chronologie/20siecle/Apollinaire/apo_ma_0.html (August 15, 2007).

65. The "call to order" is discussed extensively by Romy Golan in her book *Modernity & Nostalgia: Art and Politics in France between the Wars* (New Haven, CT: Yale University Press, 1995). See also Janine Mileaf and Matthew S. Witkovsky, "PARIS," in Leah Dickerman, ed., *Dada* (Washington, DC: National Gallery of Art, 2005), 349–72.

66. "Purism" is discussed extensively throughout Christopher Green's *Cubism and Its Enemies: Modern Movements and Reaction in French Art, 1916–1928* (New Haven, CT: Yale University Press, 1987). See also Kenneth E. Silver, *Espirit de Corps: The Art of the Parisian Avant-Garde and the First World War, 1914–1925* (Princeton, NJ: Princeton University Press, 1989).

67. Neil Baldwin, *Man Ray: American Artist* (New York: Clarkson N. Potter, 1988), 71.

68. Tomkins, *The Bride and the Bachelors,* 47.

69. Ibid.

70. Lois W. Banner, *American Beauty: A Social History . . . Through the Centuries of the American Idea, Ideal, and Image of the Beautiful Woman* (New York: Alfred A. Knopf, 1983); see especially "The Culture of Beauty in the Early Twentieth Century," 202–25, and "The Pursuit of Beauty as Woman's Role: The Beauty Contest, 1800–1921," 249–70. See also Ring, "New York Dada," 231–41.

71. Ring, "New York Dada," 234.

72. I am grateful to Wendy Diamond, resources librarian at California State University, Chico, for pointing out the relationships between the names Rose, Shoshana, and Suzanna. In modern Hebrew, *shoshan* is also "rose." The name is also spelled Susannah, a transliteration used in the Old Testament. See Patrick Hanks and Flavia Hodges, *A Dictionary of First Names* (Oxford: Oxford University Press, 1990), 310–11.

73. Ades, *Marcel Duchamp,* 41.

74. Krauss, *Originality of the Avant-Garde,* 200.

75. Tomkins, *Duchamp,* 230.

76. Duchamp informed Arensberg, in a letter written from Buenos Aires on January 7, 1919, "Charlie (Chaplin) is much appreciated here and I have seen several of his old films again and can't wait to see Charlie in 'Soldier's Life'" (Naumann and Obalk, *Affectionately, Marcel,* 74). See also Francis M. Naumann, "Marcel Duchamp: A Reconciliation of Opposites," in *Marcel Duchamp: Artist of the Century,* ed. Rudolf E. Kuenzli and Francis M. Naumann (1989; Cambridge, MA: MIT Press, 1996), 21–22. Naumann points out similarities between Charlie Chaplin appearing in drag in his 1915 movie *A Woman* and Duchamp's Rrose Sélavy.

77. Duchamp, *in the infinitive: a typotranslation,* 12.

78. Marta Braun, *Picturing Time: The Work of Etienne-Jules Marey (1830–1904)* (Chicago: University of Chicago Press, 1992), 287.

79. See Henderson, *Duchamp in Context,* for her numerous entries in the index under the heading "optics," 363; see also "Optical Advertisement, History and Present," http://optickareklama.cz/ENG/histoire-soucasnost.php (July 9, 2007).

80. F. Honore, "Novel Changeable Photographs," *Scientific American,* April 2, 1910, 283.

81. Henderson, *Duchamp in Context,* 85.

82. *WMD,* 65. See also discussions of this subject by Anne Collins Goodyear and Michael R. Taylor in their essays elsewhere in this volume.

83. Herbert R. Lottman, *Man Ray's Montparnasse* (New York: Harry N. Abrams, 2001), 40.

84. Tomkins, *Duchamp,* 225.

85. Robert L. Herbert, Eleanor S. Apter, and Elise K. Kenney, eds., *The Société Anonyme and the Dreier Bequest at Yale University: A Catalogue Raisonné* (New Haven, CT: Yale University Press, 1984), 563.

86. Roland Barthes, *Camera Lucida*, trans. Richard Howard (New York: Hill and Wang, 1981), 85.

87. A survey of issues of *Vanity Fair* published between 1920 and 1921 shows hundreds of photographs of fashion models, socialites, and celebrities whose images project code for proper dress, standards of beauty, and proper comportment.

88. *WMD*, 74

89. Barthes, *Camera Lucida*, 6.

90. Banner, *American Beauty*, 274–75.

91. While no exact date can be given for this photograph, it can be dated prior to April 1921. As part of the label for the faux product *Belle Haleine: Eau de Voilette*, it was published on the cover of the April issue of *New York Dada*. See Schwarz, *Complete Works*, vol. 2, 686–89. In 1938 Duchamp reproduced the cover, full-size, for inclusion in the *Boîte-en-valise*. It is interesting to note that this photograph of Rrose Sélavy, as part of the *Belle Haleine* label, was the only photographed image of her widely circulated and published prior to 1959. Apparently, Duchamp had hoped to include a photograph of Rrose in the 1945 issue of *View* magazine devoted to him. In a letter dated December 24, 1944, he wrote Man Ray, who was in Hollywood, asking if he had a photograph of Rrose Sélavy (see Naumann and Obalk, *Affectionately, Marcel*, 248). Man Ray likely had not brought one with him when he fled France in 1940, for no image of Rrose appeared in the publication. Two images of Duchamp *en travesti* appear in Robert Lebel's 1959 monograph, *Marcel Duchamp*. One is identified as "Marcel Duchamp disguised as a woman"(p. 19), and the other is labeled "Marcel Duchamp: Study for a female portrait" (p. 21). Neither title offers a connection with Duchamp's alter ego Rrose Sélavy. This important connection was first made in 1968, when one of the 1921 Paris versions of Duchamp *en travesti*, labeled Rrose Sélavy (pl. 17), was included in William S. Rubin's *Dada, Surrealism, and Heritage* (New York: Museum of Modern Art, 1968), 17. A year later, an image of Duchamp identified as Rrose appeared in Schwarz, *Complete Works*, vol. 2, 487. In 1973 the same image appeared in *WMD*, 104. Also, that year the same version appeared in the Philadelphia Museum of Art's exhibition catalogue *Marcel Duchamp* (see p. 128), along with the example dedicated to and formerly owned by Samuel White (see p. 17). The example of Rrose included in this exhibition (pl. 17) next appeared in the 1977 exhibition "L'Oeuvre de Marcel Duchamp" at the Musée National d'Art Moderne, Centre National de Art et Culture Georges Pompidou, and was illustrated in the exhibition's catalogue raisonné assembled by

Jean Clair (no. 131, p. 104). After these dates, images of Rrose appear with increasing frequency. Today she is a public fixture.

92. Helen Molesworth, "Rrose Goes Shopping," in *The Dada Seminars*, ed. Leah Dickerman with Matthew S. Witkovsky (Washington, DC: Center for the Advanced Study of the Visual Arts at the National Gallery of Art, 2005), 173–90.

93. *WMD*, 74.

94. Naumann and Obalk, *Affectionately, Marcel*, 98. This date would place Duchamp in Paris at or near the end of the Paris Dada's second season. See William A. Camfield, *Francis Picabia: His Life and Times* (Princeton, NJ: Princeton University Press, 1979), 166.

95. Antonio Castronuovo, "Rrose Sélavy and the Erotic Gnosis," *Tout-fait: The Marcel Studies Online Journal*. Of the additions, Duchamp's remains the most enigmatic. Along with his name, he added the phrase "en 6 qu'habilla rrose Sélavy" (later misremembered by Duchamp as "Pi Qu'habilla Rrose Sélavy"). Rrose's first name now contained the double *r*. Numerous attempts have been made at interpreting the inscription's meaning. One of the more interesting is provided by Antonio Castronuovo. He proposes that the phrase sounds phonetically like "Picabia l'arrose c'est la vie." This would broaden the meaning from "Eros c'est la vie" to the phrase "Arroser la vie"—that is, "have a drink over it, make a toast to life." Http://www.toutfait.com/issues/volume2/issue_5/articles/castronuovo/castronuovo.html (August 8, 2005). Additional possible readings exist. On August 6, 2008, this author received an e-mail message from Patricia Black, chairperson of the Department of Foreign Languages and Literature at California State University, Chico, in response to my question whether Duchamp could have playfully blended Spanish (especially the Argentinean dialectic) into the phrase he wrote on Picabia's *L'oeil cacodylate*. After consulting with Char Prieto, a colleague in the department specializing in Argentinean Spanish, she sent the following: "In Spain, C'est la vie is often connected with sexual innuendos (se la vi, I saw her thing)." Black also offers, "Int'l Phonetic rendering is: [a (with nasal symbol) si ska bi ja rroz s (open e) la vi] That could turn into 'en si ce qu'habilla Rrose Selavy.' Visually almost like 'ainsi,' thus that which dressed Rrose Selavy."

96. Camfield, *Francis Picabia*, 169.

97. Baldwin, *Man Ray*, 86–87.

98. "Portfolio: Photographs of or about Marcel Duchamp," *Étant donné Marcel Duchamp* 7 (2006): 222–24. This entry is accompanied by five photographs of Duchamp with the star/comet tonsure. It suggests that Georges de Zayas could be the photographer. Additionally, the claim is made that the tonsure was administered outside Paris at the estate of Georges Ribemont-Dessaignes. However, doubt exists regarding where the tonsure was administered

as well as who photographed the event. An image of Duchamp with the star/comet tonsure (quite likely a cropped version of the photograph [cat. 19] included in this exhibition), is reproduced on p. 24 of Robert Lebel's 1959 monograph *Marcel Duchamp*. The legend for this image, found on p. 98, identifies the photograph, "Marcel Duchamp: Star shaved by Georges de Zayas (Paris, 1921)." Duchamp was known to have contributed to the content and design of the book, carefully reviewing and approving all details; see Paul B. Franklin, "1959: Headline, Duchamp," in *Étant donné Marcel Duchamp* 2 (2006): 140–75. It seems certain that Duchamp approved the legend crediting de Zayas with the haircut while leaving the photographer unidentified. The reference to Paris is intriguing. Could it mean that the events took place in Paris? See n. 100 below.

99. Tomkins, *Duchamp*, 237. Also, a study of maps of the neighborhood at the time shows a number of small parks. I appreciate James Housefield pointing out that the type of park bench on which Duchamp is shown seated was commonly found in Parisian parks.

100. In an e-mail sent to James W. McManus on December 15, 2007, Jeanne Brun identified two letters from Georges Ribemont-Dessaignes to Tristan Tzara that help set a time frame for the events. They indicate that the tonsure and photographs were executed elsewhere, prior to Duchamp's second visit to Ribemont-Dessaignes' home in Les Houveaux, outside Paris. The first letter, dated August 9, 1921, refers to Duchamp's recent visit without mention of the tonsure. The second letter, dated September 17, 1921, includes the passage "Vu Marcel Duchamp qui est venu deux fois ici. La dernière fois il avait une partie de la tête rasée, en forme d'étoile à cinq branches suivie d'une assez large avenue. Vous dire l'effet est inutile! Depuis, j'ai appris qu'il a un échiquier sur le cuir chevelu. Les carrés blancs étaient rasés complètement." She offered the following translation, "[I] saw Marcel Duchamp who has been here twice. The last time he had a part of his head shaved in the shape of a five-pointed star followed by a sufficiently wide avenue. To tell you the effect is useless! Since, I have learned that he had a chessboard on his scalp. The white squares were shaved completely." Describing the tonsure as having been executed prior to Duchamp's second visit, Ribemont-Dessaignes leaves open the question of where it took place. Both letters referred to are in the Tristan Tzara collection at the Bibliothèque littéraire Jacques Doucet, Paris, France.

101. *WMD*, 26–27. Also, I am grateful to Jennifer Mundy, who provided me with a transcript of a 1946 interview where Picabia stated that Duchamp, "arrived one day to dine with me. He had had a star shaved on his head. He had had a special cut and had had it done totally for himself—and a little for me. It amused us both."

102. "Cinquefoil (Rose of Venus)," http://altreligion.about.com/library/glossary/symbols/bldefscinqefoil.htm (September 7, 2007).

103. Paul B. Franklin, "Portrait d'un poète en jeun homme bi: Pierre de Massot, Marcel Duchamp et l'héritage Dada," *Étant donné Marcel Duchamp* No. 2 (1999): 72–73.

104. Baldwin, *Man Ray*, 84.

105. Ibid., 71.

106. Schwarz, *Complete Works*, vol. 2, 693.

107. See Naumann and Obalk, *Affectionately, Marcel*, 107. Also in this collection of letters, see Duchamp's July 6, 1921, letter to Ettie Stettheimer, signed "Rose-Mar-cel," 99; and his September 1, 1921, letter to the three Stettheimer sisters, signed "Rrose Sélavy," 101.

108. George Baker, "Keep Smiling," in *Dada Seminars*, 191.

109. Jones, *En-gendering*, 154.

110. Jennifer Blessing, "Rrose is a Rrose is a Rrose: Gender Performance in Photography," in *Rrose is a Rrose is a Rrose, Gender Performance in Photography* (New York: Guggenheim Museum, 1997), 23. See also Jones, *En-gendering*, 100.

111. Lewis Kachur, *Displaying the Marvelous: Marcel Duchamp, Salvador Dalí, and Surrealist Exhibition Installations* (Cambridge, MA: MIT Press), 98.

112. Ibid., 47.

113. E-mail from Charlotte Jirousek, associate professor, Department of Textiles and Apparel, Cornell University, to Aubrie Koenig, February 21, 2007: "Turkish traditional headdresses, particularly those of brides, often involve coins. The piece he has on his forehead is similar to pieces worn on the head by women, although I cannot be sure that the piece by itself is not a neckpiece rather than a head piece. Headgear is traditionally very important as a marker of identity, status, gender. The headdress of married women differs from that of single girls, and the wrapping of the forehead is the most common addition for married women. The details of the headdress, however, change from village to village, and most markedly from region to region. The coins are traditionally accumulated as part of the dowry of the bride, and are worn on the headdress but also as necklaces by the bride and by married women in general on special occasions, which include weddings and holidays."

114. In December of 2005, while attending the "Marcel Duchamp and Eroticism" colloquium held at the University of Orleans and the Musée des Beaux-Arts in Orleans, France, I asked Michael Taylor his opinion regarding the possibility that the wig worn in this photograph might be the same one on the figure in *Étant donnés*. While he thought it possible, he could not be certain.

115. Cabanne, *Dialogues with Marcel Duchamp*, 17.

A "MADE-UP HISTORY"

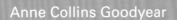

Anne Collins Goodyear

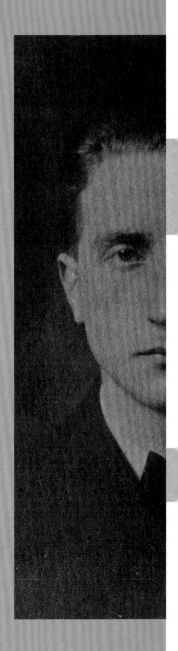

In the last analysis, the artist may shout from all the rooftops that he is a genius; he will have to wait for the verdict of the spectator in order that his declarations take a social value and that, finally, posterity includes him in the primers of Art History.
—Marcel Duchamp, from "The Creative Act," April 1957[1]

But where is
your self-portrait?
Everyone has
a self-portrait in
his first show.
—Marcel Duchamp to
Georgia O'Keeffe, 1923[3]

This essay benefited from presentation of a related version at the
Richardson Symposium, National Portrait Gallery, Smithsonian
Institution, Washington, DC, November 17, 2006.

Speaking in Houston in 1957, Marcel Duchamp offered a startling analysis of "the creative act," the ambitious but seemingly innocuous title he put to his remarks. As suggested by the first epigraph above, Duchamp did not attribute aesthetic success purely to the intentions and insights of the artist; he also accorded the viewer—"who later becomes the posterity," as Duchamp noted—a central role in that process. "All in all, the creative act is not performed by the artist alone; the spectator brings the work in contact with the external world by deciphering and interpreting its inner qualifications and thus adds his contribution to the creative act."[4] Yet if Duchamp was cognizant of the role his audience would play in the ultimate valuation of his career, he was not altogether cynical, seeing humor in the artist's need to court the public: "One accepts everything, while laughing just the same," he explained to Pierre Cabanne in 1967. "You accept to please other people, more than yourself. It's sort of politeness, until the day when it becomes a very important tribute. If it's sincere, that is."[5] Acutely aware that long-term critical acclaim required collaborative interplay between artist and audience— even one several generations removed—Duchamp carefully stacked the deck in his favor, particularly during the later half of his career. Critical to that effort, as this essay contends, was Duchamp's ongoing investment in self-portrayal, an effort that not only included self-portraiture but extended to his dissemination of portraits of himself by others. As a close examination of his writings reveals, Duchamp's often unconventional self-representation, conceptually integral to other aspects of his work, also played a practical—and surprisingly understudied —role in establishing him as one of the most important artists of our era.[6]

"But where is your self-portrait?" Duchamp asked Georgia O'Keeffe upon the opening of her first major exhibition, at the Anderson Galleries in 1923. "Everyone has a self-portrait in his first show." While O'Keeffe recalled that "we laughed about it," hidden in Duchamp's remark, as she must have realized, was evidence of his own preoccupations, for by 1923, self-portrayal had already become a leit-motif in his work.[7] Yet if O'Keeffe, in describing Duchamp, focused on a moment in their youths, it is worth noting that she did not record the exchange until five years after Duchamp's death, thereby indicating not only the importance he accorded self-portrayal early in his career but also the degree to which it came to define him at its conclusion.[8]

As suggested by Duchamp's discussion of "the creative act," for him the process of creation was bound up with both the artist's approach to aesthetic expression and with the construction of the artist's place in history. As he would tell Ulf Linde in 1961, "Art is man made and all 'truths' in art are likewise, man made. . . . One must realize that a great work of art is double man made: the artist makes the work and the spectator, posterity, makes it great." Although Duchamp would go on to tell Linde that "one can never say beforehand what people will make—it must be entirely chance," it is evident that in response to the question of how future viewers would interpret his legacy, Duchamp strategically orchestrated his self-presentation.[9] During the late 1950s and 1960s, largely through his own efforts, his legend began to assume a life of its own that promised to outlive its source.[10] As Amelia Jones has demonstrated, Duchamp's posture of silence during this era was largely belied by the large number of interviews to which

he consented.[11] Indeed, in 1965 Calvin Tomkins noted that Duchamp is "in the unusual position of being a member of the posterity that is passing judgment on his own work—a process of deciphering and interpretation which has recently been proceeding at a pace little short of phenomenal."[12] Even as Duchamp systematically discussed his work and saw new editions of his writings published, he reflected, with some humor, on the larger significance of this public exposure, observing to Pierre Cabanne in 1966: "The idea of the great star comes directly from a sort of inflation of small anecdotes. . . . the entire thing is based on a made-up history."[13] In alluding to "a made-up history," Duchamp, while seeming to dismiss the whole enterprise of hero-building, slyly suggested just how carefully he approached his own autobiography. For should Duchamp seem to poke fun at traditional modes of constructing history, he did not reject the importance of reputation, making it clear in numerous statements that he was deeply concerned with how posterity would come to judge his work. As he told James Johnson Sweeney in 1955, "You should wait for fifty years or a hundred years for your true public. That is the only public that interests me."[14]

Such apparent contradictions are very much consistent with the persona Duchamp constructed for himself over the course of his career.[15] During the conversation to which I have just made reference, Sweeney, Duchamp's interlocutor, observed to the artist that his old friend Henri-Pierre Roché noted that "you were always careful to find a way to contradict yourself."[16] Duchamp made no effort to deny it, having once told Sidney and Harriet Janis, "I have forced myself to contradict myself in order to avoid conforming to my own taste."[17] In an obituary notice for Duchamp, Jasper Johns, who greatly admired Duchamp, contrasted two recently published interviews with the artist, noting that "toward the end of one, Duchamp said, 'I'm nothing else but an artist, I'm sure, and delighted to be.' The other ended, 'Oh yes. I act like an artist although I'm not one.' There may be some malice in these contradictory self-descriptions, or, perhaps, an unwillingness to consider any definition as being final. . . . Marcel never gave you the confidence to be sure of any statement you might make about him."[18]

How do we reconcile such seemingly incompatible statements with our "picture" of Duchamp? Bound up with portraiture is the very notion of identity, a term that denotes "the quality or condition of being the same as something else."[19] To contradict oneself, then, inherently flies in the face of the sort of consistency demanded by portraiture, an art form whose goal is to achieve likeness. It would seem that portraiture per se is inconsistent with the larger identity of Marcel Duchamp himself.

To date, little has been written about portraiture and Duchamp. However, a great deal of attention has been given to the artist's invocation of alternative identities, which include R. Mutt and Rrose Sélavy (fig. 3.1 and pls. 14a, 17, 20); the boxer Georges Carpentier (pl. 26), who bore an uncanny resemblance to the artist; the persons of George W. Welch, Bull, and Pickens on a wanted poster (see pl. 25); a mercurial pictorial endorser of a monetary bond (pl. 27), based on earnings from gambling; a self-depiction as the wife of a tenant farmer (pl. 40); and himself at eighty-five, photographed when he was only fifty-eight (pls. 43, 44).[20] On one level, such playful invocations might seem to represent a form of metaportraiture—a

fig. 5.1 "Wilson-Lincoln system," detail of note from *The Green Box* by Marcel Duchamp, collotype, 1934. Philadelphia Museum of Art, Pennsylvania; The Louise and Walter Arensberg Collection, 1950

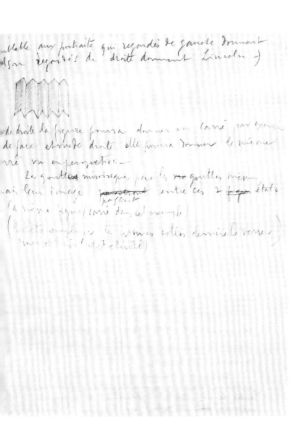

description of the multiple uses of portraiture during the twentieth century—and thus a playful critique of the genre. Indeed, Duchamp repeatedly exploited and disrupted well-accepted codes for the construction and deployment of portraiture, including fashion photography of glamorous women (Rrose Sélavy), the use of "mug shots" to identify criminals or other individuals (his *Wanted* poster and himself at eighty-five), and the inclusion of images to endorse monetary documents (his *Monte Carlo Bond,* pl. 27).[21] Even Duchamp's collusion with Alfred Stieglitz to photograph his infamous *Fountain,* with R. Mutt's name prominently displayed, may represent a deliberate pun on Stieglitz's artistic portrait photography.[22] For in photographing the urinal at Duchamp's behest, Stieglitz, perhaps unwittingly, furnished a sensitively rendered view of R. Mutt's "head"—a double entendre Duchamp must have relished—beautifully lit against the backdrop of Marsden Hartley's painting *The Warriors* (1913), just as Stieglitz had photographed artists in his circle in front of artworks.[23] However, simply to dismiss or categorize the work in this fashion, I believe, is to miss its larger significance in the trajectory of Duchamp's career.

Intellectually, Duchamp's self-portraiture, in which he appears in a myriad of guises, demonstrates the radical impossibility of fully knowing our world, one another, or even ourselves. Instead, Duchamp argues, our perspective is always inherently limited by the set of lenses or conventions we find ourselves subjected to, some of which are simply inherent in the physical laws that govern our universe. Duchamp's diverse portraiture and self-portraiture enabled the artist to demonstrate the radical multiplicity of the self when depicted in different circumstances and under different settings. It is a project to which he returned repeatedly in the final years of his life. Ultimately, I will argue, Duchamp's most significant legacy is to demonstrate that one thing, one person, can be many things at once, all depending on one's perspective. Identity, then, is not reducible to a single convenient expression but is ultimately unstable and multiple.

The conceptual centrality of portraiture for Duchamp emerges with stark power from notations included in his famous 1934 work *The Bride Stripped Bare by Her Bachelors, Even (The Green Box).* The editioned publication, usually referred to simply as *The Green Box,* ostensibly lays out the complex narrative of seduction and frustration related by its companion piece, *The Bride Stripped Bare by Her Bachelors, Even (The Large Glass),* commonly known as *The Large Glass.*[24] However, and perhaps more important, the elliptical but suggestive notes, which Duchamp originally published as collotype facsimiles of the notes he produced while working on *The Large Glass,* contain the seeds for multiple projects that surrounded and followed *The Large Glass.* These include a number of the readymades and even specific photographic portraits, such as his 1917 hinged mirror portrait (pl. 7) and a series of shaving cream portraits, made in collaboration with Man Ray in 1924 (pl. 28) and later incorporated into his famous *Monte Carlo Bond* (pl. 27). I will not delve in detail into these correlations, which have already been discussed elsewhere by James McManus and Dawn Ades.[25] Instead, I want to draw attention to one note in particular in which Duchamp describes one aspect of the virtual motion of *The Large Glass* (fig. 5.1). Identifying this mechanism as the "Wilson-Lincoln system," Duchamp explains its characteristics: "In other words, like the

portraits which seen from the left show Wilson [and] seen from the right show Lincoln." He includes in his note a diagram of the two-way portrait, and while the precise nature of the technology behind the image Duchamp described is unclear, it may well have been an early lenticular photograph, examples of which had begun in the 1910s to make their appearance in shop windows—precisely where Duchamp claimed to have spotted the double portrait.[26] Duchamp's later description of the object that inspired the "Wilson-Lincoln system" further supports identifying the image as a product of this new photographic technology, which, with its raised, faceted surface, could capture two distinct and thus alternating images. As Duchamp explained: "Because you see, those lines have two facets. And if you look at one facet you see something, if you see the other facet you see the other."[27] Even more suggestive is Duchamp's 1964 response to a proposal from the Japanese artist and scholar Shuzo Takiguchi to create a lenticular image combining a 1930 portrait of Duchamp by Man Ray (pl. 29) with a picture of Rrose Sélavy's repeated signature for the dual purposes of creating a "sign board" for a "shop for 'objects'" (to be named after Rrose Sélavy) and publishing a book in Japanese about Duchamp (pl. 83). As Takiguchi relates: "Duchamp subsequently suggested its title as the 'Wilson-Lincoln System,' taken from his note in *The Green Box*. Moreover, he OK'ed and signed it."[28]

If, on the one hand, Duchamp's focus on the changeable image of Woodrow Wilson and Abraham Lincoln constitutes a playful reference to a novelty item, the two-way portrait also makes manifest an important concept: a single pictorial framework can contain (at least) two distinct images, neither one visible

fig. 5.2 | *Our Next President,* Coshocton Specialty Co., A. S. Spiegel's Patent, Magic Moving Picture Card, 1912. Smithsonian Institution, National Museum of American History, Behring Center, Washington, DC

when the other is viewed, although both always simultaneously present.[29] What is seen all depends on one's perspective. Indeed, the very word "perspective," as described by the *Oxford English Dictionary,* contains among its definitions "a picture or figure constructed so as to produce some fantastic effect; e.g., appearing distorted or confused except from one particular point of view, *or presenting totally different aspects from different points.*"[30] Although the precise object seen by Duchamp and containing images of Lincoln and Wilson has never been identified, a "magic moving picture card," designed for the 1912 election and entitled *Our Next President,* gives a clear idea of the type of ephemera that inspired Duchamp's insight (fig. 5.2). As one slides the card to the right and then back to the left, the image visible in the window gradually shifts from Wilson to Theodore Roosevelt to William Howard Taft—the three presidential candidates of 1912.[31] Other notes, particularly those published late in Duchamp's career, in 1966, as *A l'infinitif* (also known as *The White Box*), make more extensive reference to systems of perspective and theories of n-dimensional geometry that support the same point, to wit that one can perceive only a small part of larger realities.[32]

Although the notes that appeared in *The Green Box* and elsewhere were largely written between 1912 and 1915, when Duchamp planned *The Large Glass,* which was executed between 1915 and 1923, the ideas advanced in them remained remarkably crisp in Duchamp's memory more than three decades later. Their freshness may well have been abetted by the translation of *The Green Box* into English and its rerelease in the early 1960s. However, I would also assert that captured in the notes and in other contemporary projects, specifically those concerning modes of portraiture, is evidence of thinking lodged deeply in Duchamp's mind. Many (self-) portraits executed between 1915, when Duchamp first arrived in the United States, and 1924, by which time Duchamp had returned to Paris and begun focusing intensively on professional chess, would make a conceptual reappearance in the 1950s. References to them would be further amplified in the final decade of Duchamp's career, indicating their profound importance.[33]

The 1950s would prove to be a turning point in Duchamp's career, based largely on the increased exposure to American audiences that the artist sought for himself during the 1940s. Having returned to the United States from France in 1942, in the midst of the Second World War, Duchamp found that the celebrity that had greeted his Dadaist artwork of the 1910s and early 1920s had been largely eclipsed by the growing prominence of abstract expressionism. But if the highly conceptual aesthetic of Duchamp's work, which was consolidated by his recent production of the *Boîte-en-valise,* was not in keeping with the emotional focus of abstract expressionism, the artist quickly found a new niche.[34] Rather than attempting to counter the prevailing influence of abstract expressionism during the 1940s, Duchamp assumed a central role in the consolidation and exhibition of European surrealism and Dada, art movements in which he had participated.[35]

It is worth noting that Duchamp's reentry into the United States involved the creation of a new group of experimental self-portraits, demonstrating his ongoing investment in the project of self-invention and description. These included his aforementioned *Boîte-en-valise,* first completed in 1941, a series of editioned

collections consisting of miniature reproductions of the artist's oeuvre to date (pl. 37). Largely executed following the installation of the Vichy government in France, before Duchamp was able to obtain the necessary paperwork to return to the United States, the works dramatically testified to the life of an individual forced to live in transit. As David Hopkins and Calvin Tomkins have noted, Duchamp had to pose as a cheese-seller to conduct the journeys that enabled him to gather the materials necessary to compile the boxes.[36] Upon receiving his *Boîte-en-valise*, Duchamp's longtime friend and collector Walter Arensberg drafted a letter to the artist recording his response: "You have invented a new kind of autobiography. It is a kind of autobiography in the performance of marionettes. You have become the puppeteer of your past."[37]

Duchamp highlighted his willingness to subvert traditional modes of self-portrayal when he helped to coordinate the 1942 exhibition "First Papers of Surrealism," held in New York to benefit the French Relief Societies. At his suggestion, coupled with that of André Breton, each of the participating artists was represented by means of a "compensation portrait," illustrating his presence with a face that was not his own. Representing Duchamp was a woman originally photographed by Ben Shahn for the Farm Security Administration (pl. 40). This *Compensation Portrait,* which has been discussed at length by David Hopkins, reignited Duchamp's construction of the female persona of Rrose Sélavy and posed renewed questions about the relationship of appearance and identity.[38] Duchamp further defied convention by filling the installation space with a maze-like sculpture, *Sixteen Miles of String* (using only a mile of the material), which obstructed access to other works. Declining to appear for the opening, he instead invited Carroll Janis, the young son of dealer Sidney Janis, to gather friends to play boisterously in the installation as guests arrived for the party.[39] If the maze was ephemeral, however, Duchamp still saw to it that it was well documented by two photographers, John (or Hans) Schiff and Arnold Newman (pl. 41).[40] Strikingly, Newman's photographic portraits of Duchamp, which depict the artist behind his string maze, seem to juxtapose the artist's own visage with the reproduction of the *Three Standard Stoppages,* which appeared in the show's exhibition catalogue directly above his *Compensation Portrait,* suggesting Duchamp's own sensitivity to the composition.

A further foray into the realm of self-portrayal played out in 1945, in an issue of the surrealist journal *View* devoted to Duchamp (pl. 42a and b). On the final page of the magazine, which is packed with articles about and pictures of and related to Duchamp, the artist appeared in the guise of a much older man in his *Self-Portrait at Eighty-Five* (pl. 43)—although he was only fifty-eight at the time. Placed beside a profile picture of the artist by Alfred Stieglitz made when Duchamp was thirty-five (pl. 24), the two images make a sly reference to Duchamp's famous self-depiction in his *Wanted: $2,000 Reward* (see pl. 25). While Arturo Schwarz seems to suggest that the image may be another readymade picture chosen by Duchamp because of its physiognomic resemblance to his own features, the existence of a pair of related images in the archives of the Philadelphia Museum of Art supports David Hopkins's contention that Duchamp staged his own aging, suggesting again the artist's growing attention to the passing of time and the question of

his legacy.[41] Duchamp's autobiographical impulse was further enhanced by the series of essays about the artist and the numerous reproductions of portraits of him included in the magazine as a whole.[42]

Duchamp's use of self-portrayal to resuscitate his reputation after returning to the United States in the early 1940s was augmented by other aligned activities. By 1949, Duchamp's prominence in the United States was sufficiently reestablished to elicit an invitation to participate in the San Francisco Museum of Art's "Western Round Table on Modern Art," designed to demonstrate the intellectual integrity of modern art, which was then under assault in certain political circles as "communistic" and worse. The panel provided Duchamp an opportunity to defend his own approach to art making.[43]

This experience certainly contributed to the sixty-two-year-old Duchamp's focus on the relationship of his own legacy to that of modern art as a whole. Opportunities to pursue this question actively presented themselves in the guise of "emissary" for the disposition of the collection of Walter and Louise Arensberg in 1950 and as executor for the estate of his friend and collector Katherine Dreier, with whom he and Man Ray had established The Société Anonyme, Inc., and who died of cancer in 1952.[44] Through Duchamp's efforts, these important collections, each of which contained significant holdings of his work, would go to three major American museums: the Philadelphia Museum of Art, the Museum of Modern Art in New York, and the Yale Art Gallery.

At the time of Dreier's death, Duchamp was already involved with "Duchamp Brothers and Sister: Works of Art," an exhibition at the Rose Fried Gallery in New York that he had organized. The show inspired a significant amount of press coverage, including a major article in *Life* describing him as "Dada's Daddy" (pl. 51). Duchamp happily cooperated with Eliot Elisofon in staging the prominent portrait of him in the guise of his infamous 1912 painting *Nude Descending a Staircase (No. 2)* (see fig. 1.2), even offering to remove his own clothes.[45] Opposite the black-and-white photograph appeared a vivid color reproduction of a cubist portrait of Duchamp by his brother Jacques Villon that appeared in the show. Duchamp's pleasure in the *Life* article is obvious from his comments to Walter and Louise Arensberg, to whom he wrote: "The art magazines are very keen about the idea of 'a family of artists' and I have to go through interview after interview. *Life* will have 4 pages in color. *Art News, Art Digest* . . . maybe the *New Yorker*."[46] The following year, he would assist Sidney Janis in organizing an exhibition devoted to Dada.[47]

It is against this backdrop that Duchamp's renewed emphasis in the 1950s on self-portraiture and portraiture of himself must be understood. Out of the Rose Fried exhibition would grow new portraits of Duchamp on the part of his living artist siblings (Raymond Villon-Duchamp had died in 1918). The above-mentioned abstract painting by Jacques Villon included in the exhibition would shortly thereafter be transformed into an etching (pl. 52). Duchamp's sister Suzanne would similarly create an etching of her brother, which he admired greatly (pl. 53).[48] A portrait drawing by his brother-in-law, Jean Crotti (pl. 5), based on Crotti's 1915 sculpture of Duchamp, would also go into circulation at the same moment through the channels established by this show.[49]

Crotti's decision to send his portrait drawing of Duchamp to the Rose Fried Gallery was most likely inspired by a letter he received from Duchamp in August 1952.[50] Ostensibly written to restore Crotti's flagging spirits, Duchamp's letter more importantly provides insight into his own frame of mind during this period, making his veiled references to the lasting implications of his self-portraiture particularly meaningful. It could well be that in composing his missive, Duchamp had the expectation that his words would one day be visible in a new context, such as the present one, perhaps intuiting that Crotti had aspirations of preparing a study on him, as his brother-in-law would confirm in a letter written nearly a year later.[51] "Throughout history artists have been like gamblers at Monte Carlo," Duchamp wrote to Crotti, "and the blind lottery causes some to stand out and others to be ruined. . . . I don't believe in painting in itself. Every canvas is made not by the painter but by those who see it and grant it their favors; in other words, a painter doesn't exist who understands himself what he does." The artist's unmistakable reference to his own *Monte Carlo Bond* (pl. 27) is reiterated by a repeated reference to the player at Monte Carlo later in his letter. Interspersed with this imagery, Duchamp developed another powerful metaphor, harkening back to yet another early self-portrait, as Rrose Sélavy cast as Belle Haleine on a bottle of perfume (pl. 15). "I believe in the original perfume [of an artwork]," Duchamp assured Crotti, "but like all perfume it evaporates very quickly (a few weeks, a few years at most). What remains is a dried shell classified by historians as 'the history of art.'"[52]

These observations resonate with passages included in the notes penned by Duchamp for *The Green Box*, demonstrating a remarkably consistent trajectory of thought on his part. Taken together, the documents provide notable insight about how assiduously Duchamp crafted an ever-shifting persona designed to elude the danger of historical irrelevance. Along these lines, Duchamp's description of the evaporation of the essence, or "perfume," of a unique work of art clearly echoes his account of the "Breeding of Colors." Calling for the extraction of "perfumes of reds, of blues of greens or of grays," Duchamp notes that to harvest them one must "imprison" the fruit from which they are derived, until one is left with the "dryness of *'nuts and raisins,'* that you get in the ripe imputrescent colors (rarified colors.)."[53] Indicating his disdain for the practice of painting, Duchamp's articulation of the shortcomings of the medium is heightened even further in his letter to Crotti. In warning his brother-in-law about the rapid evaporation of the "original perfume," Duchamp appears to be specifically making reference to the quick dissolution of the historical importance of original works of art, paintings in particular, the creation of which he had deliberately rejected in famously laying down his paintbrushes in 1918 with the completion of *Tu m'*.[54]

As he explained to Otto Hahn in 1966, Duchamp purposely attempted "to wipe out the idea of the original [in the visual arts], which exists neither in music, nor in poetry."[55] The rationale for this is clear in the larger context of the interview, where Duchamp compares success to "a brush fire . . . one has to find wood to feed it." Despite the public commotion surrounding the exhibition of *Nude Descending a Staircase* in the United States in 1913, he would not be known at all, he explained, had he not "replenished" the "Nude with the Readymade, then

the Readymade with the Large Glass."[56] By extension, Duchamp replenished his reputation through the continual redeployment of aspects of his oeuvre, which thereby enabled him as an artist to escape the inevitable law of the historical depletion of the unique original.

Although Duchamp's use of chance operations is rightly understood as an important technique in his repertoire, particularly in the creation of *The Large Glass*, it must also be noted that Duchamp was unwilling to subject his own reputation or livelihood to happenstance.[57] Indeed, it was precisely this awareness of the need to control chance where personal fortune is concerned that Duchamp resorted to in the development of his *Monte Carlo Bond* and made reference to in his letter to Crotti. In carefully analyzing the game of roulette, Duchamp believed he had devised a system by which to beat the odds, thus being able to provide a reliable return to investors in his *Monte Carlo Bond*.[58] Critical to this larger effort in the context of his career as a whole was his careful use and deployment of his own likeness, in a vast array of appearances, each offering itself up to the public ready to receive it.[59]

Duchamp's implicit allusion in his letter to Crotti to *Monte Carlo Bond,* in which Duchamp's likeness—thanks to the elaborate application of soap lather (see pl. 28)—is morphed into an apparition resembling the Greek god Mercury, brings to mind a note from *The Green Box* that seems to anticipate this self-portrayal: "The whole picture seems to be in papier mâché because the whole of this representation is the sketch (like a mold) for a reality which would be possible by slightly distending the laws of physics and chemistry."[60]

Thus through portraiture, Duchamp slyly suggests, he has found a way to "distend" natural and historical laws that would impose limited perspective—and limited duration—on those who cannot escape them. If his self-portrayal in changing guises seemed to challenge laws of nature by creating a persona of flexible gender, age, and physiognomy, this changeability, even more important, created the possibility for perpetual self-renewal. Indeed, as Duchamp would tell Calvin Tomkins in the 1960s, his decision to invent Rrose Sélavy "was not to change my identity, but to have two identities."[61] Around the same time, as though confirming that Rrose Sélavy remained vital, Duchamp would tell another interviewer who inquired after his famous female persona, "She's still alive; manifests herself little or not at all."[62] It was perhaps in this spirit that Duchamp and Man Ray created a Polaroid picture of Duchamp in the mid-1950s wearing a woman's wig (pl. 55).[63]

Duchamp's careful attention to his own likeness in the 1950s built upon a large body of portraiture that already existed, not only by his own hand but by avant-garde friends such as photographers Alfred Stieglitz (pls. 23, 24) and Edward Steichen (pl. 9), the painter Florine Stettheimer (pl. 22), and the Dadaist Baroness Elsa von Freytag-Loringhoven (pl. 13). However, in the 1950s, this imagery was reorganized and redeployed as the artist's attention shifted to the question of his legacy. One of the most powerful avenues through which this was to occur was a 1959 monograph by Robert Lebel.

Lebel, a French art historian, had met Duchamp in New York in 1936 while seeing an exhibition at Stieglitz's American Place and had established a

strong friendship with the artist. In the early 1950s, he commenced a history of Duchamp's life and work in which he willingly included his subject as collaborator.[64] Invited to participate in the layout of Lebel's book (pl. 62), Duchamp took full advantage of the opportunity to combine images to construct a compelling narrative about the development of his own persona and his work. As Duchamp had once commented to his friend Katharine Kuh, "an art book should carry its message through pictures not through words."[65] While the book includes reproductions of many of Duchamp's best-known art works, what is particularly striking is the large number of portraits of the artist that are reproduced.

But perhaps even more interesting is Duchamp's creation of a new self-portrait for deluxe versions of the tome—originally published in French—a choice that raised his profile still further.[66] Inscribed "Marcel déchiravit," or "Marcel tore this quickly," Duchamp's *Self-Portrait in Profile* (pl. 58) consisted of an origami-paper silhouette made using a zinc template designed by the artist (pl. 57) and pasted against a background of velvety black flocked paper.[67] The work relies on a combination of negative and positive space. Just as a shadow is formed by the absence of light, so Duchamp's silhouette exists by virtue of the absence of a portion of white or colored paper pasted over a dark ground.

Like all of Duchamp's self-portraiture, the silhouette fits tightly within the larger trajectory of his career and boasts particularly close affinities to *The Green Box*. The connection is hardly coincidental, as a translated edition of the notes was currently being prepared, with Duchamp's input, by the artist Richard Hamilton and the (unrelated) art historian George Heard Hamilton. In terms of technique alone, the construction of the silhouette by means of a zinc template duplicated Duchamp's use of such templates to create editions of *The Green Box* that replicated the scraps of paper on which he had written his notes.[68] But perhaps even more important are the conceptual connections between his notes and the form of this particular self-portrait, which seems to build on repeated references to shadows, molds, "negative apparitions," and multidimensionality prevalent in *The Green Box* and elsewhere.

Such textual references aside, Duchamp's use of a shadowlike profile to capture his features also demonstrates an obvious parallel with his final painting, *Tu m'* of 1918 (fig. 5.3). In addition to echoing the cast shadows of such works as his hat-rack and bicycle wheel, which appear on the canvas, Duchamp makes a playful nod to the work's title with its implicit reference to self and other. In so doing, the artist conjures up a suggestive remark made to Katharine Kuh around

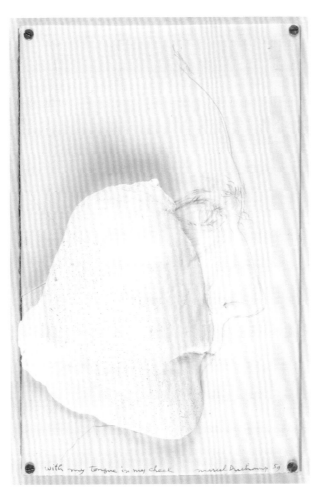

fig. 5.4 | *With My Tongue in My Cheek* by Marcel Duchamp, plaster, pencil on paper, mounted on wood, 1959. Musée National d'Art Moderne, Centre Georges Pompidou, Paris, France

fig. 5.5 | *Torture-morte* by Marcel Duchamp, painted plaster, artificial houseflies, and paper mounted on wood, in a glass box, 1959. Musée National d'Art Moderne, Centre Georges Pompidou, Paris, France

the time he began creating *Marcel déchiravit*: "I was never interested in looking at myself in an aesthetic mirror. My intention was always to get away from myself, although I knew perfectly well that I was using myself. Call it a little game between 'I' and 'me.'"[69] In referencing the break between self and physical trace implied by the act of creating a portraiture of shadows, Duchamp nuances his self-portrait still further, linking it to the mythical origins of portraiture itself.[70]

The appearance of Lebel's monograph galvanized Duchamp, who once again turned to portraiture as a form of gloss upon the work. In April 1959, shortly before La Hune bookstore launched what would be the first exhibition of Duchamp's work in Paris, held in conjunction with the release of Lebel's monograph, Duchamp received word that the author had been commissioned to do a second book with Duchamp, for which Lebel would provide the text and Duchamp, working independently, would provide the images.[71] That summer, Duchamp sent Lebel three unusual artworks, each replete with references to the history of art, to the religious use of devotional imagery, and to the self—*With My Tongue in My Cheek* (fig. 5.4), *Torture-morte* (fig. 5.5), and *Sculpture-morte*—all of which the artist sealed individually in glass boxes. Both *With My Tongue in My Cheek*, a three-dimensional realization of the silhouette Duchamp had created for the deluxe version of the monograph, and *Torture-morte* were cast from the artist's own body. *Sculpture-morte,* with its nod to the art work of Giuseppe Arcimboldo (1527–1593), was made from marzipan vegetables.[72] When the publisher who had commissioned the joint project between Duchamp and Lebel saw the works, he promptly withdrew the offer on the basis of what he described as "poor jokes."[73]

The humorous darkness of the pieces may have been inspired in part by the artist's growing consciousness of his own mortality. Receiving news of the death of his close friend Henri-Pierre Roché the same day Lebel invited him to create the new works, Duchamp immediately noted that Roché had lived to see the "de

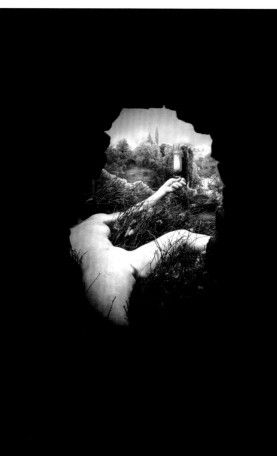

luxe" version of Lebel's monograph and remarked, "I am beginning to reckon the chances I have of seeing the 'ordinary' [edition] in the window of bookshops."[74] Three years later he would tell another friend: "You know, when a man lives beyond 65, there is no publicity because everybody assumes they've been dead for years."[75]

Portraiture provided Duchamp with a channel to posterity and with a means to evade his inevitable physical death. Having absented himself from the book party thrown by La Hune bookstore in honor of the monograph, Duchamp may have wanted to send—via his creation of *With My Tongue in My Cheek, Torture-morte,* and *Sculpture-morte*—a humorous reminder that he was indeed still alive, as Agnès de la Beaumelle has suggested. Along these lines, both in appearance and concept, the pieces also relate to Duchamp's final work, *Étant donnés* (fig. 5.6a and b), on which the artist was secretly at work and which would be unveiled only posthumously.[76] In similar fashion, this piece requires the viewer to look through a barrier to see a sculptural installation beyond.

Several months later, having indeed survived to see the "'ordinary' [edition] in the window of bookshops," Duchamp took advantage of the opportunity to create yet another complex self-portrait, and one once again enclosed by glass (fig. 5.7). The invitation Duchamp received to design the window of Bamberger's Department Store grew out of publicity efforts on the part of the Grove Press in New York, which had acquired the rights to Lebel's French monograph and had succeeded in bringing out an English edition of the text just seven months after the appearance of the French version. While Hellmut Wohl has provided a remarkable account of the window's creation and reception, what remains unclear is where the idea to create a shop window in honor of the book originated. Given Duchamp's long interest in glass windows and shop displays, it is easy to imagine that he planted the seed for this particular advertising campaign himself.[77]

To create the window, Duchamp borrowed from the Philadelphia Museum of Art *Nude Descending a Staircase (No. 3)*, a photographic reproduction created by Duchamp in 1916 of his famous painting. He combined it with five nude mannequins requisitioned from the store, which were appropriately arranged. The reference to the artist, who repeatedly identified himself with this infamous painting, might have been clear enough, particularly in conjunction with the reproduction of selected works and open copies of the book. However, the conflation of biography, artwork, and portraiture is completed by Duchamp's prominent inclusion of the dust jacket for the new book, featuring a double-exposed portrait by Victor Obsatz (pl. 54).[78] The intriguing tableau is even "signed" by Duchamp at the center of the window with explanatory text crediting the artist with the installation. Duchamp's development of this complex mode of self-portraiture or autobiography recalls a 1913 note on "the question of shop windows," as Wohl has observed. In it Duchamp muses: "When one undergoes the examination of the shop window, one also pronounces one's own sentence. In fact, one's choice is 'round-trip'. From the demands of the shop window, from the inevitable response to shop windows, my choice is determined."[79]

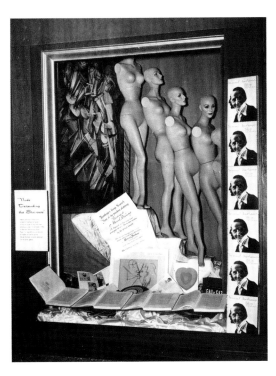

fig. 5.6a and b *Étant donnés: 1. la chute d'eau, 2. le gaz d'éclairage (Given: 1. Waterfall, 2. The Illuminating Gas)* by Marcel Duchamp, mixed-media assemblage, 1946–66. Philadelphia Museum of Art, Pennsylvania; gift of the Cassandra Foundation, 1969

fig. 5.7 Bamberger's window installation by Marcel Duchamp, Newark, New Jersey, by Peter Handy-Boesser, gelatin silver print, 1960. Philadelphia Museum of Art, Pennsylvania, Marcel Duchamp Archive; gift of Jacqueline, Paul, and Peter Matisse in memory of their mother, Alexina Duchamp

The impact of Lebel's monograph can hardly be underestimated.[80] Billy Klüver, a founder of Experiments in Art and Technology, recalled that the book's appearance was "like a bomb on the New York art scene."[81] Internationally, the work inspired exhibitions related to the book's publication in Paris, Stockholm, and Zurich.[82]

Among the artists to be deeply affected by the book was Jasper Johns, whose interconnection with Marcel Duchamp has been repeatedly scrutinized.[83] Concluding an "appreciation" of Duchamp, published in the wake of his death, Johns observed: "The art community feels Duchamp's presence and his absence. He has changed the condition of being here."[84] While Johns's words have a marked philosophical cadence, they also reflect quite literally upon the physical properties of Duchamp's torn "Marcel déchiravit" *Self-Portrait in Profile.*

Indeed, for Johns, *Marcel déchiravit,* a silkscreen version of which he acquired, was to have important consequences.[85] In 1964, Johns created a two-part homage to Duchamp in which this work played an integral role.[86] Jasper Johns's *M.D.* (pl. 66) and his *According to What* both extrapolate on Duchamp's likeness according to terms laid out in Duchamp's notes.[87]

Contained in Johns's own sketchbook notes, a habit of recording he adopted around the time he met Duchamp, are at least two separate references during the year 1964 to Duchamp's silhouette profile.[88] As Johns explained: "Duchamp did a work which was a torn square (I think it's called something like *Myself Torn to Pieces*). I took a tracing of the profile, hung it by a string and cast its shadow so it became distorted and no longer square." Johns's approach corresponds virtually precisely to Duchamp's description in *The Green Box* of the projection of the cast shadows of readymades, a technique he was to use in creating his final painting, *Tu m'* (see fig. 5.3).[89] In working with Duchamp's *Self-Portrait in Profile,* Johns was, of course, manipulating his own "readymade" until it became something else: a shadow of its former self.

Johns's first response to Duchamp's profile, with its anamorphotic transformation, which Richard Shiff has described, would lead to other variations, in the spirit of Duchamp's dictate concerning transformation.[90] The work was first transferred to a small canvas, hinged to the lower left of Johns's monumental composition *According to What.* The canvas, with its reference to Duchamp's interest in hinged pictures, can be swung down to reveal his likeness.[91]

In a related lithograph of 1971 (pl. 67), Johns "opens" the hinged canvas, revealing yet another version of his portrait and rendering visible the string from which he had originally suspended Duchamp's profile. As he explains: "The print simultaneously shows the hinged canvas closed and open." With regard to the canceling of his signature, he clarified for John Coplans what had occurred: "I didn't cross it out. The cross was there before I signed it, but I planned to sign it that way. I have deliberately taken Duchamp's own work and slightly changed it, and thought to make a kind of play on whose work it is, whether mine or his."[92] Intriguingly, the artist would later adopt the shadow as a form of self-depiction in his series *The Seasons,* where the Duchamp portrait once again appears in the canvas "Fall."[93]

Johns, of course, is not the only one of Duchamp's contemporaries to have portrayed Duchamp or to have responded to the deep body of self-depiction he created. As the accompanying exhibition and this catalogue seek to demonstrate, Duchamp's legacy has been powerfully extended through the very practice of portraiture and the acute sensitivity to self-representation that ran throughout his career. For Duchamp, self-portrayal was not an appendage to other aspects of his career but part and parcel of a larger set of conceptual concerns, including his posthumous reputation. By concerning himself with the construction of an identity that was inherently multifaceted, and thus impossible to encapsulate through a single gesture, Duchamp consciously constructed for himself an elusive likeness, the portrayal of which came to serve as a conceptual challenge in itself. As Mel Bochner, who created his own portrayal of Duchamp in 1968 (pl. 81), has observed, "It has occurred to me that the sheer number of people who felt it was necessary to create a likeness of Duchamp is interesting."[94]

I close with a very recent work that makes clear reference to Duchamp, his physical death, and his intellectual survival: Douglas Gordon's 2004 *Proposition for a Posthumous Portrait* (pl. 100). With its mirrored shelf, Gordon's sculptural work, much like Johns's piece, plays with notions of revelation and hiddeness alluded to by Duchamp in his notes. This unconventional memento mori, which sets forth a skull with a star carved into it, makes reference to Duchamp's photograph in a hinged mirror (pl. 7), Irving Penn's portrait of Duchamp standing in a corner (pl. 48), and the famous photographs of Duchamp with an unconventional tonsure (pls. 18, 19).[95] While the picture of Duchamp sporting the image of a star cut into his hair may well have contained a veiled reference to a note by Duchamp describing "a comet [with] its tail in front," or even the "milky way" of *The Large Glass,* Gordon's piece suggests another reading: the assumption of star status by Duchamp in the wake of his death, in large part through his insistence on art's conceptual dimensions.[96]

Through portraiture Duchamp "coined" his image, encouraging its continued circulation, even after his death. By tightly tying portraiture to his oeuvre as a whole, Duchamp demonstrated his deep commitment to constructing an image that is not unilateral but rather multivalent. Fascinated by the process of the transformation of one thing into another, Duchamp in turn speculated about the conceptual significance of possibility as an expression of creative potential itself. "The possible is/an infra-thin," wrote Duchamp in a series of notations largely concerned with liminality. "The possible implying/the becoming—the passage from/one to the other takes place/in the infra thin."[97] Elsewhere he mused that "the figuration of a possible" did not imply "the opposite of impossible" nor even something "probable" or "likely."[98] Thus Duchamp's deployment of his everchanging likeness functions not as a mere catalogue of options but an invitation for creative intervention. Through this practice, the problem of inadequate or improper representation falls away, guaranteeing a rich terrain of possibility for the future.

1. Marcel Duchamp, "The Creative Act," in Lebel, *Duchamp*, 77. Duchamp's talk, "The Creative Act," was delivered in English in the Session on the Creative Act, Convention of the American Federation of the Arts, Houston, Texas, April 1957.

2. Walter Arensberg, draft of letter dated May 6, 1943, quoted by Ecke Bonk, *Marcel Duchamp: The Portable Museum*, trans. David Britt (London: Thames and Hudson, 1989), 167. Bonk notes that the letter was marked "not sent," making it unclear whether this observation made it to Duchamp (ibid., 193, n. 10). The letter is also quoted in Tomkins, *Duchamp*, 316.

3. Marcel Duchamp to Georgia O'Keeffe, 1923; quoted in O'Keeffe, contribution to "A Collective Portrait of Marcel Duchamp," in d'Harnoncourt and McShine, *Marcel Duchamp*, 213.

4. Duchamp, "The Creative Act," 77–78.

5. Marcel Duchamp, in Cabanne, *Dialogues with Marcel Duchamp*, 91.

6. One index of his ongoing importance was his recent selection by British art students as "the most influential artist in the United Kingdom." Joanne Allen, "Marcel Duchamp Is Art Students' Favourite," *Art Newspaper* 170 (June 2006): 9. Francis Naumann makes a similar point in his essay in this volume. For an overview of recent and historic scholarship on Duchamp, please see the bibliography published in this volume.

7. O'Keeffe, in d'Harnoncourt and McShine, *Marcel Duchamp*, 213.

8. O'Keeffe made her remark in reply to an invitation from Anne d'Harnoncourt and Kynaston McShine, who sought to chronicle the responses of various living artists to Duchamp for their "Collective Portrait of Duchamp," included in the catalogue for their 1973 retrospective exhibition, d'Harnoncourt and McShine, *Marcel Duchamp*.

9. Marcel Duchamp, in conversation with Ulf Linde, included in Serge Stauffer, ed., *Marcel Duchamp, Interviews und Statements* (Stuttgart: Edition Cantz, 1992), 123–24. Translation mine.

10. Duchamp very likely recognized that the legend that grew up around him would soon part ways with the historical individual who inspired it. As Howard Singerman points out, building on the work of F. R. Ankersmit, "[e]ven in the case of proper names, of Napoleon or Duchamp, our language does not point to an individual body, but to a historical role, and even more, to the arguments, assumptions, and interpretations that fill out that role." Howard Singerman, "Sherrie Levine's Art History," *October* 101 (Summer 2002): 112.

11. Jones, *En-Gendering*, especially 63–109. Anne d'Harnoncourt notes that "for a man of intense privacy, he remained extraordinarily accessible." (Anne d'Harnoncourt, introduction to d'Harnoncourt and McShine, *Marcel Duchamp*, 44.)

12. Calvin Tomkins, "Not Seen and/or Less Seen: Marcel Duchamp," *New Yorker*, February 6, 1965, 37.

13. Marcel Duchamp, in conversation with Pierre Cabanne; see Cabanne, *Dialogues with Marcel Duchamp*, 104. Cited by Jones, *En-Gendering*, 69. Duchamp was not alone in reflecting on the mechanisms for constructing "greatness" in the public eye at this moment. Compare with Daniel J. Boorstin, *The Image: A Guide to Pseudo-Events in America* (1961; New York: Vintage Books, 1992).

14. Marcel Duchamp, in conversation with James Johnson Sweeney, "A Conversation with Marcel Duchamp," televised interview for NBC conducted in 1955 and aired in January 1956, edited version published in *WMD*, 133. Quoted in Tomkins, *Duchamp*, 393.

15. As Calvin Tomkins observes, by 1912 and 1913, "contradiction—including self-contradiction—was already becoming one of Duchamp's defining character traits." See Tomkins, *Duchamp*, 122.

16. Sweeney, "A Conversation with Marcel Duchamp," in *WMD*, 133.

17. Introduction to d'Harnoncourt and McShine, *Marcel Duchamp*, 35; from Harriet and Sidney Janis, "Marcel Duchamp: Anti-Artist," originally published in *View* 5, no. 1 (March 1945): 18; reprinted in Robert Motherwell, ed., *Dada Painters and Poets: An Anthology* (1951; Cambridge, MA: The Belknap Press, 1981), 307.

18. Jasper Johns, "Thoughts on Duchamp," *Art in America* 57, no. 4 (July–August 1969): 31; reprinted in *Jasper Johns: Writings, Sketchbook Notes, Interviews*, ed. Kirk Varnedoe, comp. Christel Hollevoet (New York: Museum of Modern Art, 1996), 22–23.

19. *The American Heritage Dictionary*, 3d edition, s.v. "identity."

20. It is worth noting that Duchamp's own family members provided a precedent for name changes. Duchamp's father, born Justin-Isidore Duchamp, chose instead to call himself Eugène, while his eldest brother, Gaston, an illustrator and painter, rechristened himself "Jacques Villon." Another older brother, Raymond, to create a link between his parents and the former Gaston, became "Raymond Duchamp-Villon" (Tomkins, *Duchamp*, 16, 24, and 26). Duchamp humorously referred to Jacques Villon's abandonment of his given names in an interview with Pierre Cabanne; see Cabanne, *Dialogues with Marcel Duchamp*, 90; also cited in George H. Bauer, "Duchamp's Ubiquitous Puns," in *Marcel Duchamp: Artist of the Century*, ed. Rudolf Kuenzli and Francis M. Naumann (1989; Cambridge, MA: MIT Press, 1996), 135. It should also be noted that Man Ray and Francis Picabia abetted many of Duchamp's transformations, with Man Ray participating in the construction of Rrose Sélavy and the photographs of Duchamp with soap-saturated hair, and Picabia creating a *Portrait of Rrose Sélavy*, featuring a picture of the boxer Georges Carpentier signed Rrose Sélavy, for the cover of *391*, Paris, no. 19 (October 1924).

21. On the similarity of Man Ray's photographs of Duchamp as Rrose Sélavy to portraits of glamorous women in *Vanity Fair*, see Dawn Ades, "Duchamp's Masquerades," in *The Portrait in Photography*, ed. Graham Clarke (London: Reaktion Books, 1992), 107–8. On the development of a system of frontal and profile photographs to identify criminals, see Allan Sekula, "The Body and the Archive," *October* 39 (Winter 1986): especially 28–40.

22. The photograph has been widely reproduced. For one source see Pepe Karmel, "Marcel Duchamp: The Not So Innocent Eye," in *Modern Art and America: Alfred Stieglitz and His New York Galleries*, ed. Sarah Greenough (Boston: Bulfinch Press for the National Gallery of Art, 2000), 226.

23. On Duchamp's love of punning, see Bauer, "Duchamp's Ubiquitous Puns," 127–48. As William Camfield has argued, Duchamp likely commissioned and influenced the photograph that Stieglitz produced of the *Fountain*, although Stieglitz seems to have selected the backdrop of Hartley's *The Warriors*; see William A. Camfield, "Marcel Duchamp's *Fountain*: Its History and Aesthetics in the Context of 1917," in *Marcel Duchamp: Artist of the Century*, especially 76 and 84. On Stieglitz's photograph see also Pepe Karmel, "Marcel Duchamp," 220–27. For examples of Stieglitz's photographs of artists in front of artworks, see Greenough, *Modern Art and America*.

24. For an excellent overview of *The Large Glass*, see Tomkins, *Duchamp*, 1–14.

25. See James W. McManus, "Trucage photographique et déplacement de l'objet: À propos d'une photographie de Marcel Duchamp prise devant un miroir à charnières (1917)," *Les Cahiers du Musée national d'art moderne* 92 (Summer 2005): 94–111; and Dawn Ades, "Duchamp's Masquerades," 94–114 and 212–14.

26. For Duchamp's description of the "Wilson-Lincoln system," see *WMD*, 65. There is some debate among scholars about exactly what sort of image Duchamp saw. Although the term "lenticular photography" was not coined until 1936 (see *The Oxford English Dictionary*, 2nd ed., s.v. "lenticular"), the photographic technology to produce these images existed by at least 1910, as described in F. Honoré "Novel Changeable Photographs," *Scientific American*, April 2, 1910, 283. I thank James W. McManus for this reference. Literary references to "changeable" pictures using slats date back to the late sixteenth and early seventeenth centuries, when such works were described as "perspectives" or "turning pictures"; see Allan Shickman, "Turning Pictures in Shakespeare's England," *Art Bulletin* 59, no. 1 (March 1977): 66–70. Duchamp's own interest in the subject of "perspective" is demonstrated by a 1913 note included in *A l'infinitif* (first published in 1966); see *WMD*, 86–88. Importantly, the note includes a reference to Jean François Niceron's 1638 treatise on perspective, which includes a detailed description of "changeable" slat images (see plate 18). I thank James W. McManus for alerting me to the relevance of Duchamp's reference to Niceron in his discussion of the "Wilson-Lincoln system." For more on the implications of the "Wilson-Lincoln system" for Duchamp's approach to portraiture, notably his *Allégorie de genre* (1943), see Michael R. Taylor's essay in this volume. While rare, three-way images in nineteenth-century American examples often combined portraits of presidents; such images were also used by 1888 in shop signs. See Michael O'Malley, "The History and Conservation of an Early 19th Century Slat Painting," paper presented at the Western Association for Art Conservation Annual Meeting, Santa Fe, New Mexico, September 28, 1992, Curatorial Files, Smithsonian American Art Museum, *Triple Portrait* (depicting James Monroe; unidentified, possibly Native American, sitter; and Thomas Jefferson by unidentified artist, oil on canvas and oil on wood panel, early nineteenth century, accession number 1967.90.1); and Michael O'Malley, "The Conservation of a Three-Way Painting," *Journal of the International Institute for Conservation—Canadian Group* 21 (1996): 3–8.

27. Duchamp, quoted in Jeanne Siegel, "Some Late Thoughts of Marcel Duchamp, from an Interview with Jeanne Siegel," *Arts Magazine* 42, no. 3 (December 1968–January 1969): 22; quoted in Henderson, *Duchamp in Context*, 213.

28. Shuzo Takiguchi, Preface to "Toward Rrose Sélavy: A marginal note to *To and From Rrose Sélavy*," *To and From Rrose Sélavy* (Tokyo: Rrose Sélavy, 1968), 1. Takiguchi also recounts this story in Shuzo Takiguchi, contribution to "A Collective Portrait of Marcel Duchamp," in d'Harnoncourt and McShine, *Marcel Duchamp*, 222.

29. Anne d'Harnoncourt and Walter Hopps similarly single out this note as an indication that "there are myriad aspects to any given element." However, they interpret the significance of the note in a slightly different vein, arguing that Duchamp's citation of the lenticular image indicates that "everything can be read at least two ways at once." While not dismissing this interpretation, I wish to further nuance our understanding of this note, sug-

gesting instead that rather than asserting the potential for different sight-based readings occurring *simultaneously,* Duchamp recognized that different sight-based interpretations were possible *successively* without one canceling out the correctness of the other, but simply demonstrating the use of a new system of perspective; intellectually, however, the two meanings can be held in tandem. See Anne d'Harnoncourt and Walter Hopps, *Étant Donnés: 1. la chute d'eau, 2. le gaz d'éclairage, Philadelphia Museum of Art Bulletin* 64, nos. 299–300 (April–September 1969); 2nd reprint (Philadelphia Museum of Art, 1987), 16.

30. *The Oxford English Dictionary,* 2nd ed., s.v. "perspective." Italics mine. See also O'Malley, "The Conservation of a Three-Way Painting," 3. See also n. 26.

31. I thank Harry Rubenstein for sharing this with me, November 16, 2006.

32. *A l'infinitif,* originally published in 1966, is reproduced in *WMD,* 74–101; one note entitled "perspective" actually directs the reader to "See Catalogue of Bibliotèque St. Genviève/the whole section on perspective" (p. 86), as noted above in n. 26. On Duchamp's interest in the fourth dimension and perspective, see Henderson, *Duchamp in Context,* especially 80–85, and d'Harnoncourt and Hopps, *Étant Donnés,* 16–17.

33. As Helmut Wohl has astutely observed: "Since the disclosure of *Étant donnés* many of Duchamp's seemingly random productions have begun to be recognized as parts of a coherent oeuvre." Helmut Wohl, "Marcel Duchamp in Newark," *The Burlington Magazine* 145, no. 1198 (January 2003): 38. Wohl appropriately credits Anne d'Harnoncourt and Walter Hopps for making a similar observation in *Étant Donnés;* see p. 25ff.

34. As Calvin Tomkins has observed: "Among the group of European artists and intellectuals uprooted by the war and set down in New York, Duchamp alone seemed to feel completely at home—Max Ernst described him as 'perfectly contented.'" Calvin Tomkins, *The Bride and The Bachelors* (1965; New York: Penguin Books, 1976), 60.

35. More on many of these related activities follows. For an overview, see Jones, *En-Gendering,* esp. 76–85; Tomkins, *The Bride and the Bachelors,* 62–63; and Tomkins, *Duchamp,* 367–73. Among the publications to reintroduce Duchamp to a mainstream art audience was his published statement in "Eleven Europeans in America," James Johnson Sweeney, ed., *The Museum of Modern Art Bulletin* 13, nos. 4–5 (1946): 19–21. Robert Motherwell's anthology, *The Dada Painters and Poets: An Anthology* (Boston: G. K. Hall, 1981), originally published in 1951, included several essays testifying to the formative role of Duchamp in this movement.

36. Tomkins, *Duchamp,* 323–24; David Hopkins, "The Politics of Equivocation: Sherrie Levine, Duchamp's Compensation Portrait, and Surrealism in the USA 1942–45,"*Oxford Art Journal* 26, no. 1 (2003): 57. See also d'Harnoncourt and McShine, *Marcel Duchamp,* 23.

37. Walter Arensberg, draft of letter dated May 6, 1943, quoted in Bonk, *Marcel Duchamp: The Portable Museum,* 167. See n. 2. Arensberg's appraisal of the *Boîte-en-valise* resonates with David Joselit's later description of the work as "an allegory of the self caught in the compulsive repetition of reproduction." As Joselit notes, the *Boîte* addresses both Duchamp's masculine and feminine self-constructions, through the attribution "de ou par Marcel Duchamp ou Rrose Sélavy." See David Joselit, *Infinite Regress: Marcel Duchamp 1910–1941* (Cambridge, MA: MIT Press, 1998), 188–93.

38. See Hopkins, *Politics of Equivocation,* 45–60.

39. Schwarz, *Complete Works,* vol. 2, 767.

40. On Schiff's pictures of "The First Papers of Surrealism," see Paul Franklin, "It's in the Bag: The Story of a Brown Paper Sack," *Étant donné Marcel Duchamp* 6 (2005): 174. See also Lewis Kachur, *Displaying the Marvelous: Marcel Duchamp, Salvador Dalí, and Surrealist Exhibition Installations* (Cambridge, MA: MIT Press, 2001), 187ff.

41. Schwarz characterizes the photograph as "an imaginary portrait of Duchamp, selected by the artist himself," and contrasts it with the "actual 1922 portrait" by Stieglitz (Schwarz, *Complete Works,* vol. 2, 780). Stieglitz's photograph was actually made in 1923; see plate 24. Compare with Hopkins, who correctly surmised that the aging was artificial, crediting it to "photographic angling and lighting" (Hopkins, *Politics of Equivocation,* 56). The pair of photographs also suggest the use of stage makeup to effect the transformation. Ironically, both Hopkins and Schwarz erroneously reproduce a variant photograph of Duchamp without glasses, while the photograph in *View* shows him with glasses. See Michael R. Taylor's essay in this volume for a further discussion of the conceptual roots of this picture.

42. As Carroll Janis points out, the article contributed by his parents Sidney and Harriet Janis to *View* was republished in Motherwell, *Dada Painters and Poets,* further contributing to the influence of the *View* publication. See Carroll Janis, "Marcel Duchamp Curates Dada," *Art in America* 94, no. 6 (June/July 2006): 152; see Motherwell, *Dada Painters and Poets,* 306–15.

43. On Duchamp's participation in the round-table, see Bonnie Clearwater, "Trying Very Hard to Think: Duchamp and the Western Round Table on Modern Art, 1949," in *West Coast Duchamp,* ed. Bonnie Clearwater (Miami

Beach: Grassfield Press, 1991), 46–59; Tomkins, *Duchamp,* 367–69.

44. The word "emissary" is Calvin Tomkins's and accurately conveys Duchamp's important role in negotiations concerning this collection. See Tomkins, *Duchamp,* 373.

45. Ibid., 379; see also Jones, *En-Gendering,* 63–65.

46. Duchamp to the Arensbergs, February 4, 1952; quoted by Jones, *En-Gendering.* Duchamp expressed a similar sentiment in a letter to Katherine Dreier, Marcel Duchamp to Katherine Dreier, February 18, 1952, Papers of Mary E. Dreier, Schlesinger Library, Radcliffe Institute, Harvard University. See cat. 51 on "Dada's Daddy" for more information about this publication.

47. See Janis, "Duchamp Curates Dada," 152–55; 215. See also n. 26.

48. Marcel Duchamp, Letter to Jean and Suzanne (Duchamp) Crotti, October 24, 1953, Jean Crotti Papers, AAA.

49. Please see plates 3, 4, and 5.

50. Marcel Duchamp, Letter to Jean Crotti, August 17, 1952, Jean Crotti Papers, AAA.

51. Jean Crotti, Letter to Marcel Duchamp, July 14, 1953, Jean Crotti Papers, AAA.

52. Marcel Duchamp, Letter to Jean Crotti, August 17, 1952, Jean Crotti Papers, AAA.

53. *WMD,* 70.

54. For a valuable account of Duchamp's rejection of painting, with the shortcomings of its physical properties, see Henderson, *Duchamp in Context,* 208–11. In this context, the title's implicit reference to a "tomb," or death, takes on a very specific meaning in terms of Duchamp's fear that his own legacy might be doomed if he did not abandon painting.

55. Otto Hahn, "Passport No. G255300," *Art and Artists* 1, no. 4 (July 1966): 10.

56. Ibid.,10.

57. On Duchamp's deployment of chance as an artistic technique, see Henderson, *Duchamp in Context,* 58–61, passim.

58. On Duchamp's creation of a "system" with which to play roulette for a profit, see Lebel, *Duchamp,* 50; Sweeney "Conversation with Marcel Duchamp," 1956, excerpted in *WMD,* 137; description of "The Monte Carlo Bond" published in *The Little Review* 10, no. 2 (Fall–Winter 1924–25): 18 (reprinted in *WMD,* 185). For another interpretation of the *Monte Carlo Bond* and the system on which it was predicated, see David Joselit, "Marcel Duchamp's *Monte Carlo Bond* Machine," *October* 59 (Winter 1992): 8–26.

59. While Duchamp clearly demonstrated his interest in reaching a wide audience, in particular those of posterity, I use the term "public" here in a Habermasian sense—a

public tied together by the ability to participate in a shared cultural discourse. See Jürgen Habermas, *The Structural Transformation of the Public Sphere: An Inquiry into a Category of Bourgeois Society,* trans. Thomas Burger (1962; Cambridge, MA: MIT Press, 1989), especially 23 and 37.

60. *WMD,* 71. In a similar fashion, Duchamp told an interviewer in 1963, "If I do propose to strain a little bit the laws of physics and chemistry and so forth, it is because I would like you to think them unstable to a degree." Quoted in Francis Roberts, "'I propose to Strain the Laws of Physics': Interview with Marcel Duchamp [1963]," *ARTnews* 67, no. 8 (December 1968): 63. Compare with Duchamp's reference to violating the rules of chemistry in his late interview (1963; published 1968) with Francis Roberts. For a persuasive argument that Duchamp is emulating Mercury here, see James W. McManus, "Rrose Sélavy, 'Machinist/Erotaton,'" in *Marcel Duchamp and Eroticism,* ed. Marc Décimo (Newcastle, Eng.: Cambridge Scholars Publishing, 2007), 66–70.

61. Tomkins, *Duchamp,* 231.

62. Quoted by Ades, "Duchamp's Masquerades," 106. Duchamp was responding to a question posed by Serge Stauffer; see Stauffer, *Marcel Duchamp,* 178.

63. The photograph also seems to anticipate *Étant donnés,* as Duchamp wears the blond wig that will appear on the prostrate female figure in the installation. I thank James W. McManus for this information, conversation, October 12, 2007.

64. Naumann, *Art of Making Art,* 157 and 188. The book's publisher, Arnold Fawcus, also issued the invitation to Duchamp to participate. Duchamp learned on April 7, 1953, that Lebel had been commissioned to write a biography of him, which Lebel wished to combine with a catalogue of his work. (Jennifer Gough-Cooper and Jacques Caumont, "Ephemerides on and about Marcel Duchamp and Rrose Sélavy," in *Marcel Duchamp: Work and Life,* ed. Pontus Hulten [Cambridge, MA: MIT Press, 1993], entry for April 7, 1953.) For a detailed account of the development and publication of this monograph, see Paul Franklin, "1959: Headline, Duchamp," *Étant donné Marcel Duchamp* 7 (2006): 141–75.

65. Duchamp to Katharine Kuh, October 8, 1951; quoted in Naumann, *Art of Making Art,* 192; and in Gough-Cooper and Caumont, "Ephemerides," entry for November 15, 1958.

66. For more on reproductions by Duchamp included in the deluxe and grand-deluxe versions of the book, see Naumann, *Art of Making Art,* 188–92. Although the *Self-Portrait in Profile* has been dated to 1958 by Arturo Schwarz, author of the authoritative Duchamp catalogue raisonné, a dating followed by other

scholars, correspondence between Marcel Duchamp, Robert Lebel, and Arnold Fawcus recently published by Paul Franklin demonstrates that the edition of the profile was actually complete by February 1957. The original edition was of 130 pieces; this number was later increased to 137. See Franklin, "1959: Headline, Duchamp," 146; compare with Schwarz, *Complete Works*, vol. 2, 811.

67. My thanks to Jacqueline Matisse Monnier and Dona Hochart for their translation of Duchamp's inscription, conversation with the author, June 20, 2006. For more on Duchamp's interest in black velvet, see Henderson, *Duchamp in Context*, 213.

68. Francis Naumann makes the same observation in his *Art of Making Art*, 192; see page 112 for a description of Duchamp's method for creating the notes for *The Green Box*.

69. Katharine Kuh, interview with Marcel Duchamp, in Katharine Kuh, *The Artist's Voice: Talks with Seventeen Artists* (New York and Evanston: Harper and Row, 1962), 83.

70. Portraiture, Pliny tells us, was "invented" when Dibutade, daughter of the Corinthian potter Boutades, sought to record the likeness of the lover compelled to leave her. The maiden traced his shadow onto a wall, creating an "exact" transcription of his presence, based on the image cast by his shadow. Her father then cut out the form and filled it in with clay, which he fired, to produce a copy of the young man's form (Pliny, *Natural History* 35.151–52). Intimately connected with the "birth" of self-portraiture, around 1500, is the mirror, with its inevitable link to the story of Narcissus, who wasted away by the side of a pond transfixed by the reflection of his own features; on the indexical claims of portraiture, see Anne Collins Goodyear, "The Portrait, the Photograph, and the Index," in *Photography Theory*, ed. James Elkins, *The Art Seminar*, vol. 2 (New York: Routledge, 2007), 211–15, 385–88.

71. Robert Lebel, "Duchamp au musée," *Catalogue raisonné de Marcel Duchamp*, ed. J. Clair (Paris: Musée National d'Art Moderne, Centre National d'Art et de Culture Georges Pompidou, 1977), 123.

72. Agnès de la Beaumelle, catalogue entry on *With My Tongue in My Cheek, Torture-morte*, and *Sculpture-morte*, in *Rendezvous: Masterpieces from the Centre Georges Pompidou and the Guggenheim Museums* (New York: Guggenheim Museum Publications, 1998; distributed by Harry N. Abrams), 629.

73. Lebel, "Duchamp au musée," 123. The publisher's decision to cancel the project on the basis of what he considered "des mauvaises plaisainteries" is quoted, without attribution, in a curatorial statement about *Sculpture-morte* and *Torture-morte* included in the curatorial files of the Musée National d'Art Moderne, Centre National d'Art et de Culture Georges Pompidou.

74. Gough-Cooper and Caumont, "Ephemerides," entry for April 15, 1959.

75. Ibid., April 4, 1962.

76. Beaumelle, 629. The full title of Duchamp's posthumously unveiled installation is *Étant donnés: 1. la chute d'eau, 2. le gaz d'éclairage* (Given: 1. The Waterfall, 2. The Illuminating Gas). The title derives from a note in *The Green Box* (*WMD*, 28).

77. See Helmut Wohl, "Duchamp in Newark," 38. Further evidence of Duchamp's larger thinking is suggested by Duchamp's active involvement in the procurement of objects for an exhibition at the Sidney Janis Gallery related to the French launch of the book in April 1959. (Ibid., 39, "Appendix.")

78. Wohl identifies these as photographic "prints" (ibid., 36), but close study of the photograph in the Philadelphia Museum of Art Archives indicates that these images are actually a series of dust jackets from the book (or possibly stacked books).

79. Duchamp, *A l'infinitif* (*The White Box*), note dated 1913, in *WMD*, 74; quoted by Wohl, "Duchamp in Newark," 38. The autobiographical window installation at Bamberger's also calls to mind Rosalind Krauss's assertion that *The Large Glass* itself constitutes a form of self-portraiture, a conclusion based in large part on the linguistic game of "Mar" for "Mariée," or bride, in the upper part of the glass and "cel," for "Célibataires," in the lower part of the glass, a connection made manifest in a note Duchamp included in *The Large Glass*. Rosalind E. Krauss, "Notes on the Index: Part I," in *The Originality of the Avant-Garde and Other Modernist Myths* (1985; Cambridge, MA: MIT Press, 1993), 202.

80. As Helmut Wohl has documented, the Grove Press of New York published George Heard Hamilton's translation of Lebel's book on November 6, 1959, seven months to the day after the French version appeared under the aegis of the Trianon Press in Paris (Wohl, "Duchamp in Newark," 36).

81. Author's interview with Billy Klüver, January 13, 1999.

82. Naumann, *Art of Making Art*, 210–13.

83. Roberta Bernstein traces this back to Max Kozloff's essay "Jasper Johns and Duchamp," *Art International* 3, no. 2 (March 1964): 42–45. (See Roberta Bernstein, *Jasper Johns' Paintings and Sculptures, 1954–1974: "The Changing Focus of the Eye"* [1975; Ann Arbor: UMI Research Press, 1985], 224, n. 7). Since then, numerous other scholars have examined the interconnection, including Bernstein, Ruth Fine and Nan Rosenthal, Richard Shiff, Dorothy Kozinski, Barbara Rose, and Francis Naumann.

84. Jasper Johns, "Marcel Duchamp (1887–1968)," *Artforum* 7, no. 3 (November 1968): 6; reprinted in *Jasper Johns: Writings, Sketchbook Notes, Interviews*, 22.

85. The silkscreen was created to celebrate the release of Lebel's monograph. See Schwarz, *Complete Works*, vol. 2, 817.

86. Bernstein notes that the work was reproduced in "25 numbered copies of Ulf Linde's *Marcel Duchamp* (1963)" and in Arturo Schwarz's *Marcel Duchamp/Ready-Mades, Etc.* (1964), both of which Johns owns. (Bernstein, *Jasper Johns' Paintings and Sculptures*, 119.)

87. Johns's *According to What* has been widely reproduced; the work is discussed at length in Francis Naumann, *Jasper Johns: According to What and Watchmen* (New York: Gagosian Gallery, 1992).

88. Johns, Book A, 44 and 49, 1964, reprinted in *Jasper Johns: Writings, Sketchbook Notes, Interviews*, 55 and 56. Bernstein notes that Johns began this system of recording his ideas around the time that he and Duchamp met. (Bernstein, *Jasper Johns' Paintings and Sculptures*, 61.)

89. On Duchamp's note "Shadows cast by readymades," see *WMD*, 33. Johns reviewed *The Green Box* upon its publication in English in 1960, and hence he was well-acquainted with its contents. See Jasper Johns, "Duchamp," *Scrap* (New York), no. 2 (December 23, 1960): 4. The review is reprinted in *Jasper Johns: Writings, Sketchbook Notes, Interviews*, 20–21. Another note by Duchamp on the topic "Cast Shadows" was published separately by Roberto Matta in *Instead*, February 1948; it is reprinted in *WMD*, 72; while this note is also relevant to Johns's project, it is not certain that Johns would have been familiar with it in 1964, though it is possible. On Duchamp's use of a projector to cast shadows onto the canvas for *Tu m'* see Henderson, *Duchamp in Context*, 209.

90. Richard Shiff, "Anamorphosis: Jasper Johns," in *Foirades/Fizzles: Echo and Allusion in the Art of Jasper Johns* (Los Angeles: Grunwald Center for the Graphic Arts, Wight Art Gallery, University of California, Los Angeles, 1987), 151.

91. John Coplans observes: "The hinged canvas is at the bottom of *According to What*, face to the painting and signed on the back." Johns responds: "On the face of the canvas is the shadow of Duchamp." John Coplans, "Fragments according to Johns: An Interview with Jasper Johns," *The Print Collector's Newsletter* 3, no. 2 (May–June 1972): 29–32; reproduced in *Jasper Johns: Writings, Sketchbook Notes, Interviews*, 139. For a reproduction of *According to What*, which includes a view of the open canvas, see Nan Rosenthal, "Drawing as Rereading," in *The Drawings of Jasper Johns*, Nan Rosenthal and Ruth E. Fine (Washington, DC: National Gallery of Art, 1990), 26.

92. Johns, quoted by Coplans, "Fragments," 141. Johns's impulse to show "simultaneously . . . the hinged canvas closed and open" also has resonance with Marcel Duchamp's *Door:*

11, rue Larray. As d'Harnoncourt and McShine explain, in the apartment that Duchamp occupied at this address he "installed a door that served two doorways (between the studio and the bedroom, and the studio and the bathroom). The door could be both open and closed at the same time." The door was later retrieved and exhibited. See d'Harnoncourt and McShine, *Marcel Duchamp*, 300; quoted in Scharwz, *Complete Works*, vol. 2, 717, who also provides the exhibition history of this object.

93. I thank Ruth Fine for alerting me to the inclusion of Duchamp's silhouette in the "Fall" panel.

94. Mel Bochner, telephone conversation with the author, May 2, 2007.

95. I thank Sean Kelly for pointing out the formal similarity between Penn's portrait and Gordon's work.

96. Marcel Duchamp, "1912" note from *The Green Box, WMD*, 26. On the relationship of the 1921 photograph of Duchamp with the star tonsure to this note, see Schwarz, *Complete Works*, 673, cat. no. 371. Note that although Duchamp marked the photograph with a date of 1919, prompting Schwarz to assign it this date, the picture was actually made in 1921. See "Portfolio: Photographs of or about Marcel Duchamp," *Étant donné Marcel Duchamp* 7 (2006): 224, caption 8-12. For further discussion of the significance of this imagery, see pls. 18 and 19 and James W. McManus's essay, all in this volume.

97. From the mid-1930s to the mid-1940s, Duchamp penned a series of notes devoted to the phenomenon of the "infra-thin," a term of his devising that captures his interest in liminality. The notes were not published during his lifetime but appear in *Marcel Duchamp, Notes*, trans. Paul Matisse (Boston: G. K. Hall, 1983); the note quoted here appears as note 1. On the "liminal moments" captured in Duchamp's notes on infra-thin, see Henderson, *Duchamp in Context*, 213–14.

98. This note was originally published by Pierre André Benoit (PAB: Alés, France, 1958); it is reprinted in *WMD*, 73.

MARCEL DUCHAMP

#6

AND PORTRAITURE

Michael R. Taylor

With the reckless insouciance of a schoolboy drawing pornographic fantasies on a lavatory wall, Marcel Duchamp altered and transformed a cheap chromolithograph of Leonardo da Vinci's *Mona Lisa* through the addition in pencil of an upturned mustache and a rakish goatee, adding as well the deliciously scurrilous inscription "L.H.O.O.Q." in the bottom margin of the postcard. When read aloud in French, L.H.O.O.Q. has the double meaning of "elle a chaud au cul," which can be translated as "she has a hot ass" or, as Duchamp preferred, "there is fire down below."[1] This iconoclastic gesture, carried out in Paris in 1919, a year that commemorated the four-hundredth anniversary of Leonardo's death, reveals Duchamp's irreverent attitude to the genre of portraiture and the canonical traditions of art upheld by such hallowed institutions as the Louvre, where the *Mona Lisa* has hung almost continuously since the museum opened in 1793. Indeed, the lasting success of Duchamp's risqué Dadaist joke on the *Mona Lisa* is no doubt due to the fact that the painting was at that time, as now, perhaps the most famous and easily recognizable portrait in the world.

Much of the literature on this notorious assisted readymade concentrates on Duchamp's profound challenge to fixed notions of authorship and gender roles, as the artist's graffiti-like addition of facial hair irrevocably altered the sexual identity of the unknown sitter in Leonardo's enigmatic painting, whose name has passed down into history as the *Mona Lisa* or *La Gioconda*, because she is thought to have been the wife of the Italian nobleman Francesco del Giocondo. *L.H.O.O.Q.* suggests that the subject portrayed may in fact be a man, perhaps even Leonardo himself, who like Duchamp was a note-making, diagram-drawing artist whose work embraced recent developments in science and technology. As Jack Spector has pointed out, Duchamp was perhaps aware, through his newfound friendship with fellow Dadaist André Breton, of Sigmund Freud's 1910 study *Leonardo da Vinci and a Memory of His Childhood,* in which the Viennese psychoanalyst explored the Renaissance artist's possible homosexuality.[2] L.H.O.O.Q. thus offers a scandalous solution to the *Mona Lisa*'s mysterious smile by drawing attention to the sexual ambiguity in Leonardo's life and work. As Duchamp later recalled, "The curious thing about that mustache and goatee is that when you look at it the Mona Lisa becomes a man. It is not a woman disguised as a man; it is a real man, and that was my discovery, without realizing it at the time."[3]

As numerous Duchamp scholars have suggested, *L.H.O.O.Q.* anticipates the artist's transgressive feminine alter ego, Rrose Sélavy, who made her first appearance in his work in 1920. But rather than read the work retrospectively through the lens of Rrose Sélavy's sexual indeterminacy, I would locate the subversive nature of *L.H.O.O.Q.* in the sacrilegious, scatological *potache* (schoolboy) humor that Duchamp shared with his Dadaist colleagues, especially Man Ray and Francis Picabia, as well as his lifelong interest in puns and wordplay. In an unpublished interview with museum curator James Johnson Sweeney, Duchamp connected *L.H.O.O.Q.* with his passion for *calembours,* or puns, citing the example of "lustucru" (a simpleton or ass), which can also be understood as "l'eusses tu cru?" ("Had you believed it?"), a delightful play on words that Duchamp invented at the age of fourteen and later viewed as an important forerunner of the phonetic "L.H.O.O.Q" inscription.[4] Duchamp's great hero in this regard was Jean-Pierre

Brisset, a masterful inventor of puns and word games, whose delirium of imagination can be seen as a powerful, formative influence on the artist after he was introduced to his work in 1914 through the poet and critic Guillaume Apollinaire.[5] As Duchamp explained to Sweeney, in a section of their extended interview that was published in the *Museum of Modern Art Bulletin,* "Brisset's work was a philological analysis of language—an analysis worked out by means of an incredible network of puns. He was sort of a Douanier Rousseau of philology."[6] Duchamp's admiration for Brisset's obsessional punning, in which a sexual subtext is omnipresent,[7] and the work of other French authors, such as Raymond Roussel and Alfred Jarry, confirmed his belief that "as a painter it was much better to be influenced by a writer than by another painter."[8] He may also have found inspiration for *L.H.O.O.Q.* in the "Clinamen" section of Jarry's dauntingly dense masterpiece *Gestes et opinions du docteur Faustroll, 'pataphysician* (Exploits and Opinions of Doctor Faustroll, 'Pataphysician).[9]

In this "neoscientific" novel, which was published posthumously in 1911 (although a few fragments of the book had appeared in the *Mercure de France* in 1895), Jarry nominated Henri Rousseau, the "artist painter decorator, called the Customs-officer (douanier)," to operate an anthropomorphic painting machine, which he dubbed the "mechanical monster" because of its lack of precision and control.[10] This futuristic device—characterized by Jarry as a half-machine, half-beast called Clinamen—was intended to transform the holdings of the "National Department Storehouse," a barely disguised reference to the Louvre, by ejaculating "onto the walls' canvas the succession of primary colors ranged according to the tubes of its stomach."[11] However, the act of putting Rousseau in charge of transforming the Louvre by spraying its masterpieces with the salutary hose of the painting machine also declared Jarry's confidence that the customs-officer-turned-artist would one day enliven the national museum through his use of flat colors and distorted perspectives—painting techniques that Jarry found to be far superior to those of the old master paintings that traditionally hung there.

Jarry's notion of a gyrating mechanical apparatus that would cover the paintings in the Louvre with the contents of its stomach provides a powerful precursor to Duchamp's Dadaist gesture of adding a mustache and beard in black pencil to an image of the *Mona Lisa,* as well as to Duchamp's similarly outrageous suggestion that one could "use a Rembrandt as an ironing board!"[12] The swerve of Jarry's Clinamen machine, like an out-of-control high-pressure water hose that assumes its own violent and unpredictable course, also supplies us with a wonderful metaphor for Duchamp's subversion of the genre of portraiture, because the French author understood it as a spontaneous deviation of one element in a system that results in the complete reengineering of the whole.[13] This idea strongly resonates with Duchamp's work and ideas, which embrace free will and oppose fatalistic thinking and rigid conformity, as we can see in his iconoclastic, nonconformist approach to portraiture. Like Jarry's Clinamen machine, which created new paintings over existing canvases through a spinning-top motion that ensured an even distribution of colors, Duchamp's portraits bend the rules but continue to play the game, while at the same time fundamentally altering our conception of artistic practice and identity.

That Duchamp was interested in the Clinamen chapter of Jarry's *Gestes et opinions du docteur Faustroll, 'pataphysician* can be seen in his numerous references in the 1950s and 1960s to the sensual qualities of oil paint, which he claimed led artists to fall in love with their medium. In a 1960 radio interview, Duchamp told Georges Charbonnier that he believed painting to be a form of great pleasure in itself, an almost onanistic pleasure. Painters became addicted to the smell of turpentine and oil paint, and this form of "olfactory masturbation" led to repetition in their work.[14] Although Duchamp no doubt had in mind the paint-spattered, gestural canvases of Willem de Kooning, Robert Motherwell, and other abstract expressionist artists, whose work he considered "a debacle in painting,"[15] this attempt to equate the habit-forming, physical side of painting with onanistic pleasure ultimately looks back to Jarry's Clinamen chapter, in which the French author also likened the compulsive nature of painting to masturbation.[16]

Despite his radical, Clinamen-like assault on portraiture's time-honored traditions and conventions, its role in Duchamp's oeuvre has been almost completely overlooked in previous scholarly studies of his life and work, even though the artist made a wide range of portraits of family members, friends, and colleagues throughout his career. Duchamp also made a number of self-portraits, ranging from *Sad Young Man on a Train,* a 1911 cubist painting of the artist smoking a pipe in the corridor of a train traveling from Paris to Rouen, to *With My Tongue in My Cheek,* a 1959 portrait that contains a plaster cast of the artist's puffed out cheek and references his ongoing investigation into the *infra mince* and his secret work on *Étant donnés: 1. la chute d'eau, 2. le gaz d'éclairage.* As I hope to show, the artist's prolonged engagement with the genre of portraiture, which he used primarily as a vehicle for unloading his radical ideas, affected a Clinamen-like swerve that would have important ramifications for those contemporary artists who have followed in his footsteps.[17]

Like most aspects of Duchamp's mature work, his revolt against tradition embodied in works such as *L.H.O.O.Q.* needs to be seen within the context of the scandal surrounding his *Nude Descending a Staircase (No. 2)* (see fig. 1.2). On March 18, 1912, on the day of the press view of the Salon des Indépendants exhibition in Paris, Marcel Duchamp received an unexpected visit from his two brothers at his studio in Neuilly-sur-Seine. Jacques Villon and Raymond Duchamp-Villon informed their younger brother that his *Nude Descending a Staircase (No. 2)* had been rejected by the hanging committee of the Cubist Room in a blatant act of censorship. The Société des Artistes Indépendants, which had been founded under the democratic principle of "no jury, no prizes," had previously adopted a liberal exhibition policy, believing that the abolition of juries and prizes would lead to greater artistic freedom. The painting was due to have been shown alongside other cubist paintings, but Albert Gleizes, after conferring with other members of the hanging committee, including Jean Metzinger, Robert Delaunay, and Henri Le Fauconnier, rejected the work on the grounds that it had "too much of a literary title, in a bad sense—in a caricatural way. A nude never descends the stairs—a nude reclines."[18]

The painting was thus considered "inaccrochable," a word used by Gertrude Stein to describe a work of art whose risqué subject matter deems it unfit for

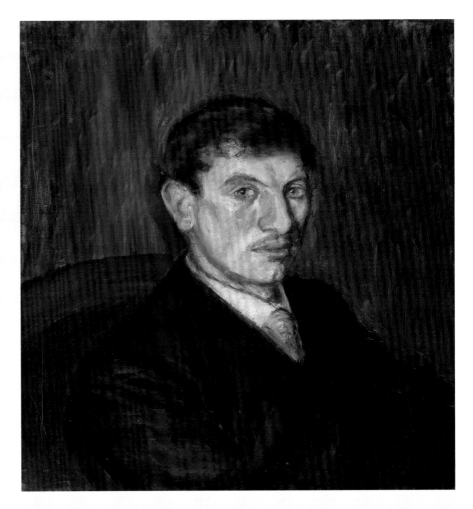

Portrait of Marcel Lefrançois by Marcel Duchamp, oil on canvas, 1904. Philadelphia Museum of Art, Pennsylvania; The Louise and Walter Arensberg Collection, 1950

fig. 6.1

public showing.[19] The cubist painters clearly wished to avoid the charge, often leveled against avant-garde artists at this time, that they deliberately courted scandal; they felt that because of the descriptive title, including the word *nu,* the work would have been seen as a deliberate provocation. Duchamp's older brothers exhorted him to at least change the title to appease the hanging committee members, but since the words "NU DESCENDANT UN ESCALIER" were painted in capital letters along the bottom left corner of the canvas, this was out of the question. Later that day, Duchamp withdrew his painting in disgust.

Prior to the *Nude Descending* controversy, Duchamp's work can be characterized as a remarkable series of youthful experiments with avant-garde styles— starting with impressionism, and followed by postimpressionism, fauvism, and cubism—that took place in quick succession over the course of little more than a decade. Duchamp began with a number of charming portraits in watercolor or India ink of family members, such as his sisters, Magdeleine, Suzanne, and Yvonne, and his paternal grandmother, Catherine Méry. He soon progressed to more ambitious oil paintings, including a now-lost portrait of Suzanne, made around 1902, known today through a quick ink sketch that the artist drew from memory in 1949, which shows his sister seated in profile and possibly playing a piano.[20] Duchamp's restless curiosity and refusal to conform to accepted tastes ensured that he did not remain loyal to one signature style for long, and it is interesting to note that the shift from one style to another usually took place within the realm of portraiture. This can be seen as early as 1904, in the *Portrait of Marcel Lefrançois* (fig. 6.1), a childhood friend of the artist and the nephew of Clémence, a cook in the Duchamp household in the small Normandy village of Blainville-Crevon.[21] As Duchamp later recalled, "this portrait of a young friend of mine was already a reaction against the Impressionist influence. In this painting I wanted to try out a technique of the Renaissance painters consisting in painting first a very precise black and white oil and then, after it was thoroughly dry, adding thin layers of transparent colors. This technique of precision was deliberately in contrast with my first attempts at oil painting

and it helped me to keep my freedom of development instead of sticking to one formula."[22]

Although Duchamp credits this technique, rather vaguely, to the "Renaissance painters," he probably had in mind the work of his artistic hero, Leonardo da Vinci, who used this technique in his unfinished *Adoration of the Magi* (1481), in which both the initial drawing and various stages of the almost-monochrome underpainting can be clearly seen.[23] Leonardo used black and white underpaint, with some overpainting in brown, to block in the composition and establish the tonal foundations of the panel painting—thus giving volume and substance to the forms and evenly distributing lights and darks—before applying the major colors and successive layers of transparent glazes to obtain his signature *sfumato* atmosphere.[24] As the *Portrait of Marcel Lefrançois* attests, Duchamp used portraiture to move beyond his earlier interest in the work of Claude Monet and impressionism, adopting the techniques of Leonardo da Vinci and other painters of the Italian Renaissance to obtain a smooth, translucent surface that allowed for a remarkable command of detail, which can be seen in the careful delineation of his friend's knotted tie. Although the artist later added another, heavier layer of oil paint to the facial features of Marcel Lefrançois, the scratched and scumbled background of the painting retains the Leonardo-like appearance of the initial composition.

Three years later, in his *Portrait of Yvonne Duchamp-Villon*, Duchamp painted a relaxed, informal portrait of his sister-in-law in a fashionable hat, utilizing the *intimiste* style of Edouard Vuillard, in which the subjects, frequently women, become enmeshed with their decorative surroundings.[25] In the original composition, Yvonne Duchamp-Villon (née Bon) was joined on the couch by a large border collie, whose profile with perked ears is still visible as a pentimento. Although at some stage Duchamp removed the dog's head, he did not paint over its distinctive black and white coat of thick, coarse hair because it easily blended into the couch in a flurry of thick brushstrokes. What distinguishes Duchamp in these portraits is less his early attainment of success in appropriating the styles of established modern artists whose work he admired—although his precocious versatility is certainly unusual among his peers—than his deliberate refusal to repeat himself. No sooner had he achieved mastery in one style than he attempted another.[26]

Around 1910, Duchamp discovered the work of Paul Cézanne, probably through the "Exposition Cézanne," which was held at the Galerie Bernheim-Jeune in Paris in January of that year. Cézanne would have an important but rather short-lived influence on Duchamp's paintings, beginning with the *Portrait of the Artist's Father* (fig. 6.2), which he made in Rouen later that year. Once again it is fascinating to see how Duchamp uses the genre of portraiture as a vehicle to explore new painting techniques, as is clear in the solid, planar structure, somber earth tones, and heavy modeling used in this portrait of Justin-Isidore (known as Eugène) Duchamp, a work the artist later described as "a typical example of my cult of Cézanne mixed up with filial love."[27] The laboriously gained forms, built up from a profusion of

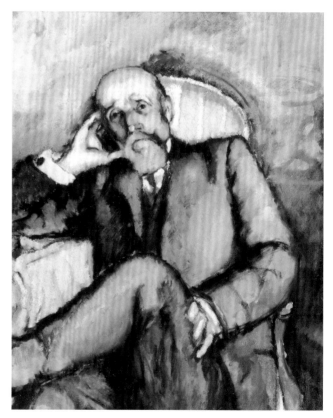

fig. 6.2 *Portrait of the Artist's Father* by Marcel Duchamp, oil on canvas, 1910. Philadelphia Museum of Art, Pennsylvania; The Louise and Walter Arensberg Collection, 1950

fig. 6.3 *The Chess Game* by Marcel Duchamp, oil on canvas, 1910. Philadelphia Museum of Art, Pennsylvania; The Louise and Walter Arensberg Collection, 1950

fig. 6.4 *Portrait of Dr. Dumouchel* by Marcel Duchamp, oil on canvas, 1910. Philadelphia Museum of Art, Pennsylvania; The Louise and Walter Arensberg Collection, 1950

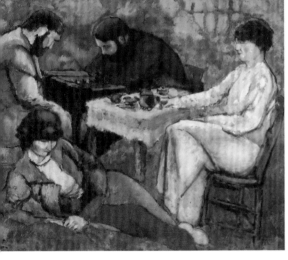

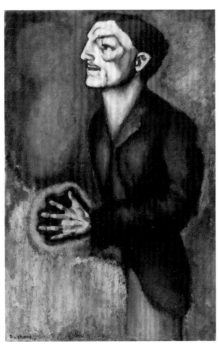

carefully placed, undisguised brushstrokes, imbue the figure of his father with enormous weight, density, and the sense of permanence that is found in all of Cézanne's greatest portraits. Greatly indebted to Cézanne's portrait of his own father, seated and reading a newspaper, Duchamp's portrait is nonetheless a penetrating psychological study of Eugène Duchamp, who was a shrewd businessman and successful notary in Blainville-Crevon, as well as a kind and benevolent father who indulged and supported his children's decision to become modern artists by granting them early access to their inheritance through generous monthly allowances.[28] Duchamp *père* is shown seated in an armchair, head in hand, with one leg crossed over the other in a relaxed pose that also recalls Cézanne's *Portrait of Ambroise Vollard* of 1899. However, it is the keen, deep-set eyes that capture our attention, as the notary studies his son with the watchful gaze of a father.

The rapid-fire succession of Duchamp's stylistic excursions can be seen again in the fauvist-inspired *The Chess Game* (fig. 6.3), which he painted in August 1910, just a few months after the Cézanne-inspired portrait of his father. The work depicts his brothers, Raymond Duchamp-Villon (shown on the left) and Jacques Villon, and their respective wives, Yvonne Duchamp-Villon and Gaby Villon, all of whom were carefully posed in the garden of Villon's studio at Puteaux.[29] The two bearded men are shown hunched over a chess board, deep in thought, as they contemplate their next moves. Their wives, on the other hand, are excluded from their game and lost in their own thoughts. Careful not to break the players' concentration, Yvonne Duchamp-Villon lies semirecumbent on the grass, while Gaby Villon nervously fingers a tea set on the table in a scene of crushing boredom that has its roots in the restless ennui of Emma Bovary, the central protagonist of Gustave Flaubert's classic 1857 novel, *Madame Bovary*. This dysfunctional family scene foreshadows the radical division of the sexes in the artist's magnum opus *La Mariée mise à nu par ses célibataires, même* (*The Large Glass*), that great allegory of frustrated sexual desire in which the nine uniformed bachelors in the lower panel are perpetually thwarted from copulating with the elusive, fourth-dimensional bride above. Thickly painted, with bursts of unexpected color such as the blue highlights in the men's hair and the fluid ground of mint-green grass, *The Chess Game* is indebted to the fauvist paintings of Henri Matisse and Kees van Dongen, as well as the basic composition and rugged impasto surfaces of Cézanne's paintings of card players of the 1890s.

In his mysterious and hermetic *Portrait of Dr. Dumouchel* (fig. 6.4), another work from 1910, in which the influence of Matisse and other fauve painters is evident in the scrubby paint handling and use of non-naturalistic, iridescent colors, Duchamp enveloped the head and hand of his childhood friend with a strangely colored emanation, like a halo or an aura. This nimbus has been explained by reference to the possible influence of an esoteric book by two leading theosophists, Annie Besant and Charles Webster Leadbeater, entitled *Thought-Forms*.[30] First published in London in 1901 and translated into French as *Les formes-pensées* in 1905, this copiously illustrated volume

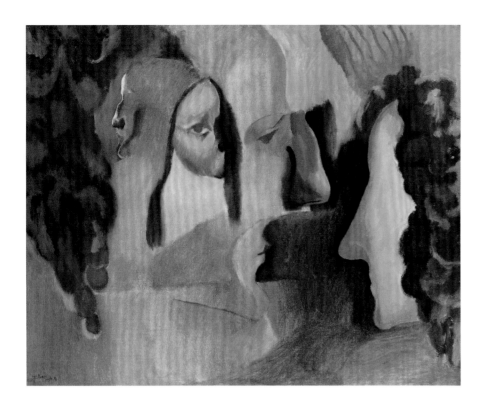

fig. 6.5 | *Yvonne and Magdeleine Torn in Tatters* by Marcel Duchamp, oil on canvas, 1911. Philadelphia Museum of Art, Pennsylvania; The Louise and Walter Arensberg Collection, 1950

argued that auras (or corporal radiations) emanate from the body and manifest themselves in different colors depending on the individual's sensibility. From this color key, Dumouchel's vibrating body aura signifies his "Love of Humanity," "High Spirituality," and "Devotion to a Noble Ideal."[31] Although there is no evidence that Duchamp ever read this popular occultist treatise, the mauve-colored aura that surrounds the sitter's left hand suggests that Dumouchel, who was a medical student in the field of radiology, possessed special healing powers or extrasensory perceptions.[32] While the use of complementary greens and reds were a standard device in fauvist painting to convey a heightened sense of emotion, the hieratic aura, which has been compared to theosophy, spirit photography, and X-rays,[33] probably relates to the recent work of František Kupka, a neighbor of Duchamp's brothers in Puteaux.[34] The Czech artist's visionary paintings, which often combined esoteric and occult symbolism with vibrant color, may have encouraged the younger artist to look beyond Matisse and Von Dongen and explore more recent developments in avant-garde painting, such as cubism.

Duchamp's concurrent interest in the pictorial investigation of movement and spatial ambiguity made the cubist paintings of Pablo Picasso and Georges Braque especially appealing, and he soon experimented with their monochrome palette and use of multiple viewpoints in works such as *Yvonne and Magdeleine Torn in Tatters* (fig. 6.5), which was painted during a family vacation at the Villa Amélie at Veules-les-Roses, Normandy, in September 1911. In this tentative and rather naïve exploration of cubist fragmentation and simultaneity, Duchamp created a dreamlike composition from the floating forms of his younger sisters' profiles, paying close attention to their distinctive Roman noses, a trait shared by most members of the family, including the artist himself, as well as their long curly hair, which he rendered like cascading bunches of overripe grapes.[35] The disjunctions in scale between the four profiles, two for each sister, and the careful distribution of their forms in a collage-like field that fills the entire canvas, recall cubist compositions, especially those incorporating *papier collés,* as Duchamp humorously alluded to in the title, with its rather misogynistic suggestion that his sisters have been "torn in tatters" (*déchiqueter* in French) by the artist in much the same way that Picasso or Braque would tear or cut up pieces of paper and then glue them onto paper or canvas. It should be pointed out, however, that Duchamp subjected his own silhouetted features to the same fate in his 1957 *Self-Portrait in Profile* (pl. 58), which was torn from a metal template of Duchamp's profile and signed "Marcel déchiravit."

In the *Portrait of Chess Players* (fig. 6.6), also painted in 1911, Duchamp returned to the subject of his brothers playing chess, although this time he eliminated their wives from the composition and focused instead on the chess game as a cerebral, strategic activity that takes place both on the board and in the mind of its protagonists. Revealing a far more sophisticated understanding of cubist principles than *Yvonne and Magdeleine Torn in Tatters,* Duchamp created a flat surface pattern by fusing the heads of Jacques Villon and Raymond Duchamp-Villon with their chess pieces, thus also underscoring the conceptual nature of the game itself, which he came to view as an art activity in its own right, as he later explained to Truman Capote: "A chess game is very plastic. You construct it. It's mechanical sculpture and with chess one creates beautiful problems and that beauty is made with the head and hands."[36] Duchamp later admitted that he struggled to obtain the muted, *grisaille* palette of the *Chess Players,* which he had intended to paint in the "wood" colors favored by Picasso and Braque in their cubist paintings because he had so recently been enamored of the violent color distortions of Matisse and fauvism. However, he achieved the desired effect by painting the work at night, replacing the natural light conditions he usually worked under with the artificial source of an old gas lamp. The green tinge of the gaslight encouraged him to replace the vivid hues of the *Chess Game* and *The Portrait of Dr. Dumouchel* with the wood browns, colorless grays, and slightly yellowish ochres found in so many cubist paintings of the early 1910s. When he woke up the next morning, Duchamp was delighted with the results. This "delay" between completing the painting at night and seeing the finished work the next day became a key concept in his work, which would become increasingly important after he moved to New York in 1915 and began work on *The Large Glass,* which he subtitled a "Delay in Glass," perhaps in recognition of his open-ended approach to the work that deliberately put off closure into an ever distant future.

In 1912 Duchamp completed a full-length, cubist self-portrait entitled *Sad Young Man on a Train* (see fig. 3.7), in which the sensation of the train's forward motion, combined with the artist's melancholic state of mind, is closely aligned with the theoretical and artistic ideas of the Italian futurists, especially their exploration of movement and dynamism in painting and sculpture, as well as the invention of chronophotography by the French scientist-photographer Étienne-Jules Marey, in which multiple exposures of a moving figure could be captured in a single photograph. These ideas would coalesce in his controversial *Nude Descending a Staircase (No. 2)* (see fig. 1.2), in which Duchamp used what David Joselit has evocatively described as a poetics of "mensuration" to transform the nude's "immensurable" flesh into a diagrammatic armature made up of a series of some twenty different static positions whose fractured volumes and linear panels fill almost the entire canvas.[37] The slightly earlier *Sad Young Man on a Train,* rendered in a dark-toned, monochromatic palette, uses a similar diagrammatic scaffolding of linear elements, which Duchamp called "elementary parallelism," to depict the artist on the Paris-Rouen express train in late December 1911, traveling from the

fig. 6.6 *Portrait of Chess Players* by Marcel Duchamp, oil on canvas, 1911. Philadelphia Museum of Art, Pennsylvania; The Louise and Walter Arensberg Collection, 1950

109

French capital to his family home in Blainville-Crevon in Normandy to celebrate the New Year.[38]

Duchamp's primary concern in the work was the depiction of two movements: the moving locomotive and the swaying, robotlike figure of the artist himself, smoking his trademark pipe and moving about in the lurching corridor of the express train. The French title, *Jeune homme triste dans un train*, includes a pleasing alliteration between the *tr* sounds of *triste* and *train* to connect the sadness of the artist, whose semitransparent, mechanomorphic form is suggested through the multiplication of delicately faceted planes and volumes, with the speeding locomotive, an effect that Duchamp found to be rather humorous.[39] A variant title, "Marcel Duchamp *nu (esquisse)*," written on the reverse of the work,[40] suggests that the artist could have made a naked self-portrait, which has led several commentators to remark on the fact that Duchamp may well be masturbating in the painting.[41] The vibratory movement of the express train clanking down the tracks would thus parallel Duchamp's jerking motions, which on all points brings to mind Alphonse Allais's famous couplet: "La trépidation excitante des trains / Nous glisse des désires dans la moelle des reins" (The titillating motion of trains / Sends desire coursing all through our veins).[42]

The artist's interest in cubist portraiture came to a sudden end with the rejection of his *Nude Descending a Staircase (No. 2)*, which he defiantly removed from the 1912 Salon des Indépendants exhibition rather than paint out its offending title. This sudden and completely unexpected act of censorship on the part of Albert Gleizes and several other painters and sculptors associated with the Salon Cubists, including the artist's elder brothers, led to Duchamp's permanent break with cubism. Indeed, he would never again officially join an avant-garde group, although he often participated in activities associated with the international Dada movement, whose schismatic, *anti-passéiste* position he shared, and with the later surrealist group in Paris and New York, which included many of his closest friends and colleagues. He was bitterly disappointed that his fellow cubist painters should now be imposing strict rules that stifled innovation and artistic freedom. The most revolutionary art movement of the twentieth century was barely four years old and already reactionary followers like Gleizes and Metzinger, whom Francis Picabia humorously dubbed the "Bouvard and Pécuchet Cubists" after the bumbling heroes of Flaubert's tragicomic novel of bourgeois stupidity, had imposed strict guidelines on what could and could not be included on a cubist canvas.[43]

Flaubert's novel resonates with cruel parallels with Gleizes and Metzinger's derivative paintings and their 1912 pedagogical treatise *Du cubisme,* which attempted to explain the movement to a wider audience in the hope that this would put an end to the satirical cartoons and caricatures of cubism in the popular press and give it the respectability they craved.[44] Unlike Duchamp and Picabia, who reveled in scandal and controversy, these sober-minded artists were deeply concerned with the general public's hostile reaction to the movement, hence their efforts to explain it in their humorless book. The end result was that Gleizes and Metzinger codified cubism as an academic movement, with rigid rules and conventions. While Duchamp's faceted disintegration of the mechanized figure and

fig. 6.7 *Jacques Villon, Marcel Duchamp, and Raymond Duchamp-Villon at Puteaux* by an unidentified artist, gelatin silver print, c. 1912. Philadelphia Museum of Art, Pennsylvania; gift of Jacqueline, Paul, and Peter Matisse in memory of their mother, Alexina Duchamp

the subdued, monochromatic tonality were typical of cubist painting of the time, the serial depiction of vibratory movement went beyond Gleizes and Metzinger's understanding of cubism in its attempt to map the motion and energy of the nude's biomechanical body as it passes through space. Duchamp's interest in plotting the static phases of a moving subject was closely analogous to representations of speed and velocity in the work of the futurists. This interest may also have concerned his French colleagues, for whom the painting's possible affinities with the rival Italian group, as well as its unconventional subject matter and literary title, broke the dogmatic rules set out in Gleizes and Metzinger's treatise and forced them to censor the work.

Duchamp's growing distrust of the traditions and conventions of oil painting, following the humiliating rejection of *Nude Descending* by the Salon's cubist-dominated hanging committee, led him to question almost every aspect of the art-making process, especially in terms of materials and technique. This event also helped to liberate the artist from a career as a professional painter, which he now saw as doomed to repetition and bound by reactionary rules imposed by artists like Gleizes and Metzinger, whom he scornfully viewed as "monkeys following the motions of the leader without comprehension of their significance."[45] Duchamp's newfound independence also coincided with his increasingly close friendship with Picabia, who shared his impious irreverence and interest in questioning and breaking the cultural norms of art. Duchamp later described his approach to art making after 1912 as stemming from his desire to push "the idea of doubt of Descartes . . . to a much further point than they ever did in the School of Cartesianism: doubt in myself, doubt in everything. In the first place never believing in truth."[46] Duchamp believed that in the modern era, professional painters had become so engrossed with the sensual appeal of their oil-based medium and its application that they had ignored the intellectual side of art making in favor of "retinal" painting that appealed to the eye rather than the mind.

The rejection of *Nude Descending a Staircase (No. 2)* also led to a serious rift between Duchamp and his older brothers, leading the young artist to leave Paris and move to Munich in 1912. A photograph of the three brothers (fig. 6.7), taken in the immediate aftermath of the *Nude Descending* controversy, encapsulates the profound differences between them. Duchamp, with his hair slicked back, sports a modern suit and tie that contrasts directly with the bohemian outfits of his older brothers, especially Raymond Duchamp-Villon, who wears a pair of Dutch clogs on his feet. Raymond and Jacques are also shown holding their cats in a gesture that conforms to the cliché of the artist as a sensitive soul who can commune with animals and nature. The older brothers' outmoded attitudes and attire look back to the nineteenth-century model of the artist as romantic outsider, a view perhaps best exemplified by Charles Baudelaire's 1863 essay "The Painter of Modern Life," in which he described the privileged artist-dandy as a *flâneur* who distinguishes himself from the teeming crowds of the Parisian metropolis that threaten his individualism by adopting and playing out a self-fashioned, antibourgeois identity as a means of "combating and destroying triviality."[47] In stark contrast to the clichéd romanticism of his brother's outfits, Duchamp presents himself as a man of his own time, the twentieth century, an

epoch that he believed would be "more abstract, more cold, more scientific" than previous centuries.[48] His open-legged stance mimics that of Raymond, with one foot facing forward and the other to the side, while the placement of his pipe in front of his crotch suggests an irreverent humor that is completely absent in the stoic, serious demeanors of his brothers, as they stroke their cats with the loving care and devotion that they reserved for their art works. Duchamp later expressed his utter disdain for the kind of antiquated bohemianism adopted by his brothers, which was also prevalent among other friends and colleagues in Paris, such as the poets Max Jacob and Guillaume Apollinaire. "One day," he recalled in an interview with Pierre Cabanne, "I went with Picabia to have lunch with Max Jacob and Apollinaire—it was unbelievable. One was torn between a sort of anguish and an insane laughter. Both of them were still living like writers of the Symbolist period, around 1880, that is."[49]

While living in the Bavarian capital Duchamp made *Bride* (fig. 6.8), the first painting he had completed since the controversy surrounding *Nude Descending a Staircase (No. 2)*. Duchamp later recounted to the English pop artist Richard Hamilton that he had painted the biomechanical bride with his fingers, an infantile gesture that can be interpreted as a reversion to childhood innocence and purity, perhaps bringing back memories of his first artistic experiences, when paint was pushed around and applied without any thought of rules or convention.[50] This back-to-basics desire to replicate the liberating, tactile process of applying pigment with his fingers as a child speaks to his need to reinvent painting by questioning its foundations as a handcrafted enterprise in which technical facility was valued more than intellectual content. In the works he made following his return to Paris, such as the two versions of the *Chocolate Grinder*, Duchamp began to look for a way out of what he considered the straitjacket of avant-garde painting, with its emphasis on compressed space, asymmetry, and fragmentation. The artist painted *Chocolate Grinder, No. 1*, of 1913, in a dry, impersonal painting style, akin to the mechanical drawing used in architectural plans. This quasi-scientific approach came out of his studies of perspective and optics while working as a librarian at the Bibliothèque Saint-Geneviève in Paris. These studies encouraged him to introduce into his paintings "the precise and exact aspect of science, which hadn't often been done, or at least hadn't been talked about very much. It wasn't for love of science that I did this; on the contrary, it was in order to discredit it, mildly, lightly, unimportantly. But irony was present."[51]

In the emblematic *Chocolate Grinder, No. 2*, of the following year, we can chart Duchamp's complete rejection of the artist's individual touch, or *patte* (literally "paw mark"), as the index of creative expression.[52] The machine rollers appear to be lit from within, since all shading and modeling have been removed, thus emancipating the work from centuries of three-dimensional illusionism. This break with the past is also evident in the saturated, monochrome background that was achieved by spraying the canvas with an airbrush, while the lines of the chocolate-grinding rollers are made of threads sewn into the canvas support

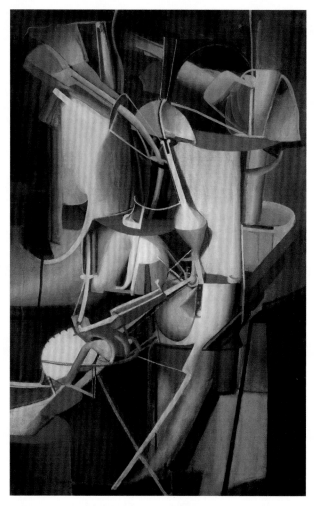

fig. 6.8 | *Bride* by Marcel Duchamp, oil on canvas, 1912. Philadelphia Museum of Art, Pennsylvania; The Louise and Walter Arensberg Collection, 1950

like a tapestry and then varnished to hold them down. Duchamp even asked a commercial bookbinder to print the title in embossed gold letters on a leather label, much like a foil-stamped title on a leather-bound book. This quest to rid painting of the master's hand as imprimatur of genius and uniqueness was parodied to ludicrous effect four years later when Duchamp invited a professional sign painter to add a realistically rendered hand, with its index finger pointing in the manner of old-fashioned directional signs, to his mural-size painting *Tu m'* (see fig. 5.3), which as a homophone consigns the dead-end occupation of painting to the grave. As the artist later recalled with great amusement, the sign painter, "A. Klang," dashed off the illusionistic pointing hand in five minutes.[53]

The differences between the two chocolate grinder paintings reveal a clear evolution in Duchamp's ideas and working practice, which moved away from manual dexterity, in which the artist's touch was paramount, toward a more cerebral approach in line with the artist's stated aim of putting "painting once again at the service of the mind."[54] Duchamp's doubt about painting's ability to engage intellectual ideas would eventually lead to a profound and systematic questioning of received ideas about art, science, language, music, and identity, perhaps best exemplified in his use of chance procedures in the *Three Standard Stoppages* to challenge the legal and scientific authority of the standard meter in the Pavillon de Breteuil in Sèvres.[55] The realization that painting was doomed to banal repetition and meaningless surface embellishment led Duchamp to formulate a new approach to the inherited traditions of Western art. This attempt to challenge accepted notions about art making can be seen in his use of quirky, unconventional materials in *The Large Glass,* such as glass, wire, lead foil, lead wire, and dust, as well as his provocative invention of the readymade, which offered a profound challenge to existing definitions of the work of art through the selection and display of aesthetically neutral, mass-produced objects, distinguished from other manufactured items in a hardware store only through his signature and an often cryptic title.

This cerebral approach to art making also applied to the realm of portraiture, to which Duchamp frequently returned during the 1910s in Dadaist works that subverted the codes and practices that had until then defined the genre. A classic example of the artist's radical approach to portraiture can be seen in the improvisatory brilliance of his aleatoric portrait *Fania (Profile)* (fig. 6.9). Made on New Year's Eve 1915, following Duchamp's acquisition of an Underwood typewriter, possibly as a Christmas present from his patrons Louise and Walter Arensberg, this work depicts the Russian actress Fania Marinoff, who at that time was an up-and-coming movie starlet as well as the wife of the prominent author, critic, and photographer Carl Van Vechten. Duchamp made the work, whose title may be a pun on movie star "profiles" in the mass-circulation newspapers and magazines of the time, by pressing the typewriter keys at random while pulling the

fig. 6.9 *Fania (Profile)* by Marcel Duchamp, dark brown ink, black typewriter ink, and graphite inscription on light tan wove paper, 1915. Philadelphia Museum of Art, Pennsylvania; The Louise and Walter Arensberg Collection, 1950

113

page out of the typewriter, resulting in a cascading waterfall of letters that flow down the page from left to right. The artist used this chance image, after turning the page upside down, as the basis for a swiftly drawn profile of Fania. The drawing places great emphasis on her large eyes and long eyelashes, her elongated nose, and her pouting mouth with its protruding tongue, which Duchamp drew in the shape of an erect clitoris, as if to draw attention to her sexual allure for moviegoers, as well as his own attraction to her as a friend and potential lover.

A comparison between this portrait and film stills of Fania Marinoff from this period reveal that Duchamp, despite the ludic origins of the work, stuck fairly closely to the physiognomic facts when he completed his word-and-image profile. A photograph of Fania reclining on a bed and clutching an iron bedpost (like a caged tiger) while playing Trina in the 1916 film *Life's Whirlpool,* shows that the artist was not exaggerating her features, including the actress's distinctive nose, which Duchamp represented through a smudgy explosion of ink. Although clearly intended as a Dadaist provocation, the close relationship between this work and Toulouse-Lautrec's images of the snub-nosed Moulin Rouge singer and actress Yvette Guilbert suggest that Duchamp's *Fania (Profile)* was not made on the spur of the moment, as many scholars have previously assumed. Instead, this multilayered image used chance procedures to create a memorable, coded portrait of his friend, whose impish good looks and exuberant personality[56] led him to compare her to the notorious French café-concert *diseuse* (reciter of songs) as represented in Toulouse-Lautrec's famous caricatures.[57] Indeed, the inspiration for Duchamp's portrait was undoubtedly Toulouse-Lautrec's 1893 lithograph of Guilbert, which emphasized, to the point of caricature, the bawdy cabaret star's gaunt, angular features, including her pronounced nose and projecting lower lip, while the strange, amorphous shape beneath her emaciated profile, probably representing one of her trademark black gloves, anticipates the black smudge used by Duchamp to indicate Fania's upturned nose.

Works like *Fania (Profile)* need to be distinguished from other, more conventional portraits that Duchamp made throughout his career, from his renditions of family members in the early 1900s to the profile sketch of Emilio Puignau, the mayor of Cadaqués, which Duchamp completed in 1968, shortly before his death. Drawing portraits of friends or loved ones has long been an outlet for artists to "keep their hands in," providing a welcome diversion from the more labor-intensive activities of oil painting or sculpting—as well as an opportunity to explore new subjects and to reconnect with the manual side of representation. This can be seen in the artist's exquisite 1926 charcoal portrait of his friend Florine Stettheimer, an unexpected marvel of fidelity that was made at the time of Duchamp's intense experimentation with film and optics. Many of Duchamp's portraits were made as gifts for his friends, usually to commemorate an evening spent together or a vacation in the country. An example is the swiftly rendered likeness of John Quinn (fig. 6.10), the prominent lawyer and art collector who brought the artist to Spring Lake on the New Jersey shore for a week's holiday in the summer of 1915. The finished drawing possesses an immediacy that is completely removed from the carefully planned execution of *The Large Glass* and

fig. 6.10 *Portrait of John Quinn* by Marcel Duchamp, pen and ink on paper, 1915. Philadelphia Museum of Art, Pennsylvania; promised gift of Alice Saligman

its related studies. Even Picasso rarely, if ever, created such a compelling portrait with so few strokes of the pen.[58]

Despite Duchamp's deliberate disregard for the conventions of oil painting after the rejection of *Nude Descending,* his interest in reinventing portraiture never waned. This is apparent in his construction of his lascivious feminine alter ego, Rrose Sélavy, in 1920, when Duchamp began signing works in her name, first as "Rose" and later as "Rrose," and had his friend and frequent coconspirator Man Ray photograph him in drag (pls. 14a, 17).[59] Duchamp used the Rrose Sélavy gesture to subvert the optimistic message of the new commodity culture, including the burgeoning art market in New York after World War I, through her gender ambiguity, lewd puns, and scurrilous behavior.[60] Like a pair of advertising executives, Duchamp and Man Ray expertly marketed her international line of luggage tags, perfume bottles, and other leisure accessories, using carefully posed publicity photographs to construct an image of Rrose as a glamorous dame with obvious star quality. The transgendered Rrose, and the increasingly elaborate readymades signed in her name, came with "a complete line of whiskers and kicks" that underscored the increasing commercialization of the New York art world. The cross-dressing Duchamp cleverly manipulated the visual language and codes of the mass media to sell an image of a highly feminized woman, who upon closer inspection is revealed to be a sham, the masquerade of an

outrageous female impersonator, whose deception casts doubt on photography's claims for authenticity and objective truth. Rrose was a fly in the ointment, a *femme savante,* who knowingly reflected back on a burgeoning consumer culture its own desires for glamour and beauty before rudely confronting them with the ambiguous message of the prostitute, whose promise of pleasure comes at a price.[61]

Rrose's polymorphous identity presented what might be Duchamp's greatest challenge to portraiture and arguably his greatest contribution. The artist was extremely fond of aliases, no doubt because they undermined what he considered to be the outmoded idea of the modern painter as having a fixed authorial identity—namely the tortured, misunderstood genius, denied fame and fortune during his or her lifetime, whose painted signatures nonetheless ensure the financial security of galleries and collectors who now own the work after the artist's death. By multiplying his name through pseudonyms such as Rrose Sélavy, Richard Mutt, Marsélavy, and Morice, and encouraging others to do the same, Duchamp destabilized the art market's future ability to authenticate and classify his own work, and in doing so adopted the fugitive identity of the criminal. The artist commemorated his newfound criminal status in the 1923 assisted readymade entitled *Wanted: $2,000 Reward* (see pl. 25), in which he set his own mug shots—two small photographs of the artist, seen from the front and in profile, whose graininess makes them barely legible—into an existing wanted poster, distributed by a New York restaurant as a joke, and amended the text to include references to his numerous aliases, including Rrose Sélavy.

Duchamp dramatically curtailed the number of portraits he made during the 1930s, preferring instead to concentrate on other projects and interests, such as chess, optics, exhibition installation, and book and magazine cover designs, although the production of *The Green Box* and the *Boîte-en-valise* (pl. 37) can be viewed as a form of indirect self-portraiture or autobiography.[62] The artist returned to the genre with great aplomb in the 1940s, as he began work in secret on *Étant donnés: 1. la chute d'eau, 2. le gaz d'éclairage* (see fig. 5.6a and b), the three-dimensional tableau construction that would preoccupy him for the next twenty years. This posthumously unveiled peephole diorama was conceived at a time when the artist was deeply sympathetic to the aims and ideals of André Breton's exiled surrealist group in New York and actively involved in designing their exhibitions and catalogues. A close examination of the history of the work and its construction reveals that Duchamp was responding to the changing conditions of surrealism during and after the Second World War, when group members embraced Tarot cards, black magic, pagan rituals, arcane imagery, and, above all, a new conception of Eros, as Alyce Mahon has persuasively argued in her recent book on the surrealist movement between 1938 and 1968.[63] Having failed to adequately oppose and defeat fascism in Europe, the surrealists began to turn to new myths, such as Breton's notion of "Les grands transparents" (the Great Transparent ones), which appealed to many younger artists, like Matta, David Hare, Gerome Kamrowski, and Arshile Gorky. As surrealism recast itself in the 1940s, replacing its earlier faith in utopian humanist ideals with an altogether darker vision of the war-ravaged world, its protagonists increasingly turned to an

interior world, such as the one seen behind the massive Spanish wooden door in *Étant donnés,* which separates the viewer from an unexpected and unimaginable landscape visible only by looking through the peepholes.

The biting satire of Duchamp's 1943 portrait of George Washington, entitled *Allégorie de genre,* reflects the artist's nihilistic mood during the Second World War, a period that brought back painful memories of the jingoistic patriotism that had led to the senseless loss of so many of his friends and even family members, including his oldest brother Raymond Duchamp-Villon, during the First World War. When *Vogue* magazine's editorial director, Alexander Liberman, asked the artist to make a portrait of the first president of the United States for the cover of the February 15, 1943, issue of *Vogue,* Duchamp produced a mocking, collage image based on the profile portraits of Washington made popular by the English painter James Sharples in the 1790s. This inflammatory "stain" portrait consists of a double image. It features Washington's right profile and trademark wigged coiffure when seen head on, and a map of the United States, with part of Mexico and Canada in black on either side, when the work is turned on its side. This visual trick alludes to the artist's interest in the "Wilson-Lincoln" effect, an optical illusion in which interchangeable portraits of Woodrow Wilson and Abraham Lincoln were made to appear simultaneously through a two-way mechanism, such as a lenticular photograph or an accordian fold system, which had so intrigued the artist when he first lived in New York in the 1910s.[64] Perhaps unsurprisingly, Duchamp's entry was rejected by Liberman and other members of the editorial staff at *Vogue,* who deemed the shoddy and highly suggestive materials used in the assemblage, which was made from padded material covered in surgical gauze that had been soaked in iodine and then fixed to the cardboard support by thirteen gold-colored stars, to be inappropriate for a portrait of the father of the country. Although the red-streaked gauze, redolent of bloodstained bandages and even a used sanitary towel,[65] was intended to represent the red and white stripes of the American flag, there can be no doubt that the disturbing associations with violence and death perceived by the *Vogue* editor reflect Duchamp's antinationalistic attitudes at a time of flag-waving, patriotic fervor induced by wartime propaganda.[66] The artist perhaps wanted to remind the magazine's readers that the first president was a slave-owning warmonger, with not just blood on his hands but saturated over his entire profile. When Duchamp called Liberman to find out why *Allégorie de genre* did not appear on the cover of the February 15 issue, the embarrassed editor told the artist that the offending work was "not right for *Vogue*" and returned it to him, along with a check for fifty dollars for "expenses."[67] Duchamp immediately sold the work to his close friend André Breton, who published a reproduction of it on the cover of the surrealist magazine *VVV* later that year.

In 1959 Duchamp made his last serious foray into portraiture when he made a self-portrait that took the form of a three-dimensional triptych. This triptych, made up of three relief sculptures entitled *Sculpture-morte, Torture-morte* (see fig. 5.5), and *With My Tongue in My Cheek* (see fig. 5.4), was made for a publication project that he was planning with his good friend and cataloguer Robert Lebel, who had recently published the first comprehensive monograph on the artist.[68]

Intended as a follow-up to *Sur Marcel Duchamp,* which was published in 1959 by Trianon Press in Paris, this second book was to have afforded the artist and writer a great deal of freedom, but it was abruptly canceled later the same year, and the circumstances surrounding the commission remain shrouded in mystery.[69] According to Lebel:

> In 1959 a Paris publishing house commissioned Duchamp and me to prepare a book that we were free to write and illustrate independently, without consulting one another. When Duchamp, then in Cadaqués, responded immediately, sending three hermetically sealed boxes containing, as illustrations, *With My Tongue in My Cheek, Torture-morte,* and *Sculpture-morte,* the commission was cancelled without further ado. . . . The sculptures, which the publisher retained as a bad joke, were in line with *Female Fig Leaf* of 1950, *Objet-Dard* of 1951, and *Wedge of Chastity* of 1954, all of which belong to the series of special experiments with relief that Duchamp made for *Étant donnés . . . ,* the work he had been secretly preparing since 1946; in it, bringing sexual cynicism to the limits, he sardonically celebrated the nuptials of eroticism and death.[70]

With My Tongue in My Cheek is a three-dimensional embodiment of tongue-in-cheek humor that denotes insincerity, irony, or whimsical exaggeration. Duchamp's title no doubt refers to his own irreverent approach to "serious" art making since the *Nude Descending* controversy, although the work should not be discounted as a clever one-liner, because the use of cast plaster, as Lebel has suggested, provides a direct connection between *With My Tongue in My Cheek* and *Étant donnés.* Duchamp had his second wife, Alexina "Teeny" Matisse, cast his own cheek and jaw in plaster—going so far as to insert a walnut in his cheek to create a bulge-like protuberance that stands for the unseen tongue of the title—before mounting the cast on a piece of paper and completing his profile in pencil, paying particularly close attention to the delicately rendered eyebrows and eyelids as well as the stubble of his five o'clock shadow.[71]

That *With My Tongue in My Cheek* was made in the Spanish coastal resort of Cadaqués in the summer of 1959 is of great significance because Duchamp was preoccupied with rebuilding the *Étant donnés* mannequin at that time, after it had suffered severe damage the year before.[72] In 1958, Duchamp and Teeny spent the first of several summer vacations in Cadaqués, a small town in Catalunya in northeastern Spain, having locked the mannequin and other works related to *Étant donnés* in the closet of his studio on the top floor of a building at 210 West 14th Street. When the couple returned from their vacation, they discovered to their horror that the mannequin had suffered extensive damage as the result of high temperatures in New York that summer. We know, for example, that the extended arm that holds the *Bec Auer* light fixture aloft accidentally fell off and was irrevocably damaged in the process, requiring a separate form to be cast from Teeny's arm and clasped hand during their summer vacation in Cadaqués in May and June 1959.[73] Creating a relief plaster sculpture of his own cheek during this time was a natural thing for Duchamp to do, given his preoccupation with

repairing the mannequin with new body casts in plaster. At the same time, the literal reference to tongue-in-cheek humor conforms to his public image as a mysterious hoaxer and master of mockery and irony. However, as Dalia Judovitz has suggested, the work turns out to be less humorous on further reflection: "The visual inscription of laughter (*rire*), associated with the tongue and cheek expression, congeals in this image with the rictus of death, the spasm of the face captured by the nineteenth-century death mask. Intended to celebrate and commemorate famous artists by capturing their lifelike likeness in plaster molds applied to the face and sometimes to the hands, the death mask ironically preserves the illusion of life through the image of death."[74]

The plaster cast of Duchamp's swollen cheek is inextricably related to the techniques used by the artist to construct the recumbent female nude that appears in *Étant donnés*. Building the figure was a lengthy process that took more than a decade to complete, beginning in the mid-1940s and carrying on until the late 1950s, and involved several stages of molding and casting.[75] Duchamp made the figure from plaster casts taken from the body of his then lover, Maria Martins, the surrealist sculptor and wife of the Brazilian ambassador to the United States. In the 1940s, both Martins and Duchamp took private lessons in body casting from Ettore Salvatore, an Italian-born sculptor who taught fine art at Columbia University between 1937 and 1968. Salvatore specialized in life and death masks and even made a rather morbid portrait of Duchamp that was cast from life (pl. 45), but which contains the deathly stillness of a funerary effigy.

Although undated, the plaster life mask was probably made around 1945, since the grueling casting session that the artist underwent to make the portrait was vividly captured in a remarkable photograph that was published in the special Duchamp issue of *View* magazine later that year under the mordant title of *Marcel Duchamp at the Age of Eighty-Five* (see pl. 43). Following standard casting techniques that must have been close to those described in Cennino Cennini's *The Craftsman's Handbook,* of about 1400, Salvatore inserted special breathing tubes into Duchamp's nostrils and asked him to wear a rubber bathing cap to protect his hair during the casting process, props that gave him the appearance of a much older man who had lost his hair.[76] The artist replaced the bathing cap with a beret in the photograph, which must have been taken shortly after his session with Salvatore, as Duchamp's face, stubble, and hairline reveal traces of a powdery substance consistent with the plaster that would have been used for his life mask. Duchamp's balding pate and aged features were also amplified in the photograph through the use of harsh lighting and a slightly raised viewpoint that hides his eyes behind a pair of darkened, reflective glasses. Isolated in the center of the photograph, against a dark background that lends an unreal remoteness to his pale, plaster-flecked features, Duchamp, who was fifty-eight years old at the time, looks nearly thirty years older, hence the title's inversion of his age. In Salvatore's life mask, Duchamp's cadaver-like visage with closed eyes appeared not as an index of life, but as an icon of death, whereas *With My Tongue in My Cheek* is full of life-affirming vitality. It also has animated features, such as a slit in the mouth and the long eyelashes drawn in pencil, that would have been eliminated in a posthumous cast. The swollen cheek, moreover, remains marvelously

pliant and supple, with none of the rigidity and immovability of the death mask. Judovitz convincingly argues that this self-portrait, as a nondeath mask, "stages life and death, language and image, humor and dead-seriousness, as a series of contextual frames on which hinges Duchamp's statement about the conditional future of the artist as 'life on credit.'"[77]

Torture-morte (see fig. 5.5), the second of the three multimedia relief constructions that Duchamp submitted to Lebel in the summer of 1959, consists of a painted plaster cast of a foot, possibly an imprint of the artist's own right foot, that has been covered by a swarm of thirteen synthetic flies and placed on a paper background before being mounted vertically on a wooden support. The title is a macabre pun on *nature morte,* the French term for still life, leading many commentators to read the title, in literal terms, as a condemnation of the tired and outmoded convention of still-life painting as a dead (*morte*) genre.[78] However, it has also been suggested that the "torture" involved in the title comes not from Duchamp's exasperation with the tradition of still-life painting but from the flies that tormented the artist during his summer vacations in Cadaqués.[79] As emblems of decomposition, the flies also denote the inevitability of death and irrevocable decay, again suggesting that Duchamp's own mortality was very much on his mind during the making of this self-portrait triptych. It should also be pointed out that it was commonplace in the Middle Ages to take molds of the feet of a recently deceased king or queen, as well as their death masks, in order to make posthumous portraits.[80] The positive cast of a human foot thus makes reference to a by-product of the death rites of kings, and perhaps even the relics of the saints, just as *With My Tongue in My Cheek* speaks to the transfigured face of the death mask as a salute to the iron laws of life and death. By the twentieth century, however, these regal body casts had become a simple technical aid used in the sculptor's studio, since plaster effigies and death masks had long been relegated to the status of dusty stage props, much like the defunct plaster casts of the academy, or the thousands of copies of the death mask of the so-called *Inconnue de la Seine* that were once placed in the windows of shops selling artist's materials as a tempting invitation to draw or sculpt a version of the drowned young waif's strange, angelic-looking face.[81]

That *Torture-morte* tapped into an existing iconography of death and embalmment related to Duchamp's ruminations on his own mortality is supported by the artist's clear reference in his cast instep to Andrea Mantegna's *Dead Christ,* a painting in which the soles of Christ's chalky gray feet are shown through a remarkable use of foreshortening. Duchamp's interest in perspective, which had been revived during the planning and construction of *Étant donnés,* would have drawn him to Mantegna's famous devotional painting, which similarly presents a seemingly life-size, truncated figure, seen from the front with dramatic foreshortening, lying flat on a stone table in an interior setting. Mantegna's picture was devised to be hung at eye level, as it is today in the Pinacoteca di Brera in Milan, so that the spectator's attention is arrested by the flat soles of the livid gray feet as they extend beyond the edge of the marble funeral slab. The viewer is immediately confronted by the open wounds on Christ's feet, with the flesh around them already discolored and decaying like torn paper. The viewer's eyes,

directed by the axial lines of the folds of Christ's loincloth, then move up the body to the wounds in his hands, which are similarly hideous and gut-wrenching. The use of extreme foreshortening, perspective, and illusionism thus intensifies the emotional impact of the wounds and the suffering of Christ to create a majestic yet touching representation of death. Duchamp no doubt intended *Torture-morte* as a direct allusion to the transfigured realism of Mantegna's *Dead Christ,* as seen in his title, with its references to personal suffering, including his own discomfiture during the casting process, and the swarm of houseflies on the sole of his foot, which evoke the dark, open wounds on Christ's feet.

The third work in the self-portrait triptych, *Sculpture-morte,* is in the style of Giuseppe Arcimboldo, the sixteenth-century Italian painter who specialized in composite heads and allegorical figures made of fruits, flowers, vegetables, plants, and grains. Duchamp's work is made of touron,[82] a kind of hard pastry whose ingredients include hazelnuts, almonds, and marzipan, that Duchamp commissioned from the *pâtissier* Bonnevie in Perpignan, just across the French border from Cadaqués.[83] The preserved portrait features edible vegetables—as well as a cherry, a bumblebee, and a beetle—on wrapping paper that has been mounted on a Masonite support. As with the fantastic fusion faces of Giuseppe Arcimboldo, Duchamp's assortment of *touron* delicacies coalesces into a profile self-portrait, vaguely reminiscent of his scandalous earlier representation of George Washington. Like Mantegna's gruesome *Dead Christ,* where the emotive effect of the recumbent corpse is achieved through the virtuoso use of foreshortening, Arcimboldo's figural gestalts are justifiably celebrated for their highly inventive use of optical illusionism, obtained through the conceit of the reversible "double" image, in which one image takes on the semblance of another after being stared at intently. Taking advantage of the slightest coincidences of shapes and colors, Arcimboldo was able to ingeniously transform one image into another, and the brilliant artifice of his witty vegetal fantasies may have appealed to Duchamp for their nonretinal qualities, in that the transformation of the fruits and vegetables into recognizable facial features took place in the mind of the viewer.

This use of double configurations had earlier appealed to the surrealists, especially Salvador Dalí, whose paintings of the late 1930s featured paranoiac double imagery owing a considerable debt to the Italian artist's earlier composite heads and figures. Duchamp saw a great deal of Dalí, who lived near Cadaqués in the small fishing village of Port Lligat, during the summer of 1959, and it is quite probable that they would have discussed their shared interest in Arcimboldo at that time. Another, more likely, scenario for the work's genesis is the fact that Robert Lebel was a recognized authority on Arcimboldo and even owned an important painting on wood panel entitled *Flora,* of about 1591, that had recently been downgraded to the work of Francesco Zucchi but is today thought to be an original work by Arcimboldo.[84] Given the collaborative nature of their proposed publication, Duchamp may have chosen to portray himself in the style of Arcimboldo to honor his friend's expertise in the work of the Northern Italian painter. Such a tribute also coincided with his current obsession with death and decay, which, like the deliberate references to art history—including the triptych format itself—becomes a recurring theme in this fascinating collective self-portrait.

In fashioning a self-portrait in the manner of Arcimboldo, Duchamp may also have been alluding to his own shifting, fragmented persona, as seen in the provocative gesture of Rrose Sélavy, which questioned fixed notions of identity and authorship. Like Arcimboldo's delirious fabrications, Duchamp's relinquishment of a fixed identity, which T. J. Demos has recently linked to the ethico-political stance of exile, meant that his fluid self-image always hovered chimerically between complete openness and deliberate obfuscation.[85]

In 1965 Duchamp humorously returned to the *Mona Lisa* for an exhibition opening invitation, in which he "shaved" the mustache and goatee that he had applied to the *L.H.O.O.Q.* postcard. To create *L.H.O.O.Q. Shaved,* Duchamp simply pasted a small reproduction of the *Mona Lisa* on the invitation card to the January 13, 1965, dinner and preview of the "Not Seen and/or Less Seen of/by Marcel Duchamp/Rrose Sélavy 1904–64" exhibition of the Mary Sisler Collection at the Cordier & Ekstrom Gallery in New York. Although the inscription "rasée L.H.O.O.Q." suggests that the artist restored Leonardo's work to its original pristine condition by erasing the offending facial hair of *L.H.O.O.Q.,* the fact that he used an immaculate reproduction of the painting in the Louvre for the Mary Sisler Collection invitation, rather than the postcard he had embellished with his penciled-on beard and mustache in 1919, suggests that the *Mona Lisa* had not been returned to its former state, in fact quite the opposite, since, as Timothy Binkley has pointed out, "the first piece makes fun of the Gioconda, the second destroys it in the process of 'restoring' it. *L.H.O.O.Q. Shaved* re-indexes Leonardo's artwork as a derivative of *L.H.O.O.Q.,* reversing the temporal sequence while literalizing the image, i.e., discharging its aesthetic delights. Seen as '*L.H.O.O.Q. Shaved,*' the image is sapped of its artistic/aesthetic strength—it seems almost vulgar as it tours the world defiled."[86] Although no longer hirsute, the gender of the mysterious sitter remains as ambiguous as the *Mona Lisa*'s smile; after *L.H.O.O.Q.,* it seems likely there will always be "fire down below" for *La Gioconda.* This Dadaist desecration has thus fundamentally altered our perception of Leonardo da Vinci's famous painting, suggesting that in the end it was Duchamp, not Rousseau, who took charge of Jarry's Clinamen machine in order to dismantle painting's inherited rituals and rid the art world of mediocrity and conformism. As we have seen, Duchamp's agile, questioning mind and mischievous sense of humor led him to produce a number of similarly provocative investigations into the nature of identity and authorship. These in turn have led to a profound and irreversible shift in our understanding of portraiture and self-representation. Portraiture, it would seem, will never be the same again.

1. Marcel Duchamp, radio interview with Herbert Crehan, broadcast by WBAJ-FM, New York, 1961, published in Robert Cowan, ed., "Dada," *Evidence* (Toronto), no. 3 (Fall 1961): 37. George H. Bauer has pointed out that a third meaning for L.H.O.O.Q. is also possible in English: "If pronounced as a single word it invites us to scrutinize the rectified masterpiece before us: LOOK. Our gaze gives us a famous portrait lady now endowed with mustache and goatee," see Bauer, "Duchamp, Delay, and Overlay," *Mid-America* (Chicago) 59, no.1 (January 1977): 63. *L.H.O.O.Q.* is illustrated in Schwarz, *Complete Works*, vol. 2, 670.

2. Jack J. Spector, "Freud and Duchamp: The Mona Lisa 'Exposed,'" *Artforum* 6, no. 8 (April 1968): 56.

3. Marcel Duchamp, radio interview with Herbert Crehan, in Cowan, "Dada," 37.

4. James Johnson Sweeney, transcript of twenty-second conversation with Marcel Duchamp, August 2, 1945; box 3, folder 19; interviews; Alexina and Marcel Duchamp Papers; Philadelphia Museum of Art, Archives; reprinted with the permission of the Estate of James Johnson Sweeney. Unfortunately, Sweeney erroneously transcribed Duchamp's wonderful early attempt at linguistic gymnastics as "L'eusses tu creux—Lustuqreut— invented at 14" in his typewritten notes for a never-published monograph on the artist. It should also be pointed out that Lustucru was then, as now, a popular brand of pasta in France.

5. Duchamp later recalled that in 1914, Apollinaire "showed me a copy [of Brisset's puns] he took from his shelves and it impressed me very much." See James Johnson Sweeney, transcript of sixth conversation with Marcel Duchamp, April 14, 1945, ibid., reprinted with the permission of the Estate of James Johnson Sweeney.

6. James Johnson Sweeney, "Eleven Europeans in America," *Museum of Modern Art Bulletin* 13, nos. 4–5 (1946): 21.

7. For an excellent introduction to Brisset's life and work, including the influence of his homophonic word play on Duchamp's ubiquitous puns, see Marc Décimo, *Jean-Pierre Brisset: Prince des penseurs, inventeur, grammairien et prophète* (Dijon, France: Les presses du réel–L'écart absolu, 2001).

8. Ibid.

9. Alfred Jarry, *Gestes et opinions du docteur Faustroll, 'pataphysician* (Paris: Bibliothèque Charpentier, Eugène Fasquelle éditeur, 1911).

10. Alfred Jarry, *Exploits & Opinions of Dr. Faustroll, Pataphysician*, trans. Simon Watson Taylor (Boston: Exact Change, 1996), 86.

11. Ibid., 88. As Simon Watson Taylor has pointed out, the "National Department Storehouse" may also refer to the Musée du Luxembourg, where academic paintings acquired by the state were exhibited. Ibid., 131, n. 40.

12. Marcel Duchamp, "Apropos of 'Readymades,'" lecture delivered at the Museum of Modern Art, New York, October 19, 1961, reprinted in *WMD*, 142.

13. "Clinamen" was the Roman author Lucretius's term for what the Greek philosopher Epicurus understood to be a sudden and indeterminate swerve in the downward motion of atoms; in other words, the agent of chaos in a perfect linear system. Building on this notion, Lucretius described an exception to Democritus's fatalistic understanding of matter, arguing instead that free will was an inherent property of the atoms themselves. This concept of the clinamen was used to refute the idea of a standard uniform flow of falling atoms, as previously suggested by Democritus, since the unpredictable and unmotivated swerve of a single atom from its preordained trajectory becomes the locus and guarantor of free will in general. For a useful general introduction to the history and application of the clinamen, see Warren F. Motte, Jr., "Clinamen Redux," *Comparative Literature Studies* (College Park, Maryland) 23, no. 4 (Winter 1986): 263–81.

14. Georges Charbonnier, "Interview with Marcel Duchamp," December 9, 1960, broadcast by the Radio Française on France Culture, published in Jennifer Gough-Cooper and Jacques Caumont, "Ephemerides on and about Marcel Duchamp and Rrose Sélavy 1887–1968," in *Marcel Duchamp: Work and Life*, ed. Pontus Hulten (Cambridge, MA: MIT Press, 1993), n.p. (entry for December 9, 1960). According to Duchamp, painters like Willem de Kooning and Robert Motherwell kept on repeating themselves for the sake of painting every day, a futile, anti-intellectual endeavor that he claimed was "the civil service side of the artist," who works for himself every day instead of working for the government. Ibid.

15. Marcel Duchamp, letter to Yvonne Lyon, January 8, 1949, quoted in Tomkins, *Duchamp*, 367.

16. Jarry, *Exploits & Opinions of Dr. Faustroll, Pataphysician*, 86.

17. See Anne Collins Goodyear's essay in this volume for more information about Duchamp's effect on contemporary artists.

18. William Seitz, "What's Happened to Art? An Interview with Marcel Duchamp on Present Consequences of New York's 1913 Armory Show," *Vogue*, February 15, 1963, 112. As Duchamp lamented in his interview with Seitz, "Even their little revolutionary temple couldn't understand that a nude could be *descending* the stairs." Ibid.

19. Ernest Hemingway recalled a visit he made to Gertrude Stein's studio apartment at 27, rue de Fleurus, in Paris in the early 1920s: "Miss Stein sat on the bed that was on the floor and asked to see the stories I had written and she said that she liked them except one called 'Up in Michigan.' 'It's good,' she said. 'That's not the question at all. But it is "inaccrochable."' That means it is like a picture that a painter paints and then he cannot hang it when he has a show and nobody will buy it because they cannot hang it either.'" See Hemingway, *A Moveable Feast* (New York: Scribner's, 1964), 14.

20. This sketch was accompanied by a description of the work, which Duchamp remembered as "a large portrait in profile . . . a big canvas, more than 1m . . . I'm practically certain that this canvas was done in Blainville around 1902." See Duchamp, letter to Suzanne Duchamp and Jean Crotti, December 31, 1949, Archives of American Art, Smithsonian Institution, Washington, DC, reprinted in Naumann and Obalk, *Affectionately, Marcel*, 284–85.

21. In a letter to Marianne W. Martin, an assistant curator in the Painting and Sculpture Department at the Philadelphia Museum of Art, Duchamp recalled that "Marcel Lefrançois was the nephew of our cook and the portrait was painted during one of his visits to his aunt." See Marcel Duchamp, letter to Marianne W. Martin, May 30, 1954; box 93, folder 15; general correspondence, Fiske Kimball Records, Philadelphia Museum of Art, Archives.

22. Marcel Duchamp, "Apropos of Myself," slide lecture delivered at the City Art Museum of St. Louis, Missouri, November 24, 1964, reprinted in d'Harnoncourt and McShine, *Marcel Duchamp*, 234.

23. Taking the artist's self-identification with Leonardo da Vinci to the extreme, Theodore Reff has suggested that Duchamp may have decided to leave his *Large Glass* "incompleted" because of the precedent of the Italian artist's unfinished major works, such as the *Adoration of the Magi*. According to this argument, both Duchamp and Leonardo "had so exhausted their inventiveness and curiosity in making the preparatory studies that the final execution became tedious." See Reff, "Duchamp & Leonardo: L.H.O.O.Q.-Alikes," *Art in America* 65, no. 1 (January–February 1977): 87.

24. For a good introduction to Leonardo da Vinci's painting techniques, see Francis Ames-Lewis, "Leonardo's Techniques," in Ames-Lewis, ed., *Nine Lectures on Leonardo da Vinci* (London: Birkbeck College, University of London, 1989), 32–44.

25. See Schwarz, *Complete Works*, vol. 2, 488.

26. Another example of this chameleon-like appropriation of another artist's style or subject matter can be found in the portrait of Gustave Candel's mother, which Duchamp completed in 1912 in the manner of Odilon Redon, an artist that he greatly admired. Duchamp had made a straightforward, naturalistic portrayal of Candel's father in the previous year, but when he came to paint his friend's mother he paid homage to Redon's hallucinatory vision by situating her disembodied bust and head on a narrow plinth.

27. Duchamp, "Apropos of Myself," in d'Harnoncourt and McShine, *Marcel Duchamp*, 243.

28. For more on the crucial financial support provided to his children by Eugène Duchamp, see Francis M. Naumann, "Money Is No Object," *Art in America* 91, no. 3 (March 2003): 67–68.

29. In a letter to a former owner of the painting, Dr. Harold Murchison Tovell (1889–1962), who had recently acquired *The Chess Game* from the estate of John Quinn, Duchamp identified the sitters as follows: "From left to right: my brother, Raymond Duchamp-Villon, who died from blood-poisoning, as a physician during the war. His wife lying on the ground. My other brother, Jacques Villon, the painter whose paintings were also in the Quinn collection. His wife sitting at the tea table." See Marcel Duchamp, letter to Harold Murchison Tovell, September 13, 1926; box 14, folder 21; correspondence; Arensberg Archives; Philadelphia Museum of Art, Archives.

30. John F. Moffitt, "Marcel Duchamp: Alchemist of the Avant-Garde," in Maurice Tuchman, ed., *The Spiritual in Art: Abstract Painting, 1890–1985* (New York: Abbeville Press, 1986), 258–59.

31. Ibid., 259.

32. When Walter Arensberg asked Duchamp specifically about the mauve halo around the young doctor's hand, he replied that "it has no definite meaning or explanation except the satisfaction of a need for the 'miraculous' that preceded the cubist period." See Duchamp, letter to Louise and Walter Arensberg, July 22, 1951; box 6, folder 35; correspondence; Arensberg Archives; Philadelphia Museum of Art, Archives, reprinted in Naumann and Obalk, *Affectionately, Marcel*, 303.

33. Jean Clair has provided the fullest account to date of the *Portrait of Dr. Dumouchel*, including the relevance of the medical training of the artist's childhood friends and older brother—Dumouchel, Raymond-Duchamp-Villon, and Ferdinand Tribout—for Duchamp's understanding of X-rays. See Clair, *Duchamp et la photographie* (Paris: Chêne, 1977), 14–25.

34. For an excellent discussion of Kupka's influence on Duchamp, see Linda Dalrymple Henderson, "X Rays and the Quest for Invisible Reality in the Art of Kupka, Duchamp, and the Cubists," *Art Journal* 47, no. 4 (Winter 1988): 323–40. As Henderson convincingly argues,

Duchamp most likely learned of the possible relevance of X-rays for modern painting from Kupka, whose contemporaneous writings display a remarkable scientific erudition, as well as a profound interest in higher dimensions, and a belief in a complex, vital reality beneath the surface of the visible world.

35. Linda Dalrymple Henderson has argued that the darkened nose of Magdeleine, seen second from the left, again links Duchamp's image specifically to X-rays. Because the nose consists primarily of cartilage instead of bone, an X-ray will produce a dark, triangular gap where the X-rays pass readily through the nose, but are resisted by the denser bones of the skull. See Henderson, *Duchamp in Context*, 9.

36. Duchamp, quoted by Truman Capote in Richard Avedon, ed., *Observations* (New York: Simon and Schuster, 1959), 55.

37. David Joselit, *Infinite Regress: Marcel Duchamp, 1910–1941* (Cambridge, MA: MIT Press, 1998), 71.

38. Cabanne, *Dialogues with Marcel Duchamp*, 29.

39. Ibid.

40. Angelica Zander Rudenstine, *Peggy Guggenheim Collection, Venice: The Solomon R. Guggenheim Foundation* (New York: Solomon R. Guggenheim Foundation, in association with Harry N. Abrams, 1985), 260. As Rudenstine points out, when the painting was first publicly exhibited at the Armory Show of 1913, it was listed in the New York catalogue as *Nu* (sketch), and in the Chicago and Boston catalogues as *Sketch of a Nude*. Ibid., 261.

41. This reading was first proposed by Joseph Masheck, who argued that "the young man may well be masturbating: his penis occupies a prominent place in the center of this scene on a jouncing train; it bends slightly upward on its downward-angled axis and an arc of dots trails down from the organ." See Masheck, "Introduction: Chance Is Zee Fool's Name for Fait," in Masheck, ed., *Marcel Duchamp in Perspective* (Englewood Cliffs, NJ: Prentice-Hall, 1975), 5. This interpretation, which suffers from a rather literal reading of the abstract linear elements of the painting as a tumescent and possibly ejaculating penis, can be challenged on the grounds that Duchamp probably intended the work to be a sketch (*esquisse*) for his next painting, the *Nude Descending a Staircase (No. 2)*. It is also extremely doubtful that the artist would have simultaneously masturbated *and* smoked a pipe in the public corridor of an intercity train, thus risking physical injury with every jolt of the moving train!

42. Duchamp greatly admired the writings of Alphonse Allais and almost certainly knew this widely published couplet from its publication in Guillaume Apollinaire's 1907 erotic novel, *Les onze mille verges*. See Apollinaire, *Les onze mille verges, or The Amorous Adventures of Prince Mony Vibescu*, trans. Nina Rootes (London: Peter Owen, 1976), 54.

43. Picabia's derisory nicknames for Gleizes and Metzinger were taken from Gustave Flaubert's unfinished 1872–1880 novel *Bouvard et Pécuchet*. See Gough-Cooper and Caumont, "Ephemerides," entry for April 4, 1916. By wittily labeling Gleizes and Metzinger the "Bouvard and Pécuchet Cubists," Picabia emphatically linked their extensive discussion and theorization of cubism, developed during regular meetings held at Jacques Villon's studio in Puteaux at the time of the publication of their academic treatise *Du cubisme*, with the farcical attempts of Flaubert's copy clerks to understand scientific theory.

44. Albert Gleizes and Jean Metzinger, *Du cubisme* (Paris: Eugène Figuière, 1912).

45. Duchamp in "A Complete Reversal of Art Opinions by Marcel Duchamp, Iconoclast," *Arts and Decoration* (New York) 5, no. 2 (September 1915): 428.

46. Seitz, "What's Happened to Art?" 113.

47. Charles Baudelaire, "The Painter of Modern Life," in Jonathan Mayne, ed., *The Painter of Modern Life and Other Essays*, trans. Jonathan Mayne (New York: Da Capo Press, 1964), 28.

48. Duchamp in "A Complete Reversal," 427.

49. Cabanne, *Dialogues with Marcel Duchamp*, 24.

50. Richard Hamilton, "The Large Glass," in d'Harnoncourt and McShine, *Marcel Duchamp*, 60. Recent technical analysis of the painting at the Philadelphia Museum of Art has revealed that Duchamp did not paint the work with his fingers, since brushstrokes are clearly visible under a microscope and in some cases to the naked eye. However, Duchamp's false recollection provides invaluable insights into his disgust with the sensual aspects of painting, as well as his concerted effort to rethink art making and the creative act after the *Nude Descending* debacle.

51. Cabanne, *Dialogues with Marcel Duchamp*, 39.

52. As Duchamp later explained to Calvin Tomkins, "There was never any essential satisfaction for me in painting. I just wanted to react against what the others were doing—Matisse and the rest. All that work of the hand. In French, there is an old expression, '*la patte*,' meaning the artist's touch, his personal style, his 'paw.' I wanted to get away from '*la patte*,' and from all that retinal painting." See Tomkins, "Not Seen and/or Less Seen," *New Yorker*, February 6, 1965, 48.

53. Duchamp explained to James Johnson Sweeney that he asked the sign painter to do the hand as an extension of his ideas on the readymades, since there is "something to a professional sign painter which you cannot imitate yourself. You can see it from the painting—even from the photograph. He did it in five minutes. It was wonderful." See Sweeney, transcript of nineteenth conversation with Marcel Duchamp, July 12, 1945; box 3, folder 16; interviews; Alexina and Marcel Duchamp Papers; Philadelphia Museum of Art, Archives, reprinted with the permission of the Estate of James Johnson Sweeney.

54. Duchamp in Sweeney, "Eleven Europeans in America," 20.

55. Duchamp dropped three sewing threads from a height of one meter and then fixed them to strips of canvas with varnish to preserve the curvilinear pattern in which they fell. The artist called the set of measuring devices that resulted from this experiment the "meter diminished," whose trio of arbitrary lengths destabilized the very premise of a single unit of measurement. See Arturo Schwarz, ed., *Marcel Duchamp: Notes and Projects for The Large Glass* (New York: Harry N. Abrams, 1969), 150, n. 96.

56. Duchamp later expressed his pleasure upon learning that "Fania is still the same crazy little girl" that he knew in New York in the 1910s. See Duchamp, letter to Ettie Stettheimer, July 9, 1922, Yale Collection of American Literature, Beinecke Library, Yale University, New Haven, Connecticut, reprinted in Naumann and Obalk, *Affectionately, Marcel*, 118.

57. For more on Guilbert, see Mary Weaver Chapin, "Stars of the Café-Concert," in *Toulouse-Lautrec and Montmartre* (Washington, DC: National Gallery of Art, in association with Princeton University Press, 2005), 139–41.

58. In a letter dated August 30, 1915, Quinn informed their mutual friend, Walter Pach, that "Duchamp looked thin and so I invited him to go down to Spring Lake as my guest." See Judith Zilczer, *The Noble Buyer: John Quinn, Patron of the Avant-Garde* (Washington, DC: Hirshhorn Museum and Sculpture Garden, 1978), 66, n. 21.

59. Duchamp first doubled the *r* of her name in 1921, when he signed Picabia's *L'oeil cacodylate,* a large canvas filled with the signatures and graffiti of his friends and colleagues. Rose thus became Rrose ("Eros"), as in Rrose Sélavy ("Eros, c'est la vie"). Please see James W. McManus's essay in this volume for more on the development of Rrose Sélavy.

60. As Helen Molesworth has persuasively argued, Duchamp's construction of his Rrose Sélavy alter ego needs to be understood within the context of two distinct forces that were at work in shaping the taste of the American consumer in the 1910s, namely the lively sense of competition between art museums and the new department stores, and the invention of the trademark. See Molesworth, "Rrose Sélavy Goes Shopping," in Leah Dickerman, ed., *The Dada Seminars* (Washington, DC: Center for Advanced Study in the Visual Arts at the National Gallery of Art, 2005), 173–89.

61. My understanding of the Rrose Sélavy gesture owes a profound debt to Amelia Jones's pioneering scholarship on Duchamp's adoption of a feminine alter ego, which she interprets as a radical challenge to the stability and hegemony of patriarchal or masculine authority. See Jones, *En-Gendering*, 146–90.

62. Duchamp's patron Walter Arensberg congratulated him on having invented "a new kind of autobiography" in the *Boîte-en-valise*. See Arensberg, letter to Marcel Duchamp, May 21, 1943; box 73, folder 3; correspondence; Arensberg Archives; Philadelphia Museum of Art, Archives.

63. Alyce Mahon, *Surrealism and the Politics of Eros, 1938–1968* (London: Thames and Hudson, 2005).

64. Duchamp referred to the "Wilson-Lincoln system (i.e., like the portraits which seen from the left show Wilson seen from the right show Lincoln—)" in a note, accompanied by a drawing of the concertina-like device, that was later published in *The Green Box*. See Marcel Duchamp, *La Mariée mise à nu par ses Célibataires, même* (*The Green Box*) (Paris: Édition Rrose Sélavy, 1934), reprinted in Richard Hamilton, ed., *The Bride Stripped Bare by Her Bachelors, Even*, trans. George Heard Hamilton (London: Percy Lund, Humphries & Co., 1960), n.p. The "Wilson-Lincoln" effect was an advertising device used during Woodrow Wilson's election campaigns that featured images of former president Abraham Lincoln on one side, and Wilson on the other. When viewed off-center, from the left or the right, the images of either Wilson or Lincoln appear, thus reinforcing in the viewer's mind a connection between the policies and ideals of the two men. Wilson was elected president in 1912 and was in office throughout Duchamp's first sojourn in the United States, from 1915 to 1918. For more on the scientific origins of the "Wilson-Lincoln" effect, see Anne Collins Goodyear's essay in this volume.

65. The idea that Duchamp's *Allégorie de genre* may have been intended to represent a sanitary napkin was first suggested by the French surrealist poet, writer, and ethnographer Michel Leiris. See Leiris, "The Arts and Sciences of Marcel Duchamp," *Fontaine 7* (Paris), no. 54, 1946, reprinted in Leiris, *Brisées: Broken Branches*, trans. Lydia Davis (San Francisco: North Point Press, 1989), 105.

66. According to Duchamp, the *Vogue* editors "lost their minds" when they saw the work with its stained reddish-brown stripes, which reminded them of dried blood. "They thought it would cause a scandal. So they refused the project." See Cabanne, *Dialogues with Marcel Duchamp*, 85.

67. Dodie Kazanjian and Calvin Tomkins, *Alex: The Life of Alexander Liberman* (New York: Alfred A. Knopf, 1993), 160.

68. Robert Lebel, *Sur Marcel Duchamp* (Paris: Trianon Press, 1959). The idea of a second publication, containing illustrations of the three new works that Duchamp was to make that summer, was suggested as early as April 1959, since Duchamp asked Lebel, in a letter dated April 15, 1959, "when do you need the 3 illustrations? I hope not before July because in principle I accept, but will I have the pleasure of pleasing the both of us?" Duchamp, letter to Robert Lebel, April 15, 1959, quoted in Paul B. Franklin, "Coming of Age with Marcel: An Interview with Jean-Jacques Lebel," *Étant donné Marcel Duchamp* 7 (2006): 20.

69. Robert Lebel's son, Jean-Jacques Lebel, suggested in a recent interview that the project "had to do with Arnold Fawcus of Trianon Press," but the exact details of the proposed publication remain unclear. See Franklin, "Coming of Age with Marcel," 21.

70. Robert Lebel, "Duchamp au musée," in Jean Clair, ed., *Marcel Duchamp*, vol. 3 (Abécédaire) (Paris: Musée National d'Art Moderne, Centre National d'Art et de Culture Georges Pompidou, 1977), 123; reprinted in an English translation in Schwarz, *Complete Works*, vol. 2, 820.

71. Tomkins, *Duchamp*, 406.

72. Jacqueline Matisse Monnier, interview with the author, Villiers-sous-Grez, March 30, 2007. I am thankful to the artist's stepdaughter for providing me with this crucial, previously unpublished information about the damage to the *Étant donnés* mannequin in the summer of 1959.

73. Alexina "Teeny" Duchamp, interview with the author, Rouen, May 10, 1994.

74. Dalia Judovitz, *Unpacking Duchamp: Art in Transit* (Berkeley: University of California Press, 1995), 117.

75. I am grateful to Anne d'Harnoncourt, Paul Matisse, Jacqueline Matisse Monnier, Walter Hopps, and Alexina "Teeny" Duchamp for providing me with invaluable insights into Duchamp's working process in constructing the mannequin in the 1940s and 1950s.

76. Cennino d'Andrea Cennini, *The Craftsman's Handbook: The Italian 'Il Libro dell'Arte,'* trans. Daniel V. Thompson, Jr. (New Haven, CT: Yale University Press, 1933), 124–29.

77. Judovitz, *Unpacking Duchamp*, 117.

78. Judovitz, for example, sees the work as staging "the death of painting and sculpture both literally and figuratively." Ibid., 151.

79. Gough-Cooper and Caumont, "Ephemerides," entry for June 30, 1959.

80. According to Ernst Benkard, this practice began with the death of Charles VI of France in 1422, when Maître François d'Orleans, court painter since 1408, made a death mask, as well as molds of the king's hands and feet, for the purpose of making a magnificent post-humous portrait of the deceased monarch." See Benkard, *Undying Faces: A Collection of Death Masks,* trans. Margaret M. Green (New York: W.W. Norton, 1929), 21.

81. Walter Sorell, *The Other Face: The Mask in the Arts* (New York: Bobbs-Merrill, 1973), 209–10.

82. Robert Lebel, "The Ethic of the Object," trans. Boris Guelfand, *Art and Artists* (London) 1, no. 4 (July 1966): 19.

83. Gough-Cooper and Caumont, "Ephemerides," entry for June 30, 1959.

84. Although Lebel firmly believed that his painting was made by Arcimboldo, the work was reattributed to Zucchi in the mid-1950s by Francine-Claire Legrand and Félix Sluys. See Legrand and Sluys, *Giuseppe Arcimboldo et les Arcimboldesques* (Paris: La Nef de Paris, 1955), 93. This attribution was challenged in Pontus Hulten, ed., *The Arcimboldo Effect: Transformations of the Face from the 16th to the 20th Century* (New York: Abbeville Press, 1987), 161, where the work was reattributed to Arcimboldo.

85. T. J. Demos, *The Exiles of Marcel Duchamp* (Cambridge, MA: MIT Press, 2007).

86. Timothy Binkley, "Piece: Contra Aesthetics," *Journal of Aesthetics and Art Criticism* 35, no. 3 (Spring 1977): 272.

Portraits

MARCEL DUCHAMP

plate # 1

Portrait of Marcel Duchamp
Hans Hoffmann (1880–1966)
Gelatin silver print, 33 × 25.4 cm (13 × 10 in.), 1912
David Fleiss, courtesy Galerie 1900–2000, Paris

This portrait by the German photographer Hans Hoffmann captures Duchamp at age twenty-five, when he lived in Munich for two summer months. As Duchamp said later in life, "In 1912 it was a decision for being alone and not knowing where I was going."[1] This self-enforced isolation resonates in Hoffmann's portrait in Duchamp's solemn, distant expression and the austerity of his formal attire. It was during his seclusion in Munich that Duchamp received a letter from the critic Guillaume Apollinaire prompting him to have this portrait taken. The photograph was intended for inclusion in Apollinaire's book *Les peintres cubistes*, published the following year.[2] The book contained essays on several French cubists, including Duchamp and his brother Raymond Duchamp-Villon.[3] Years later, this photograph was used as part of an installation by the German artist Rudolf Herz, who paired it with a photograph of Adolf Hitler also taken by Hoffmann.[4]

AK/JWM

1. Tomkins, *Duchamp*, 93.
2. Ibid., 95.
3. Guillaume Apollinaire, *Les peintres cubistes* (*Méditations esthétiques*) (Paris: E. Figurère, 1913), unpaginated.
4. See Rudolf Herz, *Zugswang* (New York: Jewish Museum, 2002), which was published as a pamphlet for the exhibition "Mirroring Evil: Nazi Imagery/Recent Art."

Marcel Duchamp, Raymond Duchamp-Villon, and Jacques Villon with Dog
Gelatin silver print, 11 × 17 cm (4⁵⁄₁₆ × 6¹¹⁄₁₆ in.), c. 1912
Walt Kuhn, Kuhn Family Papers and Armory Show Records, 1859–1978,
Archives of American Art, Smithsonian Institution, Washington, DC

plate # 2

In a picture collected by the American modernist Walt Kuhn during a trip to Europe, Marcel Duchamp (at left) displays a cool sensibility that sets him apart from his two older brothers, the avant-garde sculptor Raymond Duchamp-Villon (center) and painter Jacques Villon (right).[1] (Concerned that his artistic activities might bring unwelcome attention to his family, Jacques Villon, the first-born son of the Duchamp family, had dropped his given name in favor of a pseudonym, partially adopted, in turn, by Raymond.) Unlike his brothers, Duchamp is clean shaven, wears his hair combed back, and rocks forward in his chair.

Although his brothers had encouraged his career, Duchamp had already demonstrated his independence by withdrawing his most radical work to date, *Nude Descending a Staircase (No. 2)*, from a cubist exhibition with which his brothers were involved, rather than modify it. Shortly after this photograph was taken, Duchamp's groundbreaking painting would provoke an unprecedented *succès-de-scandale* when it toured the United States in the Armory Show, co-organized by Kuhn, which introduced American audiences to modernism.

ACG

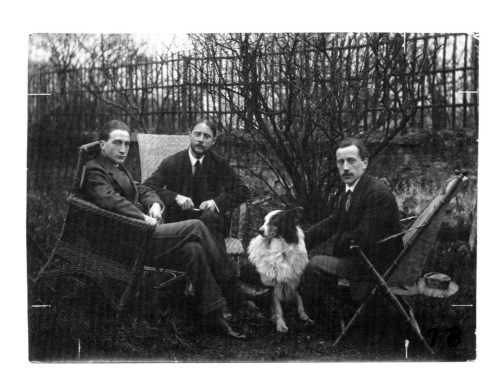

1. For more on the implications of Duchamp's appearance vesus that of his brothers, see Michael R. Taylor's essay in this volume.

131

plate # 3

Jean Crotti's Portrait de Marcel Duchamp sur mésure
Peter A. Juley (1862–1937)
Gelatin silver print, 23 × 17.5 cm (9⁹⁄₁₆ × 6⅞ in.), 1915
Archives Marcel Duchamp, Villiers Sous Grez, France

First exhibited in 1916, and today known only through this photograph by Peter A. Juley, Jean Crotti's *Portrait de Marcel Duchamp sur mésure* captured the attention of critics and the public alike, earning publication in the popular magazine *Vanity Fair*.[1] "It is an absolute expression of my idea of Marcel Duchamp. Not my idea of how he looks, so much as my appreciation of the amiable character that he IS," Crotti told a newspaper reporter. "How may such an appreciation be visualized without making it conventional and commonplace?"[2] The work's title suggests that, like a tailor, Crotti created the work "to measure," perhaps literally molding the soft metal surface of the forehead from Duchamp's own head.[3] Crotti's invocation of the notion of measurement may have referred to Duchamp's recent *Three Standard Stoppages*

(1913–14), a work in which Duchamp playfully challenged the standard measurement of the meter by dropping threads of this length from the height of a meter and fixing the curved results on canvas affixed to glass. The forms would later reappear in *The Large Glass* (1915–23) and in *Tu m'* (1918).[4] A multitude of fine wires reflect Duchamp's thick hair, while glass eyes give the likeness a penetrating expression. As William Camfield notes, the metallic coiffure may reflect (or possibly inspired) a note penned by Duchamp in the fall of 1915 for *The Green Box*, in which he describes a comb designed to exert "control" over "lead wires . . . laid one against the other . . . like hair." Two months before Crotti's work was exhibited, Duchamp had identified and inscribed an appropriate comb, one of his early readymades.[5] The enduring importance of the sculpture for Crotti is made evident through a pair of related drawings based on this photograph (see pls. 4, 5).

ACG

1. The sculpture was originally purchased by Walter and Louise Arensberg, but it appears to have been transferred back to Crotti at an unknown date. When Katherine Dreier contacted Crotti in January 1949 seeking to add the sculpture to the collection of the Société Anonyme, he replied that the work had been lost or destroyed (correspondence cited in William A. Camfield, "Jean Crotti and Suzanne Duchamp," in *Tabu Dada: Jean Crotti and Suzanne Duchamp, 1915–1922*, ed. William Camfield and Jean-Hubert Martin [Bern: Kunsthalle, 1983], 64, n. 29). Although Camfield makes reference to René Barotte's claim that the sculpture was in Crotti's studio after his death, this seems doubtful, as no other record of its survival exists. An undated inscription on the back of a photograph of the sculpture preserved in Crotti's papers reads, "Anciennement coll. Arensberg USA." (See "Photographs of Works by Crotti," in the Jean Crotti Papers, AAA.) Authorship of this photograph has mistakenly been attributed to Man Ray; however, Peter Juley's stamp actually appears on the verso of a vintage 1917 photograph at the Museum of Modern Art (MoMA). (I thank Scott Gerson, Kathy Curry,

Adrian Sudhalter, and Lee Ann Daffner for the opportunity to see this in MoMA's conservation lab on July 27, 2006.) This is consistent with a letter from Duchamp to Crotti dated May 19, 1921, in which Duchamp tells his brother-in-law that he has picked up the "clichés" (either prints or photographic negatives) of the "head" (a reference to the photographs of *Portrait de Marcel Duchamp sur mésure*) from the studio of Peter Juley. (Francis Naumann identifies and translates this letter and connects it with the sculpture; see his essay "Affecteusement, Marcel: Ten Letters from Marcel Duchamp to Suzanne Duchamp and Jean Crotti," *Archives of American Art Journal* 22, no. 4 [1982]: 15 , 19, n. 55.) The address of Juley's studio provided in the stamp confirms that the stamp was placed on the photograph at a time roughly contemporaneous with the exhibition of the sculpture, since the firm moved in May 1917 (e-mail from Andrew Thomas to Anne Goodyear, August 9, 2006). For publication of this image in *Vanity Fair*, see Frederick James Gregg, "The New Sculpture, and the Painter-Sculptors," *Vanity Fair*, June 1916, 87; the publication of the image there further supports attributing the photograph to Juley. Although these images are

uncredited, Juley went on to become a frequent contributor of photographs to *Vanity Fair*. I thank Andrew Thomas for bringing this article to my attention and for the information about Juley's career.
2. Jean Crotti, letter in *The World Magazine* (New York), August 27, 1916, quoted by R[obert]. C[ody]., "Mr. Jean Crotti," *The Soil* (New York) 1, no. 1 (December 1916); cited by Camfield in "Crotti and Suzanne Duchamp," 12.
3. William Camfield points out that the phrase "sur mésure" is used by tailors to mean "made to measure"; see Camfield, "Crotti and Suzanne Duchamp," 12.
4. Duchamp himself titled *Three Standard Stoppages* on the basis of a sign he saw at a

shop in Paris that rewove fabric. The sign may have advertised "Stoppages et talons," leading to the use of the phrase "*stoppages étalon*," meaning "mending standard," in the original French title of the piece. I thank James W. McManus for pointing out this connection. On the *Three Standard Stoppages* and Duchamp's titling of the piece, see Ann Temkin, "Marcel Duchamp, 3 Standard Stoppages (3 Stoppages Étalon), Paris, 1912–14," in *Dada in the Collection of the Museum of Modern Art*, ed. Anne Umland and Adrian Sudhalter, with Scott Gerson (New York: Museum of Modern Art, 2008), 113–15.
5. Camfield, "Crotti and Suzanne Duchamp," 12–14.

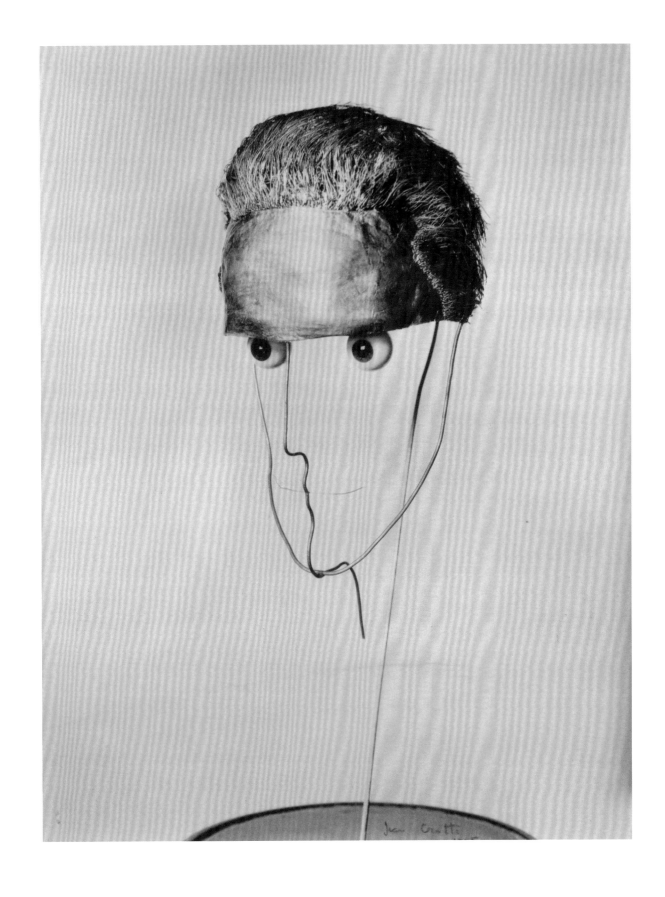

133

plate # 4

Marcel Duchamp
Jean Crotti (1878–1958)
Pencil on paper, 54.5 × 34.3 cm (21½ × 13½ in.), inscribed 1915
The Museum of Modern Art, New York; purchase (158.1970)

This pair of drawings by Jean Crotti, now in the collections of the Philadelphia Museum of Art (PMA) and the Museum of Modern Art (MoMA), respectively, clearly derives from the artist's lost 1915 sculptural portrait of Marcel Duchamp, *Portrait de Marcel Duchamp sur mésure* (see pl. 3). The more finished quality of the drawing in PMA's collection (pl. 5), coupled with the inscription at the bottom right of MoMA's drawing, which specifies "First study for the portrait made to measure of Marcel Duchamp," indicates that the PMA drawing was the second of the two works to be created.[1] Although each work is inscribed 1915, circumstantial evidence raises the intriguing possibility that this pair of drawings might actually have been produced about 1952, as Marcel Duchamp worked with Sidney Janis on the organization of an exhibition devoted to Dada.[2]

In preparation for the exhibition, Duchamp contacted his sister and brother-in-law, Suzanne Duchamp and Jean Crotti, and requested the loan of Crotti's 1916 *The Clown,* a work consisting of lead wire, glass eyes, and colored paper on glass. Duchamp added, "If you think of anything else from the period, tell me," and directed that *The Clown* (and presumably anything else) be sent to the Rose Fried Gallery.[3] An inscription on the verso of the PMA's drawing and a documentary photograph by John Schiff indicate that in addition to *The Clown,* Crotti also sent the more polished of his two drawings to the Rose Fried Gallery.[4] The drawing may well have been intended as a stand-in for the lost sculpture it evoked, and it might also have served as an homage to his brother-in-law because, in all likelihood, Crotti's sculpture was no longer extant in 1952.[5] The appearance of Crotti's drawing at the Rose Fried Gallery is the first historical record of its existence.[6] Before sending the work abroad, Crotti photographed it with its mate on an easel in his studio, showing the relationship between the two works.[7]

Most suggestive, however, is the evidence provided by the composition of the works themselves. Despite the claim inscribed on the MoMA drawing that it is the "first study" for the sculptural portrait of Duchamp, both drawings are clearly based on *the photograph* of the sculpture made by Peter Juley, which Duchamp carried across the ocean for Crotti in 1919.[8] The angle from which the sculpture is represented on paper and the details included in the drawings clearly correspond to the two-dimensional reproduction of it captured by Juley's camera. The close correlation suggests neither a schematic "plan" for the sculpture nor an image based on a three-dimensional model. Evidence of careful study and execution of the drawing in the collection of MoMA, the first of the pair, is provided by Crotti's use of horizontal and vertical marks to guide his composition, as well as small holes demonstrating the use of a compass to create the eyes.[9]

Duchamp was very much on Crotti's mind at the time he solicited a contribution to the Dada exhibition at the Janis Gallery. In a letter written to his brother-in-law, dated July 14, 1953, Crotti tells Duchamp of a visit by Sidney and Harriet Janis and says that he and Suzanne did their best to complete a questionnaire for them. Crotti also informed them, as he did Duchamp, that he was writing his own short treatise about Duchamp, "not based on anecdotes but on my impressions," an approach quite similar to the one he took with the sculpture itself, which Crotti described in 1916 as "an absolute expression of my idea of Marcel Duchamp. Not my idea of how he looks, so much as my appreciation of the amiable character he IS."[10] References to Duchamp's importance for Crotti, and specifically to the 1915 sculptural composition of Duchamp, recur repeatedly in the biographical notes the artist was creating in the 1950s about his career. In one chronology, written in the third person, Crotti noted under the year

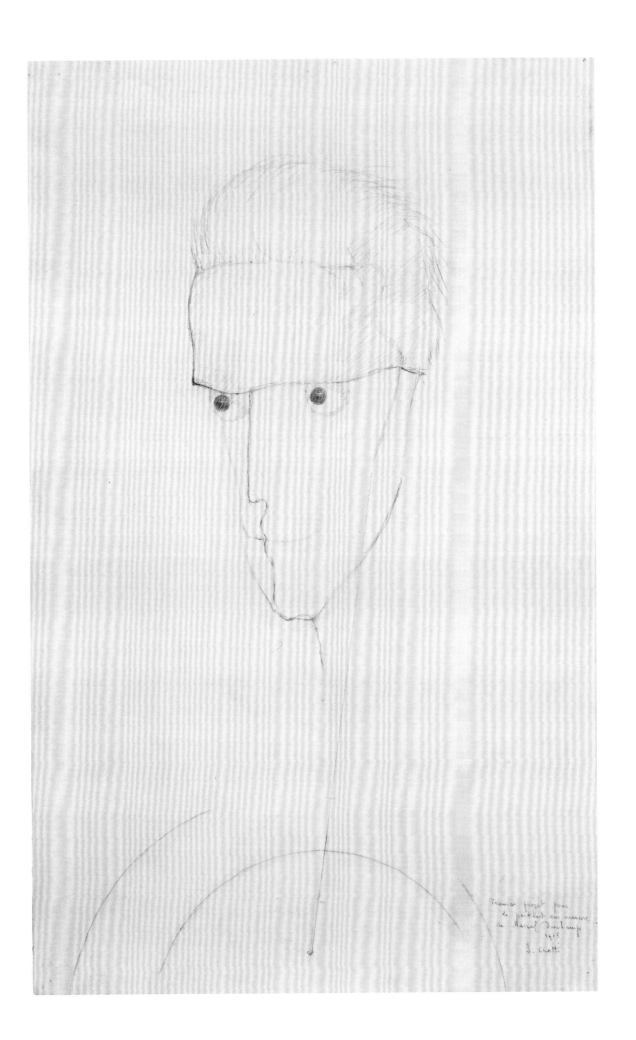

Premier projet pour
le portrait sur mesure
de Marcel Duchamp
1915
J. Crotti

1914: "Duchamp was one who had a great influence on his [i.e., Crotti's] thinking, he [Duchamp] enabled him [Crotti] to concretize certain ideas deeply hidden in his subconscious." Under 1915 he refers to both *The Clown* and the *Portrait de Marcel Duchamp sur mésure,* which, he claims, "are considered as the most important [Dadaist] works of the era." Finally, he goes on, under a 1917 entry containing "extracts from the press," to include praise of the sculpture that this pair of drawings documents: "The most sensational of these [works] and the one that obtained the greatest real success was the portrait of Marcel Duchamp by Jean Crotti, executed in lead wire. The effect is fantastic."[11]

Although no conclusive physical evidence demonstrates that the drawings were made in the early 1950s, a number of suggestive factors, ranging from their composition, to the appearance of the PMA drawing at the Rose Fried Gallery in about 1953, to Crotti's state of mind in the early 1950s, suggest that this possibility must be considered.

ACG

1. The full inscription, as written in French, reads: "Premier project pour/le portrait sur mésure/de Marcel Duchamp/1915/J.Crotti." William Camfield points out that the phrase "sur mésure" is used by tailors to mean "made to measure." Otherwise, the translation is my own. William A. Camfield, "Jean Crotti and Suzanne Duchamp," in *Tabu Dada: Jean Crotti and Suzanne Duchamp, 1915–1922,* ed. William Camfield and Jean-Hubert Martin (Bern: Kunsthalle, 1983), 12.
2. This possibility is also raised by Iris Schmeisser in her catalogue entry on Jean Crotti, *Marcel Duchamp,* the drawing in MoMA's collection; see Schmeisser, "Jean Crotti, Marcel Duchamp," in *Dada in the Collection of the Museum of Modern Art,* ed. Anne Umland and Adrian Sudhalter, with Scott Gerson (New York: Museum of Modern Art, 2008), 92–96.
3. Duchamp letter of August 17, 1952, Jean Crotti Papers, AAA.
4. John Schiff's photograph appears in the "Marcel Duchamp" file in the Papers of the Rose Fried Gallery, microfilm, AAA. The inscription on the back of the Philadelphia Museum of Art (PMA) drawing is visible from the front and is documented in the catalogue record for the object, Department of Prints, Drawings, and Photographs, PMA. Unfortunately, neither Schiff's photograph nor the "Rose Fried" inscription on the back of the PMA drawing are dated.
5. Like many lost Dada objects of the period, including Baroness Elsa von Freytag-Loringhoven's *Portrait of Marcel Duchamp*

of about 1920 (see pl. 13), the work may have been intended as an ephemeral artifact made of delicate materials; indeed, lead, from which the sculpture is supposed to have been made, is extremely soft. (I thank MoMA conservator Scott Gerson for this observation, based on our conversation of July 27, 2006.) When Katherine Dreier contacted Crotti in January 1949 seeking to add the sculpture to the collection of the Société Anonyme, he replied that the work had been lost or destroyed (correspondence cited by Camfield, "Crotti and Suzanne Duchamp," 64, n. 29). Although Camfield makes reference to René Barotte's claim that the sculpture was in Crotti's studio after his death, this seems doubtful, as no other record of its survival exists. An undated inscription on the back of a photograph of the sculpture preserved in Crotti's papers reads, "Anciennement coll. Arensberg USA." (See "Photographs of Works by Crotti," in Jean Crotti Papers, AAA.)
6. See letter from Francis Naumann to Charles K. Williams, September 4, 2003, curatorial file for Jean Crotti, *Portrait of Marcel Duchamp,* Department of Prints, Drawings, and Photographs, PMA.
7. The picture appears to have been taken in the early 1950s. However, a UV test showed no evidence of the use of brightening agents in the paper, indicating that the paper must have been made before approximately 1955, when such whiteners were widely introduced. (Their first appearance was in 1950.) I thank National Portrait Gallery conservator Rosemary Fallon

for administering this test and independent conservator Sarah S. Wagner for introducing me to a paper on the subject. (See Paul Messier, Valerie Baas, Diane Tafilowski, and Lauren Varga, "Optical Brightening Agents in Photographic Paper," *Journal of the American Institute for Conservation* 44, no. 1 [2005]: 1–12; also published in JAIC Online at http://aic.stanford.edu/jaic/articles/jaic44-01-001_indx.html.) It should also be noted that Crotti seems to have been documenting a number of his pieces at this time. (See "Photographs of Works by Crotti," in the Jean Crotti Papers, AAA.)
8. This photograph was taken by Peter Juley, not Man Ray, as has often been assumed. Indeed, Peter Juley's stamp appears on the verso of a vintage 1917 photograph at MoMA (I thank Scott Gerson, Kathy Curry, Adrian Sudhalter, and Lee Ann Daffner for the opportunity to see this in MoMA's conservation lab), and Duchamp, in a letter to Crotti of May 19, 1921, tells his brother-in-law that he has picked up the "clichés" (either prints or photographic negatives) of the "head" (a reference to the *Portrait de Marcel Duchamp sur mésure*) from the studio of Peter Juley. (Francis Naumann identifies and translates this letter and connects it with the sculpture in his essay "Affecteusement, Marcel, Ten Letters from Marcel Duchamp to Suzanne Duchamp and Jean Crotti," *Archives of American Art Journal* 22, no. 4 [1982]: 15, 19, n. 55). The similarity of the drawing to the photograph was noticed by Scott Gerson at MoMA, per conversation with the author, July 27, 2006, as well as by William Camfield, "Crotti and Suzanne Duchamp," 64, n. 29.
9. Scott Gerson noted during his physical examination of the object on July 27, 2006,

that the drawing was made using a compass, as indicated by the presence of compass points in the center of the eyes. Gerson also observed horizontal and vertical lines on the paper and thus concluded that the drawing was not done freehand.
10. Jean Crotti, draft of letter to Marcel Duchamp, July 14, 1953, in "From Crotti to Various People," Jean Crotti Papers, AAA (author's translation). It is unclear whether the letter was actually sent or just drafted; although Harriet Janis is not mentioned by name, Crotti refers to a visit from "des Sidney Janis," suggesting that both Mr. and Mrs. Sidney Janis were present. Jean Crotti, letter in *World Magazine* (New York), August 27, 1916, quoted by C[ody]., "Mr. Jean Crotti," *The Soil* 1, no. 1 (New York), December 1916; cited by Camfield, *Crotti and Suzanne Duchamp, 1915–1922,* 12.
11. The original French reads: "1914: Crotti part pour les États Unis, invité par son frère. Il s'installe pour plusieurs mois à New York où il fait la conaissance de Marcel Duchamp lequel eut une grande influence sur ses pensées, ce qui lui permit de concréteser certaines idées profoundement cachées au fond de son subconscient. 1915: C'est là que se situe son oeuvre Dadaiste dont le 'portrait sur mésure' de Marcel Duchamp et le 'Clown au Cirque' sont considerées commes les plus importante de cette époque." From "Extraits de Presse" 1917: [citation illegible] "La plus sensationnelle de ces [word illegible] et celle qui a obtenu le plus réel succès fut le portrait de Marcel Duchamp part Jean Crotti, exécuté en fils de plomb. L'effet est fantastique." Translations by the author, from "Crotti Autobiographical Writings," Jean Crotti Papers, AAA.

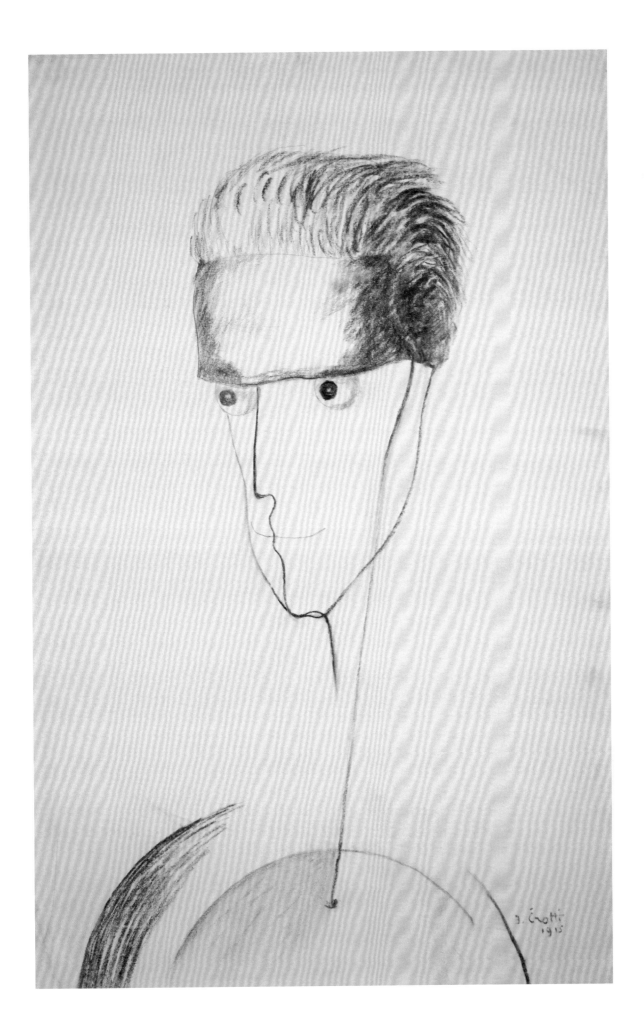

Portrait of Marcel Duchamp
Jean Crotti (1878–1958)
Graphite and charcoal on off-white wove paper, 54.6 × 34.6 cm
(21½ × 13⅝ in.), inscribed 1915
Philadelphia Museum of Art, Pennsylvania; gift of C.K. Williams II, 2001

plate # **5**

plate # 6

Marcel Duchamp, Francis Picabia, and Beatrice Wood at the Broadway Photo Shop, New York City
Unidentified photographer
Photo postcard, 13.3 × 8.9 cm (5¼ × 3½ in.), 1917
Philadelphia Museum of Art, Pennsylvania

In her autobiography, Beatrice Wood recalls that Marcel Duchamp and Francis Picabia took her to Coney Island on June 21, 1917, to help console her hurt feelings after she was jilted by her first lover, Henri-Pierre Roché.[1] Sometime during that day, the three visited the Broadway Photo Shop, at 1591 Broadway in New York City, where they had their group portrait taken.[2] Photographed by an attendant using a photo-postcard machine,[3] this now-famous photograph shows the three together in a studio setup that featured an ox cart before a painted backdrop of a forest scene. At least three copies, printed on postcards, were made, providing each person a souvenir of the occasion.

On the same day that the three had their group photograph taken, Duchamp and Picabia sat for their "five-way" portraits.[4] (The portrait of Picabia is not included in this exhibition.) In addition to the setup already described, the Broadway Photo Shop featured the popular hinged-mirror setup. This setup had gained popularity, both in Europe and the United States, by late in the nineteenth century and could commonly be found in storefront photography studios and at amusement parks. It required the sitters to position themselves, seated with their back to the camera, facing a pair of hinged mirrors. The camera, in this case a photo-postcard machine operated by an attendant, produced an image showing the sitter from the back accompanied by four reflected images. Printed on postcards, the five carefully cropped images sitting around a table create confusion—which is the image of the sitter, and which are the reflections?[5] Duchamp's carefully contrived pose, with one hand resting on the table and the other supporting the pipe held in his mouth, intimates his having assumed command of the situation, creating an image suited to his own purposes.[6] The reflections in this souvenir image prefigure the manner in which Duchamp would fracture his artistic persona into a cast of characters, including Rrose Sélavy and R. Mutt. While the photograph cannot be categorized as a readymade, its "ready made" components—hinges, mirrors, and the confusion of identity—seem to fit perfectly within the vocabulary of the private language that Duchamp was developing at that time.

JWM

1. Beatrice Wood, *I Shock Myself: The Autobiography of Beatrice Wood*, ed. Lindsey Smith (San Francisco: Chronicle Books, 1985), 37.
2. The location where this photograph was taken has mistakenly been described by a number of authors as Coney Island. See Lebel, *Duchamp*, item 47, 99. In that note Duchamp informs us that the photograph was taken at the Broadway Photo Shop, and not Coney Island. See also James W. McManus, "Trucage photographique et déplacemeny de l'objet: À propos d'une photographie de Marcel Duchamp pris devant un mirior à charnières (1917), in *Les Cahiers du Musée national d'art moderne*, 92 (Paris: Éditions du Centre Pompidou, été, 2005), 94–107.
3. McManus, "Trucage photographique," 96–99. A careful comparison of the group portrait and each man's "five-way" portrait shows them in the same dress, providing evidence that all the photographs were taken on the same day. Interestingly, even though Wood posed with both men for the group portrait, there is no evidence that she sat for a five-way portrait too.

4. See Naumann, *New York Dada*; see page 68 for a reproduction of this photo postcard.
5. *Octavio Paz, Marcel Duchamp: Appearance Stripped Bare,* trans. Rachel Phillips and Donald Gardner (New York: Seaver Books, 1978), 138–51. In this passage Paz provides a clear description of Duchamp's concept of the "sign of accordance."
6. McManus, "Trucage photographique," 103–5.

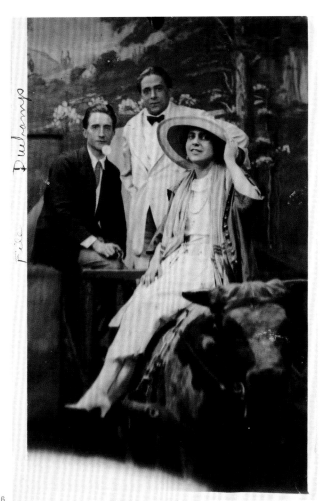

plate # 6

plate # 7

Portrait multiple de Marcel Duchamp (Five-Way Portrait of Marcel Duchamp)
Unidentified photographer
Photo postcard, 8.9 × 13.3 cm (3½ × 5¼ in.), 1917
Private collection, courtesy of Francis M. Naumann Fine Art

plate # 7

plate # 8

Sheet of Studies Including a Portrait of Marcel Duchamp
Francis Picabia (1879–1953)
Pen and black ink with ink wash on wove paper, 17.5 × 21.6 cm
(6⅞ × 8½ in.), c. 1917
Philadelphia Museum of Art, Pennsylvania; The Louise and Walter
Arensberg Collection, 1950

The sketch of Duchamp's portrait on this sheet appears to have been taken directly from one of the reflected images of him in the photo postcard made in 1917 in New York (see pl. 7).[1] Picabia, who also had his photograph taken before the hinged-mirror setup on that occasion, likely carried one of the postcards bearing Duchamp's portraits with him when he left for Europe in the autumn of 1917, settling briefly in Barcelona before moving on to Paris, where he would meet Germaine Everling.[2] In November or December of 1917, Picabia made a pen and ink portrait of Duchamp identified as a *Sheet of Studies Including a Portrait of Marcel Duchamp* when he and Germaine Everling were in the Martiniques.[3]

Noticeable also on this page is Picabia's use of the interplay between handwritten text and drawn imagery, suggesting a prefiguration of his monumental canvas, *L'oeil cacodylate* (1921). Both works provide us insights into Picabia's and Duchamp's shared intent to challenge the traditions of painting.

JWM

1. Comparing it with the second image from the right (reversed) in the Duchamp photograph, one gets the sense that Picabia used the photograph as his source.
2. William A. Camfield, *Francis Picabia, His Art, Life and Times* (Princeton, NJ: Princeton University Press, 1979), 112–13.
3. In an e-mail to this author on August 2, 2004, William Camfield wrote: "The drawing must date from late November–early December, 1917 when Picabia and his new love, Germaine Everling, were in the Martiniques. The lighter hand is Picabia's; the heavier ink is in Germaine's hand. It reflects the playful, 'honeymoon' atmosphere of the moment. Picabia refers to the recent publication of *Cinquante deux miroirs* that was finished in Barcelona in the fall of 1917 and bears the date of October 1917."

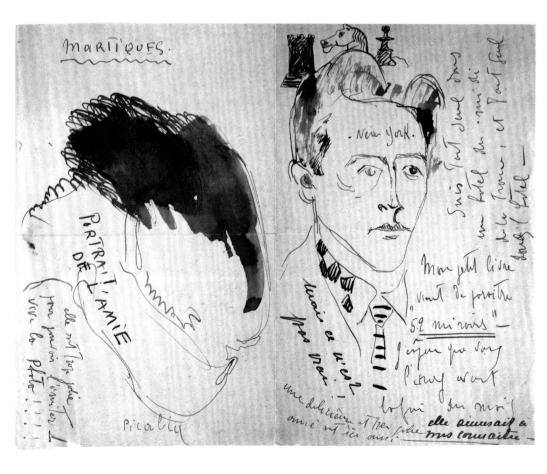

Marcel Duchamp
Edward Steichen (1879–1973)
Platinum print, 24.4 × 19.1 cm (9⅝ × 7½ in.), 1917
Philadelphia Museum of Art, Pennsylvania; the Louise and
Walter Arensberg Collection, 1950

plate # **9**

"I aim at the expression of something psychological in the man when I make a photographic portrait," explained Edward Steichen in 1902. "I am not satisfied with the mere reproduction of his features and expression. I aim to know him and his work, to study him from different points, before I venture upon his portrait."[1] Steichen's 1917 photograph of Marcel Duchamp, one of a pair of images Steichen made of the French-born artist, suggests the high regard in which Steichen held him. An accomplished portrait photographer, who had made a point of introducing himself to artists he admired by creating photographic portraits of them, Steichen, together with his friend Alfred Stieglitz, had played a critical role in introducing Americans to modern European art through exhibitions at Stieglitz's 291 Gallery.[2] Upon his arrival in New York in 1915, Duchamp quickly became acquainted with the circle of avant-garde artists who had coalesced around this progressive gallery. Picturing Duchamp's strong profile, which would become a leitmotif in portraits and self-portraits of Duchamp, Steichen captures the artist's intellectual intensity, independence, and quintessential elegance. Describing Duchamp during this period, Georgia O'Keeffe, Stieglitz's companion and future wife, recalled that he conducted himself "with a grace that I had never seen in anyone before and have seldom seen since."[3]

ACG

1. Undated clipping [summer 1902], Steichen scrapbook, Steichen Archive, Museum of Modern Art, New York; quoted by William Innes Homer, "Eduard [*sic*] Steichen as Painter and Photographer, 1897–1908," *American Art Journal* 6, no. 2 (November 1974): 50.
2. See Homer, "Eduard Steichen," 48–50; and Anne McCauley, "Edward Steichen: Artist, Impresario, Friend," in *Modern Art and America: Alfred Stieglitz and His New York Galleries,* ed. Sarah Greenough (Washington, DC; National Gallery of Art; Boston: Bulfinch Press, 2000), 55–69 and 488–91.
3. Georgia O'Keeffe, contribution to "A Collective Portrait of Marcel Duchamp," in d'Harnoncourt and McShine, *Marcel Duchamp.*

plate # 10

Abstract Portrait of Marcel Duchamp
Katherine Sophie Dreier (1877–1952)
Oil on canvas, 45.7 × 81.3 cm (18 × 32 in.), 1918
The Museum of Modern Art, New York; Abby Aldrich
Rockefeller Fund (279.1949)

"Instead of painting the sitter as seen ordinarily in life, the modern artist tries to express the character as represented through abstract form and color," wrote Katherine Dreier in reference to her *Abstract Portrait of Marcel Duchamp*.[1] She continued: "[T]hrough the balance of curves, angles, and squares, through broken or straight lines, or harmoniously flowing ones, through color harmony or discord, through vibrant or subdued tones, cold or warm, there arises a representation of the character which suggests clearly the person in question, and brings more pleasure to those who understand, than would an ordinary portrait representing only the figure and face. . . . The new form . . . gives chance for the different sides of a character, as well as a greater range of emotion to be portrayed."[2] Dreier's self-consciously modern depiction of her friend not only relies on color and shape to evoke Duchamp's present, but it also seems to include representational features, including a *D* on its side at center and an upside-down pipe, frequently visible in pictures of the artist, in the center left.[3] The golden circle at center evokes Duchamp's *Bicycle Wheel*, his first readymade. The composition's colors, the overlapping and sharp-angled forms, and particularly the diagonally sloping, elongated triangle at center, appear to reflect Duchamp's 1918 *Tu m'*, the last painting of his career, which Dreier commissioned.

ACG

1. Dreier also produced a much more conventional likeness of Duchamp, now lost, around the same time. This portrait, *Marcel Duchamp Triangles* (see fig. 2.1), is discussed at greater length in Francis Naumann's essay in this volume.
2. Katherine S. Dreier, *Western Art and the New Era* (New York: Brentano's, 1923), 112.
3. I thank Francis Naumann for bringing these features to my attention.

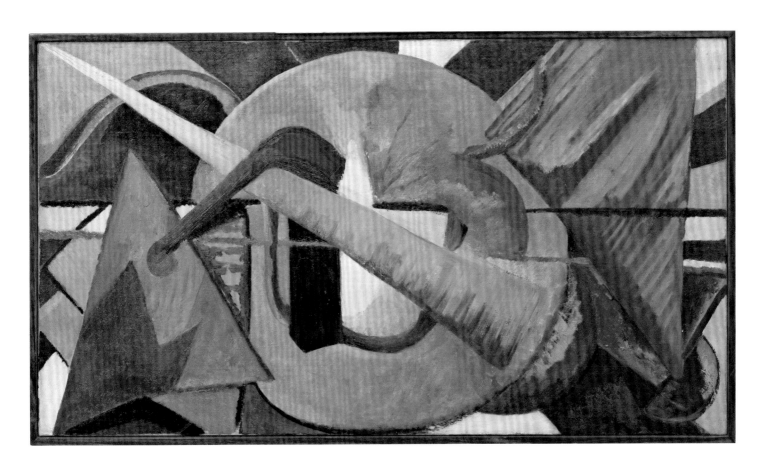

plate # 11

Duchamp with Partial Tonsure
Marcel Duchamp (unidentified photographer)
Gelatin silver print, 9.8 × 7.8 cm (3⅞ × 3¹/₁₆ in.), 1919
Private collection, courtesy of Sean Kelly Gallery, New York

On March 9, 1919, writing from Buenos Aires to Jean Crotti (soon to be his brother-in-law) in Paris, Duchamp informed him that Yvonne Chastel (Crotti's former wife) had cut his hair and applied a potent remedy to his head in an effort to restore his hair.[1] The photograph taken at the time, and possibly by Chastel, gives the appearance that Duchamp's head was entirely shaved. However, as Sean Kelly has pointed out, a closer examination reveals that his entire head was not shaved, only the upper part, leaving a band of hair just above the ears that approximates somewhat the Flemish style of the tonsure.[2] This photograph offers the first visible evidence of Duchamp's appropriation of the theme of the *célibat* important in the construction of his feminine alter ego, Rrose Sélavy.[3]

JWM

1. Schwarz, *Complete Works,* vol. 2, 673.
2. Conversation between this author and Sean Kelly at the Sean Kelly Gallery, New York, February 10, 2005. See "Tonsure," Wikipedia, http://en.wikipedia.org/wiki/Tonsure (October 6, 2008).
3. See James W. MacManus's essay in this volume.

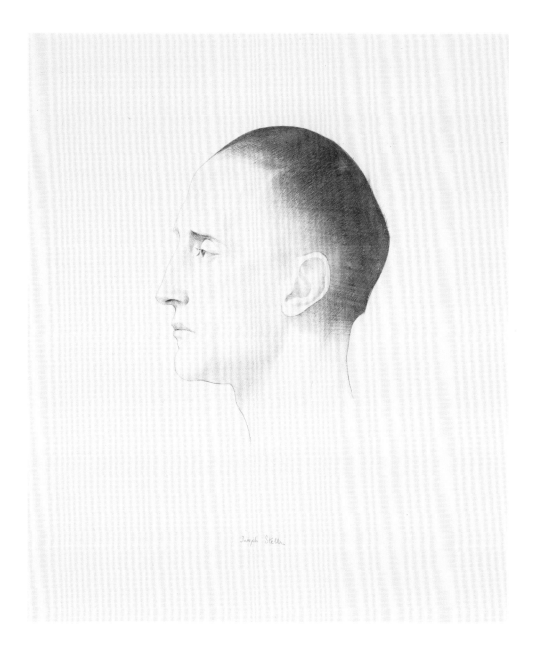

Marcel Duchamp
Joseph Stella (1877–1946)
Silverpoint on paper, 61.6 × 47.6 cm (24 ¼ × 18 ¾ in.), c. 1920
The Museum of Modern Art, New York; Katherine S. Dreier Bequest
(210.1953)

plate # 12

Acquainted with Duchamp through the Société Anonyme and the collectors Walter and Louise Arensberg, Joseph Stella portrayed Duchamp after his return to the United States from Paris in early 1920. Given Duchamp's tonsure-like haircut, replete with historical associations, Stella's neoclassical style, which evokes a long tradition of profile portraiture, is particularly appropriate in this instance.[1] Using silverpoint, a medium favored by Renaissance artists, because it enabled him to "draw with all precision . . . reveal[ing] instantly the clearest graphic eloquence,"[2] Stella meticulously documents the shape of Duchamp's closely shorn skull.

As Francis Naumann notes, the haircut most likely stemmed from Duchamp's efforts to eradicate a scalp infection that he developed in Buenos Aires. The dramatic change from his longer, elegant hairstyle upset many of his friends,

including Ettie Stettheimer, who told Duchamp, "Samson, you know, lost his strength with his hair. You seem to be in danger of losing your mystery!" Stettheimer worried that the haircut was too revealing, exposing "with brutal frankness" the lines of his skull.[3] However, the change in Duchamp's appearance seemed only to enhance, rather than diminish, his allure.

JEQ

1. Stella's work is part of a post–World War I "return to order," a revival of the classical tradition among the European avant-garde. See Barbara Haskell, *Joseph Stella* (New York: Whitney Museum of American Art; distributed by Harry N. Abrams, 1994), 135. For more on the early twentieth-century revival of the classical tradition, exemplified in the work of such artists as Pablo Picasso and Fernand Léger, see Elizabeth Cowling and Jennifer Mundy, *On Classic Ground: Picasso, Léger, de Chirico and the New Classicism, 1910–30* (London: Tate Gallery Publications, 1990). For a fuller discussion of the metaphorical implications of this haircut, as well as commentary on a photograph by Man Ray from this time also evoking Duchamp in profile (fig. 4.2), see James W. McManus's essay in this volume.
2. Joseph Stella, quoted in Joann Moser, comp., *Visual Poetry: The Drawings of Joseph Stella* (Washington, DC: Smithsonian Institution Press for the National Museum of American Art, 1990), 17. For more on Stella's use of silverpoint, see Haskell, *Joseph Stella*, 123–24.
3. Francis Naumann, in his essay in this volume, notes the significance of Duchamp's short haircut and quotes Ettie Stettheimer's response to it.

plate # **13**

Baroness Elsa's Portrait of Marcel Duchamp
Charles Sheeler (1883–1965)
Platinum print, 20.3 × 15.2 cm (10 × 8 in.), c. 1920
The Bluff Collection LP

Although best known for her outrageous behavior and voracious sexual appetite, the Baroness Elsa von Freytag-Loringhoven was a prolific artist who shared with Duchamp an interest in the ready-made. The Baroness, a key figure in the New York Dada movement, was proclaimed by one contemporary to be "the only one living anywhere who dresses dada, loves dada, lives dada."[1] Her unique portrait of Duchamp is composed entirely of found objects, including peacock feathers, a gear, a wound-up clock spring, wires, and a fishing lure, all bursting out of a wine glass.[2] The portrait embodies rather than depicts Duchamp, suggesting subtle references to the artist and his work. As Michael Taylor has observed, the feathers may invoke Rose Sélavy, Duchamp's newly minted feminine alter ego, while the wine glass evokes Duchamp's playful and fun-loving personality, as well as his *Large Glass*.[3] In an ironic inversion of the narrative of *The Large Glass*, the Baroness nursed an unrequited love for Duchamp, who rejected her frequent romantic overtures. Her fantastical portrait, which she had intended to give to Duchamp as a trophy for "The Most Inventive Artist," represents an attempt to "capture" the elusive Duchamp.[4]

JEQ

1. [J]ane [H]eap, "Dada," *The Little Review* 8, no. 2 (Spring 1992): 46. For more on the Baroness, see Irene Gammel, *Baroness Elsa: Gender, Dada and Everyday Modernity* (Cambridge, MA: MIT Press, 2001).

2. The Baroness also created a collage and pastel portrait of Duchamp, which, while somewhat more conventional, is decidedly modern in spirit. The work is discussed at greater length in Francis Naumann's essay in this volume and is reproduced in Francis Naumann with Beth Venn, *Making Mischief: Dada Invades New York* (New York: Whitney Museum of American Art; distributed by Harry N. Abrams, 1996), 124.

3. Michael R. Taylor, "New York," in Leah Dickerman, ed., *Dada: Zurich, Berlin, Hannover, Cologne, New York, Paris* (Washington, DC: National Gallery of Art, in association with Distributed Art Publishers, 2005), 291. As Francis Naumann has documented, Duchamp's female alter ego, Rose Sélavy, whose existence was first documented in 1920, evolved into Rrose Sélavy in the summer of 1921; see Naumann, *New York Dada*, 228, n. 59; on the evolution of the identity of Rose/Rrose Sélavy, see also James W. McManus's essay in this volume.

4. For more on the Baroness, see Amelia Jones, "'Women' in Dada: Elsa, Rrose, and Charlie," in Naomi Sawelson-Gorse, ed., *Women in Dada: Essays on Sex, Gender, and Identity* (Cambridge, MA: MIT Press, 1998), 142–72; Amelia Jones, "Eros, That's Life, or the Baroness's Penis," in Naumann with Venn, *Making Mischief*, 238–47; and Rudolf E. Kuenzli, "Baroness Elsa von Freytag-Loringhoven and New York Dada," in Sawelson-Gorse, *Women in Dada*, 442–75.

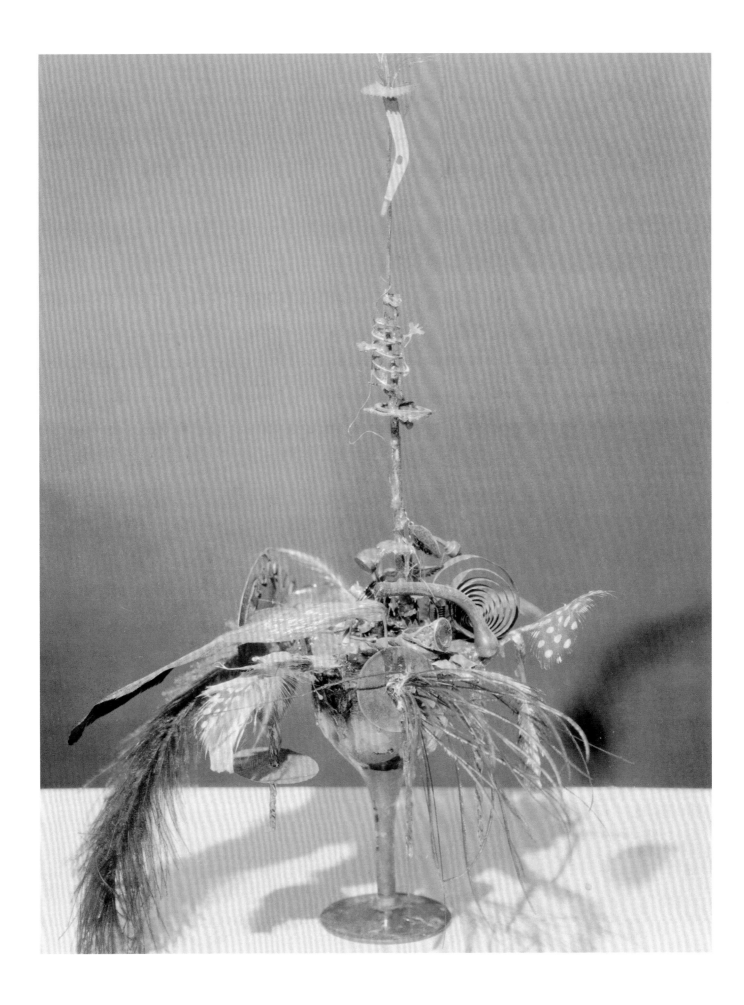

Rrose Sélavy (recto) *and Duchamp Looking Through the Brawl at Austerlitz* (verso)

Marcel Duchamp (1887–1968) and **Man Ray** (1890–1976)
Gelatin silver print, 25.4 × 20.3 cm (10 × 8 in.), 1921 (printed 1966)
Philadelphia Museum of Art, Pennsylvania, Marcel Duchamp Archive; gift of Jacqueline, Paul, and Peter Matisse in memory of their mother, Alexina Duchamp

With the images printed recto and verso on this sheet, Man Ray conflates two works by Duchamp, *Rrose Sélavy* and *Brawl at Austerlitz* (both from 1921), into one discussion, suggesting the rich complexity and intertextuality of Duchamp's works. Printed in 1966, they remind us of the anartist Duchamp's anarchism—fronted by Rrose Sélavy, signatory for both works, an agent for creating disruption.

During 1921 Man Ray photographed Duchamp in the guise of Rrose Sélavy on three occasions—the first two in New York and the third in Paris later in the year. This image comes from Rrose's second sitting, done sometime before April of that year.[1] Here Duchamp, in the guise of Rrose Sélavy, assumes the identity of another pseudopersonality, Belle Haleine. In the years following World War I, the fashion and beauty industries were gaining prominence. Advertisements for fashions, cosmetics, and perfumes filled the pages of prominent magazines like *Vanity Fair.* Parodying these efforts, Rrose, through the creation of the faux perfume *Belle Haleine: Eau de Voilette,* mocks advertising and marketing campaigns aimed at standardizing notions of taste and beauty. Lending her image to the project, Rrose, corporate figurehead (whose gender identity is questionable), appears as Belle Haleine, spoofing celebrity figures (e.g., Coco Chanel) who were transforming their identities into product brand names.[2]

La Bagarre d'Austerlitz (*Brawl at Austerlitz*), also dated 1921, an assisted readymade, consisted of a window made to Duchamp's specifications by hired craftsmen, giving it the look of a salesman's sample.[3] In this photograph Duchamp is seen peering through the glass. Not visible are the signatures of Duchamp and Rrose Sélavy, which appear on the object's side panels, giving it a brand-name identification. Strong echoes of Duchamp/Rrose, the anarchist assaulting commercialized conventions of taste and beauty, persist. Scrawled across the two large glass panels are white streaks in the shape of möbius strips. "These smudges imitate a glazier's markings, their placement in the middle of each pane a deliberate affront to taste and vision," as Janine Mileaf and Matthew S. Witkovsky have observed.[4] The image of Rrose Sélavy (recto) and the Möbius strip (verso) establish an intriguing correspondence suggesting that both serve emblematically, representing surfaces that are not orientable.[5]

JWM

1. Schwarz, *Complete Works*, vol. 2, 686, no. 385. This is one of three photographs taken for use as part of the readymade *Belle Haleine: Eau de Voilette.* Another version appeared on the label.
2. Lois W. Banner, *American Beauty: A Social History . . .Through Two Centuries of the American Idea, Ideal, and Image of the Beautiful Woman* (New York: Alfred A. Knopf, 1983), 275–77.
3. Naumann, *Art of Making Art*, 88.
4. Janine Mileaf and Matthew S. Witkovsky, "Paris," in Leah Dickerman, ed., *Dada: Zurich, Berlin, Hannover, Cologne, New York, Paris* (Washington, DC: National Gallery of Art, in association with Distributed Art Publishers, 2005), 363.
5. Roger Penrose, *The Road to Reality: A Complete Guide to the Laws of the Universe* (New York: Alfred A. Knopf, 2005), 234–36.

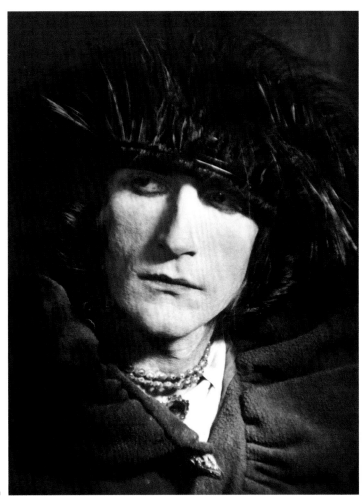

plate # 14a

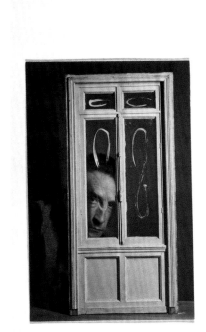

for Rrose — 1966

Rrose Sélavy — Man Ray 1921

plate # 14b

Belle Haleine: Eau de Voilette (Beautiful Breath: Veil Water)
Marcel Duchamp (1887–1968)
Photographic collage on light blue paper, 52.4 × 20.3 cm
(10⅝ × 8 in.), 1921
Private collection

By 1920 a fairly widespread economic prosperity based on greater mass production of consumer goods nurtured an emphasis on consumption. Movies and mass-circulation magazines became popular, helping to promote a national mass consumer culture. The desire to fabricate one's "identity," drawn in part from images of new moderns seen on the silver screen and in the pages of magazines like *Vanity Fair,* bolstered the growth of the fashion and beauty industries, and with them the creation and promotion of brand-name products linking the consumer with celebrities (figures such as King Edward VII, Henry Ford, and Coco Chanel) whose names and images adorned advertisements and product labels.

Questions regarding labels assigned to objects, fixing their identities—an issue already addressed by Duchamp with his readymades—

inform challenges he presents regarding the individual's identity in a modernist mass culture. In 1920 he introduced Rose Sélavy through the readymade *Fresh Widow.* Signed, dated, and copyrighted by the fictitious Ms. Sélavy, authorship of the object was transferred from its maker to her—establishing her as a brand name, giving her a trademark, and granting her celebrity status. In 1921 Rose—the pseudo-celebrity, a brand name/ trademark turned entrepreneur—underwrote a pseudo-product, the perfume labeled *Belle Haleine: Eau de Voilette.*[1] Described as an assisted readymade, *Belle Haleine: Eau de Voilette* consists of an appropriated Rigaud *Un Air Embaume* perfume bottle and case.

Man Ray, collaborating with Duchamp, created a new label for the faux product featuring Rose's photograph along with typography renaming the product "Belle Haleine / Eau de Voilette / RS / New York / Paris."[2] Reduced in size from the photograph collage shown here, the new label replaced the Rigaud original.

The photograph collage contains an important inscription by Man Ray that reads, "Marcel Duchamp (par procuration—Man Ray)."[3] The pretense of legitimacy created by means of power of attorney further alerts us that the two are spoofing fabrications of identity and authenticity, in this case advertising and/or legal language used as a means of certification.[4]

JWM

1. The act of signing the object, dating it, and applying its brand name, *Fresh Widow,* puts it in compliance with the 1909 copyright act. On Rrose Sélavy and the issue of trademark, see Helen Molesworth, "Rrose Sélavy Goes Shopping," in *The Dada Seminars,* ed. Lech Dickerman and Matthew S. Witkovsky (Washington, DC: Center for Advanced Study in the Visual Arts at the National Gallery of Art, 2008), 178–83.
2. Playfully structured, the first part of the name reads Belle Haleine, which translates as "beautiful breath." The second part is manipulated, twisting the phrase *eau de violette* to read *Eau de Voilette.* Inverting the *i* and *o,* the reference is shifted from the name of a flower to the French word that means veil or a hat-veil.

3. "Marcel Duchamp (by power of attorney—Man Ray)."
4. Duchamp's father was a notary, who through the application of his signature and stamp could assign authenticity to a document. The magic of this act was not lost on Duchamp. In 1919 Duchamp fashioned a faux check, drawn on the invented "The Teeth's Loan and Trust Company, Consolidated," as payment to his dentist. In 1920 Duchamp and Man Ray, along with Katherine Dreier, founded the Société Anonyme, Inc. (translated "Incorporated, Incorporated"), and Rose Sélavy copyrighted *Fresh Widow.* Likewise, *Monte Carlo Bond* of 1924 provides an opportunity to parody questions of authenticity. This faux document, which purports to be a legitimate bond, is riddled with playful allusions to French law covering corporate structure and activity. See James W. McManus, "Rrose Sélavy, Machinist/ Erotaton," in *Marcel Duchamp and Eroticism,* ed. Marc Decimo (Newcastle, Eng.: Cambridge Scholars Press, 2007).

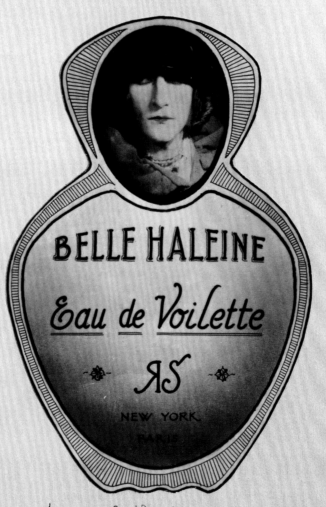

plate # **16**

Cover of *New York Dada*, 1921
Edited by Marcel Duchamp, with Man Ray
National Gallery of Art Library, Washington, DC;
David K. E. Bruce Fund

The first edition of the journal *New York Dada,* published in 1921 and edited by Duchamp and Man Ray, features an image of Duchamp's *Belle Haleine: Eau de Voilette* (1921) against a background on which the phrase "new york dada april 1921" appears upside down and continuously repeated.[1] *Belle Haleine,* a rectified readymade created with a Rigaud perfume bottle, was a collaborative effort of Duchamp and Man Ray, in which Duchamp pasted Man Ray's photograph of Rrose Sélavy to the front of the perfume bottle and replaced Rigaud's initials with "RS."[2] The addition of "New York" above "Paris" on the bottle's label identifies the "product," and Rrose herself, as an international creation. Adorned in pearls and a feathered hat, Rrose plays on conventional perceptions of femininity, throwing into question the nature of gender, and thus identity itself, as a fixed and stable entity. At this time, the word *rose* was commonly used in constructed titles for perfume.[3] The reuse of Rose's image on a perfume bottle makes explicit the association of femininity and commodity especially prevalent in advertising.[4]

The fact that this would be the first, and last, publication of *New York Dada,* underscores that the Dada movement failed to gain a strong following in the United States. Shortly after the publication of the journal, many proponents of Dada, including Man Ray, would leave the country. Although Duchamp was involved with Dada artists and ideas, he remained ambivalent about the movement. It is significant that Rrose, his eternally evasive alter ego, appears on the front of the journal rather than Duchamp himself. In this context, Belle Haleine takes on another layer of meaning, signifying Duchamp's unwillingness to firmly adhere to a specific artistic movement as well as to a particular identity.

JEQ

1. Translated as "Beautiful Breath, Veil Water," *Belle Haleine* possibly references Helen of Troy ("beautiful Helen"), an archetypal figure of beauty, while *voilette* plays on "eau de violette" (violet water), a common term for perfumed water. See Jones, *En-gendering,* 172–73, for more on the possible meanings of *Belle Haleine.*
2. Duchamp, in fact, credited Man Ray with adding the initials "RS." See Schwarz, *Complete Works,* vol. 2, 687.
3. For a further discussion of this topic, please see James W. McManus's essay in this volume.
4. Jones, *En-gendering,* 172–73.

153

plate # 17

Rrose Sélavy
Marcel Duchamp (1887–1968) and **Man Ray** (1890–1976)
Gelatin silver print, hand-retouched by Duchamp in black ink
and pencil, 13.8 × 9.8 cm (5⁷/₁₆ × 3⁷/₈ in.), 1921
Private collection

Of the personae created by Duchamp, Rrose Sélavy is by far the most important. We first encounter her in 1920 as the not seen signatory Rose, "copyrighting" the readymade *Fresh Widow*.[1] She made her first two "appearances" in early 1921 in New York. Over the course of the year her image, her location, and the spelling of her name all underwent changes. Her last appearance was in Paris near the end of that year. After this brief flurry of appearances she remained in the shadows, hidden from sight for the rest of her career.

By the 1920s to be beautiful meant the adoption of artificial means—clothing, hairstyle, and makeup (which had recently assumed legitimacy)—adding up to construct the "feminine mystique."[2] Early in 1921, posing for the first time before Man Ray's camera in drag as Rose, Duchamp coolly took aim, poking fun at moral, beauty, and fashion arbiters, inviting us to interrogate that "mystique." Inserted into the conversation as a pseudo-celebrity, she rubs up against images of celebrities and fashion models populating the pages of *Vanity Fair* magazine, images that provided code to class-conscious audiences identifying what constituted correct behavior and dress and standards of beauty. Rose mimics the subtly erotically charged images of female celebrities and fashion models whose portrayal on the pages of fashion magazines and in department store display windows waver between those of consumer and product to be consumed.

Sometime before April 1921, Rose made her second "appearance" before Man Ray's camera. Designedly fetishized and more feminized, the image produced in this photograph shows Duchamp cross-dressed as Rose promoting the fictitious product *Belle Haleine: Eau de Voilette* (see pl. 15).

That June, Duchamp, along with Rose, left New York for Paris, where he quickly renewed his friendship with Francis Picabia. The following month Picabia, in the July 10 special issue of *391*, made public for the first time the not-so-subtle alteration of Rose Sélavy's first name.[3] Adding a second r, it now read Rrose, the spelling that Duchamp would continue to use, in effect transforming her name into "Eros c'est la vie."

Man Ray arrived in Paris on July 22. Shortly after that, Gabrielle Buffet-Picabia provided him an important introduction—to the couturier Paul Poiret. By August he had received an assignment to photograph the season's offerings for the dress designer, the photographs appearing in *Vanity Fair* and other important magazines.[4]

During that fall the mischievous, inventive spirit shared by Duchamp and Man Ray, previously seen in the first two appearances of Rose,

1. Tomkins, *Duchamp*, 231.
2. Lois W. Banner, *American Beauty: A Social History . . . Through Two Centuries . . . of the American Idea, Ideal, and Image of the Beautiful Woman* (New York: Alfred A. Knopf, 1983); see especially "The Culture of Beauty in the Early Twentieth Century," 202–25, and "The Pursuit of Beauty as Woman's Role: The Beauty Contest, 1800–1921," 249–70.
3. Antonio Castronuovo, "Rrose Sélavy and the Erotic Gnosis," *Tout-fait, the Marcel Studies Online Journal*, http://www.toutfait.com/issues/volume2/issue_5/articles/castronuovo/castronuovo.html (August 8, 2005).
4. Neil Baldwin, *Man Ray, an American Artist* (New York: Clarkson N. Potter, 1988), 81–87.
5. Herbert R. Lottman, *Man Ray's Montparnasse* (New York: Harry N. Abrams, 2001), 40.
6. Schwarz, *Complete Works*, vol. 2, 693.

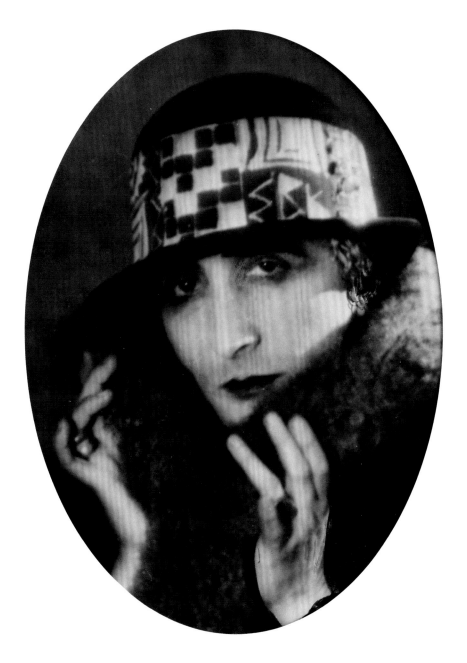

surfaced again.[5] And, as before, the weapon of irony was used to launch an assault—hurling the androgyne Rrose into fray, the male authors mocking the commercially marketed recipes for the construction of feminine identity. Rrose, established not only as a persona but a trademark and brand name, was ready to contribute to the fun.

The example shown here comes from Rrose's third and last photographed "appearance" before Man Ray's camera. The charade of the feminine masquerade is more fetishized than her previous two appearances as Rose. Arturo Schwarz draws our attention to the retouching of the print (presumably by Duchamp) that softens his features—attention given to makeup and the curls over the left ear and the eyebrows, adding sleeves at the wrists, and intensifying the shadow of the ring on the left hand. A more feminine and erotic Rrose (playing against the veiled *célibat*) emerges, costumed with the aid of Germaine Everling's (Picabia's girlfriend and later his second wife) hat and fur-trimmed coat. Moving beyond the gender play of the first two versions, here there is an actual female presence, in the form of Everling's arms and hands (she is behind Duchamp in drag, hidden from the camera's eye), physically surrounding the *célibat*.[6]

JWM

plate # 18

Tonsure (side view)
Marcel Duchamp (photographed by Man Ray, 1890–1976)
Gelatin silver print, 11.6 × 8.6 cm (4⁹⁄₁₆ × 3⅜ in.), 1921
Private collection

Some time between August 9 and September 17, 1921, Duchamp had his head partially shaved in the manner of the star/comet tonsure shown in the two photographs illustrated.[1] Considerable mystery continues to surround the event, including who administered the tonsure, where it took place, and the reason for the tonsure. Previous authors have also questioned the identity of the photographer.

Prominent among the names mentioned, both as barber and photographer, has been Georges de Zayas.[2] It has also been assumed that the event took place outside Paris at the home of the Dada painter/poet Georges Ribemont-Dessaignes. However, recently discovered letters written by Ribemont-Dessaignes to Tristan Tzara discount recollections that the event took place at his home.[3] But if not there, where?

Duchamp never confirmed de Zayas as either the barber or photographer. That confirmation comes from Robert Lebel.[4] Others seem likely candidates as well, leaving open questions of attribution. Yvonne Chastel comes to mind, having shaved Duchamp's head in a partial tonsure in 1919. She may also have photographed him afterward (pl. 11). In late 1921, when Duchamp received the star/comet tonsure, the two were sharing an apartment at 22 rue de la Condamine in Paris. Man Ray, who was also living at that address, deserves consideration. The year before, while still in New York, he and Duchamp collaborated in attempting to make an experimental film featuring Baroness Elsa von Freytag-Loringhoven having her pubic hairs shaved. Writing later about the incident, Man Ray identified himself both as a photographer and barber.[5]

In considering the question of who the photographer was, it is important to recall that throughout 1921 Man Ray was collaborating with Duchamp as the coauthor of the images of Rrose Sélavy. The two photographs of Duchamp with the star/comet tonsure included in this exhibition (from a greater number taken when the tonsure was being administered and later) can be traced to him. The negative for the photograph showing Duchamp from the side was discovered in Man Ray's archives among other negatives.[6] The print showing Duchamp from the rear carries on its verso Man Ray's studio stamp, "MAN RAY / 31^bis, RUE / CAMPAGNE / PREMIÉRE / PARIS XIV^e."[7]

Discounting Ribemont-Dessaignes's home as the location where the tonsure was administered, we are left without a good answer. One possibility is the neighborhood around rue de la Condamine. Among the many photographs of Duchamp with the tonsure not included in this book are those showing him, wrapped in a blanket, seated on a bench after the tonsure had been completed. The type of bench seen was then common in public parks, several of which existed in the neighborhood. Another photograph, taken indoors, looks as though it might have been made prior to the completion of the tonsure. Could this scene be the apartment shared by Duchamp and Yvonne Chastel?[8] Not all the photographs were taken on the same day. Comparing the two photographs in

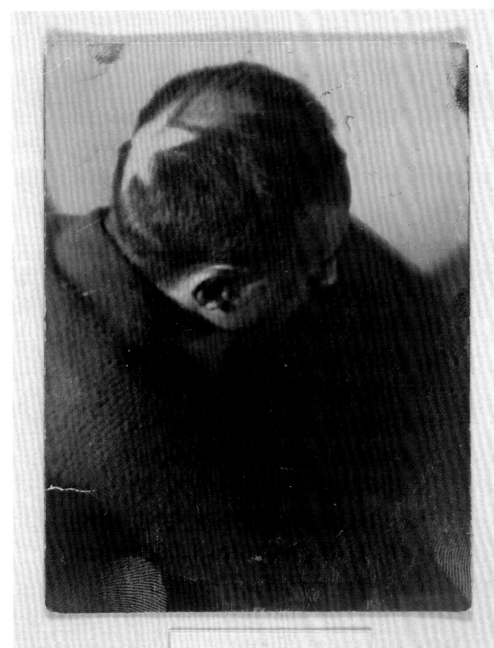

Marcel Duchamp

this exhibition with the others mentioned, the stubble visible in the field of the comet makes the case that they were taken some time later.

Duchamp's motive behind the star/comet tonsure poses a challenge. Ribemont-Dessaignes, seeing it, thought the effect "useless." The configuration of the star/comet tonsure certainly recalls Duchamp's 1912 note describing the "headlight child" that is reproduced in *The Green Box*. The pattern of the "headlight child" defined in that note parallels that of the star/comet tonsure. Also, his penchant for word play raises some intriguing possibilities. The *Larousse* gives meanings for *barbe* and *barber* that invite consideration.[9] Among the definitions given for *barbe* are references to

shaving and as a name for a comet's beard (or tail). *Barber* is defined as "to bore stiff." Boredom is an issue often addressed in Duchamp's writings and expressed in his work.[10] The tonsure historically served as a symbol of the *célibat*—one who withdraws from society. By 1921 Duchamp had repeatedly withdrawn from artistic, social, familial, and romantic engagements.[11] The five-point star shares the shape of the five-petaled wild rose, thought to be a secret symbol revealing the feminine principle. From Roman times it has been called the "Rose of Venus," its shape mimicking the pentagrammatic path traced by the planet Venus, making it a symbol of the goddess of love—*Eros c'est la vie*.[12] Considering Duchamp's annotation of one of the photographs of him with the star/comet tonsure, a case can be made that the tonsure is intended as a reference to Rrose Sélavy (as seen in the photograph *Voici Rrose Sélavy* [pl. 20]).

JWM

1. See n. 100 in James W. McManus's essay in this volume.

2. See "Portfolio: Photographs of or about Marcel Duchamp," *Étant donné Marcel Duchamp* 7 (2006): 222–24. Five photographs of Duchamp after having his hair cut are accompanied by text, based on a claim by Robert Lebel, suggesting de Zayas may also be the author of the photographs.

3. See n. 98 in James W. McManus's essay in this volume.

4. "Portfolio: Photographs," 224.

5. Man Ray, *Self-Portrait* (Boston: Little Brown, 1963), 263.

6. Frank Kolodny, fax to James W. McManus, February 7, 2008.

7. The appearance of this stamp suggests that the print was made at a later date. Man Ray moved his studio to this location around June 1922. According to Steven Manford, Man Ray used this studio stamp from the mid-1920s into the 1960s. See Manford, *Beyond the Photo: The Stamps of Man Ray* (Paris: Carnet de Rhinocéros, jr., 2006), unpaginated.

8. "Portfolio: Photographs," 222–23.

9. *Dictionaire Français Anglais/Anglais Français Larousse*, nouvelle edition, s.v. "barbe" and "barber."

10. See Naumann and Obalk, *Affectionately, Marcel*. The theme of boredom is repeated in letters to family and friends. Also, the title of his 1918 work, *Tu m'*, has been read as a contraction of the phrase "tu m'emmerdes," or, "you bore the shit out of me."

11. See James W. McManus's essay in this volume.

12. Cinquefoil (Rose of Venus), http://altreligion.about.com/library/glossary/symbols/bldefscinqefoil.htm (September 7, 2007).

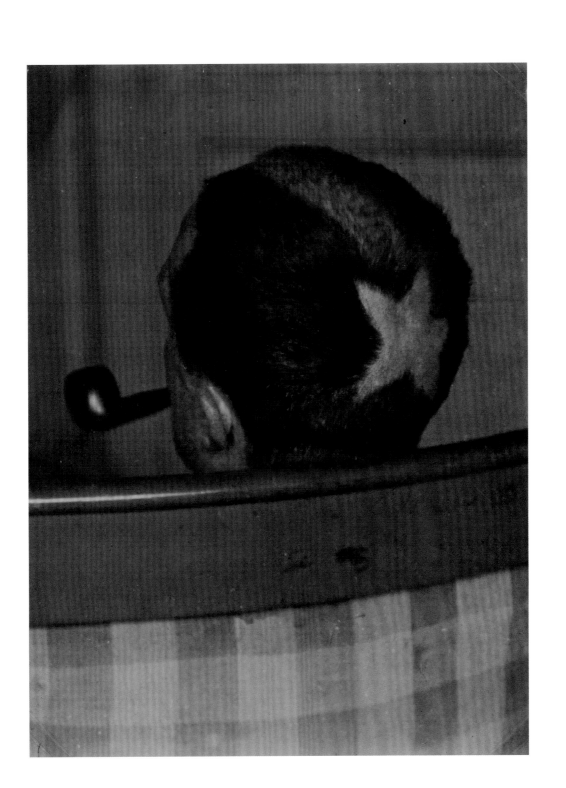

Tonsure (rear view)
Marcel Duchamp (photographed by Man Ray, 1890–1976)
Gelatin silver print on postal card, 12.1 × 9 cm (4¾ × 3½ in.), 1921
Private collection, courtesy Sean Kelly Gallery, New York

plate # 19

plate # **20**

Voici Rrose Sélavy, 1921
Marcel Duchamp (photographer unidentified)
Modern print from glass-plate negative, 7.8 × 12.7 cm (3 ¼ × 5 in.), after 1935 (printed 2008)
Philadelphia Museum of Art, Pennsylvania, Marcel Duchamp Archive; gift of Jacqueline, Paul, and Peter Matisse in memory of their mother, Alexina Duchamp

Sometime after 1935, Duchamp made a collage, pasting a cropped print of the 1921 photograph of himself with the star/comet tonsure on a piece of white paper, inscribing it with the legend, "Voici Rrose Sélavy, 1921."[1] The legend provides important clues to understanding correspondences in Duchamp's mind between his constructed identity of the CÉLibat operating in relationship with that of the MARiée that contribute to fashioning his female alter ego, Rrose Sélavy.[2]

The collage has since been lost. What survives is a small glass-plate negative taken "after 1935." Duchamp kept this glass-plate negative stored in a Gevaert "Ultra Panchro 3000" box along with the 1917 photo postcard of himself, Francis Picabia, and Beatrice Wood taken at the Broadway Photo Shop (pl. 6). Additional items found in the box include a smaller box for J. Jougla brand 9-by-12 cm glass photographic plates, along with eight other glass-plate negatives of the same size. All are dated "after 1935," which coincides with his 1936 trip to the United States to repair *The Large Glass* and to collect images for *Boîte-en-valise*, the project he had recently begun.[3]

The negatives show the *Chocolate Grinder* and *Dr. Dumouchel* (see fig. 6.4) (which were in the Arensberg collection in Hollywood), the *Three Standard Stoppages* before the canvas panels were trimmed and attached to their glass plates (located at Katherine Dreier's home in West Redding, Connecticut), and *Nous Nous Cajolions* (in the collection of Pierre Massot, Paris). Each of the works recorded on these plates, with the exception of *Voici Rrose Sélavy*, was included in the *Boîte-en-valise*. The contents of this box invite interesting questions. Did Duchamp carry with him on his 1936 journey a glass-plate camera and use it to record images of his works? If he did, they must have been for study purposes because photographs used for the *Boîte* were taken by professional photographers.[4] Does the presence of the glass-plate negative of *Voici Rrose Sélavy* among this group suggest he might have considered its inclusion in the *Boîte* as well? If so, he must have changed his mind because it is not included.

JWM

1. Archives of the Philadelphia Museum of Art, Alexina and Marcel Duchamp Papers, box 21, folders 1–9.
2. For a further discussion of this relationship see James W. McManus's essay in this volume.
3. For an extensive and informative discussion of Duchamp's efforts at gathering images for his *Boîte-en-valise,* see Ecke Bonk, *Marcel Duchamp: The Box in a Valise* (New York: Rizzoli, 1989).
4. For example, the commercial photographer Sam Little was hired to photograph the works from the Arensberg collection. Similarly, in 1938, Robert Coates photographed *The Large Glass.*

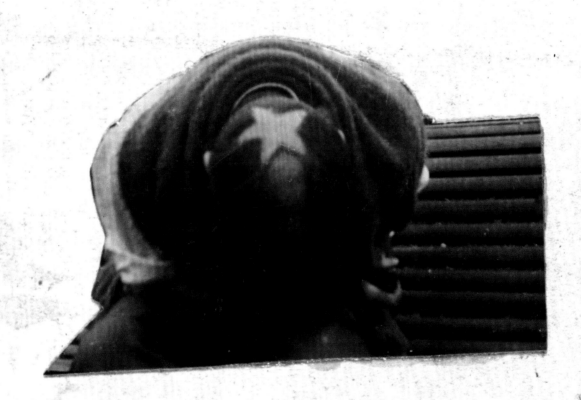

Voici
rrose sélavy.

1921

plate # **21**

Cela Vit (Portrait of Marcel Duchamp)
Man Ray (1890–1976)
Etching, 38.1 × 28.6 cm (15 × 11¼ in.), 1971
(after 1923 painting)
Tristan N. Baum

Closely collaborating with Duchamp in the creation of Rrose Sélavy ("Eros, C'est la vie"), Man Ray photographed Duchamp in the guise of his female alter ego on three separate occasions in 1921. In 1922, he made an abstract photograph that he titled ƎƧOЯROSE SEL À VIE ("Rose, Salt of Life").[1] The following year Man Ray painted the now-lost portrait of Marcel Duchamp, *Cela Vit*, on which the etching shown here is based. During the course of his career, Man Ray photographed Duchamp on numerous occasions. However, the photograph used as the basis for this work is not his. It is the 1912 photograph by Hans Hoffmann (pl. 1).[2] Here the decollated head of Duchamp floats in the picture space over what Man Ray described as "some imagined motifs in the background so the painting was not too factual."[3] George Baker attaches considerable importance to the title, noting a shift in meaning from Duchamp's "c'est la vie" ("that is [just] life") to "cela vit" ("that is [there] is living [alive]").[4] Man Ray encodes the work with the rebuslike inscription appearing in the lower right corner. Combining an image of a rose next to the words "Cela Vit," the pictorial pun operates enigmatically, suggesting the lack of separation between Rrose and Marcel.[5]

JWM

1. For an illustration of this piece, see Jones, *En-gendering*, 152.

2. See *Man Ray: The Photographic Image*, ed. Janus, trans. Murtha Baca (Woodbury, NY: Barrons, 1980), 182. Man Ray informs the reader that he set out to make a painting that mimicked a photograph, causing confusion about whether it was a painting or a photograph. Roughly thirteen years later, he used the same photograph for his portrait of Duchamp seen through an overlaid photogram of the *Glissière* (*Glider Containing a Water Mill in Neighboring Metals*, 1913–15), also included in this exhibition (pl. 35).

3. Ibid.

4. See George Baker, "Keep Smiling," in *The Dada Seminars*, ed. Leah Dickerman and Matthew S. Witkovsky (Washington, DC: Center for Advanced Study in the Visual Arts at the National Gallery of Art, 2005), 191.

5. A similar image was fashioned by Duchamp earlier. Concluding a letter to Ettie Stettheimer written on July 6, 1921, he signed it "Rose-Mar-cel." See Naumann and Obalk, *Affectionately Marcel*, 99. And, in his 1924 photograph *Ciné Sketch*, Man Ray shows Duchamp in the role of Adam, where he is nude except for a rose covering his genitals, another possible allusion to Rrose Sélavy. See Michael R. Taylor, *Thomas Chimes: Adventures in Pataphysics* (Philadelphia: Philadelphia Museum of Art, 2007), 120.

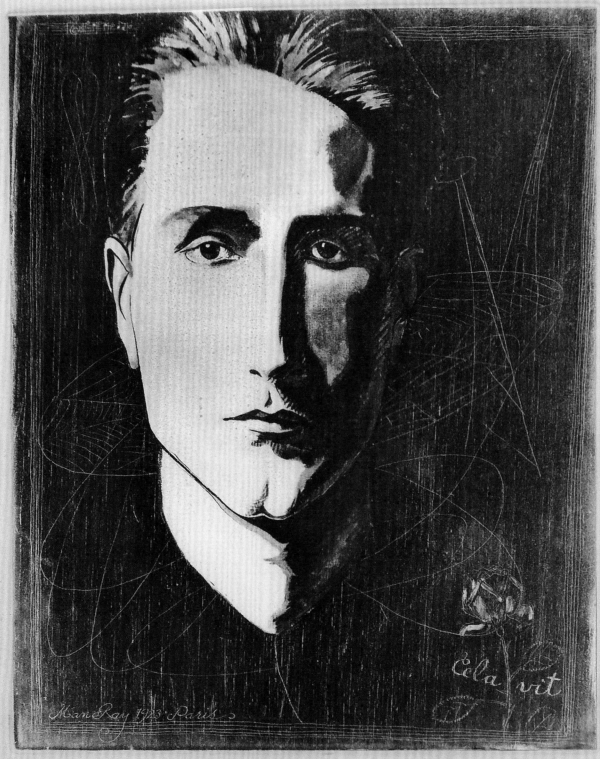

E/A Joi Tristan Baum Man Ray

Framed by a continuous string of alternating letters *M* and *D*, Florine Stettheimer's portrait of Marcel Duchamp seems set in a diaphanous world of temporal, spatial, and gender ambiguity. Rrose Sélavy's "serpentine, seemingly boneless" shape rises genie-like from a crank wound by the seated Duchamp.[1] The twin figures are painted in pale washes of color, suggestive of the ephemeral aspect of Duchamp's persona, and placed amid a variety of symbolic elements. Duchamp's transatlantic affiliations are referenced by the entwined French and American flags. His love of chess and involvement in the Société Anonyme are symbolized by the knight. Stettheimer's image of the clock, located in the center of the picture plane, activates the sensation of axial rotation, reminiscent of Duchamp's *Bicycle Wheel* (1913–15) and *Rotary Glass Plates* (1920) and suggesting his interest in time and space.[2]

Henry McBride summed up the painting with his observation, "The most complicated character in the whole contemporary range of modern art has been reduced to one transparent equation," as Duchamp sits "perched aloft upon a Jack-in-the-Box contraption which he is surreptitiously manipulating to gain greater height for his apotheosis."[3]

AK

1. Barbara J. Bloemink, *The Life and Art of Florine Stettheimer* (New Haven, CT: Yale University Press, 1995), 144.
2. Ibid., 145.
3. McBride, as quoted in ibid., 143–44.

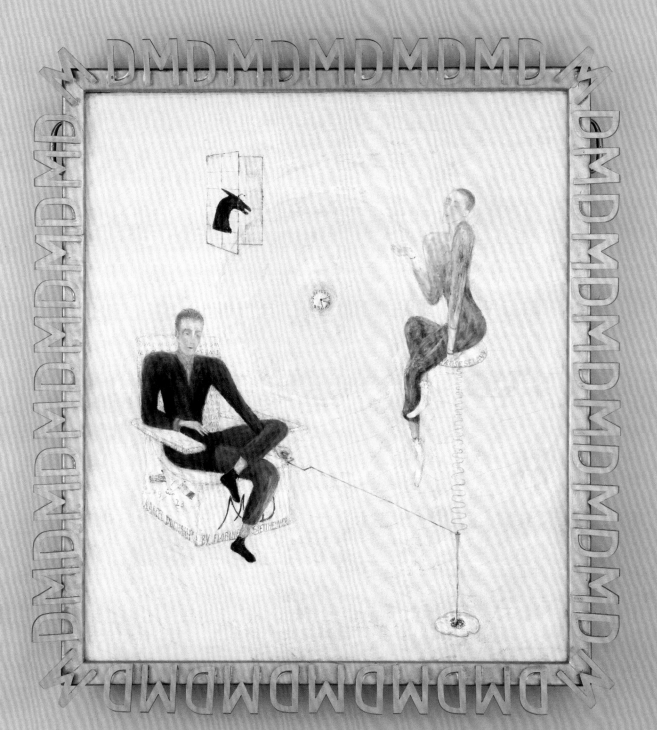

plate # 23

Marcel Duchamp
Alfred Stieglitz (1864–1946)
Palladium print, 20.2 × 19.1 cm (7¹⁵⁄₁₆ × 7½ in.) sight, 1923
National Gallery of Art, Washington, DC; Alfred Stieglitz Collection
1949.3.586

"He is ever the master of masters," wrote Alfred Stieglitz to his friend Julian Levy in November 1934. "[W]hatever he does he always amazes me and fills me with great delight."[1] Acquainted with Marcel Duchamp since 1915, when Duchamp arrived in New York—and the United States—for the first time, Stieglitz played an important role in the artist's early career. As owner and director of the avant-garde Fifth Avenue gallery 291, Stieglitz had helped promote modern art in America, providing encouragement to an important circle of American and European artists. Perhaps most famously, Stieglitz photographed Marcel Duchamp's *Fountain*, bearing the artist's pseudonym for the occasion, "R. Mutt," after it was rejected in 1917 from an exhibition of the Society of Independent Artists. In making this pair of photographs in early 1923, Stieglitz participated in yet another artistic "prank" on Duchamp's part. Taken from the front and from the side, the pictures adopt a well-known idiom in criminal photography. Around this time, Duchamp, who was headed back to France after an extended sojourn in the United States, would produce a humorous version of a wanted poster (see pl. 25) featuring images of himself. Although Duchamp appears not to have used Stieglitz's photographs, the conceptual relationship between the two projects is clear.[2]

ACG

1. Alfred Stieglitz to Julien Levy, November 16, 1934, Julien Levy Archive, Connecticut; this letter was exhibited in "Dreaming in Black and White: Photography at the Julien Levy Gallery," Philadelphia Museum of Art, June 17–September 17, 2006. I thank Sarah Greenough for her assistance with the transcription of this letter.
2. Ecke Bonk makes a connection between Stieglitz's photographs and those included in *Wanted: $2,000 Reward*. Although visual analysis suggests that the photographs on the poster were not actually by Stieglitz, Bonk's observation about the relationship of the two projects is invaluable. See Ecke Bonk, pl. 56, "Ready made rectifié: 'WANTED/$2,000 REWARD,'" in *Marcel Duchamp, The Portable Museum: The Making of the Boîte-en-valise, de ou par Marcel Duchamp ou Rrose Sélavy, Inventory of an Edition*, trans. David Britt (1986; London: Thames and Hudson, 1989), 243. I thank Sarah Greenough for her input on this question.

Marcel Duchamp
Alfred Stieglitz (1864–1946)
Palladium print, 25 × 20.2 cm (9 13/16 × 7 15/16 in.), 1923
National Gallery of Art, Washington, DC; Alfred Stieglitz Collection
1949.3.585

plate # 24

plate # **25**

Wanted: $2,000 Reward
Marcel Duchamp (1887–1968)
Lithograph, 20.8 × 16.2 cm (8¾₆ × 6⅜ in.), 1961
(replica of 1923 original)
Frances Beatty and Allen Adler

Originally created in 1923, Duchamp's *Wanted: $2,000 Reward* was the last work of art that the artist completed before leaving New York in 1923 to return to France, where he would largely remain until 1942.[1] Duchamp based the work, a rectified readymade, on a joke notice designed for tourists that he found in a New York restaurant. The poster advertised a reward for information concerning one George W. Welch, who used the aliases Bull and Pickens and operated a bucket shop in New York under the name "Hooke, Lyon, and Cinquer." Duchamp, who clearly relished the impersonation described in this poster, pasted two head shots of himself in the blank spaces and had a printer add yet another alias to the poster, that of his recently created alter ego, Rrose Sélavy.[2]

Although *Wanted* challenges traditional conceptions of the creative process, the work also played a significant role in Duchamp's construction of his artistic identity. By invoking a series of pseudonyms, including that of Rrose Sélavy, Duchamp highlighted his playful adoption of alternative personas. And with regard to associating himself with the crime of having "operated a bucket shop," Duchamp also raised the specter of chance and his use of gambling as a metaphor for the pursuit of recognition.[3] Duchamp's selection of a poster advertising remuneration in the amount of $2,000 in exchange for information leading to the capture of the fugitive may also have been deliberate. At the time that he created *Wanted*, $2,000 was the highest price that Duchamp's work had commanded. The $2,000 reward offered matched the price that the Arensbergs had paid for *Nude Descending a Staircase*, as well as the amount that they would ask of Katherine Dreier for *The Large Glass*.[4]

The significance of *Wanted* is further suggested by Duchamp's re-creation of the work at key moments in his career. In 1938, Duchamp replicated *Wanted* for inclusion in the *Boîte-en-valise*, a portable museum of his art and a summation of his artistic production to that time.[5] Duchamp would again resurrect *Wanted*, with a new inscription in his own hand, which read "by or of Marcel Duchamp or Rrose Sélavy," for the poster advertising his 1963 exhibition at the Pasadena Art Museum (pl. 65), his first full-scale retrospective in the United States. Duchamp's various alterations of *Wanted*, which became a touchstone of his oeuvre, demonstrate how he continually shifted his identity, playing what he called "a little game between 'I' and 'me.'"[6] The easily reproducible nature and flexible format of *Wanted* also led other artists, such as Julien Levy, Richard Pettibone, Sturtevant, and Gavin Turk—all featured here—to appropriate the work for their own ends. In doing so, these artists assimilated and built upon Duchamp's legacy, engaging with the crucial issues, such as identity, replication, and the status of art itself, that *Wanted* leaves open for discussion.

JEQ/ACG

1. *Wanted: $2,000 Reward* is conventionally dated to 1923. See, for example, Schwarz, *Complete Works*, vol. 2, 699. Francis Naumann notes that although 1923 is the favored date, Duchamp himself dated the poster "1921/ or 22" in a list compiled in the mid-1940s (Duchamp Archives, Philadelphia Museum of Art); see Naumann, *Art of Making Art*, 91, 94 n. 54. During his sojourn in Paris, Duchamp would make three trips back to the United States, but he did not relocate there permanently until after World War II.

2. See pl. 23, n. 2.

3. Duchamp's association of himself with betting and gambling through his reference to a "bucket shop" is discussed by Keith Hartley, "Andy Warhol. The Photomat Self-Portraits," in *Andy Warhol: Selbstportraits/Self-Portraits*, ed. Dietmar Elger (Ostfildern-Ruit: Hatje Cantz, 2004), 50. For more on Duchamp's invocation of the metaphor of gambling with respect to his career, see pls. 27 and 28 and Anne Collins Goodyear's essay in this volume.

4. Francis Naumann establishes the connection between the reward on *Wanted* and the price paid for *Nude Descending a Staircase* and *The Large Glass*. Naumann speculates that Duchamp may have in fact equated the amount of $2,000 with his own artistic value. See Naumann, *Art of Making Art*, 94 n. 54. Calvin Tomkins also mentions the connection between the reward on *Wanted* and the price that Dreier paid for *The Large Glass* (Tomkins, *Duchamp*, 250).

5. Ecke Bonk describes the process of replication for the *Boîte-en-valise* in further detail. See Bonk, *Marcel Duchamp, The Portable Museum: The Making of the Boîte-en-valise, de ou par Marcel Duchamp ou Rrose Sélavy, Inventory of an Edition*, trans. David Britt (1986; London: Thames and Hudson, 1989), 243.

6. Katharine Kuh, interview with Marcel Duchamp, in Katharine Kuh, *The Artist's Voice: Talks with Seventeen Artists* (New York: Harper and Row, 1962), 83, quoted in Anne Collins Goodyear's essay in this volume. Goodyear discusses Duchamp's words in terms of his use of the portrait profile and his reference to the origins of portraiture itself.

WANTED

$2,000 REWARD

For information leading to the arrest of George W. Welch, alias Bull, alias Pickens. etcetry. etcetry. Operated Bucket Shop in New York under name HOOKE, LYON and CINQUER. Height about 5 feet 9 inches. Weight about 180 pounds. Complexion medium, eyes same. Known also under name RROSE SÉLAVY

plate # **26**

Portrait of Rrose Sélavy
Francis Picabia (1879–1953)
Cover for *391*, no. 19, 36.9 × 55.2 cm (14½ × 21¾ in.), 1924
The Museum of Modern Art Library, New York City

The interplay between imagery and text on the cover of the last issue of *391* reads like a playground/battleground for its editor, Francis Picabia, who used his journal as a weapon to carry out his assault on André Breton and his nascent surrealism. The term *l'instantanéisme*, printed numerous times across the cover, highlights what William A. Camfield called Picabia's "antidote to Surrealism."[1] Accompanying the text is Picabia's profile portrait of the internationally renowned French boxer Georges Carpentier, whose profile and dandyish qualities were strikingly similar to those of Duchamp.[2] Picabia appears to have been trafficking on the similarity of the two men's profiles to create identity confusion. Picabia took some license, slightly adjusting Carpentier's facial features and adding the pipe clenched tightly in his teeth, making him look more like Duchamp.[3] The artist's allegiance to Dadaist irreverence is further demonstrated by crossing out Carpentier's signature in the lower part of the drawing and replacing it with Rrose Sélavy's, affecting a crisis of gender identity. Made present through her signature, the feisty Rrose could step in, entering the ring against Picabia's opponents.[4]

JWM

1. William A. Camfield, *Francis Picabia: His Art, Life and Times* (Princeton, NJ: Princeton University Press, 1979), 208.
2. Carpentier was awarded the Croix de Guerre and the Médaille Militaire. He was given the nickname "the Orchid Man" by his manager, François Deschamps, because of his polished, debonair appearance. http://www.boxrec.com/media/index.php/Georges_Carpentier (October 5, 2008).
3. An examination of a number of photographs of Carpentier failed to show him pictured with a pipe. By contrast, Duchamp is regularly seen holding or smoking a pipe.
4. Picabia had borrowed from Duchamp on previous occasions for his own purposes. Among them are his reproduction of *L.H.O.O.Q.* (sans beard) on the cover of the March 12, 1920, issue of *391*, and his alteration of the spelling of Rose, giving it the second *r*, which affected its meaning, in the July 10, 1921, issue of *391*.

Pourquoi payer le luxe de votre fournisseur ou son ignorance ?

Pour être un penseur il faut penser.

Pourquoi payer votre fournisseur ou son ignorance ?

Das leben ist ein schöne abord.

Pourquoi payer le luxe ou son ignorance ?

Tout appel non justifié expose aux poursuites judiciaires et du Salon des Tuileries.

Pourquoi payer son ignorance.

C'est ainsi que les saintes images ont une vague odeur de fromage.

Pourquoi ?

Saviez-vous qu'il y a une Adaptation Française ?

E. L. T. MESENS

— En rêve.

— Les bordels font une impression très forte.

— On croirait entrer dans un Conservatoire.

— Les invalides justifient le cubisme.

— Le pôle positif aime le pôle négatif, puisqu'on vit on aime.

— J'aime la bière et les roses trémières.

— Un homme en costume d'Adam.

— Les chats sont heureux de vivre en dessous des chaises.

— La vache a du sentiment.

RENÉ MAGRITTE

Le conscient est l'Évolution Dernière et Tardive du système organique, et par conséquent aussi, ce qu'il a dans ce système de moins achevé et de moins fort.

Un Instantané te...

LES BALLETS SUÉDOIS DONNERONT
LE 27 NOVEMBRE
AU THÉATRE DES CHAMPS ÉLYSÉES

" RELÂCHE "

BALLET
INSTANTANÉISTE

EN DEUX ACTES, UN ENTR'ACTE CINÉMATOGRAPHIQUE

ET LA QUEUE DU CHIEN
PAR

FRANCIS PICABIA
MUSIQUE
D'

ERIK SATIE
CHORÉGRAPHIE DE JEAN BORLIN

Apportez des lunettes noires et de quoi vous boucher les oreilles.

RETENEZ VOS PLACES

Messieurs les ex-Dadas sont priés de venir manifester et surtout de crier : « A BAS SATIE ! A BAS PICABIA ! VIVE LA NOUVELLE REVUE FRANCAISE ! »

" 391 "
N° 19 **PRIX : 2 Frs**

Dépositaire " AU SANS PAREIL "
37, Avenue Kléber, PARIS

Le Gérant, PIERRE DE MASSOT

DADAISME, INSTANTANÉISME

Journal de l'Instantanéisme

POUR QUELQUE TEMPS

L'INSTANTANÉISTE EST UN ETRE EXCEPTIONNEL
CYNIQUE ET INDÉCENT

LE SEUL MOUVEMENT C'EST, LE MOUVEMENT PERPÉTUEL !

L'INSTANTANÉISME : EST POUR CEUX QUI ONT QUELQUE CHOSE A DIRE.

Dans son prochain numéro " 391 " donnera une liste des premiers Instantanéistes, hommes exceptionnels.

IL N'Y A QU'UN MOUVEMENT C'EST LE MOUVEMENT PERPÉTUEL !

L'INSTANTANÉISME : NE VEUT PAS D'HIER.

L'INSTANTANÉISME : NE VEUT PAS DE DEMAIN.

L'INSTANTANÉISME : FAIT DES ENTRECHATS.

L'INSTANTANÉISME : FAIT DES AILES DE PIGEONS.

L'INSTANTANÉISME : NE VEUT PAS DE GRANDS HOMMES.

L'INSTANTANÉISME : NE CROIT QU'A AUJOURD'HUI.

L'INSTANTANÉISME : VEUT LA LIBERTÉ POUR TOUS.

L'INSTANTANÉISME : NE CROIT QU'A LA VIE.

L'INSTANTANÉISME : NE CROIT QU'AU MOUVEMENT PERPÉTUEL.

171

plate # 27

Monte Carlo Bond
Marcel Duchamp (1887–1968)
Photocollage on letterpress print, 31.4 × 19.5 (12⅜ × 7¹¹⁄₁₆ in.), 1924
Private collection

Created in 1924, after he had left New York for Paris, Marcel Duchamp's *Monte Carlo Bond*, like his *Wanted: $2,000 Reward* (1923), reveals the artist's keen understanding of the authoritative role of traditional portraiture, even as he subverts it.[1] Reminiscent of his use of Man Ray's photograph of himself as Rrose Sélavy in the mock perfume label *Belle Haleine: Eau de Voilette* (see pl. 15), Duchamp has collaged another likeness—playfully transformed with Man Ray's assistance by the application of soapsuds to his hair and face—to a bond of his own invention. Duchamp designed the document as he worked out a system to beat the roulette tables in Monte Carlo, with the intention of generating profits. Announcing the stock offering in *The Little Review* at Duchamp's request, Jane Heap described the terms of the venture:

> Marcel Duchamp has formed a stock company of which he is the Administrator, etc. Shares are being sold at 500 francs. The money will be used to play a system in Monte Carlo. Stockholders to receive 20 percent interest, etc. Some of the shares have arrived in this country and are very amusing in makeup. They carry a roulette wheel with a devil-like photograph of Marcel pasted upon it, they are signed twice by hand—Rrose Sélavy (a name by which Marcel is almost as well-known as by his regular name) appears as president of the company. . . . [Marcel] will go to Monte Carlo in early January to begin the operation of his new company.[2]

In advertising his new enterprise, Duchamp hoped to attract thirty investors, and he numbered his bonds accordingly, although fewer than eight of the collaged bonds were actually created.[3] The company's statutes, describing the operation of the company and the rights of the stockholders and board of directors, were published on the back of each bond. The key indicator of the certificate's authenticity, as Duchamp wrote Ettie Stettheimer, who agreed to invest, was the inclusion in the upper right of a fifty-centime stamp.[4] Indeed, when Duchamp later created a lithographed edition of the bond for publication in the 1938 Christmas edition of the magazine *XXe Siècle* and inclusion in his *Boîte-en-valise*, the stamp was left out.[5]

Duchamp's unconventional approach to "playing" the market is buttressed in documents whose authoritative gestures quickly dissolve into a Dadaist joke. The signatories to the company, whose distinct identities should provide a check to one another and a protection to investors, are, in fact, simply the artist and his alter ego, and the authoritative likeness that seems to endorse the venture is yet another of the artist's aliases, this time the god Mercury.[6] The motto emblazoned repeatedly in the background, with an air of respectability, is a pun: "moustiques domestiques demistock" ("domestic mosquitoes half-stock").[7] But if the document is clearly a spoof, it was not without philosophical significance for Duchamp, who would later write to his brother-in-law Jean Crotti: "Throughout history artists have been like gamblers at Monte Carlo, and the blind lottery causes some to stand out and others to be ruined."[8]

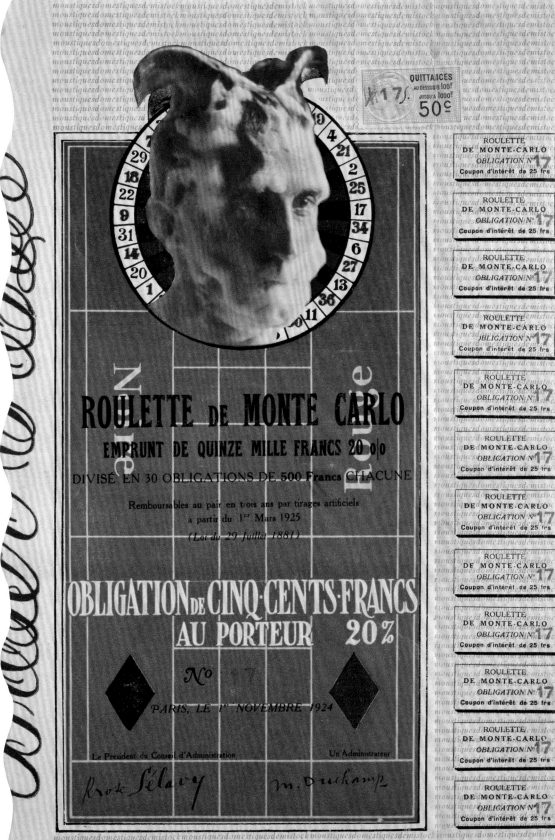

Duchamp's assumption of the guise of Mercury, with a liberal application of soapsuds molding his hair into an imitation of the god's winged helmet, is appropriate for the *Monte Carlo Bond,* in light of Mercury's identification—among other things—as the god of commerce.[9] But as is typical of Duchamp, his self-stylization introduces other readings as well, including allusions to alchemical transformation.[10] The juxtaposition of Duchamp (aka Mercury) with the roulette wheel suggests the role of the wheel in alchemy, which, through circulatory transformation, unites opposites. Its round shape may refer to the distillation flask in which contrasting entities, the sun (male) and the moon (female), are brought into union. In this context, Duchamp's evocation of Mercury takes on yet more significance, representing, as it does, the intrinsic pairing of elements male (Duchamp) and female (associated with the element of Mercury).[11] A further detail reinforces Duchamp's invocation of alchemical forces: November 1, 1924, the date of issue, fell on a Saturday, the day of Saturn, whose alchemical metal is lead. March 1, 1925, the date when the bond matured, fell on a Sunday, the day of Soleil, whose alchemical metal is gold. Thus, through the alchemical traditions he parodies, Duchamp playfully suggests that riches will result from something base, just as the artist has enhanced his own powers through the fluid shifts of identity he repeatedly invokes.[12]

ACG/JWM

1. This work is the subject of David Joselit's "Marcel Duchamp's *Monte Carlo Bond* Machine," *October* 59 (Winter 1992): 8–26.
2. J[ane] H[eap], "Comment" [advertisement for *The Monte Carlo Bond*], *The Little Review* 10, no. 2 (Fall–Winter 1924–25): 18. Reprinted in *WMD,* 185. Francis Naumann discusses Duchamp's approach to Heap and her assumption of the role of his "advance agent" in New York. See Naumann, *Art of Making Art,* 101.
3. Schwarz, *Complete Works,* vol. 2, 703.
4. Naumann, *Art of Making Art,* 101.
5. Ibid., 137.
6. The identification of Duchamp as Mercury is made by James W. McManus, "Rrose Sélavy: Machinist/Erotaton," in *Duchamp and Eroticism,* ed. Marc Decimo (Newcastle, Eng.: Cambridge Scholars Press, 2007), 66–70. As McManus points out, the inscription "Loi du 29 Juliette, 1881," prominently featured in the center of the bond, refers to the freedom of press law that required publishers to identify their directors. In so listing himself and Rrose Sélavy, Duchamp adds a further air of legitimacy to his bond (ibid., 66).
7. Naumann, *Art of Making Art,* 100.

8. Marcel Duchamp, letter to Jean Crotti, August 17, 1952, Jean Crotti Papers, AAA.
9. As James W. McManus points out, Mercury is also the god of salt, bringing to mind Robert Desnos's anagram of Duchamp's name, "Marchand du Sel," or "Salt Seller"; see McManus, "Rrose Sélavy," 67. The anagram was originally published in *Littérature,* nouvelle série 7 (December 1, 1922). One hundred forty-four of Desnos's puns and wordplays were published under the title "Rrose Sélavy," 14–22. The anagram "Marchand du Sel" appears on p. 15.
10. These are treated at length by McManus in "Rrose Sélavy," 56–70.
11. Ibid., 67.
12. Ibid., 68.

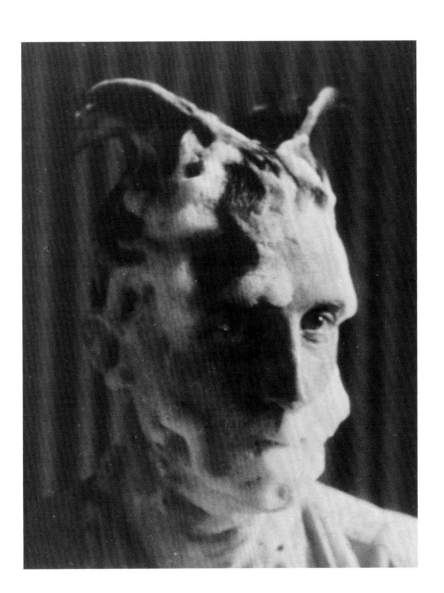

Duchamp with Shaving Lather for Monte Carlo Bond
Man Ray (1890–1976)
Gelatin silver print, 12.2 × 9.2 cm (4¹³⁄₁₆ × 3⅝ in.), 1924
Philadelphia Museum of Art, Pennsylvania; gift of Jacqueline, Paul, and
Peter Matisse in memory of their mother, Alexina Duchamp

plate # 28

plate # **29**

Profile Portrait of Marcel Duchamp
Man Ray (1890–1976)
Gelatin silver print, 29.8 × 24.8 cm (11¾ × 9¾ in.), 1930 (printed later)
Library of Congress, Washington, DC

The profile portrait, with its long and august history, is a format favored by Duchamp, as can be seen in a number of works included here. Since antiquity, profile images of a ruler's head on coins and medals provided a schematic means for establishing identity.[1] During the 1920s and 1930s, this pose once again assumed considerable popularity and was used extensively by portrait photographers, including Man Ray.[2]

Duchamp's image in this photograph fluctuates between positive and negative, the effect of a technique called *solarization*.[3] Although the profile in portraiture generally connotes a concrete identity by emphasizing each sitter's unique physiography, here solarization disrupts the stability of the image, leaving a sense of ambiguity that seems appropriate when considering Duchamp's penchant for mystery.

JWM

1. Shearer West, *Portraiture* (Oxford: Oxford University Press, 2004), 77–78.
2. See Man Ray, *Man Ray's Celebrity Portrait Photographs* (New York: Dover, 1995), xi. Man Ray gave the subject of each photograph included a rating from 0 to 20, according "to a little game once popular among the Surrealists." Twenty points was given when he felt fully attuned to the personality and had an unqualified interest in the photograph of that person. He gave this portrait of Duchamp a 19. (Virginia Woolf received a 3, James Joyce a 6, and Juliet Man Ray, 20).
3. Bruce Museum, Greenwich, Connecticut, *Man Ray's Paris Portraits—1921–1939* (March 13, 1999–June 20, 1999) http://www.tfaoi.com/newsm1/n1m105.htm (December 14, 2007). "Solarization resulted from the partial development of a photograph when a light is quickly turned on and off during development and resulted in a flattening of the tonal range and beautiful, etched black outlines. There are many conflicting versions of the discovery of solarization, including that of Lee Miller, the photographer who was then Man Ray's assistant and one of his favorite models. Solarization, she wrote, resulted when something ran across her foot in the darkness during the development of a photograph, causing her to turn on and off a light."

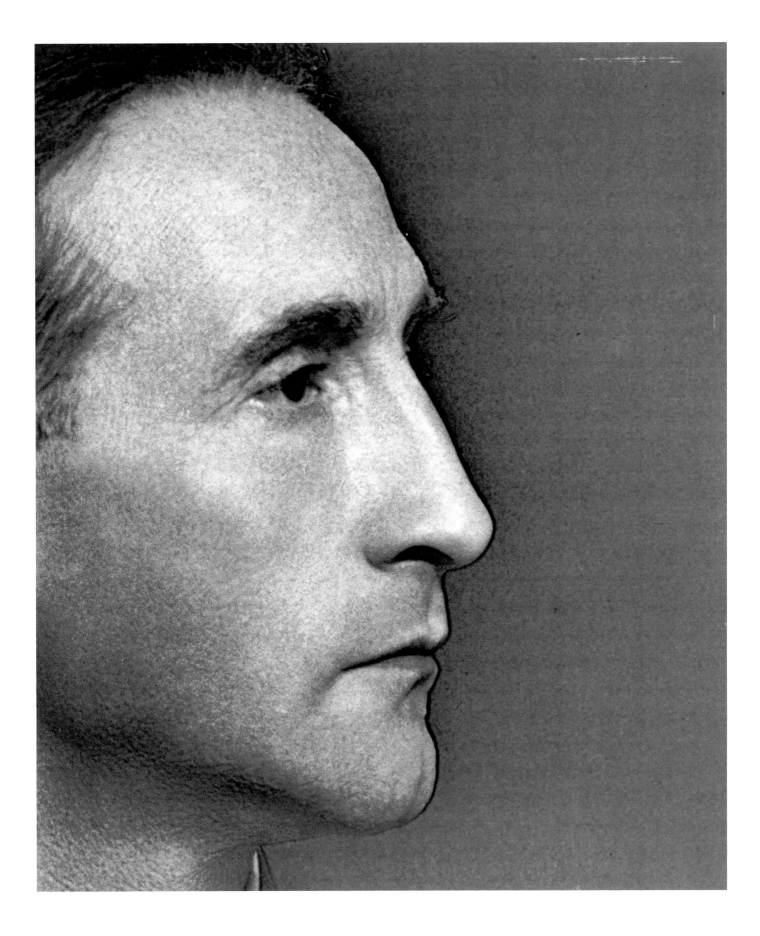

plate # **30**

176
177

Drawing of Marcel Duchamp
Daniel MacMorris (1893–1981)
Pencil and pastel on paper, 38.7 × 26.7 cm (15¼ × 10½ in.) sight, 1936
Mary McMorris and Leonard Santoro

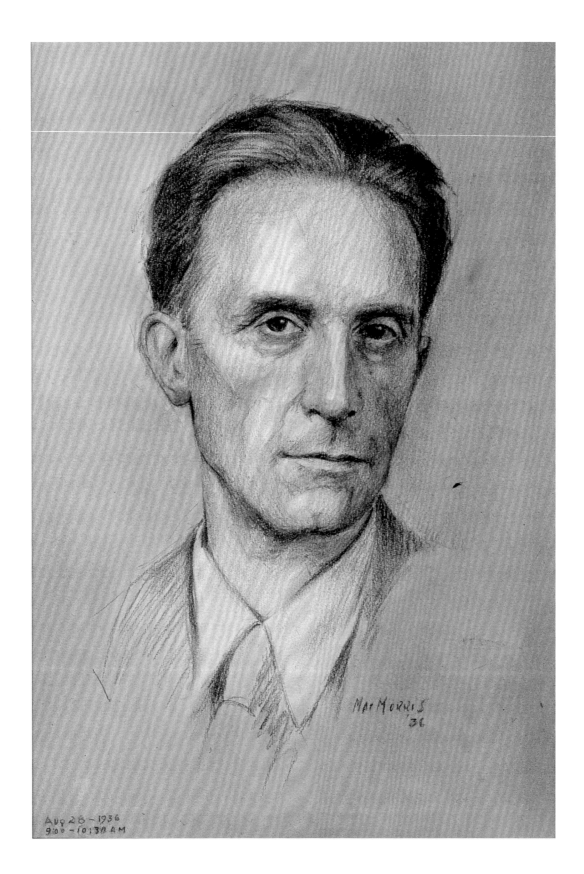

Hollywood 20th August 36

Dear McMorris

Delighted with my trip —
Returning to-morrow by way of the grand
Canyon — and stopping in Cleveland
 Will arrive in N.Y. Thursday
morning early ——
 Leaving again the same day for Redding
— Could I pose for you between 9 and
10 that morning?

— Will be back the following Monday
31st — and sail Wednesday 2nd Sept.
 Vivement Paris qu'on se repose!
 Affectueusement
 M. Duchamp

Letter from Marcel Duchamp to Daniel MacMorris,
August 20, 1936
Mary McMorris and Leonard Santoro

plate # **31**

plate #**32**

Drawing of Marcel Duchamp
Daniel MacMorris (1893–1981)
Pencil and pastel on paper, 40 × 26.7 cm (15¾ × 10½ in.) sight, 1936
Mary McMorris and Leonard Santoro

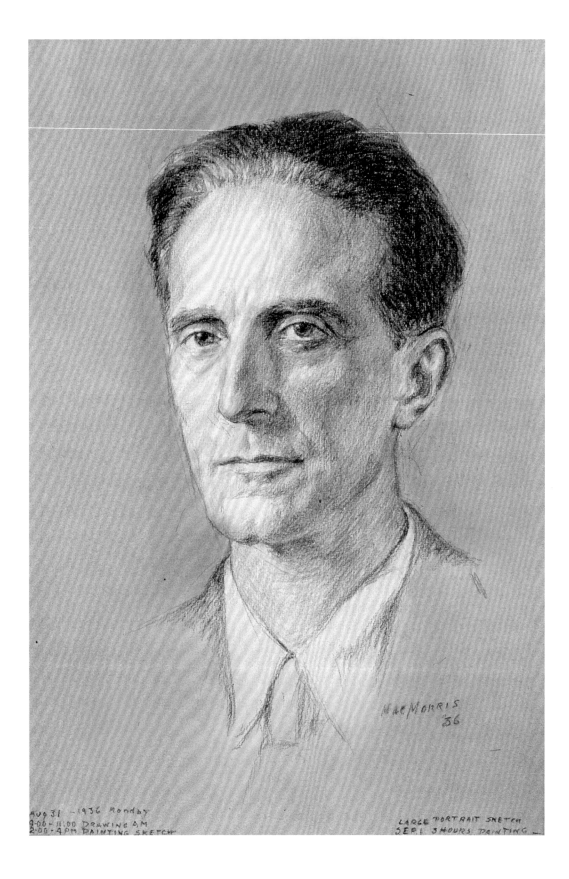

MacMORRIS
'36

Aug 31 - 1936 Monday
9:00-11:00 DRAWING AM
2:00-4PM PAINTING SKETCH

LARGE PORTRAIT SKETCH
SEP.1 3HOURS PAINTING

NEW YORK CENTRAL SYSTEM

EN ROUTE Cleveland

Cher Mac Morris
Merci pour votre long
télégramme —
Malheureusement
je ne peux pas prolonger
mon séjour —
J'ai fait mes plans
pour finir le verre à
Redding et je pense
trouver assez de
temps pour poser
pour vous.

j'arrive Jeudi matin
vers 7 h ½ à New York
et je pourrais poser
entre 8 et 9 si cela
n'est pas trop tôt
pour vous. —
Je sonnerai à votre
porte vers 8h. Jeudi
matin —
Bien cordialement
M Duchamp

plate # **34**

Marcel Duchamp
Daniel MacMorris (1893–1981)
Oil on canvas, 96.5 × 59.7 cm (38 × 23½ in.), 1937
Mary McMorris and Leonard Santoro

Daniel MacMorris was introduced to Duchamp by Katherine Dreier in 1936. Duchamp, who was in the United States to repair his *Large Glass,* spent time in Dreier's studio space in Carnegie Hall, New York, where MacMorris had his studio. Duchamp was quite willing to comply with MacMorris's request that he sit for a portrait, as is evident in the letters framed with MacMorris's studies. The resulting painting, recently rediscovered by Francis Naumann after having been unlocated by scholars for several decades, shows Duchamp in front of his *Nude Descending a Staircase (No. 2)* (1912). Although Duchamp's *Nude* was first displayed at the 1913 Armory Show, the work was still being exhibited and still stirring up controversy throughout the United States. A 1938 article from *Art Digest* called the *Nude* "a picture which has turned Frankenstein on its own creator," underscoring the extent to which Duchamp was identified with, and even overshadowed by, this work.[1] According to MacMorris, Duchamp declared that he had become "only a shadowy figure behind the reality of that painting."[2] Duchamp's willingness to pose for MacMorris evidences his awareness of his obfuscation by the notorious *Nude.* MacMorris sought to remedy this fact by making Duchamp the focus and relegating the *Nude* to the background. Holding his trademark pipe, Duchamp appears polished and debonair, hardly what one would expect of the creator of such an unconventional painting. The shadows that obscure the *Nude* fall onto Duchamp himself, veiling the lower half of his body. Though meant to differentiate Duchamp from his painting, MacMorris's portrait in fact visualizes the interconnection of the two, demonstrating the degree to which Duchamp's oeuvre is inseparable from his identity.

JEQ

1. "Marcel Duchamp's 'Frankenstein,'" *Art Digest* 12 (January 1, 1938): 22.
2. Duchamp made the statement to MacMorris while posing for his portrait, and his remarks were later published in "Marcel Duchamp's 'Frankenstein'" (ibid.), which also included a reproduction of MacMorris's 1937 portrait of Duchamp. Calvin Tomkins notes that Duchamp's answers to MacMorris are characteristic of the playful and often contradictory approach he adopted when fielding questions about himself and his work (see Tomkins, *Duchamp,* 306–7).

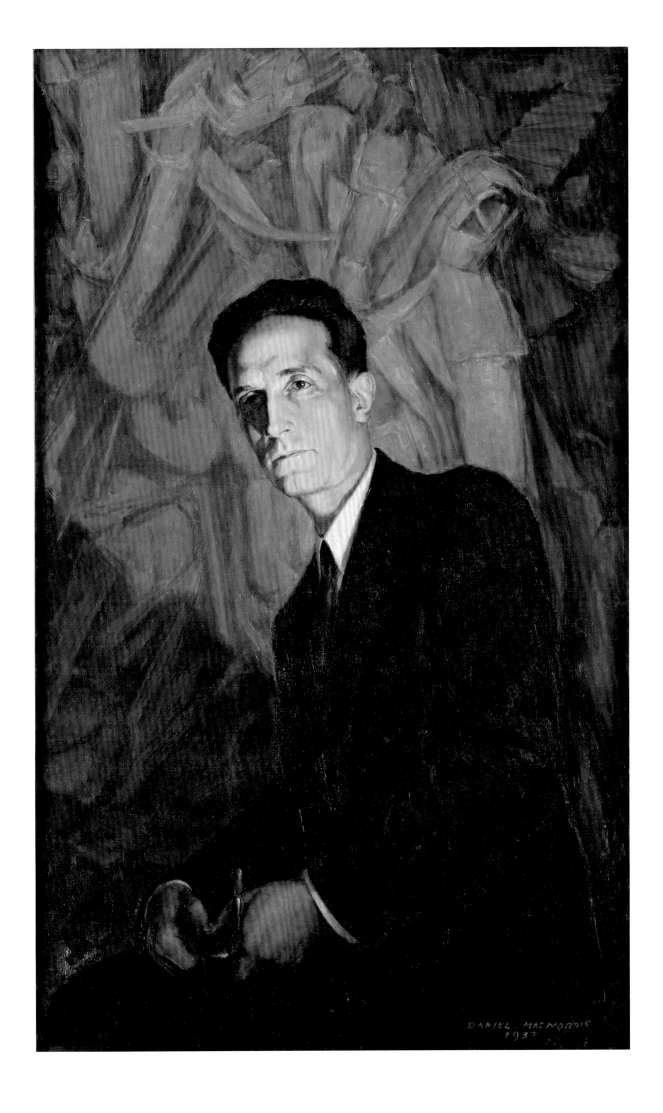

plate # **35**

Portrait of Marcel Duchamp Overlaid with a Photogram of the Glissière
Man Ray (1890–1976)
Gelatin silver print, 17.1 × 12.1 cm (6¾ × 4¾ in.), c. 1936
Private collection

Man Ray's photograph melds the photographer Hans Hoffmann's 1912 portrait of Duchamp (pl. 1) with a photogram of Duchamp's *Glissière contenant un Moulin à eau (en métaux voisins)*, 1913–15, commonly referred to as the *Glider*, their conflation amplifying Duchamp's identity as the bachelor (*célibat*).[1] Ecke Bonk has noted that Man Ray used the small celluloid print of the *Glider* that Duchamp was preparing for inclusion in his *Boîte-en-valise*, laying it over the Hoffmann portrait to create the composite image seen here.[2] The celluloid reproduction of this key component of *The Large Glass* was printed in early 1936. Late that spring, Duchamp would travel to the United States to undertake painstaking repairs to *The Large Glass*, which had shattered following its exhibition at the Brooklyn Museum in 1926. It seems appropriate that as Duchamp revisited this seminal artwork, Man Ray combined one of its defining features with a photographic portrait of Duchamp made during his 1912 trip to Munich, where he had produced his first studies for *The Large Glass*. This is not the first time that Man Ray joined images of the *Glider* and Duchamp into a single composition. Around 1924 he photographed Duchamp in a Paris studio, resting horizontally on a table. In front of him, and held up by him, is the semicircular glass panel containing the *Glider*, which had been made earlier as a study for *The Large Glass*.[3] With both photographs one senses the construction of a monogram—the presence of Marcel providing the M, and the D supplied by the semicircular glass panel of the *Glider*. Duchamp explored a similar motif elsewhere, applying strips of brass in the shape of an M to the outer shell of his 1934 *Notes in a Green Box*, and again for the supports stabilizing the central panel in his 1941–68 *Boîte-en-valise*. In 1967 Duchamp attached a small image of the *Glider*, silkscreened on Plexiglas, to the front cover of *A l'infinitif*, where it serves metonymically as a compensation self-portrait.

JWM

1. A photogram is a photographic image made (without a camera) by placing objects directly onto the surface of a photo-sensitive material such as photographic paper and then exposing it to light. The complete English language translation of the French title is *Glider Containing a Water Mill in Neighboring Metals.* Done between 1913 and 1915, this piece, on glass, is an important early study for *The Large Glass.* See *WMD*, 56–57. In the note "~~Chariot~~, Sleight, Glider," Duchamp outlines ways in which the *Glider* symbolizes the travails of the bachelor (*célibat*). Note: My strikethrough of the word *chariot* is intentional. In his note Duchamp struck through this word but left it in the text.

2. See Ecke Bonk, *Marcel Duchamp, The Box in a Valise* (New York: Rizzoli, 1989), 207–9. Bonk describes how Duchamp made the celluloid miniature of *Glider* and illustrates how it was used as the mask over the Hoffmann portrait, creating the photogram.
3. For an illustration of this photograph see *Duchamp, Man Ray, Picabia*, ed. Jennifer Mundy (London: Tate Gallery, 2008), 84. This photograph is also reproduced as a collotype in Marcel Duchamp's *The Bride Stripped Bare by Her Bachelors, Even (The Green Box)*, 1934.

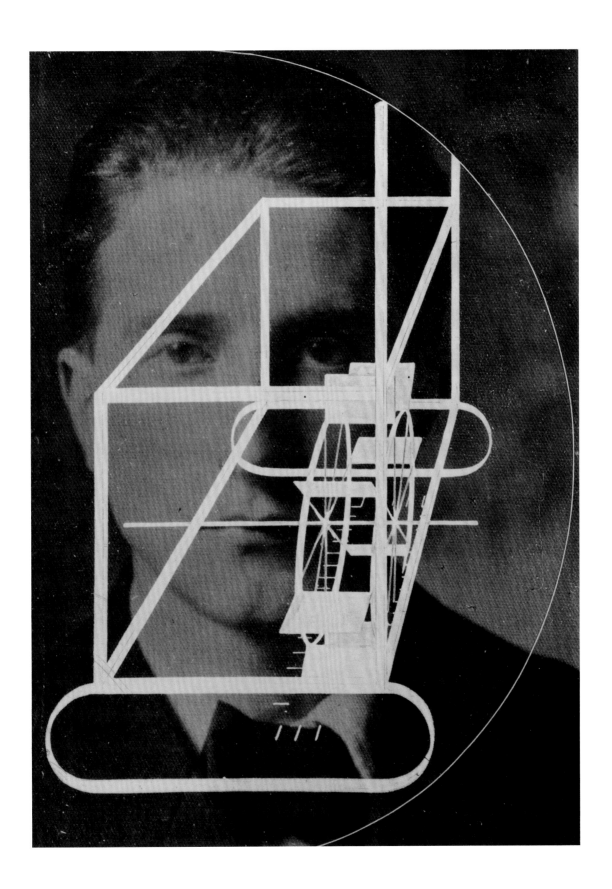

plate # 36

Mary Reynolds and Marcel Duchamp
Costa Achilopulu (?) (lifedates unknown)
Gelatin silver print, 15 × 14.9 cm (5⅞ × 5⅞ in.), 1937
The Art Institute of Chicago, Illinois; gift of Frank B. Hubachek, 1970.796
[Not in exhibition]

Works presenting isolated images of Marcel Duchamp's head are not uncommon—for example, Man Ray's lost painting *Cela Vit (Portrait of Marcel Duchamp)* (pl. 21), Florine Stettheimer's 1923 portrait (fig. 3.4), Ettore Salvatore's life mask (pl. 45), and Isabelle Waldberg's 1958 sculpture (fig. 2.3). The photograph shown here, part of a group of seven taken while Duchamp and Mary Reynolds were in London in 1937, depicts Reynolds draped in a classical robe, fingering a measuring tape, while Duchamp's disembodied head appears to rest on the tabletop next to her elbow. The work became part of the circulated imagery of Duchamp when it was included in Robert Lebel's 1959 Duchamp monograph, where it appeared without attribution. Since then it has become associated with Man Ray. Recently, both Sheldon Nodelman and Paul B. Franklin have questioned this attribution. Franklin, basing his work on archival research, concurs with Nodelman that it is not likely the work of Man Ray. Franklin offers that the photograph (along with the other six) was likely taken by Costa Achilopulu.[1] However, Nodelman and Franklin differ in their views regarding the possible narrative functions of this photograph and the others making up the group. Nodelman points out that the composition and dramatic characterization of the photograph "echo countless pictorial treatments by Renaissance and Baroque masters . . . of the dramatic legend of Salome . . . with the head of John the Baptist." Franklin, in turn, argues for a correspondence with Duchamp's earlier work the *Three Standard Stoppages* (1913–14), which he had restored in 1936. Through the efforts of both authors, we are reminded of the considerable potential for reading meaning into works both by or about Marcel Duchamp.

JWM

1. See Sheldon Nodelman, "Duchampiana: The Decollation of Saint Marcel," *Art in America* 94 (October 2006): 107–19. See also Paul B. Franklin, "A Whodunit," *Étant donné Marcel Duchamp* 8 (2007): 158–63.

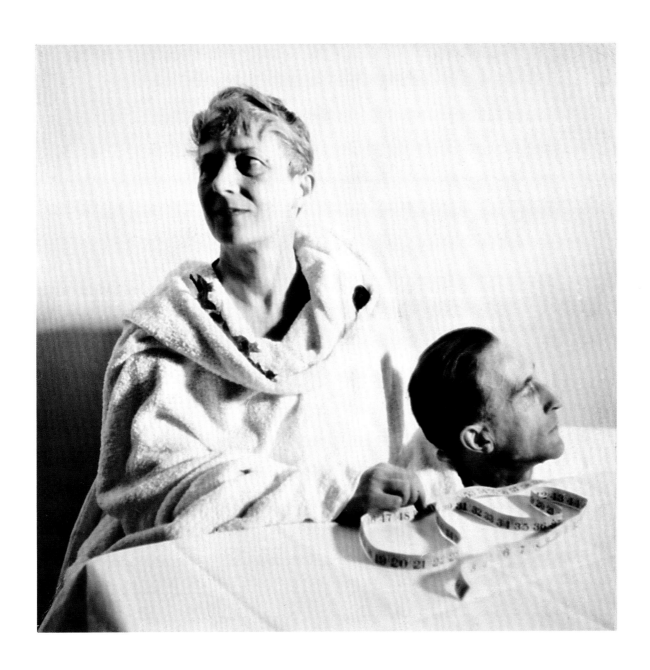

plate # 37

Boîte—Series D
Marcel Duchamp (1887–1968); assembled by Jacqueline Matisse Monnier
Mixed media (case covered in light green linen, lining light green Ingres paper; 68 items enclosed in box), box: 40 × 38 × 9 cm (15¾ × 14¹⁵⁄₁₆ × 3⁹⁄₁₆ in.), 1961 (based on *Boîte-en-valise*, 1935–41)
Frances Beatty and Allen Adler

"You have invented a new kind of autobiography," said Walter Arensberg, upon seeing Duchamp's completed *Boîte-en-valise* in 1943. "You have became the puppeteer of your past."[1] The *Boîte-en-valise* was first released in Paris in 1941 and labeled "de ou par Marcel Duchamp ou Rrose Sélavy" ("from or by Marcel Duchamp or Rrose Sélavy"). Functioning as a summation of the artist's career to date, and hence as a complex self-portrayal based on his artistic production, the first twenty deluxe editions contained sixty-nine miniature versions of paintings, drawings, and readymades, including *The Large Glass* and *Fountain*.[2] Duchamp carefully orchestrated the replication of his works, an elaborate process that eventually yielded three hundred reproductions.[3] The advent of World War II interrupted his production and forced him to leave France in 1942.[4]

Upon arriving in the United States, Duchamp continued to construct deluxe editions of the *Boîte-en-valise*, of which twenty-four would eventually be completed. With the help of others, such as Joseph Cornell and Xenia Cage, Duchamp also began to create versions without the leather valise, which were known simply as *Boîtes*. The *Boîtes* were issued in five groups between 1958 and 1971. In 1960, Duchamp's stepdaughter, Jacqueline Matisse Monnier, offered to help with the labor-intensive process of constructing the *Boîtes*, a project on which she worked until 1971. Among the works she assembled was the *Boîte* seen here, which belongs to Series D, distinguished by the use of green linen cases.[5]

The *Boîte-en-valise* and its successive editions embody a series of contradictions, raising questions about the relationship between the original and the replica, the handmade and the mechanical, and the artist and his legacy.[6] Although Duchamp claimed that the artist's fame is determined by luck, the *Boîte* demonstrates how carefully Duchamp considered and constructed his own legacy, leaving nothing to chance. Both portable museum and visual autobiography, the *Boîte* testifies to Duchamp's desire to preserve his oeuvre, as well as to his awareness of his own place in history.

JEQ

1. Walter Arensberg, draft of a letter to Marcel Duchamp, dated May 6, 1943, quoted in Ecke Bonk in *Marcel Duchamp, The Portable Museum: The Making of the Boîte-en-valise, de ou par Marcel Duchamp ou Rrose Sélavy, Inventory of an Edition*, trans. David Britt (1986; London: Thames and Hudson, 1989), 167. Bonk notes that the letter was marked "not sent," making it unclear whether this observation made it to Duchamp (ibid., 193, n. 10).
2. From the 1941 subscription bulletin advertising "from or by Marcel Duchamp or Rrose Sélavy," cited in Naumann, *Art of Making Art*, 140.
3. Duchamp carefully documented and reproduced his own work, then provided craftsmen with examples and maquettes from which to execute successive reproductions. The long and involved process, which took years to complete, demonstrates Duchamp's careful forethought, technical skill, and great precision (Naumann, *Art of Making Art*, 136–37).
4. It is worth noting that in order to gather the materials for his boxes, Duchamp posed as a cheese-seller so that he could travel safely through the occupied zones of France. Tomkins, *Duchamp*, 223–24. Peggy Guggenheim, who

was returning to the United States at this time, also brought back some of Duchamp's materials in her own luggage. For a detailed history of the *Boîte-en-valise*, see Bonk, *Portable Museum*. The work's status as a self-portrait is also discussed in Anne Collins Goodyear's essay in this volume.
5. The green linen of the *Boîte*—Series D recalls Duchamp's *Boîte Verte (The Green Box)*, a collection of notes and documentation pertaining to *The Large Glass*. Both the *Boîte Verte* and the *Boîte-en-valise* evidence Duchamp's desire to document and preserve his oeuvre.
6. At the time that Duchamp was preparing the reproductions for the *Boîte*, he was also formulating his ideas on the *infra-mince*, or the infra-thin, which concerns the subtle differences between things that are seemingly identical. For more on replication and the infra-thin, see Naumann, *Art of Making Art*.

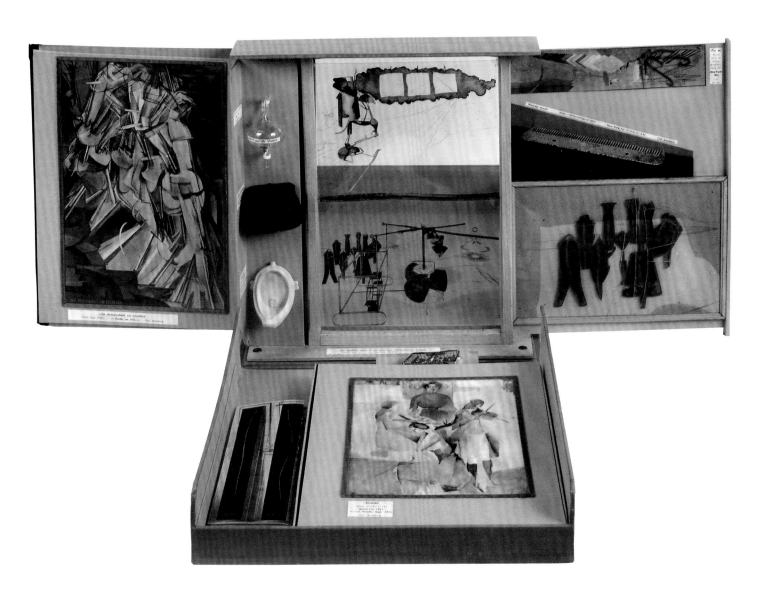

plate # **38**

Sad Young Man on a Train
Marcel Duchamp (1887–1968)
Collotype, 23.3 × 14.6 cm (9¹⁄₁₆ × 5¾ in.), c. 1961 (after a 1938
collotype, after original 1911 painting)
Frances Beatty and Allen Adler

Originally created in 1938 for his *Boîte-en-valise*, Marcel Duchamp's collotype reproduction of his 1911 oil painting *Sad Young Man on a Train*, re-created for each successive edition of the *Boîte* (see pl. 37), demonstrates the importance of the work in his collected oeuvre.[1] Duchamp later acknowledged, "the sad young man on the train is myself," making the painting his first known self-portrait.[2] Although Duchamp seemed to dismiss the work lightly as a stylistic exercise in the development of a young artist, with his remark "There isn't much of the young man, there isn't much of sadness, there isn't much of anything in that painting except a Cubist influence," the work nonetheless provides fascinating clues about the artist's approach to self-representation.[3] As would become characteristic, the self-portrait disguises its subject, even as it seems to reveal him. While Duchamp included "autobiographical" details, such as his ubiquitous pipe and a reference to a train journey from Paris to Rouen, he simultaneously destabilized their significance with the alliterative word play of the title—in French "Jeune homme triste dans un train," with its repetition of the *tr* in *triste* (sad) and *train*—which he found funny.[4] Nor was the artist willing to entertain the notion of deep tragedy as an explanation for the mood evoked by the title, telling Pierre Cabanne that "the young man is sad because there is a train that comes afterward."[5] Thus, the seeming pathos initially suggested by the image suddenly shifts to an inside joke, never fully accessible to the viewer. Such intellectual transformations are matched by the imagery itself in which Duchamp depicted himself in a state of transition, a passenger transversing the canvas in an ever-evolving and increasingly indistinct fashion. Against this backdrop, the artist's decision to re-create this painting in the form of a print as he took the train from Nazi-occupied Paris to the unoccupied city of Marseilles, posing as a cheese merchant, to gather materials for his autobiographical *Boîte-en-valise*, becomes all the more appropriate and intriguing, as does this work's voyage through time with the creation of subsequent additions of the *Boîte*.[6]

ACG

1. *Sad Young Man on a Train* (*Jeune homme triste dans un train*) has been widely discussed. For a detailed account of the physical attributes of the work and an overview of its interpretation, see Angelica Zander Rudenstine's entry on the work in *Peggy Guggenheim Collection, Venice, The Solomon R. Guggenheim Foundation* (New York: Harry N. Abrams, 1985), 259–69; for a more recent discussion of the work and its relationship to *Nude Descending a Staircase*, see David Hopkins, *Marcel Duchamp and Max Ernst: The Bride Shared* (Oxford: Oxford University Press, 1998), 9–10; on the desire of Walter and Louise Arensberg for a replica of the painting, see Naumann, *Art of Making Art*, 148, 167–71.
2. Marcel Duchamp, in interview with Calvin Tomkins, in Tomkins, *Duchamp*, 76.
3. Ibid.
4. Cabanne, *Dialogues with Marcel Duchamp*, 33 and 29.
5. Ibid., 29. This contrasts strikingly with Arturo Schwarz's attempt to read biographical content into the work, specifically concerning Duchamp's relationship with his sister Suzanne. Schwarz, *Complete Works*, vol. 1, 109–11.
6. Duchamp described this subterfuge, which enabled him to gather materials for the *Boîte-en-valise*, in an interview with Calvin Tomkins. See Tomkins, *Duchamp*, 323–24.

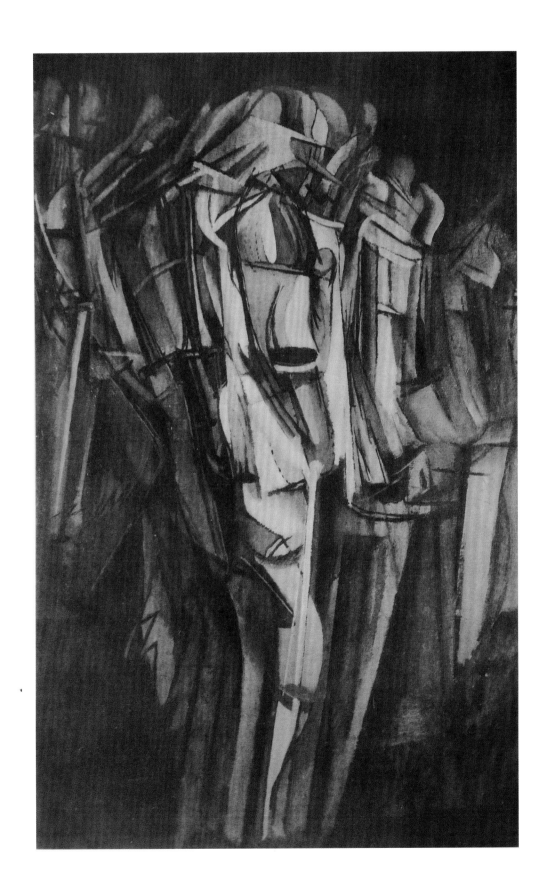

plate # **39**

Marcel Duchamp at Villa Air-Bel
André Gomès (died 1997)
Gelatin silver print, 16.1 × 10.3 cm (6⅜ × 4¹/₁₆ in.), 1942
(printed 2005 by Laboratoire Jean Sabier)
Douglas Vogel

By 1942, in the wake of the Nazi occupation of France, Duchamp, like many of his fellow artists, had fled Paris to the south of France. One of the important gathering places was the Villa Air-Bel outside Marseilles. Paul B. Franklin has described Duchamp as a frequent visitor to the estate where André Gomès photographed him in February of 1942.[1]

Among those photographs, which appear as ordinary snapshots, two provide direct allusions to Duchamp's readymades. The photograph shown here, a later reproduction of the 1942 original, portrays Duchamp seated on a stone wall in front of a barren tree. Nestled in the branches is the head of a garden rake, which can be read as a reference to the readymade *Comb* (1916)[2]—a dog-grooming comb to which Duchamp applied an inscription that translates, "Three or four drops of height have nothing to do with savagery."[3] A second photograph (not illustrated) also shows Duchamp before a tree, this time standing. Impaled on the tree's trunk, as if it were a household bottle rack, are a number of empty wine bottles, alluding to another of Duchamp's readymades, the *Bottle Rack* (1914).[4] The two photographs considered together offer a compelling suggestion that Duchamp and Gomès joined in making playful references to the readymades.

Prior to his departure for New York on May 14, 1942, Duchamp gave Gomès and his wife (Henrietta, who was an art dealer) a recently completed *Boîte-en-valise* (see pl. 37).[5]

JWM

1. Paul B. Franklin, "Notes," for Lebel, "Last Evening with Duchamp," in *Étant donné Marcel Duchamp* 7 (2006): 180–81.
2. The title for this readymade in French is *peigne*, a word close in sound to *peine* (pain) and *peindre* (to paint), proximities that would likely have been attractive to Duchamp, the master wordsmith and punster.
3. Schwarz, *Complete Works*, vol. 2, 643.
4. For an illustration of this photograph see *Étant donné Marcel Duchamp* 7 (2006): 180. For an illustration and description of Duchamp's readymade, *Bottle Rack*, see Schwarz, *Complete Works*, vol. 2, 615.
5. Franklin, "Notes," 180.

plate # 40

Compensation Portrait
Marcel Duchamp (1887–1968) (from appropriated photograph by Ben Shahn)
Published in *The First Papers of Surrealism*, 1942
Smithsonian Institution Libraries, Washington, DC

The First Papers of Surrealism catalogue documents a 1942 group exhibition of surrealist work. Duchamp, recently returned to New York, co-organized the show with fellow artist André Breton. Duchamp's roles were to provide a "suitably provocative installation," which he had previously done for the 1938 surrealist exhibition in Paris, and to design the exhibition catalogue.[1] Because a number of the exhibiting artists were out of reach in occupied Europe, Duchamp and Breton suggested the use of "compensation photographs," surrogate portraits substituted for actual images of the exhibiting artists.[2] These portraits of Max Ernst, Yves Tanguy, Giorgio de Chirico, and others were, as Calvin Tomkins has proposed, "photographs that suggested some relatively obscure personal attribute or characteristic."[3] For his surrogate, Duchamp chose the face of a destitute female migrant farm worker who had been photographed by Ben Shahn for the Farm Security Administration and whose facial features echoed his own.[4] By yet again adopting a female persona, Duchamp referenced his alter ego Rrose Sélavy.

AK

1. Tomkins, *Duchamp*, 332.
2. Schwarz, *Complete Works*, vol. 2, 766.
3. Tomkins, *Duchamp*, 332.
4. For a detailed discussion of this work, see David Hopkins, "The Politics of Equivocation: Sherrie Levine, Duchamp's Compensation Portrait, and Surrealism in the USA, 1942–45," *Oxford Art Journal* 26, no. 1 (2003): 45–60.

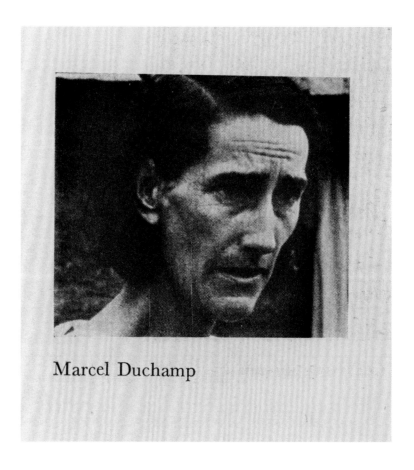

Marcel Duchamp

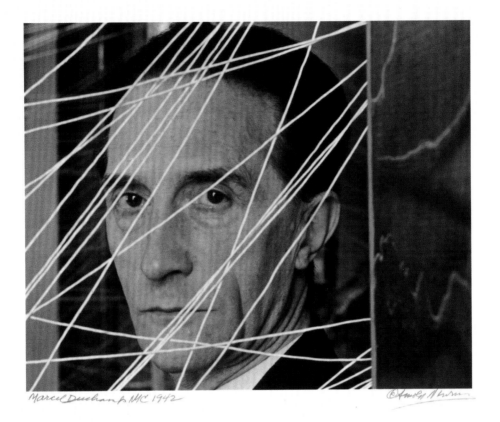

Marcel Duchamp
Arnold Newman (1918–2006)
Gelatin silver print, 35.3 cm × 27.7 cm (13⅞ × 10⅞ in.), 1942
National Portrait Gallery, Smithsonian Institution

Arnold Newman/Arnold Newman Collection/Getty Images

plate # 41

Arnold Newman photographed Duchamp at the "First Papers of Surrealism" exhibition (see pl. 40). Newman was working on a series of portraits of artists at the time he made this portrait, which places Duchamp in the environment of his work. For the exhibition Duchamp had acquired sixteen miles of string to weave a cobweb throughout the venue, thus obstructing the viewing experience and creating what T. J. Demos has described as "a space of conflict."[1] Cropping the image tightly around Duchamp's face, Newman both captures the intensity of Duchamp's gaze and translates the obstructive function of Duchamp's *Sixteen Miles of String*. Although Newman's portrait brings the viewer into close proximity with Duchamp, the crisscrossed threads function like a barricade, imposing a distancing effect. These fibers reference Duchamp's *Three Standard Stoppages*, a work that recorded the chance fall of bits of string, as well as suggesting the cracked panes of *The Large Glass*. In addition, Newman's positioning of Duchamp's features behind his work reads much like Man Ray's superimposition of a photograph of Duchamp with an image of the Glider (see pl. 35).

AK

1. T. J. Demos, *The Exiles of Marcel Duchamp* (Cambridge, MA: MIT Press, 2007), 190.

plate # 42a and b

View (front and back covers)
Cover design by Marcel Duchamp, 1945
Private collection

The March 1945 issue of *View*, an American avant-garde and literary quarterly focused on surrealism, was devoted entirely to Duchamp. The carefully chosen imagery, which includes Duchamp's self-portraits, reproductions of his work, and Frederick Kiesler's photographic triptych of Duchamp's studio, suggests that Duchamp himself was heavily involved with the design and layout of the issue.

Duchamp's design for the cover of the magazine features a wine bottle set against a velvety blue sky sprinkled with stars. The deceptively simple image is replete with references to the artist and his oeuvre. The white smoke that swirls across the sky suggests the Milky Way of *The Large Glass,* while the bottle itself brings to mind Duchamp's first readymade, the *Bottle Rack.* With its bold inclusion of Duchamp's military records in place of a traditional label, the bottle also refers to the artist himself.[1] In this regard, the smoke wafting from the "mouth" further enhances the personification of the bottle by alluding to Duchamp's pipe.[2]

Duchamp draws attention to this personification through his statement on the magazine's back cover: "When the tobacco smoke smells like the mouth that exhales it, the two odors marry through infra-thin."[3] The infra-thin concerns the liminal, the elusive, and the latent; as Duchamp wrote: "The possible is/an infra-thin."[4] By connecting the infra-thin to an ambiguous and open-ended self-portrait, Duchamp implies that the self is in a perpetual state of evolution: "The becoming—the passage from/one to the other takes place/in the infra thin."[5]

JEQ

1. Cpl. Peter Lindamood, "I Cover the Cover," *View: The Modern Magazine,* Marcel Duchamp Number, series V, no. 1 (March 1945): 3.
2. The cover image is derived from a wine bottle that Duchamp saved from a dinner with André Breton. After a series of experiments, Duchamp finally managed to make the bottle "smoke" by fitting a pipe underneath the neck of the bottle, which caused it to appear as though the bottle itself was emitting smoke (ibid.).

3. Translation by Anne Collins Goodyear. The evocation of the infra-thin given on the back of *View* also appeared among a series of notes devoted to the concept that Duchamp preserved in an envelope. Composed between approximately 1935 and 1945, the notes on infra-thin concern the nearly imperceptible barriers between things, or the liminal space between them, a concept that fascinated Duchamp. The notes on infra-thin are included in Paul Matisse, ed., *Marcel Duchamp, Notes* (Boston: G. K. Hall, 1983); although the book is unpaginated, the notes are numbered. The note published on the back of *View* appears as no. 33; a related note appears as no. 11, verso.
4. Matisse, *Marcel Duchamp, Notes,* no. 1.
5. Ibid.

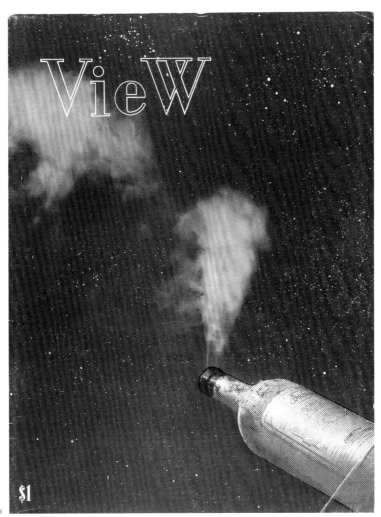

plate # 42a

QUANd

LA FUMÉE De tAbAC

seNt auSSi

De La bouche

qui L'exHaLE,

leS DeUx oDeUrS

S'ÉPousENt par

INFRA-miNce

marcel Duchamp

plate # 42b

plate #43

Marcel Duchamp at the Age of Eighty-Five for View
Unidentified photographer
Gelatin silver print, 17 × 11.6 cm (6¹¹⁄₁₆ × 4⁹⁄₁₆ in.), 1945
Philadelphia Museum of Art, Pennsylvania, Marcel Duchamp Archive;
gift of Jacqueline, Paul, and Peter Matisse in memory of their mother,
Alexina Duchamp

Created in 1945, the dramatically lit photograph of an aged, bespectacled artist, seen from the front, appeared on the final page of a special issue of the surrealist journal *View* devoted to Marcel Duchamp. The image, reproduced like a small mug shot, bore the year "1972," and the caption, "Marcel Duchamp at the Age of 85." At its left was Alfred Stieglitz's profile photograph of Duchamp (pl. 23), identified with the year "1922" (an error, as the photograph was actually taken in 1923) and the tagline, "Marcel Duchamp at the Age of 35." Together, the profile and the frontal image gently parodied Duchamp's *Wanted: $2,000 Reward* poster of 1923, a work he had recently reproduced for inclusion in the *Boîte-en-valise*.

As a pair, the two pictures had the additional effect of reinforcing important currents of the essay with which they appeared, "Marcel Duchamp: Anti-Artist," by Harriet and Sidney Janis. The Janises' emphasis on the conceptual role played by irony in the work of Duchamp was suitably reinforced by the playful pairing of the youthful with the elderly Duchamp, who was at the time a mere fifty-eight years of age. But perhaps even more important was the historical implication of the juxtaposition of the two "mug shots," which seemed to comment on the impressive legacy of this maturing artist. Concluding their 1945 essay, the Janises asserted, "the treasure trove of subtleties in creative ideas and techniques in Duchamp's work is still essentially untouched. Tapping these resources will provide a rich yield for the new generation of painters, in whose awareness lies the future of twentieth-century painting; for here, deeply embedded with meaning, is one of the great, little explored veins in contemporary art."[1] The prediction would prove uncannily prescient, as Duchamp's work would become particularly compelling for new generations of artists from the 1960s and later.

The deliberateness that lay behind the ruse of Duchamp's age becomes evident when the photograph from *View* is put beside a similar picture, evidently made at the same time, showing Duchamp without glasses. Rather than selecting a readymade, as in the manner of his *Compensation Portrait* (pl. 40), the pair demonstrates that Duchamp enacted a process of self-transformation akin to that required to create Rrose Sélavy.[2] In the variant, the faint ridge of a cap worn by Duchamp to create the illusion of a receding hairline becomes evident, and the pragmatic value of the beret he wears becomes clear, hiding as it does a full head of hair.[3]

ACG

1. Harriet and Sidney Janis, "Marcel Duchamp: Anti Artist," *View* 5, no. 1 (March 1945): 54.
2. Arturo Schwarz mistakenly identifies a photograph of an artificially aged Duchamp without glasses as the image reproduced in *View*. Although his caption seems to imply that the photograph was a readymade, chosen by Duchamp in a manner similar to that by which he selected his *Compensation Portrait* (pl. 40), the existence of variants makes Duchamp's active participation in his self-transformation apparent (Schwarz, *Complete Works*, vol. 2, 780). Following Schwarz, David Hopkins also erroneously identifies the photograph of the glassless Duchamp as the image published in *View*; however, Hopkins clarifies that the effect of aging was produced by theatrical means. (See Hopkins, "The Politics of Equivocation: Sherrie Levine, Duchamp's Compensation Portrait, and Surrealism in the USA, 1942–45," *Oxford Art Journal* 26, no. 1 [2003]: 55–56.)

3. As Michael Taylor has suggested, the transformation may have been inspired by Duchamp's experience having his face cast by Ettore Salvatore. The process required him to don a rubber cap and left his features covered in dust, artificially aging them. See Taylor's essay in this volume. See also the entry on Duchamp by Salvatore (pl. 45).

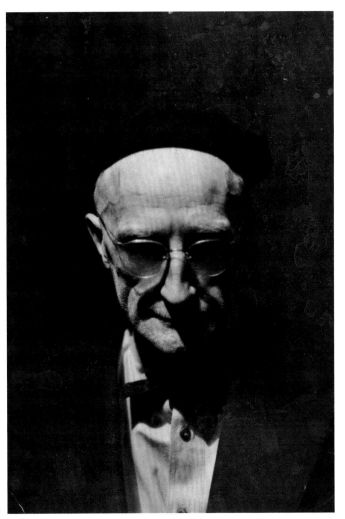

plate # 43

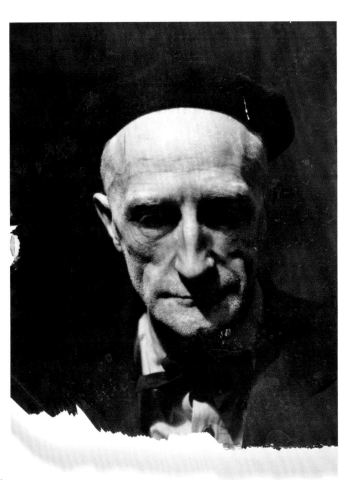

plate # 44

Marcel Duchamp at the Age of Eighty-Five
(without glasses)
Unidentified photographer
Gelatin silver print, 12.7 × 10.2 cm (5 × 4 in.), 1945
Philadelphia Museum of Art, Pennsylvania, Marcel Duchamp
Archive; gift of Jacqueline, Paul, and Peter Matisse in memory
of their mother, Alexina Duchamp

plate # 44

plate # 45

Marcel Duchamp
Ettore Salvatore (1902–1990)
Painted plaster, 27.9 × 18.4 × 14.6 cm (11 × 7¼ × 5¾ in.),
cast 1963, possibly from a c. 1945 mold
Hirshhorn Museum and Sculpture Garden, Smithsonian Institution,
Washington, DC; the Joseph H. Hirshhorn Bequest, 1981

Part of an edition of life masks of Marcel Duchamp by the New York–based sculptor Ettore Salvatore, this little-known portrait depicts Duchamp not long after his return to the United States during the Second World War. The cast image of Duchamp's face clearly resonates with Duchamp's interest in molds and "apparitions."[1] But perhaps even more interestingly, as Michael Taylor has convincingly argued, Salvatore's life mask of Duchamp may serve as a prelude to his posthumously unveiled *Étant donnés: 1. la chute d'eau, 2. le gaz d'éclairage*, which made extensive use of techniques of mold-making and casting. Indeed, Duchamp studied with Salvatore, who offered lessons in casting and sculpture through Columbia University.[2] It may be that a *New York Times* headline referring to an exhibition of chessmen caught the eye of Duchamp, a committed chess player, and brought Salvatore's classes to

his attention due to a mention of them in the same article.[3]

Although this plaster mask bears the date of 1963 on the reverse, Duchamp's relationship with Salvatore during the mid-1940s, together with the fact that this life mask was unknown to Teeny Duchamp, whom Duchamp married in 1954, suggests the mold was made much earlier.[4] Indeed, the aged appearance his features take on in this life mask may well have inspired Duchamp's playful self-portrait *Marcel Duchamp at the Age of Eighty-Five* (pls. 43, 44), as Michael Taylor has observed.[5] Just as the casting process required Duchamp to hide his hair beneath a rubber cap and left his face covered with plaster dust, so the transformative photograph succeeds in making him look substantially older than his fifty-eight years through the illusion of balding and the presence of powder on Duchamp's skin, which create the impression of sunken features and unshaven whiskers.[6] Salvatore's finished work, which accentuates Duchamp's lined forehead and hollow cheeks, complements the spoofing photograph, seeming to capture the artist at an advanced age.[7]

ACG

1. See, for example, *A l'infinitif*, in *WMD*, 85.
2. See Michael R. Taylor's essay in this volume for an extensive discussion of Salvatore's life mask of Duchamp.
3. "Pfeiffer Chessmen Will Be Exhibited," *New York Times*, June 19, 1944, 17.
4. See Michael R. Taylor's essay in this volume. The likelihood that the mold for Duchamp's features was made significantly earlier than the plaster cast itself is also supported by a group of correspondence dating to 1975, in which Joseph Hirshhorn—who had acquired Salvatore's 1963 plaster cast of Duchamp's face in 1963, at the same time he sat for his own life mask—Alfred Wolkenberg—an artist who created a life mask of Duchamp in the mid-1960s—and Teeny Duchamp tried to sort out the circumstances behind the creation of the Duchamp mask by Salvatore. As Michael Taylor has observed, Teeny Duchamp was not familiar with Salvatore's life mask of Duchamp. This is borne out by correspondence exchanged between her and Wolkenberg in which Teeny Duchamp confirms: "Personally, I have never

met, nor heard of, anyone of the name of Salvatore." See Mme Marcel Duchamp, letter to Alfred Wolkenberg, February 12, 1975; in response to Alfred Wolkenberg, letter to Mrs. Marcel Duchamp, January 27, 1975. A handwritten annotation at the bottom of Wolkenberg's letter to Teeny Duchamp, added by Olga Hirshhorn, dated May 6, 1975, reads: "Mr. Salvatore told me he made it [his life mask of Duchamp] from life. Mrs. Duchamp was not present." See also Joseph Hirshorn's letter to Ettore Salvatore, dated March 22, 1975, in which he encloses the above-mentioned correspondence between Teeny Duchamp and Alfred Wolkenberg and requests information about the Duchamp life mask, writing: "As you remember sometime back you did a life mask of me. [The mask is dated 1963] . . . At that time I purchased from you the mask of Marcel Duchamp. Would you please tell me for our records and the records of the Hirshhorn Museum how you came to do that piece." Unfortunately, no response is recorded. All correspondence cited above is from the

Smithsonian Institution Archives, Joseph Hirshhorn Papers, record unit 7449, box 4, Duchamp file.
5. See Michael Taylor's essay in this volume.
6. See ibid.
7. A later cast of Duchamp was made by Alfred Wolkenberg in the mid-1960s and incorporated into the sculpture *Marcel Duchamp Cast Alive*, 1967, created by Editions Les Maitres under Duchamp's supervision; it is reproduced in Schwarz, *Complete Works*, vol. 2 , 867.

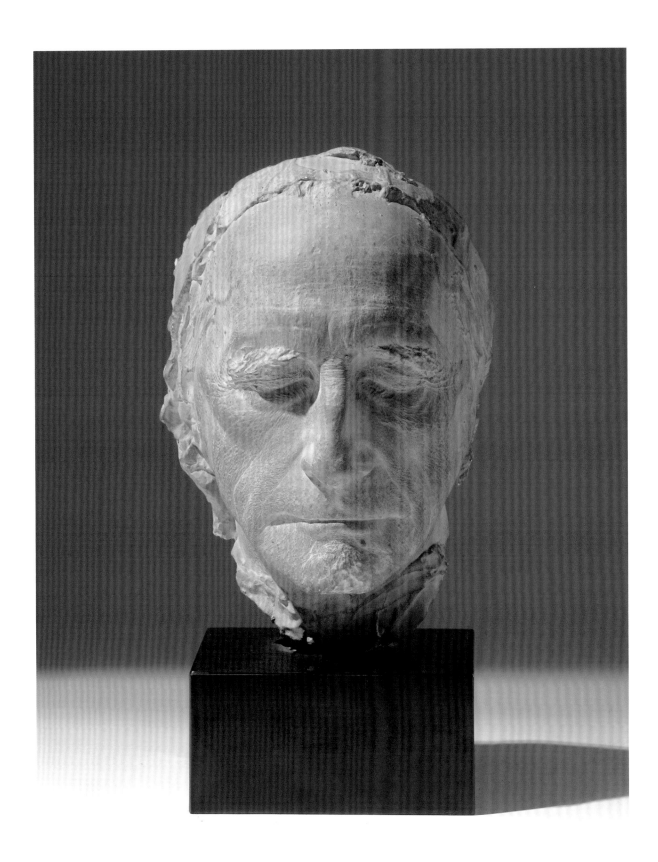

plate # 46

Marcel Duchamp
Beatrice Wood (1893–1998)
Watercolor on paper, 33.5 × 26.8 cm (13³/₁₆ × 10⁹/₁₆ in.), 1946
Private collection

Marcel Duchamp had a transformative impact on Beatrice Wood. They met in New York in 1916, and Wood was immediately attracted to Duchamp. In her autobiography, Wood describes him as "the most celebrated painter of his day, due to the sensational success of his *Nude Descending a Staircase*," and goes on to write, "Marcel at twenty-seven had the charm of an angel who spoke slang. He was frail, with a delicately chiseled face and penetrating blue eyes that saw all."[1] Wood's initial infatuation eventually matured into a lasting friendship with Duchamp. By 1946, when she painted this piece, Wood had moved to the West Coast and had become highly respected for her inventive ceramics. In this portrait she draws on the iconic elements of Duchamp's self-representation: she paints him seated, in profile, holding a cigar as his cast shadow looms behind him.

AK

1. Beatrice Wood, *I Shock Myself: The Autobiography of Beatrice Wood*, ed. Lindsey Smith (San Francisco: Chronicle Books, 1985), 23.

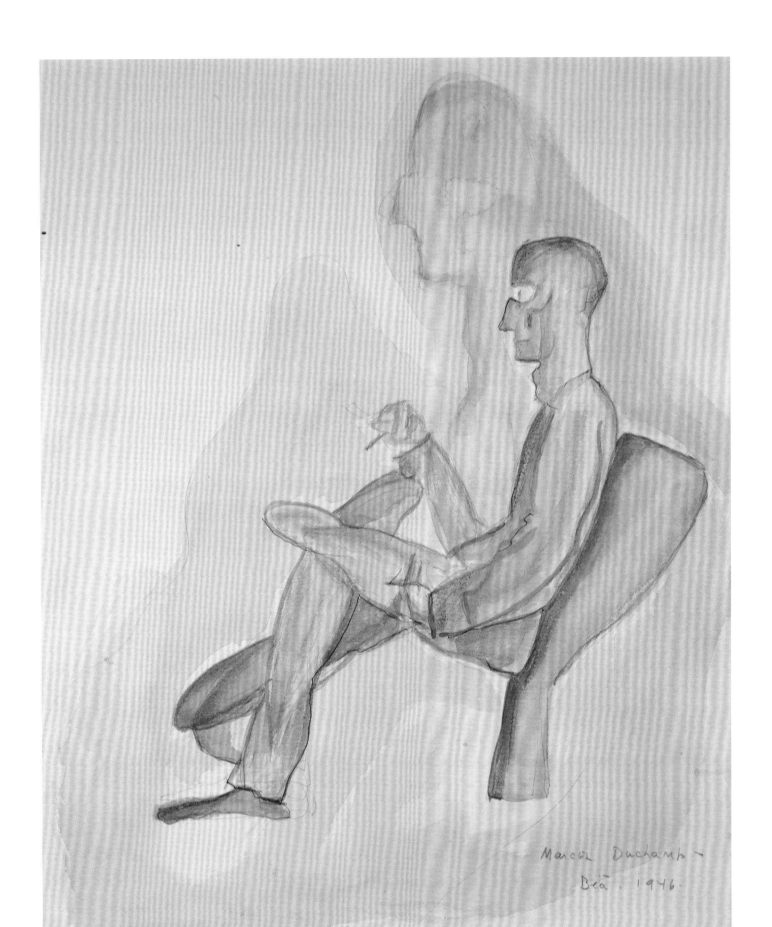

Marcel Duchamp
Béa 1946

plate # 47

Marcel Duchamp
Frederick Kiesler (1890–1965)
Pencil with pieces of paper in wood frame, frame: 227.6 × 99.4 × 32.7 cm (89⅝ × 39⅛ × 12⅞ in.), 1947
The Museum of Modern Art, New York City; gift of the D. S. and R. H. Gottesman Foundation (106.1963.a–i)

Frederick Kiesler's unconventional eight-part drawing of Marcel Duchamp provides metaphorically rich terrain, revealing a great deal about the theoretical and aesthetic interests the two held in common. Created in 1947 from a life sitting, the work may well have been inspired by Duchamp's collaboration with Kiesler the same year on both the installation design and an artwork for "Surrealism 1947," an exhibition at the Galerie Maeght in Paris.[1] Kiesler, an avant-garde architect deeply interested in the concept of cosmic "endlessness," had long admired Duchamp's own evocation of space, particularly in *The Bride Stripped Bare by Her Bachelors, Even*, or *The Large Glass*.[2] Describing the work in a 1937 essay, which Duchamp admired, Kiesler wrote: "It floats. It is in a state of eternal readiness for action, motion, and radiation. While dividing the piece into areas of transparency and non-transparency, a spatial balance is created between stability and mobility. By way of such apparent contradiction the designer has based his conception on nature's law of simultaneous gravitation and flight."[3] Eight years later, Kiesler would create a complex visual rendition of the work as situated in Duchamp's studio for a special issue of *View* (see pl. 42a and b).

In an essay published at the end of his life, Kiesler articulated the theoretical claims embedded in his portrayal of Duchamp. Although Kiesler does not directly credit Duchamp for inspiring the unconventional likeness, it is hard to imagine that their collaboration at the Galerie Maeght did not stimulate his thinking. Intimately bound up with his desire to create structural analogues for cosmic space, Kiesler's aims are best captured in his own language, ripe with allusions to *The Large Glass*: "[In 1947] I revived the galaxial idea to portray personalities fixed in space and time— [E. E.] Cummings, Marcel Duchamp, Henry Laugier. These were families of paintings [*sic*] instead of bachelors and spinsters in isolation. To do this, I had one main tool and technique: the proper dimensioning of distance between one unit and another. Thus the intervals between the units became of major importance to the correlation of the total work. One unit closer or farther, higher or lower, from another will have a great impact on the composition of the galaxy per se and also on the observer who is drawn into this man-made expanding universe."[4]

The importance of the positioning of the portrait's component parts and their arrangement relative to one another thus played a critical role in the communication of "endlessness" that fascinated Kiesler and with which he believed Duchamp was sympathetic. Kiesler's intentions

1. For information about Duchamp's sitting with Kiesler, see Jennifer Gough-Cooper and Jacques Caumont, "Frederick Kiesler and The Bride Stripped Bare . . . ," in *Duchamp: passim: A Duchamp Anthology,* ed. Anthony Hill (Sydney, Australia: Gordon and Breach Arts International, 1994), 108. Their account of the life sitting is based on the journal of Stefi Kiesler. Collaboration on the installation included the spaces of the Rain Room and the Labyrinth; the artwork they created together was the *Green Ray.*
2. On Kiesler's admiration of Duchamp, see Gough-Cooper and Caumont, "Frederick Kiesler," 99–109.

3. Frederick Kiesler, "Design—Correlation: From Brush-Painted Glass Pictures of the Middle Ages to 1920s," *Architectural Record* 81, no. 5 (May 1937): 55. Duchamp's enthusiastic response to the essay, conveyed in a letter from Duchamp to Kiesler of June 25, 1937, is quoted in Gough-Cooper and Caumont, "Frederick Kiesler," 100.
4. Frederick Kiesler, "Art in Orbit," *The Nation,* May 11, 1964, 487.

become even more evident with the return of the drawing on the occasion of this exhibition to the large three-dimensional frame that he designed for it, from which it has been separated for over four decades. The structure envelopes Duchamp, giving the subject a physical self-sufficiency and creating a sense of the very expansiveness Kiesler hoped to evoke. And indeed, Duchamp's reputation and influence has continued to grow, much as Kiesler seems to have intuited.

If governed by intellectual principles, Kiesler's rendition of Duchamp is not without humor, albeit purposeful. Adding to the strangeness of the portrait is Kiesler's decision to depict Duchamp only half-clothed, a choice Duchamp willingly obliged.[5] A clue to Kiesler's reasoning may be found in his description of Duchamp's division of *The Large Glass* "into areas of transparency and nontransparency," as quoted earlier. Perhaps in an effort to convey the notion of transparency associated with *The Large Glass*, Kiesler has depicted Duchamp's torso nude, with the exception of a necktie, which may subtly refer to the Bride, or "hanging female," of the work's upper register. Duchamp's pants remain firmly in place, secured by a belt, which may represent the work's horizon line, below which the bachelors remain anchored, unable to consummate their professed desire. The unusual portrayal may also slyly allude to a more tangible stimulus, concerning an evening party at which Duchamp and other guests removed their clothes to demonstrate their capacity for emotional detachment.[6] Whatever the explanation, Kiesler firmly insists upon the power of Duchamp's intellect, emphasizing his head through its (relatively) large size. In typical fashion, Duchamp's expression, as rendered by Kiesler, although somewhat schematic, appears unflappable, his eyes fixed on a point well beyond the frame.

ACG

5. For information about Duchamp's sitting with Kiesler, see Gough-Cooper and Caumont, "Frederick Kiesler," 108.
6. Peggy Guggenheim, *Out of This Century: Confessions of an Art Addict* (1946; New York: Universe, 1979), 270–71. The event is noted, but dismissed, by Calvin Tomkins as "improbable" in Tomkins, *Duchamp*, 342.

plate # **48**

Marcel Duchamp
Irving Penn (born 1917)
Gelatin silver print, 25.2 × 20 cm (9¹⁵⁄₁₆ × 7⅞ in.), 1948 (printed 1984)
National Portrait Gallery, Smithsonian Institution, Washington, DC;
gift of Irving Penn

In Irving Penn's photograph Duchamp cuts an elegant figure, appearing much like one of the fashion models that Penn photographed for *Vogue*. Of this method of placing his sitters in the corner, Penn recalled: "Sometime in 1948 I began photographing portraits in a small corner space made of two studio flats pushed together, the floor covered with an old piece of carpeting. . . . This confinement, surprisingly, seemed to comfort people, soothing them. The walls were a surface to lean on or push against. For me the picture possibilities were interesting; limiting the subjects' movement seemed to relieve me of part of the problem of holding on to them."[1] While such an austere background and confining space could be restrictive, Duchamp, who meets the viewer's gaze unswervingly, characteristically takes command of the space that he occupies. Indeed, Duchamp's relaxed demeanor made an impression on Penn himself.[2] The highly controlled environment of Penn's studio makes it seem as if his subjects exist in a space outside time and history. In this image Penn is able to "hold on" to the artist as he appeared at a particular moment in time, creating an image of an ever-youthful Duchamp.

JEQ/ACG

1. Irving Penn, quoted in Sarah Greenough, *Irving Penn: Platinum Prints* (Washington, DC: National Gallery of Art, 2005), unpaginated. The Duchamp photo is plate 18.
2. We thank Anne Tucker and Irving Penn for sharing Penn's observation of Duchamp's extreme ease in occupying this unconventional space (conversation between Anne Tucker, Anne Collins Goodyear, and James W. McManus, April 12, 2008; Penn's response was confirmed in an e-mail from Dee Vitale Henle to Anne Tucker, May 7, 2008, and shared with Goodyear by Tucker).

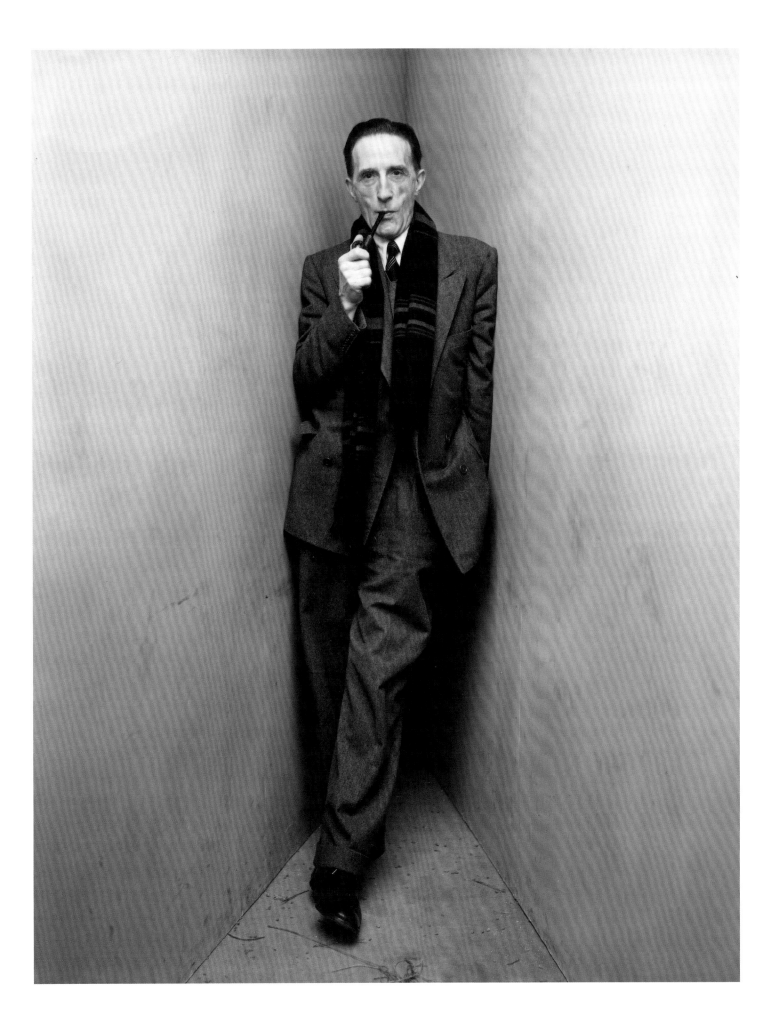

plate # 49

FBI Wanted Notice: Edward Aloyisus Hannon (Marcel Duchamp), Wanted for the Crime of Impersonation
Julien Levy (1906–1981)
Letterpress card stock with gelatin silver prints attached, 20 × 20.3 cm (7⅞ × 8 in.), c. 1950
Philadelphia Museum of Art, Pennsylvania; the Lynne and Harold Honickman gift of the Julien Levy Collection, 2001

208
209

Although known primarily as a talented dealer of surrealist art, Julien Levy created a number of spoofing "wanted" posters in the early 1950s.[1] Levy's depiction of Marcel Duchamp clearly plays homage to his *Wanted: $2,000 Reward* of 1923, similarly presenting Duchamp both in a profile and frontal view. However, the subtle inclusion of Duchamp's ubiquitous pipe in the picture at left and his jovial smile in the picture at right disrupts the format of a conventional mug shot, pointing at the work's humor. Nodding to Duchamp's ready adoption of alter egos, and alluding to his own imitation of Duchamp's work, Levy casts his friend as Edward Aloyisus Hannon, a forger sought by the law for "impersonation." Equally appropriately, Levy's *Wanted Notice,* using as its foundation an easily available poster created by the Federal Bureau of Investigation, draws on Duchamp's introduction of the "readymade," an everyday object appropriated by the artist, into modern art. Levy credited Duchamp for providing him professional encouragement early in his career and described him as one of his "godfathers [who provided] fertilizer for my thinking and feelings."[2]

ACG

1. On Levy's photography of friends, including this series, see Katherine Ware and Peter Barberie, *Dreaming in Black and White: Photography at the Julien Levy Gallery* (Philadelphia and New Haven, CT: Philadelphia Museum of Art, in association with Yale University Press, 2006), 159.
2. Julien Levy, interview with Paul Cummings, May 30, 1975, transcription, p. 11, AAA.

FEDERAL BUREAU OF INVESTIGATION
UNITED STATES DEPARTMENT OF JUSTICE
WASHINGTON, D. C.

F.P.C. 11 0 1 T 00 18
L 17 R I00

WANTED

FBI No. 4,198,366

EDWARD ALOYISUS HANNON

IMPÉRSONATION

Edward Aloyisus Hannon

Photograph taken 1944 Photographs taken 1947

DESCRIPTION

Age 39, born June 21, 1910, Cleveland, Ohio (not verified); Height, 6' 1"; Weight, 162 pounds; Build, slender; Hair, dark brown; Eyes, brown; Complexion, medium; Race, white; Nationality, American; Occupations, timekeeper, construction worker, payroll clerk, warehouse clerk, salesman; Scars and marks, scar on back of left hand near little finger, cut scar on upper lip.

CRIMINAL RECORD

Hannon has been convicted for the crime of forgery.

A Federal Grand Jury at Phoenix, Arizon[a returned an] indictment on April 16, 1948, charging Hannon with a violation of Section 76, Title 18, United States Code, the Federal Impersonation Statute.

Any person having information which may assist in locating this individual is requested to immediately notify the Director of the Federal Bureau of Investigation, U. S. Department of Justice, Washington, D. C., or the Special Agent in Charge of the Division of the Federal Bureau of Investigation listed on the back hereof which is nearest your city.

plate # 50

Portrait of Marcel
William Copley (1919–1996)
Oil on canvas, 44.8 × 37.1 cm (17⅝ × 14⅝ in.), 1951
Philadelphia Museum of Art, Pennsylvania; gift of Jacqueline, Paul, and
Peter Matisse in memory of their mother, Alexina Duchamp, 1998

Among the wide range of portraits picturing him, William Copley's surrealistic oil portrait, with its muted tonalities, was the only image of himself that Duchamp displayed in his own home.[1] Grateful to Duchamp, whom he met in 1949, for the support he had shown him as an aspiring painter and dealer, Copley would later remark: "He was certainly the most important person I've ever known. . . . He could somehow inject you with confidence and make things that seemed to be disturbing be ridiculous."[2] Copley created the portrait in 1951 when he moved to Paris, his home for the next decade.[3] Following his return to the United States, Copley would play an important behind-the-scenes role in Duchamp's career. In 1962, Copley enabled Walter Hopps to renew his acquaintance with Duchamp, a meeting that would lead to Duchamp's first retrospective. Soon thereafter, Copley became one of the few people to whom Marcel and Teeny Duchamp confided the existence of *Étant donnés*, on which Duchamp had been secretly at work for two decades. "Overwhelmed" by the piece, which he viewed in 1966 at Duchamp's small New York studio, Copley agreed to purchase it through his Cassandra Foundation and arranged for its donation to the Philadelphia Museum of Art following Duchamp's death.[4]

ACG

1. I thank Michael Taylor for this information. This is particularly interesting in light of the fact that Duchamp declined to accept the gift of Florine Stettheimer's c. 1923 portrait of him, now in the collection of the Springfield Museum of Art, offered by Ettie Stettheimer some time between 1944 and 1955, presumably in fulfillment of what she believed to be her sister's wishes. See Barbara Bloemink, *The Life and Art of Florine Stettheimer* (New Haven, CT: Yale University Press, 1995), 146; and Joseph Solomon, letter to Steven Watson, July 27, 1992, in the curatorial file for Florine Stettheimer, *Portrait of Marcel Duchamp*, Springfield Museum of Art, Springfield, MA.

2. Paul Cummings, oral history interview with William Copley, January 30, 1969, AAA and http://www.aaa.si.edu/collections/oralhistories/transcripts/copley68.htm, 22. Although the interview is officially dated to 1968, an internal reference to Duchamp's death indicates the year of the interview was 1969.

3. Copley exhibited his *Portrait of Marcel* in a 1953 group exhibition with Arthur Craven (ibid., 18–19.)

4. William Copley's reaction to seeing *Étant donnés* with Duchamp is quoted in Tomkins, *Duchamp*, 433.

In a note to Katherine Dreier a week before the opening of "Duchamp Frères et Soeur: Oeuvres d'Art"—a show organized by Marcel Duchamp that featured work by him, his brothers, and sister—at the Rose Fried Gallery in New York City, Duchamp revealed his anticipation of a major article focused on his career, writing: "I hear that the article in *Life* won't appear until April 21—with four or more pages in color."[1] The article that resulted, "Dada's Daddy," by Winthrop Sargeant, used the show at Rose Fried as a starting point and clearly fit with Duchamp's discrete campaign to rebuild his reputation in the United States after World War II. As Amelia Jones has noted, *Life* had only three years earlier celebrated the impact of Jackson Pollock.[2] Identifying Duchamp as the "spiritual leader" of Dada, celebrated for his "historical eminence," *Life*'s spread prominently featured a brightly colored portrait of Duchamp by his brother Jacques Villon, a work included in "Duchamp Frères et Soeur," opposite a time-lapse photograph by Eliot Elisofon of Duchamp descending a flight of stairs.[3] Should the allusion to Duchamp's signature canvas, *Nude Descending a Staircase (No. 2)*, have proved too subtle for some, a small reproduction of the painting next to the photograph drove the point home. Readers of the article turned the page to find a double-page spread with a color reproduction of the *Boîte-en-valise*. Thus, while seeming to avoid the spotlight—"Ambition, as he well knows, is a trap," wrote Sargeant—Duchamp subtly used the publication to garner recognition and position himself as a key force in the development of modern and contemporary art.[4]

ACG

1. Marcel Duchamp to Katherine Dreier, February 18, 1952, Mary E. Dreier Papers, Schlesinger Library, Radcliffe Institute, Harvard University, Cambridge, MA. For more on Duchamp's response to this aricle, see also Anne Collins Goodyear's essay in this volume.
2. Jones, *En-Gendering*, 63.
3. Winthrop Sargeant, "Dada's Daddy," *Life*, April 28, 1952, 100–5.
4. Ibid., 111.

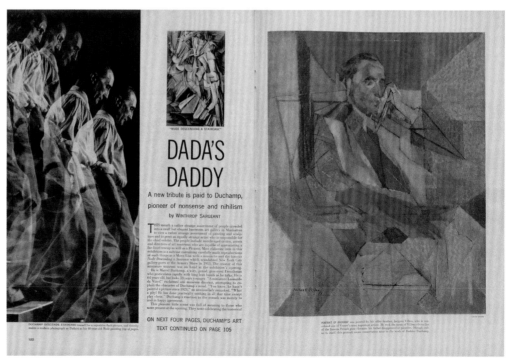

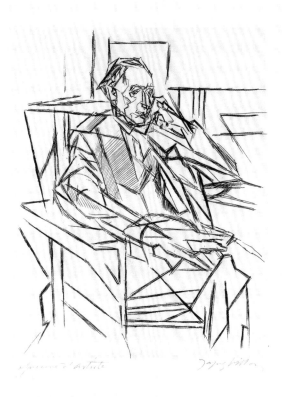

Marcel Duchamp
Jacques Villon (1875–1963)
Etching, 53.1 × 38.1 cm (20⅞ × 15 in.), 1953
National Portrait Gallery, Smithsonian Institution, Washington, DC

plate # **52**

Jacques Villon's 1953 etching of his younger brother Marcel Duchamp—related to a 1951 painting and a 1953 drawing—reflects the moment Duchamp's reputation began to eclipse that of Villon. Villon had nurtured his brother's artistic ambitions with his own avant-garde activities, enabling Duchamp's participation in the 1913 Armory Show. A 1952 show, organized by Duchamp for the Rose Fried Gallery, combined the work of the two brothers and their siblings, the result of Duchamp's growing fame. After Duchamp's return to New York during World War II, a 1945 issue of *View* was devoted to him, and a 1952 spread in *Life* declared him "Dada's Daddy" (see pl. 51). His work appeared in exhibitions at the Art Institute of Chicago in 1949 and the Sidney Janis Gallery in New York in 1953. Celebrated for his cerebral approach to art making, a quality captured by Villon, Duchamp was already focusing on his legacy

and secretly beginning his final work, *Étant donnés*, designed to be unveiled posthumously. As he explained in 1956: "The danger for me is to please an immediate public . . . I would rather wait for the public that will come fifty years—or a hundred years—after my death."[1]

ACG

1. Marcel Duchamp, in conversation with James Johnson Sweeney, "A Conversation with Marcel Duchamp," televised interview for NBC conducted in 1955 and aired in January 1956; edited transcript published as "Regions which are not ruled by time or space," in *WMD*, 137. Quoted in Tomkins, *Duchamp*, 393.

plate # **53**

Marcel Duchamp
Suzanne Duchamp (1889–1963)
Etching, 23.5 × 17.5 cm (9¼ × 6⅞ in.) image, 1953
Daria Brandt and David Ilya Brandt

"Your etched portrait pleases me a great deal," Marcel Duchamp wrote to his sister Suzanne upon his receipt of this image.[1] The 1953 likeness may have been inspired in part by "Duchamp Frères et Soeur: Oeuvres d'Art," an exhibition organized by Duchamp the previous year at the Rose Fried Gallery in New York, which combined the work of Raymond Villon-Duchamp, Jacques Villon, Suzanne Duchamp, and Marcel.[2] However, the backdrop of canvases against which she depicted her brother, who appears lost in thought, may also allude to the numerous exhibitions with which he was involved during the period, both as organizer and subject.[3] Indeed, Suzanne had delivered this portrait to her brother through their mutual friend, dealer Sidney Janis, with whom Duchamp had recently organized a major show of Dada in which his own early work appeared.[4]

ACG

1. Marcel Duchamp to Jean and Suzanne (Duchamp) Crotti, October 24, 1953, micro-film, Jean Crotti Papers, AAA (translation by the author).
2. "Duchamp Frères et Soeur: Oeuvres d'Art," ran at the Rose Fried Gallery New York from February 25 to March 1952; the catalogue does not specify a closing date. The catalogue is included in the Jean Crotti Papers, AAA.
3. The chronology included in d'Harnoncourt and McShine, *Marcel Duchamp*, 23–26, specifies no fewer than seventeen exhibition projects between 1942, when Duchamp returned to the United States, and 1953 in which Duchamp was involved as organizer, juror, or subject.

4. Duchamp's letter to Suzanne of October 24, 1953, Jean Crotti Papers, AAA, specifies that the portrait was delivered by Janis. "Dada 1916–1923," took place at the Sidney Janis Gallery, April 15–May 9, 1953. See Carroll Janis, "Marcel Duchamp Curates Dada," *Art in America* 94 (June–July 2006): 152–55, 215. Compare with Francis Naumann's discussion of this etching in his essay in this volume.

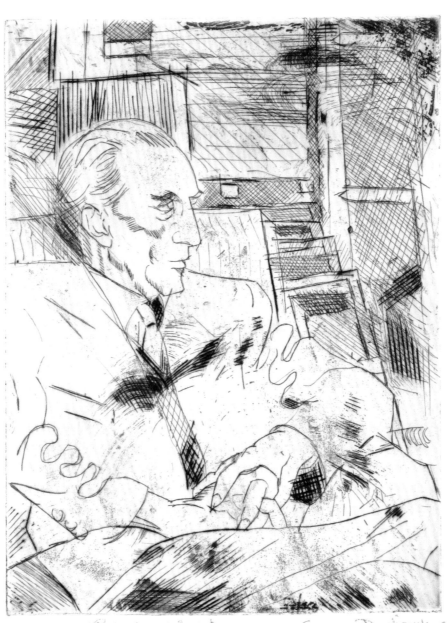

9/20 a Monsieur Picquart - amicalement Suzanne Duchamps 53

plate # 54

Portrait No. 29 (Double Exposure: Full Face and Profile)
Victor Obsatz (lifedates unknown)
Gelatin silver print, 25.4 × 20.3 cm (10 × 8 in.), 1953
Philadelphia Museum of Art, Pennsylvania, Marcel Duchamp Archive; gift of Jacqueline, Paul, and Peter Matisse in memory of their mother, Alexina Duchamp

Victor Obsatz revealed that the double exposure documented in this photograph happened by chance when the film did not advance properly.[1] It was a happy circumstance for Duchamp, who loved the outcome of his smiling features overlaying his iconic profile portrait. This dual image of Duchamp recalls the mug shots (front and side) that Duchamp used for his 1923 *Wanted: $2,000 Reward* (pl. 25), as well as his concept of "the hinge." It relates to Duchamp's notion of the third and fourth dimensions: the idea can be illustrated by a chessboard folded in half to reveal the symmetry of two once-separate fields of play. As David Joselit explains, the hinge can be understood as a "point of dimensional transfer and a site of subjective encounter," significant as a symbolic means to communicate Duchamp's belief in a continual state of becoming (opposed to what he disregarded as the status of being). The hinge recurs in his notes and works.[2] In this image the hinge is the point of convergence that allowed Duchamp's two portraits to merge as one.

AK/JWM

1. Telephone conversation between James W. McManus and Victor Obsatz.
2. David Joselit, *Infinite Regress: Marcel Duchamp, 1910–1941* (Cambridge, MA: MIT Press, 1998), 174.

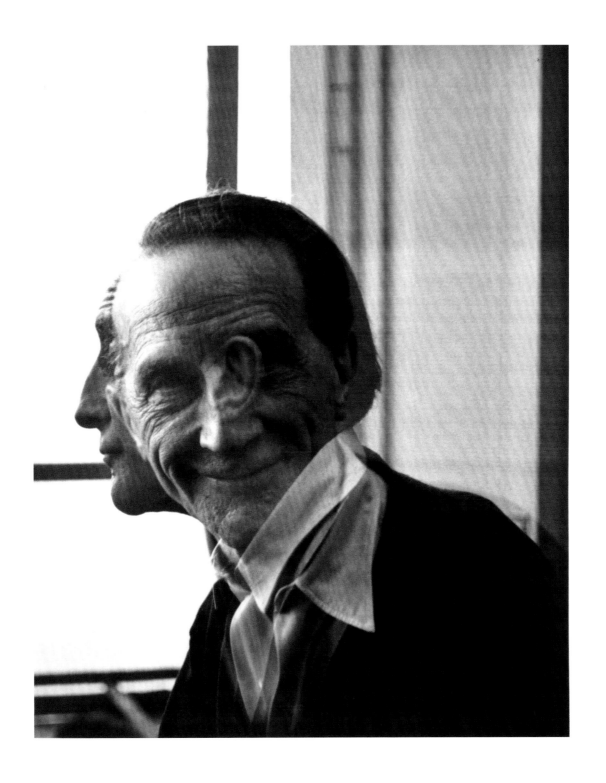

plate # 55

Marcel Duchamp in Blond Wig
Man Ray (1890–1976)
Polaroid photograph, 7.9 × 6.4 cm (3⅛ × 2½ in.), c. 1955
Archives Marcel Duchamp, Villiers Sous Grez, France

Although this photograph was taken years before the existence of Duchamp's last major work was revealed, the blond wig seen here is likely the same one worn by the mannequin in Duchamp's *Étant donnés*.[1] The wig belonged to his wife, Alexina (Teeny), and on Duchamp's head it appears out of context, a misplaced prop, like the mustache he gave *Mona Lisa* in *L.H.O.O.Q.* Man Ray was no stranger to photographing Duchamp in travesty, yet despite their long friendship, even he was excluded from knowing about Duchamp's secret project, *Étant donnés*, and could not have known that Duchamp in the blond wig was likely parodying the subject of that work. If anything, the wig was probably seen as a joking reference to Rrose Sélavy, who first came to life in front of Man Ray's lens.

This Polaroid is one of two known photographs from that series; the second differs only slightly from this image.[2]

AK/JWM

1. In December of 2005, while attending the "Marcel Duchamp and Eroticism" colloquium held at the University of Orleans and the Musée des Beaux-Arts in Orleans, France, James W. McManus asked Michael R. Taylor his opinion regarding the possibility that the wig worn in this photograph might be the same one on the figure in *Étant donnés*. While Taylor thought it possible, he could not be certain.
2. Judging from the size of the prints, Man Ray most likely used the fairly new Polaroid Land Model 80 camera. Its roll print pack contained eight plates. The other known Polaroid from this series is illustrated in *Marcel Duchamp–Man Ray: Fifty Years of Alchemy* (New York: Sean Kelly Gallery, 2004), 56, 57.

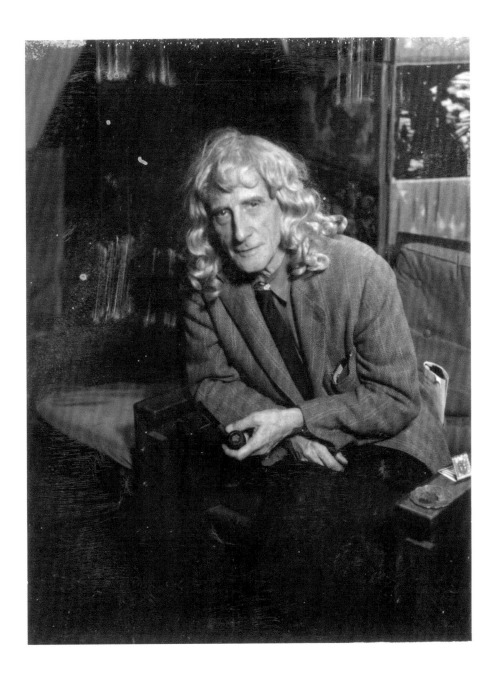

plate # **56**

Marcel Duchamp
John D. Schiff (1907–1976)
Gelatin silver print, 25.2 × 20.3 cm (9 15/16 × 8 in.), 1957
National Portrait Gallery, Smithsonian Institution, Washington, DC

John D. Schiff, who frequently photographed Marcel Duchamp and also documented his work, created this portrait of Duchamp in 1957, at a time when Duchamp's star was on the rise in the United States.[1] Two years earlier, Duchamp had officially become an American citizen. He would play an increasingly important role in the American art scene, participating in exhibitions, giving lectures, and exerting a strong influence on young American artists. In his lecture "The Creative Act," delivered in April of 1957, Duchamp sought to counter prevailing conceptions of the artistic process, positing that the artist and the spectator together create a work of art.

In contrast to the layered exposure and reflection techniques employed by Bill Eppridge, Victor Obsatz, Arnold Rosenberg, and Schiff himself in other portrayals of Duchamp, this particular photograph exemplifies a more traditional mode of portraiture. Schiff positions Duchamp in a frontal pose and under direct light, emphasizing Duchamp's forehead, nose, and hand and highlighting the wrinkles around his eyes and mouth. The sharp contrasts of light and dark, the shadowy background, and the closely cropped composition, as well as Duchamp's penetrating gaze, compel the viewer to engage with the image, embodying Duchamp's notion that a work of art is a collaboration between the artist and the spectator. In this case the collaboration is extended to involve the subject of the work of art: Duchamp himself. While Duchamp's gaze is direct, his eyes remain shrouded in shadows, imbuing the portrait with a detached and enigmatic air.

JEQ

1. For more on Schiff, who until recently has remained relatively unknown, see Paul B. Franklin, "It's in the Bag: The Story of a Brown Paper Sack," *Étant donné Marcel Duchamp* 6 (2005): 171–82.

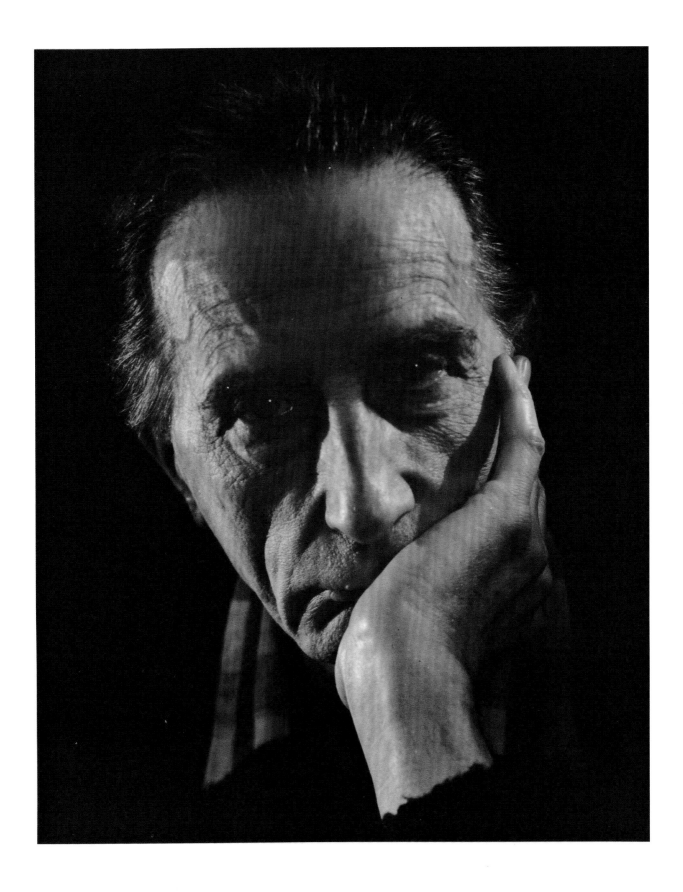

plate # 57

Template for Self-Portrait in Profile
Marcel Duchamp (1887–1968)
Zinc, 22.5 × 13.3 cm (8⅞ × 5¼ in.), 1957
Archives Marcel Duchamp, Villiers Sous Grez, France

In 1957, in preparation for the publication of the deluxe and grand-deluxe editions of Robert Lebel's *Sur Marcel Duchamp,* Duchamp created an edition of 130 (later increased to 137) numbered self-portrait profiles inscribed "Marcel déchiravit."[1] The inscription, with its Latin connotation loosely suggesting ties to ancient print-making, also signified more directly the method of the work's creation: "Marcel tore this quickly."[2] Each of the profiles were created with the aid of a zinc template, fashioned by the artist for the purpose. The use of such a template to create facsimile versions had been anticipated by Duchamp with his use of zinc templates in 1934 to create editions of the notes collected together in his *The Green Box.*[3]

Appropriately, given his affinity for boxes, the zinc template was stored by Duchamp in a small leather suitcase together with colored sheets of origami paper from which the profiles were fashioned. The paper and the template in turn were accompanied by a graphite outline of the template indicating how the profile was to be layed, at a slightly inclined angle, on a black background. After creating the numbered edition of profiles for Lebel's monograph, Duchamp would continue to use the template to make silhouette self-portraits for friends with the inscription, "Marcel déchiravit pour . . ."

Duchamp's description in 1964 of his early portrait of his younger sisters, *Yvonne and Magdeleine Torn in Tatters* (1911) (fig. 6.5), may reveal something of his approach to his own late self-depiction: "Introducing humor for the first time in my paintings I, so to speak, tore up their profiles and placed them at random on the canvas."[4] But if the silhouette self-portrait, which seems to show Duchamp's head inclined as though at work, is tinged with humor, it also reflects his fascination with shadows and the reciprocal relationship between negative and positive spaces. The shadow, which appears through the absence of light, also suggests Duchamp's sensitivity to modes of visibility and nonvisibility. Confusion surrounding his presence or nonpresence is manifested in much of his self-portraiture, where he appears in the guise of another character, and in his decision to sign his *Boîte-en-valise* "from or by Marcel Duchamp or Rrose Sélavy," which deliberately blurs the question of his relationship to the resulting object.

The powerful impact of this simple image is evident in the influence it exerted. Duchamp's silhouette became so closely identified with the artist that it was reproduced as a seriographed poster advertising an exhibition at La Hune bookstore in Paris (May 5–30, 1959) in honor of the release of the Lebel monograph. A seriographed reproduction was included in Shuzo Takiguchi's deluxe publication of *To and From Rrose Sélavy* (see pl. 83). The image also provided the basis for portraits of Duchamp by Jasper Johns (pls. 66, 67) and Ray Johnson (pl. 88), as well as for a poster of Bob Dylan by Milton Glaser.[5]

1. Although the *Self-Portrait in Profile* has been dated to 1958 by Arturo Schwarz, author of the authoritative Duchamp catalogue raisonné, a dating followed by other scholars, correspondence between Marcel Duchamp, Robert Lebel, and Arnold Fawcus recently published by Paul Franklin demonstrates that the edition of the profile was actually complete by February 1957. The original edition was of 130 pieces; this number was later increased to 137. See Paul B. Franklin, "1959: Headline, Duchamp," *Étant donné Marcel Duchamp* 7 (2006): 146; cf. Schwarz, *Complete Works,* vol. 2, 811.

2. I am grateful to Jackie Monnier and Dona Hochart for sharing this translation. On the inscription's Latin associations, see Naumann, *Art of Making Art,* 188.

3. Ibid.

4. Marcel Duchamp, "Apropos of Myself," talk delivered at the City Art Museum of St. Louis, Missouri, November 24, 1964, in Schwarz, *Complete Works,* vol. 2, 547, and quoted in d'Harnoncourt and McShine, *Marcel Duchamp,* 251; and Tomkins, *Duchamp,* 54. In Jasper Johns's tribute to Marcel Duchamp, published shortly after Duchamp's death, Johns conflated Duchamp's description of his portrait of his sister with the *Self-portrait in Profile,* obliquely referring to the work as "*Himself, quickly torn to pieces.*" Jasper Johns, "Marcel Duchamp (1887–1968)," *Artforum* 7, no. 3 (November 1968): 6.

5. Rita Reif, "Art/Architecture; Like His Posters, Available Again, a Designer Endures," *New York Times,* May 6, 2001. I thank Hannah Wong for bringing to my attention the similarity between Glaser's poster of Dylan and Duchamp's *Self-Portrait in Profile.*

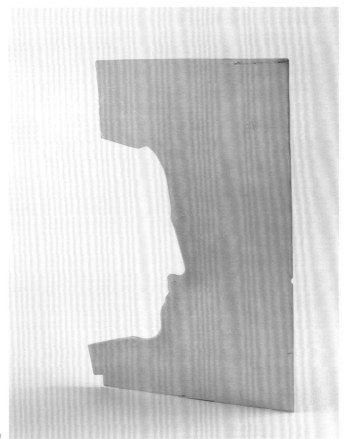

Self-Portrait in Profile
Marcel Duchamp (1887–1968)
Cut and pasted paper on velvet covered paperboard, 33.7 × 24.4 cm
(13¼ × 9⅝ in.), 1957
The Metropolitan Museum of Art, New York City; bequest of William S.
Lieberman, 2005 (2007.49.37)

plate # **58**

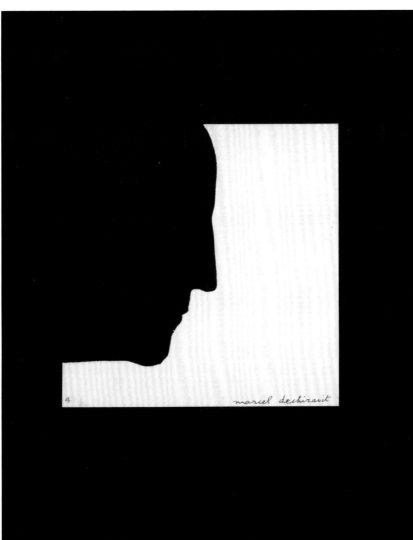

plate # **59**

Marcel Duchamp, artist, New York, January 31, 1958
Richard Avedon (1923–2004)
Gelatin silver print, 50.4 × 40.3 cm (19¹³⁄₁₆ × 15⅞ in.), 1958
National Portrait Gallery, Smithsonian Institution, Washington, DC

Richard Avedon's portrait, with its air of simultaneous revelation and mystery, captures Duchamp as the aging artist was emerging from the shadows to exert a dominant influence on a new generation of avant-garde artists. Despite his claims to have given up art, only a year earlier he had delivered his famous 1957 lecture "The Creative Act," a meditation on the work of art as a creation of both the artist and the spectator. In 1959, Robert Lebel's monograph on Duchamp would appear, heightening the artist's visibility in the United States, where he would become increasingly important for a new generation of creative talents such as Andy Warhol, Jasper Johns, Robert Rauschenberg, and John Cage.[1] At the time that Avedon took his photograph, Duchamp was in fact secretly at work on his final creation, *Étant donnés,* which was revealed only after his death in 1968.

Conveying an aura of mystery and detachment even as his public exposure increased, Duchamp remains enigmatic, seeming to appear before our eyes only to fade again into the dark background. With his wrinkled hands lightly touching the sides of his nose and casting shadows onto his mouth and cheeks, he does not meet the viewer's gaze but instead looks off to the side pensively, his dark eyes focused on some unknown object.

JEQ

1. Tomkins, *Duchamp,* 407–8.

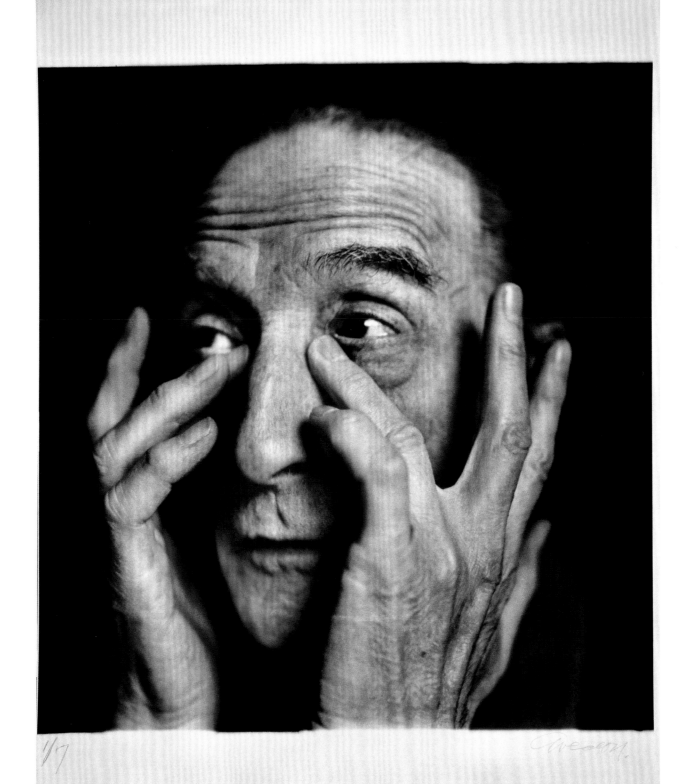

plate # 60

Duchamp at Chess Board
Arnold T. Rosenberg (born 1931)
Gelatin silver print, 50.8 × 40.6 cm (20 × 16 in.), 1958, printed later
Collection of the artist

Arnold Rosenberg's photograph of Duchamp, one of a series, is a view of Duchamp from below a sheet of glass on which chess pieces are arranged. With his furrowed brow and intense expression, Duchamp appears to be deep in contemplation as he reaches out to move his piece. Duchamp was a dedicated chess player and earned numerous accolades for his chess-playing abilities, including the title Master of the Fédération Française des Echecs.[1] Although Rosenberg's image at first seems to capture Duchamp in the midst of a game, the studied configuration of the chess pieces, the lack of squares on which to place the pieces, and the absence of another player indicate that this photograph is about the act of playing chess rather than a straightforward document of the game itself.

While Duchamp enjoyed the intellectual challenge of chess, he also relished the aesthetic nature of the game, telling Julien Levy that "you feel the shape of the board as it begins to shift its patterns and you make it become beautiful."[2] The glass in Rosenberg's portrait makes visible these "shifting" patterns, which also serve to frame Duchamp's face. The photograph brings to mind works such as *The Large Glass* and *To Be Looked at (from the Other Side of the Glass with One Eye, Close to, for Almost an Hour)* (1918).[3] In this image it is Duchamp himself, embodying the role of subject, who is to be looked at through the glass.

JEQ

1. A recently discovered manuscript of Duchamp's, entitled *A Thousand End Games,* gives an overview of his sophisticated analyses of endgame theories. For more on this subject, see Ernst Strouhal, "A Pas de Deux in Chess: Some Remarks on Marcel Duchamp's *A Thousand End Games,*" in *Étant donné Marcel Duchamp* 7 (2006): 210–13. Duchamp's interest in chess and its implications for his career as an artist are explored in Francis Naumann, "Marcel Duchamp: The Art of Chess" (unpublished manuscript).

2. Marcel Duchamp, quoted by Julien Levy, in Julien Levy interview with Paul Cummings, May 30, 1975, transcription, p. 12, AAA.
3. Strouhal has noted that the idea of chess as romantic seduction can be seen as a parallel to the narrative of sexual pursuit between the bride and her bachelors in *The Large Glass.* See Strouhal, "A Pas de Deux in Chess," 210.

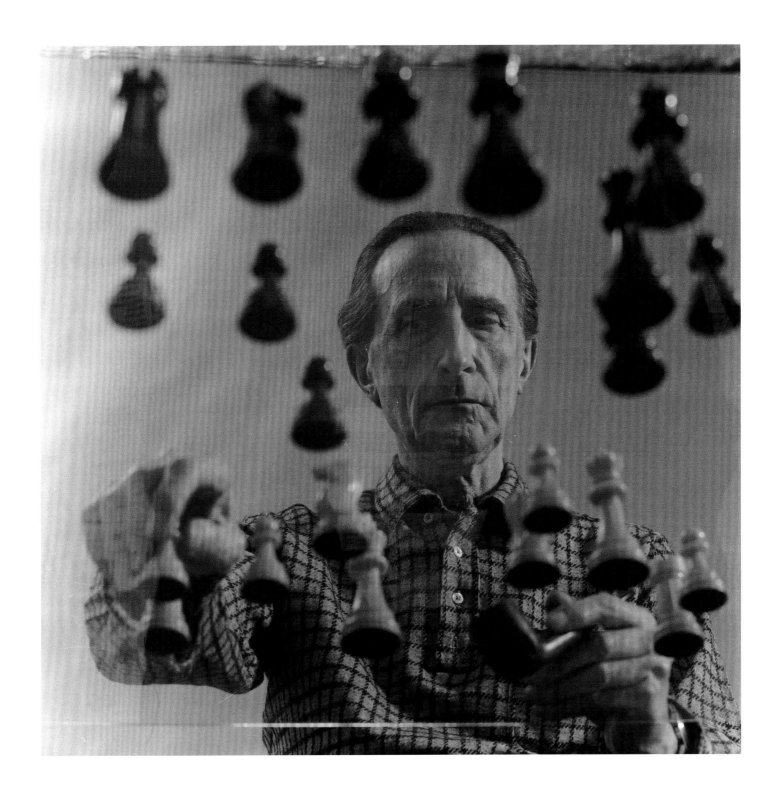

plate # 61

Marcel Duchamp Double Exposure
Arnold T. Rosenberg (born 1931)
Gelatin silver print, 35.2 × 27.6 cm (13⅞ × 10⅞ in.), 1958
Collection of the artist

In *Duchamp Double Exposure,* Arnold Rosenberg uses a multiple exposure technique to create a ghostly double portrait of Duchamp, in which two images of artist seem to merge into one. A photograph of Duchamp seen from the front, arm raised and wearing a striped shirt, is layered over a darker image of the artist in profile, framed by an illuminated window. While Duchamp's features can be vaguely discerned through the shadows that darken his profile, his face is not visible in the frontal portrait, heightening the spectral effect of the image.

Rosenberg employs a variety of visual devices that reference Duchamp's self-representation, such as the silhouette, which Duchamp used to portray himself, and the shadow, which he saw as embodying the "analysis of the successive transformations of objects" through various planes of existence.[1] In addition, Duchamp cited shadows as an example of his concept of the infra-thin, which concerns "the possible implying/the becoming— the passage from/one to the other."[2] The transparency of the layered images, which at points blend and merge together, visually expresses the ideas of transformation and passage. Rosenberg's portrait suggests that likeness, and therefore identity, is of the order of the infra-thin: undefinable, ephemeral, and fundamentally impenetrable.

JEQ

1. *WMD*, 72.
2. Marcel Duchamp, in *Marcel Duchamp, Notes,* ed. and trans. Paul Matisse (Boston: G. K. Hall, 1983), n. 1.

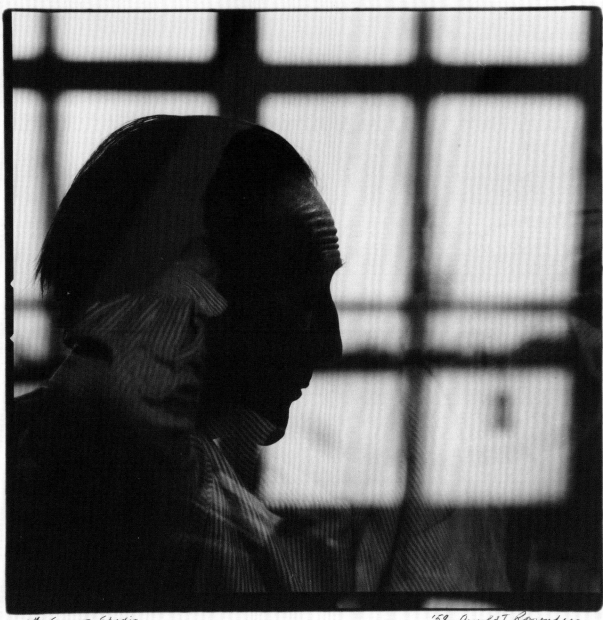

14th Street Studio '58 Arnold T. Rosenberg

plate # **62**

Deluxe edition of *Sur Marcel Duchamp*, 1959
Robert Lebel (1901–1986), in collaboration with Marcel Duchamp
Daria Brandt and David Ilya Brandt

The 1959 publication of Robert Lebel's monograph on Duchamp was by all accounts a momentous occasion.[1] The first monograph and catalogue raisonné on Duchamp, the book initially appeared as a deluxe edition in France with the title *Sur Marcel Duchamp*. It was released in Britain and the United States later that same year. Lebel's monograph opened with an overview of Duchamp's life and career and included Duchamp's lecture "The Creative Act" and essays by Henri-Pierre Roché and André Breton, who originally owned the "collaborator's copy" illustrated here.[2] Duchamp was heavily involved in the production, design, and layout of the book, and he created three new works for the ten grand-deluxe edition copies: *Self-Portrait in Profile* (pls. 57, 58), a hand-colored photographic reproduction of *The Large Glass*, and

an "imitated readymade" metal sign that read "Eau et gaz à tous les étages" (water and gas on all floors), inspired by the signs that could once be seen on the facades of Paris apartments.[3] The regular deluxe editions also included numbered hand-torn copies of *Self-Portrait in Profile*. The monograph is in effect a collaboration between Lebel and Duchamp, for, as Duchamp said, "true art criticism should be an exchange."[4] Duchamp also played an important role in publicizing the book, including arranging for exhibitions to advertise the monograph and even designing shop windows for its display.

The reverberations of Lebel's monograph were enormous. Lebel's book served as an introduction to Duchamp's work for an entire generation of young artists.[5] Especially striking is Duchamp's use of his art to provide a visual counterpart to Lebel's words. Indeed, it was the artist's orchestration of imagery, including his own self-portrait, that made the monograph an especially effective way to ensure the survival and dissemination of his legacy and to secure his place in history.

JEQ

1. The challenging process of realizing this publication is the subject of Paul B. Franklin, "1959: Headline, Duchamp," *Étant donné Marcel Duchamp* 7 (2006): 140–75. The book is also described in detail in Naumann, *Art of Making Art*, 188–92.
2. André Breton's copy was letter J, with profile 123 (see n. 3 on the system of lettering and numbering used for the grand-deluxe and collaborators' editions of the monograph). While the number and letter are clearly visible in the lower left of Duchamp's *Self-Portrait in Profile*, documentation at the Trianon Press independently confirms that this was the number and letter of the copy received by Breton. See Franklin, "1959: Headline, Duchamp," 172, n. 33.
3. As with all Duchamp's work, the piece has many layers of significance. It obviously resonates with a note included in *The Green*

Box, entitled "Preface," which reads "Given: 1st the waterfall / 2nd the illuminating gas" (*WMD*, 27). This note, in turn, points to a fueling mechanism in *The Large Glass*, a point recognized by Lebel (see Lebel, *Duchamp*, 176, pl. 206), as Francis Naumann has observed (*Art of Making Art*, 189). It also, of course, points forward in a veiled fashion to Duchamp's posthumous installation *Étant donnés*, on which he was secretly at work. In a strange historical coincidence, one of Duchamp's relatives, an advocate of improving residential access to water and gas, had actually authored pamphlets entitled "L'Eau & Le Gaz." Jennifer Gough-Cooper and Jacques Caumont, "Ephemerides on and about Marcel Duchamp and Rrose Sélavy, 1887–1968," in *Marcel Duchamp: Work and Life*, ed. Pontus Hulten (Cambridge, MA: MIT Press, 1993), entry for July 7, 1958; cited by Naumann, *Art of Making Art*, 189.

Ten grand-deluxe copies (I–X) were created, together with seventeen copies for collaborators and friends (A–Q); some of the lettered copies also included examples of the artworks created for the grand-deluxe edition. On the distinctions between grand-deluxe and deluxe copies, the numbers in each category, and the distribution of the special works created for each, see Franklin, "1959: Headline, Duchamp," 152–55; Naumann, *Art of Making Art*, 188; and Schwarz, *Complete Works*, vol. 2, 813–14.
4. Duchamp, quoted in Franklin, "1959: Headline, Duchamp," 171.
5. Calvin Tomkins, *The Bride and the Bachelors: Five Masters of the Avant-Garde* (New York: Viking, 1968), 15.

plate # **63**

Duchamp at the Museum of Modern Art with moustache and goatee
Marvin Lazarus (1918–1982)
Gelatin silver print, 23.8 × 15.1 cm (9⅜ × 5¹⁵⁄₁₆ in.), 1962, Philadelphia Museum of Art, Pennsylvania, Marcel Duchamp Archive; gift of Jacqueline, Paul, and Peter Matisse in memory of their mother, Alexina Duchamp

In 1919, in a Dada gesture, Duchamp took a post-card reproduction of Leonardo da Vinci's *Mona Lisa* and penciled in a moustache and beard. His act created an assisted readymade, desecrated a venerated masterpiece, and called attention to the questionable gender of Leonardo's model.[1] The gesture of transforming a female subject into a male one took place just prior to the creation of Duchamp's own gender alternate, Rrose Sélavy, in the 1920s.[2] Duchamp renamed his *Mona Lisa L.H.O.O.Q.*, which, when the letters are pronounced aloud in French, generates phrases variously translated as "there is fire down below" or "she has a hot bottom."[3] This photograph by Marvin Lazarus pictures Duchamp through the glass vitrine encasing *L.H.O.O.Q.* Playing off the humor of the original piece, Roberta Lazarus, Marvin's wife, drew a mustache and beard on Duchamp. The photograph was then mailed as a joke to Duchamp with the inscription, "Dear Rrose, Here's one on you, oui? Regards, Juan Ennui."[4]

AK/JWM

1. Duchamp would later observe, "the curious thing about that mustache and goatee is that when you look at it the *Mona Lisa* becomes a man. It is not a woman disguised as a man; it is a real man, and that was my discovery, without realizing it at the time." Duchamp, radio interview with Herbert Crehan, broadcast by WBAJ-FM, New York, 1961, published in Robert Cowan, ed., "Dada," *Evidence* (Toronto) 3 (Fall 1961): 37. Quoted by Schwarz, *Complete Works*, vol. 2, 670, and by Michael R. Taylor in his essay in this volume.
2. Tomkins, *Duchamp*, 231.
3. Schwarz, *Complete Works*, vol. 2, 670.
4. James W. McManus, interview with Roberta Lazarus, May 20, 2006.

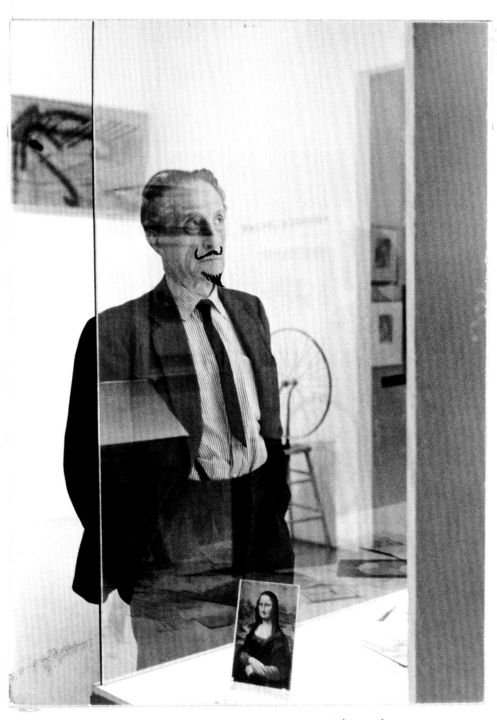

March 12, 1962

Dear Rrose,
 Here's one on you, oui ?
 Regards,
 Juan Ennui

plate # 64

Marcel Duchamp
Marvin Lazarus (1918–1982)
Gelatin silver print, 25.4 × 20.3 cm (10 × 8 in.), c. 1962
Roberta Fast Lazarus

Marvin Lazarus took this photograph at the Museum of Modern Art in New York on the final day of the "The Art of Assemblage" exhibition in 1961. The exhibition, organized by William Seitz, included thirteen of Duchamp's works.[1] This image captures Duchamp with two of his exhibited readymades. He stands framed within the spokes of his *Bicycle Wheel,* gazing up at his 1918 painting *Tu m'* (visible in the photograph is Duchamp's portrayal of the cast shadow of *Bicycle Wheel,* echoing the sculpture in the foreground), one arm familiarly tossed around the shoulder of his *Fountain.* Duchamp's inscription translates: "In my prison, by Lazarus the jailer. Affectionately, Marcel Duchamp, 1962."[2] Duchamp's remarks spin from the visual pun of his readymade's spokes and may also comment on his iconic connection to the readymade concept. Lazarus continued to photograph Duchamp for a period of three years, and in 1963 he exhibited his series at the East Hampton Gallery in a show titled "The Many Faces of Marcel Duchamp."

JWM

1. Tomkins, *Duchamp,* 416. See also William Seitz, *The Art of Assemblage* (New York: Museum of Modern Art, 1961), 158.
2. Translated by the author.

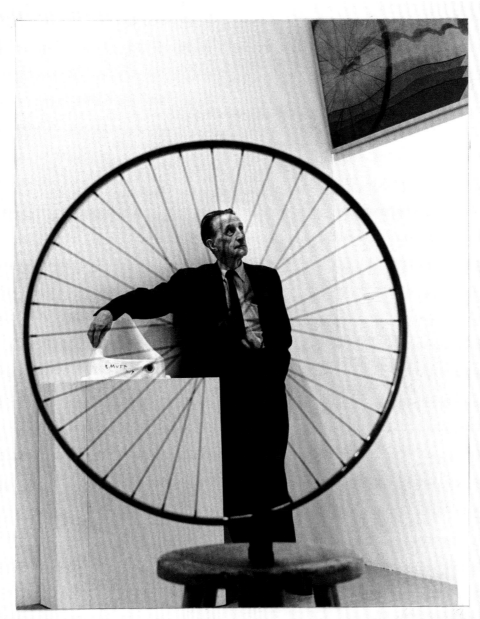

*de ma prison
pour Lazarus le geolier
after thememont
Marcel Duchamp
1962*

plate # **65**

Poster within a Poster
Marcel Duchamp (1887–1968)
Lithograph mounted on board, 87.5 × 69.5 cm (34⁷/₁₆ × 27³/₈ in.), 1963
Douglas Vogel

"I have forced myself to contradict myself in order to avoid conforming to my own taste," remarked Duchamp in 1945.[1] The 1963 exhibition at the Pasadena Art Museum, the first major retrospective of Duchamp's work, marked just such a contradiction, for, as Calvin Tomkins notes, Duchamp had discouraged such shows for years.[2] Walter Hopps, director of the museum and a great admirer of Duchamp, curated the exhibition, which included early paintings and drawings, readymades, and a reproduction of *The Large Glass*. In addition to his presence behind the scenes, offering Hopps advice and suggestions, Duchamp designed the show's poster. The result is an appropriation of Duchamp's own 1923 *Wanted: $2,000 Reward* (pl. 25)—itself an appropriation of a spoof of federally issued notices for criminals—into which Duchamp had inserted his own mug shots.[3]

Notably, *Wanted* pictures but does not name Duchamp himself, instead offering financial remuneration for information leading to the arrest of a character known variously as George W. Welch, Bull, Pickens, or Rrose Sélavy. In the Pasadena poster Duchamp added the words "by or of Marcel Duchamp or Rrose Sélavy" in his own handwriting, thus inscribing himself into the work.[4] The words "by or of," however, deliberately leave room for ambiguity as to the creator of the image, and by extension the creator of the works included in the retrospective. Duchamp's gesture underscores the fluid nature of the identity that he crafted for himself, leaving room for the contradictions that he so carefully cultivated throughout his life.

JEQ

1. Tomkins, *Duchamp*, 419, from Harriet and Sidney Janis, "Marcel Duchamp, Anti-Artist," *View* 5, no. 1 (March 1945): 18–19, 21, 23–34.
2. Tomkins, *Duchamp*, 419. But, if Duchamp ostensibly discouraged the organization of such a retrospective, he did, in fact, show his work quite often and participated in a variety of exhibitions in both Europe and the United States. Such exposure is documented in the chronology included in this volume.
3. The *Wanted* poster is conventionally dated to 1923. See, for example, Schwarz, *Complete Works*, vol. 2, 699. However, Francis Naumann notes that although 1923 is the favored date, Duchamp himself dated the poster "1921/ or 22" in a list compiled in the mid-1940s (Duchamp Archives, Philadelphia Museum of Art). See Naumann, *Art of Making Art*, 91, 94, n. 54.

4. Duchamp's signature also implicitly references his *Boîte-en-valise* (pl. 37), for which he had previously re-created *Wanted*. Duchamp signed the *Boîte-en-valise* in similar fashion but in French: "de or par Marcel Duchamp ou Rrose Sélavy," or, in English, "by or of Marcel Duchamp or Rrose Sélavy."

at the

Pasadena Art Museum

46 north los robles avenue
pasadena, california

WANTED

$2,000 REWARD

For information leading to the arrest of George W. Welch, alias Bull, alias Pickens. etcetry. etcetry. Operated Bucket Shop in New York under name HOOKE, LYON and CINQUER Height about 5 feet 9 inches. Weight about 180 pounds. Complexion medium, eyes same. Known also under name RROSE SÉLAVY

a retrospective exhibition

by or of

Marcel Duchamp

or

Rrose Sélavy

Marcel Duchamp

october 8 to november 3, 1963

plate # 66

M.D.
Jasper Johns (born 1930)
Collage and graphite pencil on stencil board, 55.2 × 45.1 cm
(21¾ × 17¾ in.), 1964
Collection of the artist

Acutely sensitive to the implications of Marcel Duchamp's work, Jasper Johns created his first visual response to Duchamp in 1964 with *M.D.*, a collage depicting a profile silhouette of the artist. The work clearly built on Duchamp's own 1957 *Self-Portrait in Profile* (pl. 58), acknowledging the artist's use of negative space to create the illusion of presence. Departing from the original, however, Johns shifts the orientation of the silhouette and the paper from which it was torn. Duchamp's likeness is flipped 180 degrees, as though in a mirror, and its downward tilt is reduced. Correspondingly, Johns has altered the shape of the paper composing the profile, creating the effect of a lozenge rather than the square present in Duchamp's self-

portrait. In altering the orientation of the work, Johns demonstrated the degree to which he had absorbed Duchamp's ruminations on perspectival systems recorded in his *Green Box,* about which Johns published a review in 1960.[1] Johns's method also reflects the influence of Duchamp's writings on the use of cast shadows in *The Large Glass*.[2] Describing the manner through which he created the image, Johns explained: "Duchamp did a work which was a torn square (I think it's called something like *Myself Torn to Pieces*). I took a tracing of the profile, hung it by a string and cast its shadow so it became distorted and no longer square."[3]

The conceptual importance of Johns's experiment is clear in two sketchbook notes made by the artist in 1964. One notation anticipates the next operation Johns would perform on his portrait of Duchamp: "(Profile? Duchamp?)—distorted as shadow/Perhaps on falling/hinged section/Something that can be erased or shifted/(magnetic area)/stretcher or/part of chair/bolt/hinge/or hinge here?/this canvas could/then be dropped to/rest on the floor."[4] Johns would transfer the collage to a canvas placed at the lower left of his monumental 1964 assemblage, *According to What*. As the sketchbook note suggests, the canvas bearing Duchamp's profile was hinged at the top, making it possible for the artist to "erase or shift" the work by swinging the panel upward to close it, rendering it invisible.

This variation on the image inspired both a drawing based on the composition and a lithograph, *Fragment—According to What—Hinged Canvas,* 1971, documenting the presence of Duchamp's profile.[5] Unlike the collage, the portrait of Duchamp as rendered in the later assemblage, drawing, and print point clearly at Johns's technique, incorporating the image of the string from which Johns suspended Duchamp's profile

1. Jasper Johns, "Duchamp," *Scrap* (New York), no. 2 (December 23, 1960): 4. The review is reprinted in *Jasper Johns: Writings, Sketchbook Notes, Interviews,* ed. Kirk Varnedoe, comp. Christel Hollevoet (New York: Museum of Modern Art, 1996), 20–21.
2. See particularly Duchamp's note "Shadows cast by readymades," *WMD,* 33. Another note by Duchamp on the topic, "Cast Shadows," was originally published by Roberto Matta in *Instead,* February 1948; it is reprinted in *WMD,* 73.
3. John Coplans, "Fragments According to Johns: An Interview with Jasper Johns," *Print Collector's Newsletter* 3, no. 2 (May–June 1972): 29–32; reprinted in Varnedoe, *Jasper Johns: Writings,* 140. On Johns's technique, see also Richard Shiff, "Anamorphosis: Jasper Johns," in *Foirades/Fizzles: Echo and Allusion in the Art of Jasper Johns* (Los Angeles: Grunwald Center for the Graphic Arts, Wight Art Gallery, University of California, Los Angeles, 1987), 151.

4. Jasper Johns, book A, 49. 1964; reprinted in Varnedoe, *Jasper Johns: Writings,* 56–57.
5. Note that in the drawing *According to What,* the orientation of Duchamp's profile has once again been flipped 180 degrees, so it faces right rather than left; on this drawing, see "*According to What,* 1969," in Nan Rosenthal and Ruth E. Fine et al., *The Drawings of Jasper Johns* (Washington, DC: National Gallery of Art, 1990), 204–5.

in order to create the cast shadow. The subsequent versions of Duchamp's image also incline the artist's head forward, in a manner similar to the orientation selected by Duchamp for his silhouette. If technique is made visible, so too in the print is the simultaneous presence and nonpresence of Duchamp's profile in *According to What*. As Johns explains: "The print simultaneously shows the hinged canvas closed and open." With regard to cancelling his signature, Johns clarified for John Coplans what had occurred: "I didn't cross it out. The cross was there before I signed it, but I planned to sign it that way. I have deliberately taken Duchamp's own work and slightly changed it, and thought to make a kind of play on whose work it is, whether mine or his."[6] The dripping spot of ink to the left of Duchamp's silhouette corresponds to a similar drip included in the hinged Duchamp panel in *According to What*. Certainly suggestive of "Duchamp's interest in the concept of controlled chance," as Nan Rosenthal has observed, the ink spot may also refer to the activity of "shooting" on the part of the bachelors who seek to obtain union with the elusive bride, an activity Johns referred to in his review of the English translation of *The Green Box*.[7] Aware that his own homage to Duchamp would never intersect precisely with the original, producing a suggestive gap protective of the creative impulse behind Duchamp's "original" and Johns's inventive "copies," Johns would later adopt the shadow as a form of self-depiction in his series *The Seasons*, where the Duchamp portrait once again appears in the canvas "Fall."[8]

ACG

6. Coplans, "Interview with Jasper Johns," 139–41.

7. See Nan Rosenthal, "Drawing as Rereading," in Rosenthal and Fine et al., *Drawings of Jasper Johns*, 28; and Varnedoe, "Duchamp," in *Jasper Johns: Writings*, 20.

8. I thank Ruth Fine for alerting me to the inclusion of Duchamp's silhouette in the "Fall" panel.

Fragment—According to What—Hinged Canvas
Jasper Johns (born 1930)
Lithograph, 91 × 75.4 cm (35¹³⁄₁₆ × 29¹¹⁄₁₆ in.), 1971
National Portrait Gallery, Smithsonian Institution, Washington, DC

plate # 67

plate # 68

Marcel Duchamp Looking at Hat Rack
Ugo Mulas (1928–1973)
Gelatin silver print, 33 × 27 cm (13 × 10⅝ in.), 1964
Archives Marcel Duchamp, Villiers Sous Grez, France

242
243

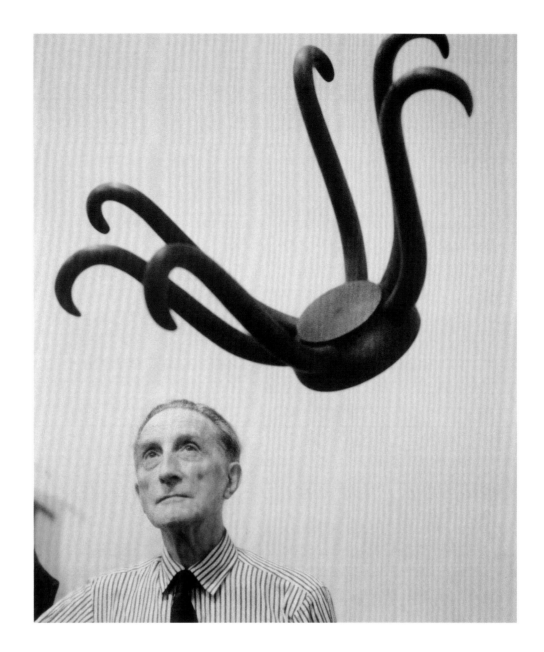

Ugo Mulas took this photograph at the Galleria Schwarz in Milan when the Schwarz edition of Duchamp's readymades was publicly announced in 1964. The Schwarz edition re-created thirteen of Duchamp's readymades in signed and numbered editions of eight.[1] Mulas's photograph portrays Duchamp standing below the Schwarz version of his readymade *Hat Rack,* its tentacles reaching out over his head. The original *Hat Rack* was created in 1917 and subsequently lost. In both incarnations the readymade was produced by suspending a once functional object from the ceiling, rendering it useless (like his readymade *Trébuchet* (or *Trap*), a coat rack nailed to the floor). *Hat Rack* and the other Schwarz edition readymades have found homes in collections around the world, and, as such, they have become important ingredients in the dissemination of Duchamp's legend.

AK/JWM

1. Francis Naumann, "Arturo's Marcel," *Art in America* 86 (January 1998): 35–39.

Duchamp Emerging from Curtains
Ugo Mulas (1928–1973)
From *New York: The New Art Scene* (Holt, Rinehart, and Winston, 1967), 1965
Smithsonian Institution Libraries, Washington, DC
[Not in exhibition]

plate # 69

In the mid-1960s the photographer Ugo Mulas collaborated with Alan Solomon to produce the book *New York: The New Art Scene* (1967). Among the artists featured was Marcel Duchamp. The two-page spread shown here introduces us to Solomon's essay in which he sheds light on Duchamp's reemergence from the shadows of the past to assume an influential role on a new generation of artists. Also seen are two photographs, the juxtaposition of which is intriguing. The image of Duchamp's readymade copyrighted by Rose Sélavy, *Fresh Widow* of 1920, plays its powers of obstruction and visual impenetrability (the glass panes are covered with black leather) against Ugo Mulas's photograph of Duchamp stepping from between two curtains. The sense of absence suggested in *Fresh Widow* is replaced by one of Duchamp situated in a cusp between being visible and invisible, recalling the title of his major exhibition, "Not Seen and / or Less Seen by / of Marcel Duchamp/Rrose Sélavy, 1904–1964," which traveled to museums across the country just prior to the completion of this book.[1]

JWM

1. For a list of sites where this exhibition traveled in 1965, see Jennifer Gough-Cooper and Jacques Caumont, "Chronological Table of Exhibitions," year 1965, in *Marcel Duchamp: Work and Life,* ed. Pontus Hulten (Cambridge, MA: MIT Press, 1993), unpaginated.

Screen Test: Marcel Duchamp
Andy Warhol (1928–1987)
16mm film, black and white, silent, 4 minutes, 1966
Film still courtesy of The Andy Warhol Museum, Pittsburgh, Pennsylvania

plate # 70

Part of a series of *Screen Tests* carried out by Andy Warhol in the mid-1960s, this filmed portrait of Marcel Duchamp captures the artist's impish smile and sense of humor.[1] Although Warhol generally required that sitters remain still during filming, Duchamp's "test" does not conform to this pattern. Instead, the artist smokes a cigar, drinks water, grins, and even seems to speak with somebody off camera—although his gesture of placing his fingers to his lips suggests he knew he was to remain quiet. Indeed, Duchamp would report shortly after the collaboration that "Warhol . . . asked me to pose, on the single condition that I keep my mouth shut for twenty minutes."[2] Duchamp's motions are enhanced by Warhol's technique, which involved filming his subjects for approximately three minutes at twenty-four frames per second, or sound speed, and playing back the film at the slightly slower rate of sixteen frames per second, the standard for silent film.[3]

Created on February 7, 1966, at the opening of an exhibition at Cordier and Ekstrom designed as a benefit for the Marcel Duchamp Fund of the American Chess Foundation, Warhol placed Duchamp in front of a painting by his friend Gianfranco Baruchello.[4] As is frequently the case with Warhol's films, the image captures the sitter's response to action outside the range of the camera. Duchamp recalled: "In my case I had a girl on my knees, at least, nearly: a very cuddly little actress came up and sat by me practically lying on top of me, rubbing herself up against me." Duchamp admired Warhol, noting "I like Warhol's spirit. He's not just some painter or movie-maker. He's a filmeur, and I like that very much."[5] Warhol, who had recorded Duchamp previously at the opening of his 1963 retrospective at the Pasadena Art Museum, eventually hoped to create a day-long film of Duchamp to be entitled, *24 Hours in Marcel Duchamp's Life*. Unfortunately, the project could not be completed prior to Duchamp's death.[6]

ACG

1. A detailed account of this screen test and related projects is provided by Callie Angell, *Andy Warhol Screen Tests: The Films of Andy Warhol Catalogue Raisonné,* vol. 1 (New York: Harry N. Abrams, in association with the Whitney Museum of American Art, 2006), 63–66; see also 259–63 and 274–75. The filming is also documented by Nat Finkelstein, who photographed the event. See Finkelstein, "Duchamp," in *Andy Warhol: The Factory Years 1964–1967* (London: Sidgwick and Jackson, 1989), unpaginated, and Nat Finkelstein, "Dinner with Dalí & Meeting Marcel," *Étant donné Marcel Duchamp* 5 (2004): 76–89.
2. Duchamp, in interview with Otto Hahn, "Passport No. G255300," *Art and Artists* 1, no. 4 (July 1966): 7.
3. See Angell, *Andy Warhol,* 21, on the technical aspects of Warhol's *Screen Tests;* as she notes, the standard speed for silent film changed in 1970 from sixteen to eighteen frames per second, slightly speeding up Warhol's films. Duchamp's positioning in front of Baruchello's painting is not unlike the positioning of his *Fountain* in front of Marsden Hartley's *The Warriors* in Alfred Stieglitz's 1917

photograph of *Fountain* (on this juxtaposition, see Naumann, *Art of Making Art,* 75).
4. An overview of the events connected with the opening as a whole is provided in Jennifer Gough-Cooper and Jacques Caumont, "Ephemerides on and about Marcel Duchamp and Rrose Sélavy, 1887–1968," in *Marcel Duchamp: Work and Life,* ed. Pontus Hulten (Cambridge, MA: MIT Press, 1993), entry for February 7, 1966.
5. Duchamp, in Hahn, "Passport No. G255300," 7.
6. See Angell, *Andy Warhol,* 66; Warhol also makes reference to the unsuccessful project in a 1985 interview, Benjamin H. D. Buchloh, "Three Conversations in 1985: Claes Oldenburg, Andy Warhol, Robert Morris," *October* 70 (Fall 1994): 37. Although *24 Hours in Marcel Duchamp's Life* did not come to fruition, Warhol did include footage of Duchamp in another project, *Fifty Fantastics and Fifty Personalities;* see Angell, *Andy Warhol,* 259–63.

plate # 71

Warhol Filming Duchamp, Deluxe Box
Nat Finkelstein (born 1933)
Box of photographs and other materials related to
Marcel Duchamp. 31.8 × 63.5 × 6.4 cm (12½ × 25 × 2½ in.),
assembled 2004 (photographs shot 1966)
Collection of the artist

Created in 2004, *Warhol Filming Duchamp, Deluxe Box* represents Nat Finkelstein's response to Andy Warhol's February 1966 screen test of Marcel Duchamp, which he photographed. In homage to Duchamp's *Green Box*—a series of notes that accompanied his *Bride Stripped Bare by Her Bachelors, Even (The Large Glass)*—Finkelstein, in collaboration with Eric Schneyderman, created his own box containing copies of his images from the opening, including pictures of Duchamp, Duchamp and the actress Benedetta Barzini, and Salvador Dalí, together with contact sheets. Also included is a copy of the issue of the journal *Étant donné Marcel Duchamp* in which Finkelstein's account of the evening appears.[1] In a sly acknowledgment of the enduring influence of Duchamp's own irreverent wit—which prefigured Warhol's own—Finkelstein added, in a hidden compartment at the bottom of the box, an altered photograph of Warhol à la *Mona Lisa,* a reference to Duchamp's famous *L.H.O.O.Q.*

As Finkelstein later recounted, Warhol's decision to film Duchamp at the opening of "Homage à Caissa," a benefit for the Marcel Duchamp Fund of the American Chess Association, constituted a performance in itself. "Andy's coming to this artshow was like a guerrilla attack," explained Finkelstein. "That's what made him, as a matter of fact that's what made all of us, a feeling like: 'Fuck you man, we'll kick our way in here.'"[2] But if the intent was aggressive—an attempt to subvert an older artistic generation—Duchamp and the "movers and shakers" in attendance at the Cordier and Ekstrom Gallery remained unfazed. "It was interesting the way that they accepted us . . . the way we were dressed, jeans and leather jackets," Finkelstein recalled.[3] Duchamp willingly cooperated with Warhol, and, as Finkelstein's photographs demonstrate, his wife and others looked on at the event in happy amusement. The outcome was one of mutual respect. "I left knowing that Mr. Duchamp had treated me like a comrade," Finkelstein concluded. "A seeker of visions in the Fraternity of Artists."[4]

ACG

1. Nat Finkelstein, "Dinner with Dalí & Meeting Marcel," appears in *Étant donné Marcel Duchamp* 5 (2004): 78–89.
2. Nat Finkelstein, "Duchamp," in *Andy Warhol: The Factory Years 1964–1967* (London: Sidgwick and Jackson, 1989), unpaginated. The quotation is included in Paul B. Franklin's introduction to Finkelstein, "Dinner with Dalí & Meeting Marcel," 77. This episode is also the subject of Mark B. Pohlad, "Reflection: Nat Finkelstein, *Warhol Filming Duchamp* (1966)," *History of Photography* 31, no. 3 (Autumn 2007): 232–38. Pohlad notes that not only Finkelstein but also Stephen Shore took photographs of Warhol and Duchamp collaborating (ibid., 236–37).
3. Finkelstein, "Duchamp," unpaginated. The phrase "movers and shakers" to describe the attendees of the opening is Finkelstein's.
4. Finkelstein, "Meeting Marcel," in "Dinner with Dalí & Meeting Marcel," 81.

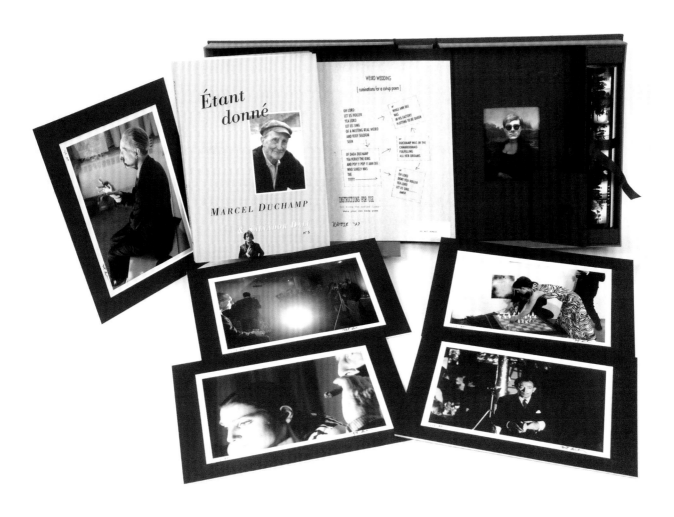

plate # 72

Ferus Poster
Richard Pettibone (born 1938)
Lithograph, 34.9 × 25.7 cm (13¾ × 10⅛ in.), 1966
Collection of the artist through Leo Castelli Gallery, New York;
photography courtesy private collection

Richard Pettibone once described Duchamp's readymades as "gifts that might be remade by anyone."[1] The concept of the readymade, in all its flexibility and fluidity, lies at the heart of Pettibone's practice. Duchamp's 1963 retrospective at the Pasadena Art Museum marked an important moment for Pettibone, who had recently completed his MFA at the Otis Art Institute in Los Angeles. Duchamp himself designed the poster for the 1963 retrospective (see pl. 65), which included examples of the readymades as well as a reproduction of *The Large Glass*. Using his own *Wanted* poster (1923) as a basis for the Pasadena poster, Duchamp added a handwritten annotation with the name of the museum, as well as the words "by or of Marcel Duchamp or Rrose Sélavy."

For the *Ferus Poster*, created for his 1965 show at the Ferus Gallery in Los Angeles, Pettibone used Duchamp's *Wanted: $2,000 Reward* as a kind of readymade, a fitting gesture in light of the fact that *Wanted* was itself an appropriation of a joke poster spotted by Duchamp. Pettibone replaced Duchamp's mug shots with his own picture and added text composed by Irving Blum, director of the Ferus Gallery, to the bottom of the poster. In addition to listing several of Pettibone's aliases, including Lee Enrose (a clear reference to Rrose Sélavy), the text names Pettibone's "crime" as having "meticulously executed selections" from the collections of important Southern Californian art collectors. The notion of copying works of art, which Blum suggested that Pettibone do for his one-man show, recalls Duchamp's reproduction of his own work for *Boîte-en-valise*, also included at the 1963 Pasadena retrospective.

The concept of the readymade likewise informs *Katherine Dreier's Living Room*. In this case, the readymade is a photograph that Pettibone most likely obtained from a reproduction in Robert Lebel's 1959 monograph on Marcel Duchamp.[2] Notably, John D. Schiff's 1948 photograph does not include human figures, focusing instead on works of art: Duchamp's *Large Glass* (1915–23), featured in the foreground, and *Tu m'* (1918), displayed over the bookcase. As with the *Ferus Poster*, Pettibone altered the readymade object—the found photograph—transforming the photograph of Dreier's living room into a print and placing it in a wooden frame.[3] The final product is Pettibone's own creation rather than a simple reproduction. *Katherine Dreier's Living Room*, both in its process and subject matter, evidences Pettibone's interest in form and aesthetics. Although Duchamp is often noted for his conceptual innovations, Pettibone emphasizes the visual aspect of Duchamp's practice, noting that "in spite of all that talk about chance & giving up taste etc. Duchamp's work is still drop dead gorgeous."[4]

1. Richard Pettibone, quoted in Michael Duncan, "A Snow Shovel Is Nice: The Works of Richard Pettibone," in *Richard Pettibone: A Retrospective* (Saratoga Springs, NY: Frances Young Tang Teaching Museum and Art Gallery at Skidmore College, 2005), 7.
2. Robert Lebel, *Marcel Duchamp*, trans. George Heard Hamilton (New York: Paragraphic Books, 1967 [1959]), fig. 43. The photographer is not credited in Lebel, but may be Walter Buschman, who visited Dreier's home to photograph *The Large Glass*, freshly repaired, in August 1936; Jennifer Gough-Cooper and Jacques Caumont, "Ephemerides on and about Marcel Duchamp and Rrose Sélavy, 1887–1968," in *Marcel Duchamp: Work and Life*, ed. Pontus Hulten (Cambridge, MA: MIT Press, 1993), entry for August 30, 1936. Pettibone had first read Lebel's monograph at Otis, recalling that "a very hip librarian" had obtained a copy for the school's library. See Duncan, "A Snow Shovel Is Nice," 15.

3. Pettibone had the photograph reproduced directly onto the canvas from a metal plate, the same process used for printing newspapers. He also used the same technique for a similar work picturing Duchamp's studio at 33 West 67th Street. Shortly after he executed *Katherine Dreier's Living Room*, Pettibone switched to the silkscreen method. See Ian Berry's interview with Pettibone (Ian Berry, "Attention Serious Artists: A Conversation with Richard Pettibone," in *Pettibone: A Retrospective*, 15–16).
4. Richard Pettibone, quoted in Francis Naumann, "Appropriating Duchamp, Appropriately," in *Pettibone: A Retrospective*, 23. Pettibone recently completed *Marcel Duchamp Wanted #2*, a new painted appropriation of Duchamp's *Wanted* poster.

WANTED

$2,000 REWARD

For information leading to the arrest of Richard Petti-bone alias Bull alias Pickens etcetry, etcetry. Reported having meticulously executed selections from Asher, Factor, Hopper, Janss, Rowan and Weisman collections for exhibition at the Ferus Gallery on Tuesday, December 14th, 1965. Known also under name Lee Enrose.

plate # 73

Katherine Dreier's Living Room
Richard Pettibone (born 1938)
Acrylic and photo-engraving on canvas, 21 × 26 cm
(8¼ × 10¼ in.), 1966
Collection of the artist through Leo Castelli Gallery, New York;
photography provided courtesy Jedermann Collection

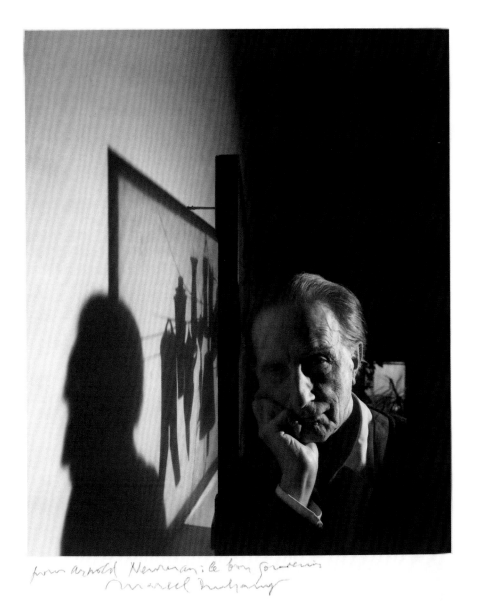

from arnold Newman: le bon souvenir
marcel duchamp

Portrait of Marcel Duchamp: Nine Malic Moulds and Cast Shadows
Arnold Newman (1918–2006)
Gelatin silver print, 35.6 × 27.9 cm (14 × 11 in.), c. 1966
Howard Greenberg Gallery, New York City

Arnold Newman/Arnold Newman Collection/Getty Images

plate # **74**

Arnold Newman's photograph poses Duchamp with a contemplative fist propped against his chin, a series of cast shadows playing across the wall beside him. In his published notes, Duchamp wrote about his interest in cast shadows as a means of analyzing "the successive transformations of objects" through various planes of existence.[1] *Nine Malic Moulds* (1914–15), with which Duchamp is pictured (see also fig. 3.3), suggests just such transmutation, with its evocation of a multiplicity of identities and modes of representation. A precursor to *The Large Glass* in both its construction and its subject, *Nine Malic Moulds* puts on display the nine bachelors, each with a distinct identity assigned by Duchamp, composed of manipulated lead and wire uniforms on a sheet of glass.[2] In Newman's photograph the cast shadow of Duchamp's profile mingles with the shadows of the nine molds, allowing Duchamp to join the ranks of his bachelors, becoming both the creator of and a player in the work. The artist's double representation, from the front and in silhouette, simultaneously conjures up a myriad of other portrayals of him, from his *Wanted: $2,000 Reward* (pl. 25) to his *Self-Portrait in Profile* (pl. 58).

AK/JWM

1. *WMD*, 72.
2. Schwarz, *Complete Works*, vol. 2, 632–33.

plate # 75

Portrait of Marcel Duchamp: Mounted
Cardiogram 4/4/66
Brian O'Doherty (born 1928)
Ink and typescript on paper, 27.9 × 21.6 cm (11 × 8½ in.),
1966
Collection of the artist

Two important ingredients serve as intellectual fodder for Brian O'Doherty's *Portrait of Marcel Duchamp*. One comes from Duchamp's own statement that works of art "die" within twenty or thirty years after first being exhibited.[1] The other is born out of Thomas B. Hess's 1965 essay, "J'Accuse Marcel Duchamp." In that damning essay, Hess complained that Duchamp "tries to turn himself into a masterpiece."[2] Rejecting Duchamp's viewpoint and Hess's assessment of him, O'Doherty had the ingredients needed to begin work on his sixteen-part *Portrait of Marcel Duchamp, 1966–1967*.[3]

Portraits are generally assumed to provide us with an accurate representation of the sitter's likeness, accompanied by indicators of her or his psychological makeup and possibly visible clues that provide insight into the sitter's profession and other personal information.[4] When the portraitist moves away from physical representation of the subject, we are left to search through other clues to find the subject's identity. This is the case with the *Portrait of Marcel Duchamp*. Obvious is the synecdochic use of the heartbeat to represent Duchamp,[5] which accomplishes two goals essential for the success of O'Doherty's intended retort—"turning his heartbeat into a work of art —to create a portrait of Duchamp—portrayed by his heartbeat—mechanomorphed and boxed— a heartbeat that would continue indefinitely— challenging Duchamp's belief that the life span of a work of art was short."[6] In each of the sixteen parts that make up *Portrait of Marcel Duchamp*, we see him represented by his heartbeat. Three are shown here. *Portrait of Marcel Duchamp, Mounted Cardiogram, 4/4/66*, records the performative aspect of the portrait while providing clinical data. *Portrait of Duchamp, 3 leads* challenges us to believe that we are witnessing his heartbeat and that somewhere nearby he is alive. In O'Doherty's *Study for Second Portrait of Marcel Duchamp, lead 1, mounting increments*, he depicts Duchamp as a series of independent and isolated heartbeats that can be "looked for with all kinds of delays."[7]

On April 4, 1966, Marcel and Teeny Duchamp were dinner guests at the home of O'Doherty and his wife, Barbara Novak. Later, O'Doherty recalled that after dinner, he asked Duchamp to come into the bedroom, where he attached him to an electro-cardiographic machine (rented for the occasion). "He lay still, clearly unperturbed. . . . The machine unfurled its long ribbon [documented with *Portrait of Marcel Duchamp, Mounted cardiogram, 4/4/66*]. I switched from lead to lead. Everything worked perfectly. The needle was steady, the heartbeat regular. . . . He said 'How am I?' That startled me, for I was after my record of his heart beat, and hadn't given a thought to potential pathology. I

1. William Seitz, "What Happened to Art? An interview with Marcel Duchamp," *Vogue*, February 15, 1963, 131. See also Cabanne, *Dialogues with Marcel Duchamp*, 67. Cabanne's interview with Duchamp took place in 1966, not long after O'Doherty had taken his portrait. In this interview Duchamp claimed that a work dies after forty or fifty years, instead of the twenty or thirty he told Seitz three years earlier.
2. Thomas B. Hess, "J'Accuse Marcel Duchamp," in *Marcel Duchamp in Perspective*, ed. Joseph Masheck (Englewood Cliffs, NJ: Prentice-Hall, 1975), 119. This article originally appeared in *ARTnews* 63, no. 10 (February 1965): 44–45, 52–54.
3. Aided by a sequence of events and publications dating from the late 1950s, by the mid-1960s Duchamp had moved from the shadows, garnering considerable critical attention and beginning to be understood as one of the major figures of the twentieth century—an assessment offered by Brian O'Doherty in an essay submitted to *Newsweek* in January 1965. The essay was rejected. In 1967 he published it as "Marcel Duchamp" in O'Doherty, *Object and Idea: An Art Critic's*

Journal, 1961–1967 (New York: Simon and Schuster, 1967), 44–47.
4. For extended discussions regarding the expectations of portraiture, see Richard Brilliant, *Portraiture* (Cambridge, MA: Harvard University Press, 1991), and Shearer West, *Portraiture* (Oxford: Oxford University Press, 2004).
5. Others appear, whether actively considered by the artist at the time of the portrait's making or not. They include Duchamp's penchant in his early work to mechanomorph the human form; his fascination with machines and mechanization as means to activate the sense of time and optical illusions in his works; and the box, a means that Duchamp had used in the construction of his self-portraits.
6. Brian O'Doherty, letter to Alexander Alberro, December 10, 1995, and in repeated conversations with this author.
7. The phrase is from Duchamp's *Green Box*, used with reference to the creation of ready-mades; see *WMD*, 32.

NEW YORK UNIVERSITY MEDICAL CENTER

UNIVERSITY HOSPITAL

ELECTROCARDIOGRAPH STUDY

Marcel Duchamp 4/4/'66

TECHNICIAN DOCTOR B. O'Doherty

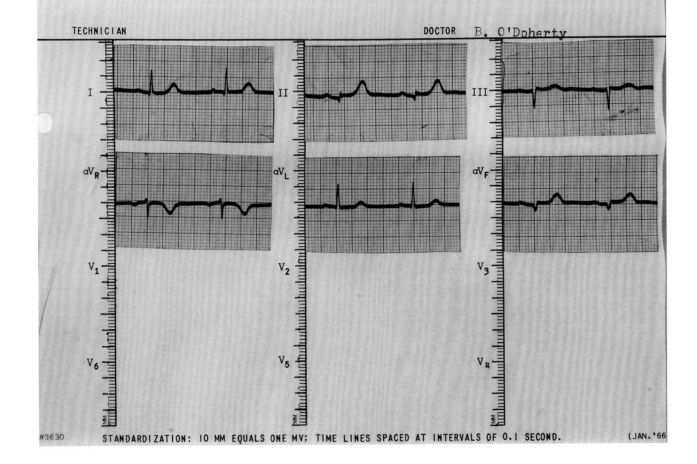

W3630 STANDARDIZATION: 10 MM EQUALS ONE MV; TIME LINES SPACED AT INTERVALS OF 0.1 SECOND. (JAN.'66

plate # **76**

Portrait of Marcel Duchamp, 3 leads
Brian O'Doherty (born 1928)
Wood, glass, Liquitex, motor, 17.8 × 78.7 × 17.8 cm
(7 × 31 × 7 in.), 1966
Collection of the artist

said it looked good to me. He stood up and said 'thank you from the bottom of my heart.' I said thank you for letting me take your portrait."[8]

Duchamp knew O'Doherty had been a doctor and asked that he sign the self-portrait "Brian O'Doherty, M.D." O'Doherty recalls, "I wasn't going to let him participate in the creation. His heart had done its work."[9] O'Doherty had what he needed to begin work turning Duchamp's heartbeat into an artwork, one that carries out his goal—Duchamp, the masterpiece, living indefinitely. O'Doherty understood his purpose. He did not want a record of a heartbeat but a heartbeat, the very signature of life, and that posed a problem—one for the artist and not the medical doctor. He wanted to animate, to bring to life, the images produced by the first three leads of the electrocardiogram (*Portrait of Marcel Duchamp, 3 leads*). Creating a kinetic image of the heartbeat like that seen on an oscilloscope was the problem. The artist took over, the solution coming when O'Doherty saw a sign advertising beer—its bouncing dot of light produced by rotating a disc punctuated with vertical slits operating behind a stationary front panel. In the design of his machine, a carpenter's spirit level with three

windows found in a shop on Canal Street would serve as the stationary front panel. On each of its windows he etched images of one of the three leads in proper sequence, linked by the calm horizontal line. Inside the box on which the spirit level is mounted is a cylindrical, motor-driven, celluloid sleeve, painted black and inscribed with vertical slits, that moves in a clockwise direction around a central fluorescent light bulb, creating, through the etched patterns on the level's windows, what O'Doherty saw: "The heart began to beat, inscribing perfectly the course traced by Duchamp's heart. I had him, alive and in my hand."[10] The heart not only began to beat, but O'Doherty took control of it. The direction of travel of the image of the heartbeat in *Portrait of Marcel Duchamp, 3 leads* is important. Traveling right to left, it reverses Duchamp's life cycle, time traveling backward. Duchamp saw this piece in O'Doherty's 1966 show at the Byron Gallery in New York City, where, according to O'Doherty, he spent considerable time contemplating the work. Unknown to anyone present (except Duchamp), he was carrying a folded piece of paper, secreted in a pocket, on which he had written his now-famous epitaph, "Besides it is

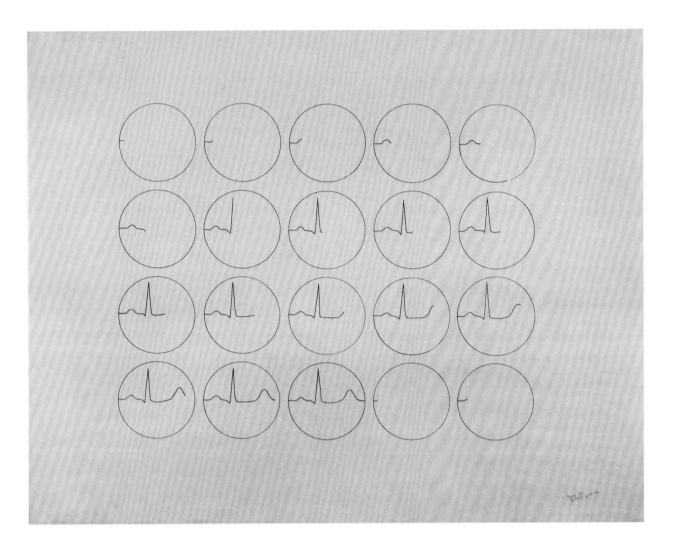

Study for the Second Portrait of Marcel Duchamp, lead 1, mounting increments
Brian O'Doherty (born 1928)
Ink on paper, 58.4 × 73.7 cm (23 × 29 in.), 1967
Collection of the artist

plate # 77

always the others who die."[11] Later he would often ask, "How am I doing?"[12]

Nearly forty years after his death, Duchamp's "heartbeat" continues nonstop. In an interesting way, *Portrait of Marcel Duchamp* offers us insight to understanding his persistent, ghostly presence. *Portrait* transforms Duchamp into a "living" masterpiece, one that parodies Hess's complaint while trumping Duchamp's assertion that works of art have short and relatively fixed life spans. O'Doherty makes the case: "By exhibiting that artwork, in gallery and museum, his theory of the death of artworks ran directly into his own heartbeat. If he insisted that my artwork, his heartbeat, was losing esthetic value by the second as it hung there on the wall—on its way to becoming an artifact, an antique for the future—would his theory suffer a little death? It was certainly at risk, as was my aim."[13]

Brian O'Doherty has constructed a bridge between the corporeal and the spiritual worlds. His "spirit level" is a double entendre, on the one hand the tool appropriated, on the other a Duchamp, who Dawn Ades, writing in the last paragraph of *Marcel Duchamp*, concludes as having haunted the second half of the twentieth century. Shortly after Duchamp's death, Man Ray declared, "His heart obeyed him and stopped."[14]—Or did it?

JWM

8. Ibid.
9. Ibid.
10. Ibid.
11. E-mail from Jacqueline Matisse Monnier, September 23, 2008, informing this author that Duchamp had written his epitaph in the 1950s and always carried it with him in a little envelope.

12. O'Doherty, letter to Alexander Alberro, December 10, 1995
13. Ibid.
14. Dawn Ades, Neil Cox, and David Hopkins, *Marcel Duchamp* (London: Thames and Hudson, 1999), 211; and Neil Baldwin, *Man Ray, American Artist* (New York: Clarkson N. Potter, 1988), 343.

plate # **78**

Marcel and Teeny Duchamp
Henri Cartier-Bresson (1908–2004)
Gelatin silver print, 17 × 25 cm (6¹¹⁄₁₆ × 9³⁄₁₆ in.), 1968
Henri Cartier-Bresson Photographs of Artists Collection/
Henri Cartier-Bresson, Archives of American Art, Smithsonian
Institution, Washington, DC

Henri Cartier-Bresson's photograph of Marcel and Alexina (Teeny) Matisse Duchamp is a portrait of a partnership, of a couple infinitely comfortable with one another and, as Teeny's son Paul Matisse put it, "harmonic."[1] Teeny, looking elegant, turns to speak to Marcel, who sits shoulder-to-shoulder with his wife, head slightly inclined in her direction. Marcel, who is the picture of the debonair elderly gentleman, looks off into the distance with a bemused, slightly mischievous smile on his face.

Duchamp's marriage to Teeny in 1954 in many ways marked a new moment in his life. Teeny, the former wife of Pierre Matisse, was well suited for Marcel, and the two by all accounts had a happy marriage.[2] This photograph of the Duchamps is from a 1968 trip they made to Paris, during which they visited Man Ray and his wife, Juliet.[3] The photograph, taken during the last year of Duchamp's life, exemplifies what Cartier-Bresson has termed "the decisive moment."[4] It is as if the viewer is *tête à tête*, or face-to-face, with the subjects, who are in the midst of conversation. The cropping of the image separates Marcel and Teeny from their surroundings and brings the focus to their facial expressions, physical closeness, and intimate exchange. Cartier-Bresson has managed to preserve a moment that captures the artist's characteristic sense of play and love of humor. The impish grin on Duchamp's face embodies the delight he took throughout his life in consistently overturning expectations, even among those closest to him.

JEQ

1. Paul Matisse, quoted in Tomkins, *Duchamp*, 385.

2. It is clear that Duchamp himself thought of his marriage to Teeny as a significant event in his life. See his note to Jean Crotti, January 31, 1954, Papers of Jean Crotti, AAA, in which he announces his marriage to Teeny along with a note about the death of Louise and Walter Arensberg.

3. Cartier-Bresson, who was known to have had a fondness for Duchamp, also photographed Duchamp and Man Ray playing chess—as René Clair had done for *Entr'acte* in 1924—as well as Duchamp seated next to several of his ready-mades. See Pierre Assouine, *Henri Cartier-Bresson: A Biography* (London: Thames and Hudson, 2005), 196–97. Cartier-Bresson's photographs of Duchamp are in the AAA.

4. Cartier-Bresson's work is intimately tied to his concept of "the decisive moment," which derives from the English title of his book *Images á la Sauvette*, published in 1952. For Cartier-Bresson, the term embodied photography's unique ability to capture and preserve fleeting, spontaneous occurrences, such as a man jumping over a puddle or a couple kissing in the street. As the photographer himself described it, the decisive moment entails "the simultaneous recognition in a fraction of a second of the significance of an event, as well as the precise organization of forms that give that event its proper expression." Cartier-Bresson's innovative use of the Leica camera—small, portable, and equipped with a sharp, fast lens—allowed him the flexibility to photograph a variety of situations, from wars and conflicts around the world to everyday happenings in the streets of Paris. For more on Cartier-Bresson's decisive moment, see Assouine, *Cartier-Bresson;* Jean Clair, "Kairos: The Idea of the Decisive Moment in the Work of Cartier Bresson," in *Henri Cartier-Bresson: The Man, the Image, and the World: A Retrospective* (London: Thames and Hudson, 2003); and Peter Galassi, ed., *Henri Cartier-Bresson: The Early Work* (New York: Museum of Modern Art; Boston: distributed by New York Graphic Society Books/Little, Brown, 1987).

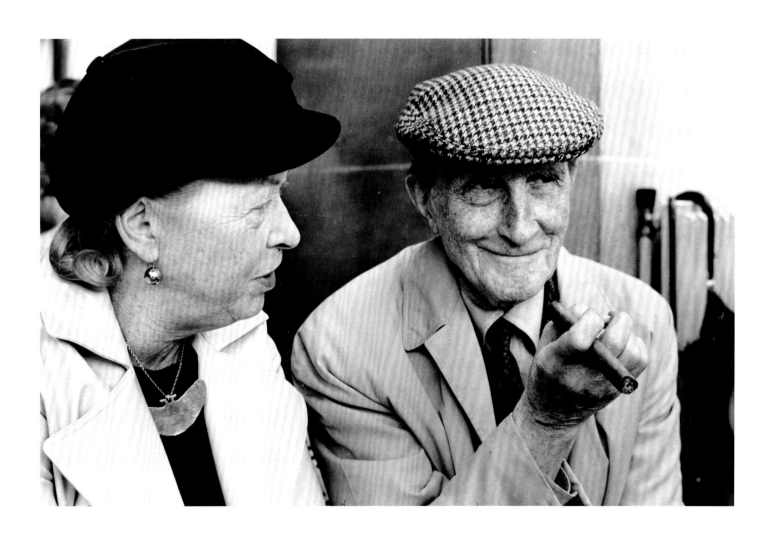

plate # 79

Triple Exposure of Duchamp Smoking a Cigar
John D. Schiff (1907–1976)
Gelatin silver print, 25.4 × 20.3 cm (10 × 8 in.), 1968
Philadelphia Museum of Art, Pennsylvania, Marcel Duchamp Archive; gift of Jacqueline, Paul, and Peter Matisse in memory of their mother, Alexina Duchamp

Like Bill Eppridge's upside-down photograph that accompanied Duchamp's obituary in *Life* magazine (pl. 85), this photo was taken the year Duchamp died. Both Eppridge and John Schiff use multiplicity, either through reflection or layered exposures, to reference Duchamp's many personas within one frame, in effect creating a singular, larger-than-life presence. In this photograph Schiff draws on the iconic elements of Duchamp's self-representation: the profile portrait, the reflection or ephemeral image, and the ever-present cigar. Schiff employs a technical twist similar to the one seen in Victor Obsatz's double exposure of Duchamp (pl. 54), and adds a third exposure to emphasize the complex and often veiled nature of Duchamp's artistic dialogue and the self-referential elements of his oeuvre. Schiff weaves together references to Duchamp's many representations, resulting in a portrait of Duchamp not as an artist but as a legend.

JWM

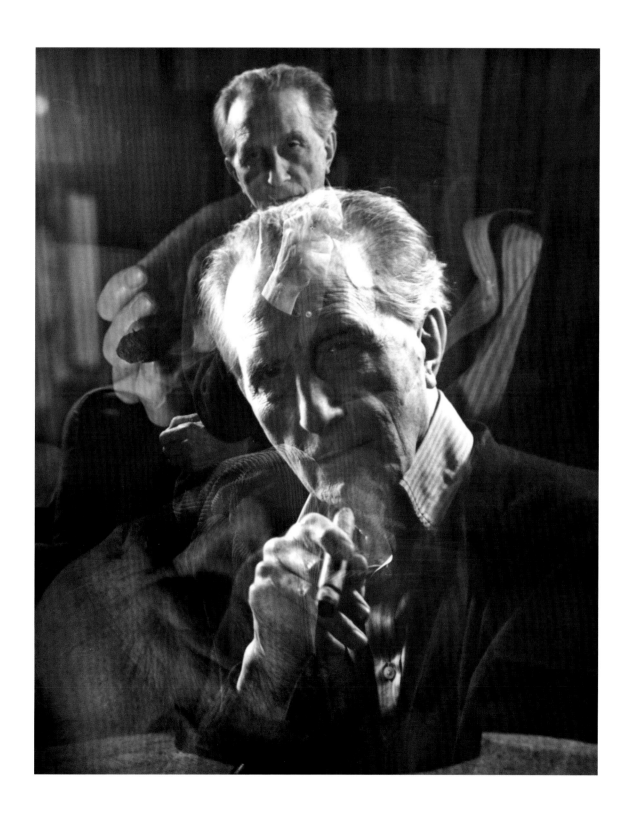

plate # **80**

Marcel Duchamp
Richard Hamilton (born 1922)
Poster, 78.7 × 57.2 cm (31 × 22½ in.), 1968
Private collection

Richard Hamilton, known for his role in the development of English pop art, became an avid follower of Duchamp after first seeing his work in a 1952 Tate Gallery exhibition.[1] During 1959 he collaborated with George Heard Hamilton on the English-language publication of Duchamp's *Notes in a Green Box.*[2]

Later, following the 1963 retrospective of Duchamp's work at the Pasadena Art Museum, Hamilton made a replica of *The Large Glass,* co-signed by Duchamp as a joint work. In 1966, Hamilton's replica was part of an exhibition he organized at the Tate, entitled "The Almost Complete Works of Marcel Duchamp."[3] For that exhibition Hamilton re-created, as a separate work on a glass panel, the *Oculist Witnesses,* an important element of *The Large Glass.*[4] For the poster Duchamp is seen behind the glass panel, looking at us through the *Oculist Witnesses.* We, in turn, view him through the *Witnesses,* suggesting the reciprocal nature of his notion of "mirrorical return."[5] A tour de force of graphic design and screen printing, the sensation that Duchamp is holding a piece of glass is created by laying down a thick layer of high gloss transparent ink for that image, on which the *Oculist Witnesses* are embossed using silver foil.

AK

1. "Twentieth-Century Masterpieces," Tate Gallery, London, July 15, 1952.
2. Marcel Duchamp, *The Bride Stripped Bare by Her Bachelors, Even: A Typographic Version by Richard Hamilton of Marcel Duchamp's Green Box,* trans. George Heard Hamilton (London and Bradford: Percy, Lund, Humphries; New York: George Wittenborn, 1960).
3. Tomkins, *Duchamp,* 436.
4. Richard Hamilton, *The Almost Complete Works of Marcel Duchamp* (London: The Arts Council of Great Britain, 1966), 62.
5. In *The Green Box,* Duchamp articulates his concept of the "mirrorical return" in connection with the activity of the *Oculist Witnesses* in *The Large Glass* (see *WMD,* 65.)

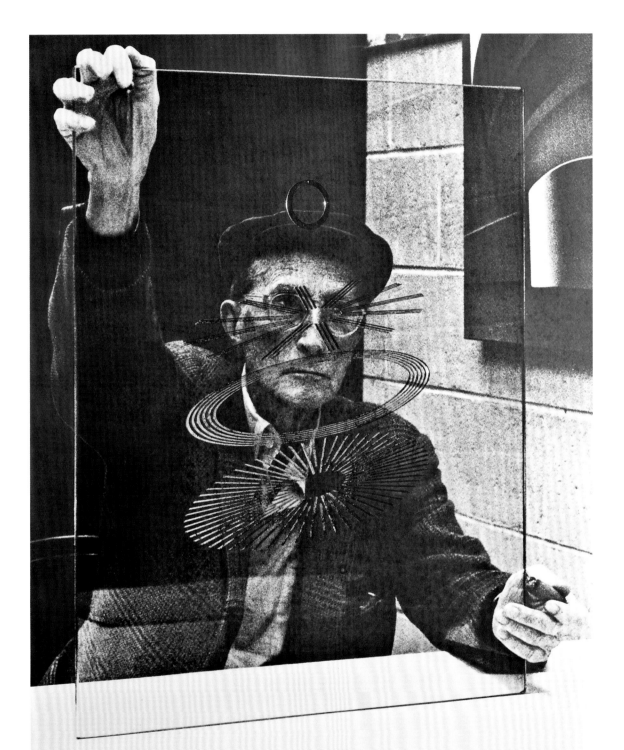

MARCEL DUCHAMP

plate # 81

Portrait of Marcel Duchamp
Mel Bochner (born 1940)
Ink on graph paper, 27.9 × 21.6 cm (11 × 8½ in.), 1968
Collection of the artist

Created in 1968, Mel Bochner's *Portrait of Marcel Duchamp* incorporates text from Duchamp's *Green Box,* which had appeared in English translation in 1960, and which provided a detailed description of the conceptual interworkings of the machinery of *The Large Glass.* The passage appropriated by Bochner, "(Blossoming) ABC," derives from Duchamp's description of the upper zone of his *Large Glass,* where he addresses the question of how to insert a "moving inscription," providing commands sent down by the bride to her bachelors and revealing the title of the work.[1] Fascinated by the physicality of language, Bochner arranges Duchamp's own language in this "word portrait" in a fashion consistent with Duchamp's own musings. As Bochner has explained, the portrait has the effect of "taking [Duchamp's] language and playing it back against him."[2] Moving from the upper left to the lower right, Bochner's text mimics the direction in which communication should flow from the bride to the bachelors. Appropriately, as Duchamp had required of the "triple cipher" through which the bride's commands were to be sent, the words are not rendered transparent but are encoded instead.[3] Following Duchamp's description of how the work's title was to be rendered on *The Large Glass,* the "moving inscription i.e. in which the group of alphabetic units. should no longer have a strict order from left to right," Bochner abandons a conventional transcription of language, shifting the emphasis instead to the individual letters and punctuation marks.[4] The visual form of the work is equally suggestive of its subject. As a whole, the sixteen-box grid brings to mind Duchamp's love of the game of chess as well as subtly suggesting the rectangular form of *The Large Glass,* with its "triple cipher" at upper center; taken individually, the boxes seem teasingly to reflect the numerous boxes in which Duchamp packaged many of his most important works, including *The Green Box* and the *Boîte-en-valise.*

ACG

1. *WMD,* 38.
2. Mel Bochner, telephone conversation with the author, May 2, 2007.
3. I thank Richard Field for deciphering the inscription for me and providing a transcription of the contents of each of the boxes, e-mail communication, June 1, 2007.
4. *WMD,* 38.

ORTHOGONAL ROUTES FOR/OF DUCHAMP
RE- "(BLOSSOMING) ABC"

1	2	3	4

```
1
T O M A K E
A N I N S C
R I P T I O
N O F I T C
T I T L E ,
) . M O V I
```

```
2
C S N I G N
O I T P I R
. E . I , N
C I H W N I
O R G E H T
L A F O P U
```

```
3
E A S T R I
G E R H A V
D N O L O N
S S H O U L
I C U N I T
P H A B E T
```

```
4
I T E B A H
P L A H C A
E - T H G I
R O T T F E
L M O R F R
E D R O T C
```

5	6	7	8

```
5
C U N I T W
P E B L L I
R E S E N(ey)(cl)(nn)(to)(o) T
N I                         O
T H E G R                   O U
C B A P P U
```

```
6
L I W D N A
L B E D I S
D E C A L P
F R O M A T
O C A N D B
A C K A G A
```

```
7
I T P I R C
S N I E H T
A R D S C ,
O M A T O W
R F , E C N
I N . - S I
```

```
8
L I U Q E R
O F D E E N
E H T O T G
N I D D R O
C C A , D L
U O H S N O
```

9	10	11	12

```
9
I B R I U M
O F T H E P
L A T D , D
I S P L A C
E A C S T A
B I L I S E
```

```
10
A B A ) [ R
N A R O L L
G N I H T Y
H T N O . )
T A L P S I
A T A . D E
```

```
11
( A L P H A
E R B O X ]
O F L E T T
C A S O R T
W I L L B E
. T H E R E
```

```
12
O L E V E D
O T ) . C D
N A B S D R
A W O T O G
L L I W H C
I H W T E B
```

13	14	15	16

```
13
P A N D S T
E R ( Y D U
P R E S E N
N O I T A T
O F T H I S
I R C S N I
```

```
14
: N O I T P
P H O T O G
C I H P A R
M E T H O D
M R E T E D
I N T H E A
```

```
15
I    F I C A N
M(r) , S I G N
R(e) ,(fh) F O(ne)(ri) (ib)
S  ( (tnu)(em)(mt)
I    C U N I(t)
L    P H B E T
```

```
16
I R C S N I
I H T Y L L
A R U T P L
U C S T N E
S E R P E R
. ) . . E C
```

plate # 82

Star (Duchamp with Star Haircut)
Ray Johnson (1927–1995)
Mixed media collage, 39.4 × 29.8 × cm (15½ × 11¾ in.), 1968
Private collection

Throughout his career Ray Johnson connected himself to Duchamp by quoting his works and name, taking on his image, and dealing with similar themes. Johnson's *Duchamp with Star Haircut,* and the two groups of images on which it appears to be based—photographs of Duchamp with a star/comet tonsure (pls. 18, 19, and 20), and Man Ray's portrait of Rrose Sélavy with a fur stole (pl. 17)—treat gender and identity as ambiguous and malleable.[1]

Duchamp's star/comet tonsure references the haircuts of monks, and therefore celibacy or even asexuality. In Man Ray's photographs of Rrose Sélavy from her third and final sitting, cross-dressing and a montage of body parts result in a confused mix of genders. Duchamp's face appears with the feminine hands of Germaine Everling, Francis Picabia's mistress, who is behind Duchamp.[2] In Johnson's image, smoke from a cigarette hides the identity of the sitter, his friend Toby Spiselman, secretary of the New York Correspondence School, who wears a toy sheriff's badge on her hat.[3] Johnson collages Duchamp's multiple identities together into one image, playing with our visual memory while knowing that his audience would only need either the star or the pose to see the connection to Duchamp.

Johnson adds another layer to the image with his label. The date 1917 corresponds neither to the 1921 date of the star/comet tonsure portraits of Duchamp or to the third sitting of Rrose Sélavy with Man Ray. It may instead refer to an important date in Duchamp's artistic career, the year he submitted *Fountain* to the Society of Independent Artists, from which it was rejected despite the deliberate absence of a jury, causing a scandal that artists continue to reference today (see pls. 95, 97).

Dated 1968, the year of Duchamp's death, *Duchamp with Star Haircut* may be thought of as a eulogy for the artist who was quickly becoming a star.[4] The obscured visage could allude to Duchamp's death, but it also points to the enigmatic identity that he cultivated and that Johnson surely admired, aspiring to an equal level of mystery in his own life and art.

KD

1. These photographs are discussed at length in James W. McManus's essay in this volume, as well as in the entries for the catalogue items referenced above.
2. Schwarz, *Complete Works,* vol. 2, 693.
3. Donna De Salvo, "Correspondences" in *Ray Johnson: Correspondences,* ed. Donna De Salvo and Catherine Gudis (Columbus, OH: Wexner Center for the Arts, 1999), 25; see also object information sheet by Muffet Jones, 1998, courtesy Richard L. Feigen & Co.; William S. Wilson, conversation with Kate Dempsey, June 2006.
4. The precise date when this work was made is difficult to determine. In a conversation with Anne Collins Goodyear and James W. McManus on April 11, 2008, William S. Wilson stated that Johnson did not date his works at the time of their completion. According to Wilson, dates added later are often not correct. This issue becomes important when we consider that other authors have considered images of Rrose Sélavy as a possible source for this work. See De Salvo, *Ray Johnson Correspondences,* 25. For a discussion of the history of the publication of images of Rrose Sélavy, see James W. McManus's essay in this volume (n. 91). By contrast, images of Duchamp with the star/comet tonsure had been published earlier and could have easily been known by Johnson.

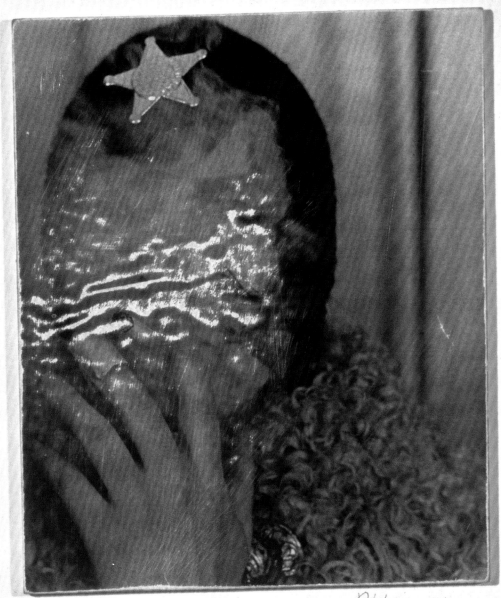

Photo by Joe Fitzen

DUCHAMP WITH STAR-HAIRCUT, NEW YORK, 1917.

Ray Johnson 1968

plate # **83**

To and From Rrose Sélavy
Shuzo Takiguchi (1903–1979)
Deluxe edition, 35 × 27.5 × 4 cm (13¾ × 10¹⁵⁄₁₆ × 1⁹⁄₁₆ in.), 1968
Private collection

Shuzo Takiguchi's *To and From Rrose Sélavy*, completed shortly after Marcel Duchamp's death in 1968, represents a complex homage to the French artist. The deluxe edition of the publication, illustrated here, consists of a boxed combination of writings and artworks that encapsulate a multivalent intellectual exchange. As Takiguchi —a Japanese-born poet, critic, and artist with ties to surrealist circles—recounts, the work grew out of his interest in creating "a shop for 'objects'" designed to test their "metaphysical and practical aspects" as used by modern artists such as Duchamp, who recast them through his readymades.[1]

Engaging in the process of exchange invited by Takiguchi's metaphorical "shop for 'objects,'" Duchamp granted him permission to name it in honor of Rrose Sélavy and even provided her signature for the shop's sign. Takiguchi combined the signature with Man Ray's 1930 profile of Duchamp (pl. 29), creating a lenticular double portrait of Duchamp and Rrose Sélavy (top right), which Duchamp christened *Rrose Sélavy in the Wilson-Lincoln System*, in reference to *The Green Box* note describing a two-way portrait of presidents Abraham Lincoln and Woodrow Wilson.[2]

Eager to share Duchamp with Japanese audiences, Takiguchi incorporated into his artwork translations of selected notes from *The Green Box* and *A l'infinitif* into Japanese. Conceptually, these writings fit with the inspiration of the store Takiguchi imagined. As he explains: "[Duchamp] makes us believe there is an identity between words and objects."[3]

Acknowledging Duchamp's conceptual gifts through its title, the work captures an implied intellectual "give-and-take" through generations and cultures. With a nod to the composition of the deluxe edition of Robert Lebel's monograph on Duchamp (pl. 62), a seriographed multiple of Duchamp's *Self-Portrait in Profile*—inscribed "Marcel déchiravit pour Shuzo Takiguchi 1967"—is included in *To and From Rrose Sélavy* (see pl. 58). Indeed, as Takiguchi proudly explains in his introduction to the project, the work represents the first Japanese "monograph" on the artist.[4] Completing the notion of an exchange appropriate to the commerce of a "shop," Takiguchi added artworks from three other artists with deep ties to Duchamp—Jasper Johns's *Summer Critic*, Shusaku Arakawa's *Still Life*, and Jean Tinguely's *Collage Drawing*, which prominently identifies itself as a tribute to Marcel Duchamp and Takiguchi.

ACG

1. Shuzo Takiguchi, preface to "Toward Rrose Sélavy: A Marginal Note to *To and From Rrose Sélavy*," in *To and From Rrose Sélavy* (Tokyo: Rrose Sélavy, 1968), 1. Takiguchi also recounts this story in Shuzo Takiguchi, contribution to "A Collective Portrait of Marcel Duchamp," in d'Harnoncourt and McShine, *Marcel Duchamp*, 222.
2. Takiguchi, preface to "Toward Rrose Sélavy," 1. For an expanded discussion of this work and *The Green Box* note about the "Wilson-Lincoln system," see Anne Collins Goodyear's essay in this volume.
3. Takiguchi, preface to "Toward Rrose Sélavy," 4.
4. Ibid., 2.

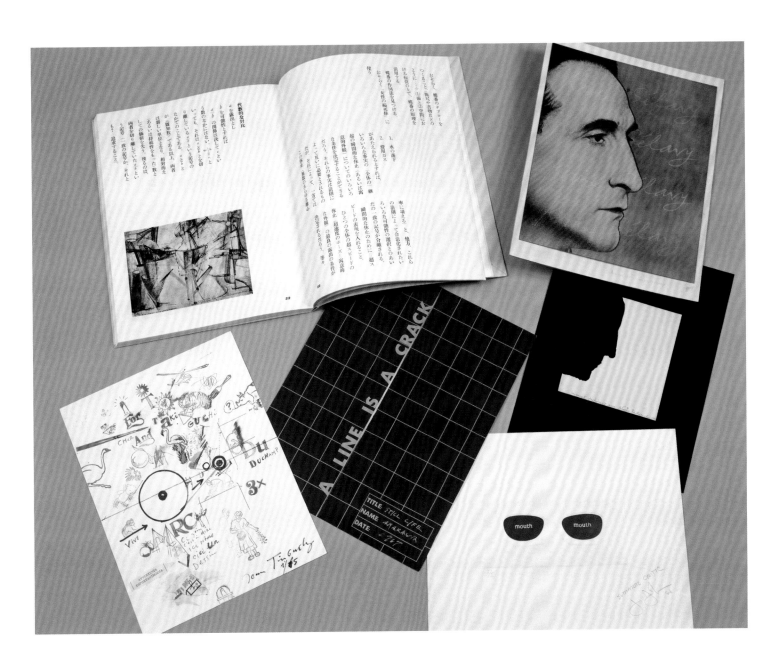

plate # 84

Account of a Dream about Marcel Duchamp
Joseph Cornell (1903–1972)
Three sheets of notebook paper, each 27 × 20 cm (10⅝ × 7⅞ in.), 1968
Joseph Cornell Papers, Archives of American Art, Smithsonian Institution, Washington, DC

Created in the late evening of October 7, 1968, Joseph Cornell's original account of a dream following Marcel Duchamp's death testifies to the strong attachment Cornell felt to Duchamp. After an initial meeting in 1933, their connection was renewed and strengthened following Duchamp's return to New York from France in 1942, in large part through Cornell's contribution to the assembly of Duchamp's deluxe *Boîte-en-valise* (Box-in-a-Valise) (see pl. 37) and several of the related second-edition *Boîtes* (Series B).[1]

Although not a conventional portrait, Cornell's vision—what psychologists might term a "big dream" given its emotional and creative vibrancy—clearly served as a form of private portrayal.[2] Repeated descriptions of the dream, such as those from October 7 and 9, illustrated here, provided the artist with an opportunity to analyze its meaning. The strange narrative involved Cornell telling Duchamp about a visit by the nineteenth-century French artist Eugène Delacroix to New York City and responding to Duchamp's doubt about such an occurrence. Ultimately, what struck Cornell as most significant about his dream was Duchamp's determination to obtain one of Delacroix's handkerchiefs, an obsession Cornell interpreted as reflecting a joint interest on the part of Duchamp and himself in "the object."[3]

Fittingly, it was precisely through the meticulous collection of objects having a personal connection to Duchamp that Cornell created a

1. Duchamp created a total of seven editions of his "boxes" housing miniature versions of sixty-nine of his works of art. Only the first edition, the deluxe edition, is properly known as the *Boîte-en-valise;* all subsequent editions are known as *Boîtes,* and their associated series letter (B–G). (For a detailed discussion of the contents of the boxes and an overview of the seven series, see Ecke Bonk, *Marcel Duchamp, The Portable Museum: The Making of the Boîte-en-valise; de ou par Marcel Duchamp ou Rrose Sélavy, Inventory of an Edition,* trans. David Britt [1986; London: Thames and Hudson, 1989]; on the titling convention, see 257.) Evidence that Duchamp explored the possibility of Cornell's collaboration as a fabricator for the *Boîte*—Series B is provided both by a diary entry by Cornell's brother, Robert, indicating that Duchamp brought a *Boîte-en-valise* to their home for their examination, and by the contents of Cornell's *Duchamp Dossier.* See Ecke Bonk, "Delay Included," 106; Ann Temkin, "Habitat for a Dossier," 84; and "Cornell's Assembly of the *Boîte* Edition," 304; all in *Joseph Cornell/ Marcel Duchamp . . . in Resonance* (Houston: Menil Foundation, and Philadelphia: Philadelphia Museum of Art, 1998). As Calvin Tomkins

points out, however, no records exist to specifying the nature of the working relationship between Duchamp and Cornell, and the fabrication was eventually entrusted to Xenia Cage—the wife of John Cage (Tomkins, *Duchamp,* 339). The *Boîtes* are discussed at length in the entry for pl. 37 in this volume.
2. On "big dreams" and their relationship to mourning, see Rebecca Cathcart, "Winding Through 'Big Dreams' Are the Threads of Our Lives," *New York Times,* July 3, 2007, http://www.nytimes.com/2007/07/03/health/psychology/03dream.html?_r=1&adxnnl=1&oref=slogin&adxnnlx=1196003035-56S7xbRw/PYkSOHZC++tgA (October 13, 2008).

3. Various accounts of this dream can be found in box 2, folder 10, "Duchamp, Marcel and Teeny, 1955–1968, undated" of the Joseph Cornell Papers, 1804–1986, AAA. On Cornell's meditation on the importance of "l'objet," see his account of the dream, October 9, 1968, 2 (box 2, folder 10, ibid.); and related diary entries on February 11 and 14, 1969, box 9, folder 20, Cornell Diary Entries, Cornell Papers, AAA. Don Quaintance provides a valuable discussion of Cornell's accounts of this dream and the dream's testament to Cornell's deep interest in the revelatory power of ephemera in his essay "Ephemeral Matter: Traces of Cornell and Duchamp," in *Cornell/Duchamp,* 245.

Oct. 7. 1968 Evening dream
 asleep from ca. 7 or so to 11

dreaming that Delacroix was visiting
N.Y.C - had put up at a hotel - He was
telling this to Marcel Duchamp who
didn't believe it - but he did believe it
when I told him (or it came to be
known) that Delacroix was alive & in
a Parisian hotel - something about wanting
to get a handkerchief from Delacroix

 (Delacroix's)
Something abt wanting to get one of D's handkerchief

also dreamed that I was quartered in
the bedroom of friends - this stemming
from actually being asked to put up in
their library (sleeping quarters) last
week - in "reality" - in real life, so-
called - this stipulent in color
 ^

a cousin of the Debussy dream

metonymic portrait of the artist he greatly admired. Best known is the compilation of materials gathered between roughly 1942 and 1953 and boxed together as the *Duchamp Dossier*, now in the collection of the Philadelphia Museum of Art. However, equally revealing is a second file consisting of similar items—scraps of paper with Duchamp's handwriting, letters and telegrams exchanged between Cornell and Marcel and Alexina (Teeny) Duchamp, publications about Duchamp—put together from approximately 1955, shortly after Duchamp's marriage, until October 1968, and now housed in the Smithsonian's Archives of American Art. Capturing the intensity of Cornell's reverence for Duchamp, the second file registers his reaction to the artist's death. It is worth stressing that it was with this collection of Duchampian ephemera that Cornell stored his accounts of his dream of Duchamp, and not with his diaries.[4] For Cornell, then, the act of retelling his final dreamed encounter with Duchamp did not constitute a mere description of a particular experience, but rather functioned as something with a magical significance of its own—a trace of Duchamp's presence. Responding to the power of the dream he experienced, Cornell consoled Duchamp's widow, Teeny, in a letter written the following day, noting that Duchamp's passing "will never sink in because, of course, he has never really left us."[5] As though echoing this sentiment, Teeny Duchamp responded to Cornell in a letter he preserved together with the draft of his own: "That is just the way I feel so I am not as sad as others expect."[6]

ACG

4. Although Quaintance asserts that these accounts are included in Cornell's "copious diaries," possibly on the basis of using microfilm, a physical examination of Cornell's papers reveals that his vivid initial descriptions of his dream were segregated from his diaries and included instead in his Duchamp "correspondence" file; Cornell maintained such files on a number of artists who interested him. (See Quaintance, "Ephemeral Matter," 245.) A conversation with Jennifer Meehan, who created the finding aid for the Cornell Papers, confirmed that the Duchamp "correspondence" file existed independently of the diaries when she undertook her description of it (conversation between the author, Hannah Wong, and Jennifer Meehan, July 12, 2007). Duchamp's death is mentioned in a diary entry of October 3, 1968 (box 9, folder 13, Cornell Diary Entries, Cornell Papers, AAA).

5. Joseph Cornell, letter to Mrs. M. Duchamp (draft), October 8, 1968, box 2, folder 10, "Duchamp, Marcel and Teeny, 1955–1968, undated," Cornell Papers, AAA.

6. Alexina Duchamp, letter to Joseph Cornell, October 14, 1968, box 2, folder 10, "Duchamp, Marcel and Teeny, 1955–1968, undated," Cornell Papers, AAA.

difficulty admitted, at the outset

Before midnight and before condolences
were penned & mailed. dream prob. sparked
the delayed letter to Paris

DREAM
*

Conversing with Marcel Duchamp and telling
him that Delacroix was staying in a N.Y.C.
hotel – he did not believe it but did believe it
when a Parisian ave was mentioned –
Something about wanting to obtain from
Delacroix one of his handkerchiefs
prob. on poss. via Duchamp

It does not seem clear Was the fact that
Delacroix was alive in our contemporary
scene taken for granted in the dream
and just the locale the source of any
doubt?
Evening of Oct 7. 68 before midnight
Monday on couch (reg. sleeping quarters
Flushing)
first dream about Duchamp since
his passing

#/#

10/9/68 Wed. Duchamp / Delacroix

item: a "distant cousin" of the Debussy
dreaming

Queried in real life about Debussy seeing
or knowing him Duchamp has spoken of
his inaccessibility, "like Einstein".

consider the dream as interpreted might
could not grant sig. by and the enigmat-
(ical) in the light of the "OBJECT"
("l'objet") in same kind seem in
same as curiously observed in
same kind of perspective,
tradition,

Delacroix – Redon – Duchamp
Redon had followed Delacroix one night out of
hero worship (MELLERIO), Duchamp openly ack-
nowledged Redon as an influence
"la royaume de l'objet". surrealism

own penchant for collecting from way back
leading into preocup. with "l'objet"

#2

Duchamp. Delacroix

plate # **85**

"Marcel Duchamp, 1887–1968," *Life* magazine,
October 11, 1968
Bill Eppridge (born 1938)
Private collection

Duchamp's obituary, which appears on pages 127–30 of the October 11, 1968, issue of *Life* magazine, highlights his acts of artistic rebellion, touches on his interest in chess and his own legend, and finishes by giving him patron saint status for a younger generation of artists. Bill Eppridge's accompanying portrait provides us with an image of an elusive Duchamp, beyond the boundaries of time and space, reminiscent of the *Five-Way Portrait of Marcel Duchamp* (pl. 7). The photograph shows Duchamp in his chair, lighting up a cigar, his reflection captured in the sheen of a table-top. The dark background, the studded leather chair, and the smoke all convey a suave, masculine aura, while at the same time Duchamp's reflection alludes via a "mirrorical return" to both

his playful personality and his alter ego, Rrose Sélavy. In a further tribute to Duchamp's love of irony, the photograph is printed upside down so that the viewer perceives Duchamp's reflection as Duchamp. This inversion of the real and the reflected suspends Duchamp's ghostlike image, suggesting a continuing presence.

AK

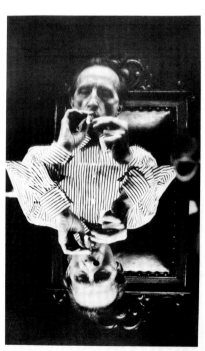

Portrait of Rrose Sélavy
Thomas Chimes (born 1921)
Oil on panel, 22.9 × 17.1 cm (9 × 6¾ in.), 1976
Philadelphia Museum of Art, Pennsylvania; gift of Deborah J. Allen
and Jukka Hamalainen, 1991

plate # **86**

Portrait of Rrose Sélavy is part of Tom Chimes's series of sepia-toned panel paintings that grew out of his intense interest in the writer Alfred Jarry. As Michael Taylor has observed, Chimes's panel portraits, which visually hover between painting and photography, are "somewhere between a family snapshot and a devotional icon."[1] Each of his subjects, including Duchamp, was carefully selected based on his sitter's association with Jarry, whose play *Ubu Roi* profoundly influenced a number of Dada and surrealist artists. Duchamp, whom Chimes admired for his interest in putting "painting once again at the service of the mind," appears in the series three times, as Mona, Adam, and Rrose Sélavy, respectively.[2] Chimes's *Portrait of Rrose Sélavy* borrows from Man Ray's 1921 photograph, but he crops the image to a more intimate

view and encases it in a wide, wooden frame. In Chimes's words, his three portraits of Duchamp are "selectively oblique," purposely portraying Duchamp in various guises, preventing him from being immediately recognizable and inviting his audience to a game of discovery.[3]

AK

1. Michael Taylor, *Thomas Chimes: Adventures in Pataphysics* (Philadelphia: Philadelphia Museum of Art, 2007), 115–16.
2. Ibid., 106; see also 119–20 on the three paintings.
3. Chimes, quoted by Taylor in ibid., 119.

275

plate # 87

A Room in Connecticut
Red Grooms (born 1937)
Oil and acrylic on Plexiglas with aluminum frame, 182.9 × 243.8 cm
(72 × 96 in.), 1984
Pennsylvania Academy of the Fine Arts, Philadelphia; John Lambert Fund

Red Grooms's 1984 witty portrait of Marcel Du-
champ, spiced by a vibrant palette, plays off a
well-known 1936 photograph of Duchamp and
his friend and patron Katherine Dreier, made
shortly after the installation of the restored *The
Bride Stripped Bare by Her Bachelors, Even (The Large
Glass)*, of 1915–23, in her home in West Redding,
Connecticut.[1] Grooms alters and expands the nar-
rative in his version of the scene, encapsulating
several important aspects of Duchamp's career.
In Grooms's version Duchamp sits with Dreier
in her living room. In the foreground Grooms
has created his own rendition of *The Large Glass*,
composed of Plexiglas with an aluminum frame.
Above Dreier and Duchamp hangs Duchamp's
final painting, *Tu m'* (1918), made on commission
for Dreier. The design of the rug on the floor, fea-
turing an interlocking pattern of reversible cubes,
is altered from the one in the original photo-
graph and invites a reading suggesting an inter-
play between Duchamp's interests in the fourth
dimension and chess. Sitting on Dreier's shoulder
is the sulphur-crested cockatoo, Koko, acquired
during 1919, when Dreier followed Duchamp to
Buenos Aires.[2] At far left stands Brancusi's *Yellow
Bird* (1920), part of Dreier's collection, and perhaps
also a veiled reference to Duchamp's role in sell-
ing a number of works for the sculptor.[3] Nearby,
on the table, is a small cubist statue of a couple
dancing, a possible suggestion regarding the odd
"dance" that Dreier and Duchamp performed in
their relationship. The view through the window
on the painting's right side shows another Bran-
cusi sculpture, *Leda* (c. 1924), sitting in the garden.
Moving around, as if to peek in the window at the
freshly restored *Large Glass*, are Walter and Louise
Arensberg, from whom Dreier had purchased the
work in 1923.[4]

ACG

1. Between the summer of 1936, when *The
Large Glass* was restored, and 1948, a number
of photographers visited Dreier's home. The
best-known photograph was taken in 1936
(possibly by Walter Buschman). In this photo-
graph Duchamp is seen standing in profile,
with his back against the *Glass* and facing
Dreier. The photograph is illustrated in Rob-
ert L. Herbert et al., *The Société Anonyme
and the Dreier Bequest at Yale University:
A Catalogue Raisonné* (New Haven, CT: Yale
University Press, 1984), 19, as well as in
d'Harnoncourt and McShine, *Marcel Duchamp*,
20. Other photographs also appear to have
influenced Grooms's double portrait of Dreier
and Duchamp. The leafy pattern on the wall-
paper in the left of the image alludes to the
pattern painted by Duchamp on the elevator in
Katherine Dreier's Milford, Connecticut, home
(to which she moved in 1946) to match her
wallpaper (a photograph with accompanying
caption is reproduced in d'Harnoncourt and
McShine, *Marcel Duchamp*, 24). Grooms's
depiction of Brancusi's *Leda* seems to reflect
John Schiff's photograph of the sculpture
outside Dreier's home in Milford (see Herbert
et al., *Société Anonyme*, 25). Finally, Grooms's
inclusion of Dreier's *Yellow Bird* by Brancusi at

the left of his painting and his depiction of a
vase filled with leafy branches may have been
influenced by John D. Schiff's 1948 photograph
of Dreier on the lift in her Milford home. For a
recent reproduction, see Jennifer R. Gross, ed.,
The Société Anonyme: Modernism for America
(New Haven, CT: Yale University Press, 2006),
139.
2. Tomkins, *Duchamp*, 212.
3. This piece, as well as *Leda*, is illustrated
in Herbert et al., *Société Anonyme*, 84 and 25,
respectively.
4. See Tomkins, *Duchamp*, 305. Duchamp had
spent the months of June and July of 1936 at
Dreier's home repairing *The Large Glass*, which
had shattered during shipping a decade earlier,
after its first exhibition.

plate # **88**

Untitled (Duchamp with "Blue Eyes")
Ray Johnson (1927–1995)
Collage on illustration board, 43.2 × 38.1 cm (17 × 15 in.), 1987
Tony and Gail Ganz

Ray Johnson treated Duchamp's image as he did those of the other celebrities that inhabit his collages, especially in his silhouette portraits, which he began making in 1976.[1] When he could, Johnson took the silhouette directly from the sitter, but in some cases, such as with a deceased subject, he resorted to making a silhouette from another image. Johnson featured Duchamp's *Self-Portrait in Profile* of 1957 (pl. 58) in at least twenty major works. He may have been drawn to Duchamp's method of tearing paper around a metal template in the shape of his profile, a method ideal for collage and repetition. Johnson's frequent use of Duchamp's image reflects Duchamp's ubiquitous presence in the art world, as well as Johnson's self-identified connection with the elder artist. Often Johnson collaged his own image onto Duchamp's profile, filling it with small depictions of his own head or layering the two so that Johnson peers through Duchamp.[2]

Although Johnson spoke of his profile collages as empty vessels and a way to put his ideas literally into other people's heads, in *Duchamp with "Blue Eyes"* Johnson seems to defer to Duchamp, filling the silhouette with drawings and collaged elements that relate directly to Duchamp's art and philosophy rather than to his own.[3] For example, the twisting fabric drawn in purple and white references Duchamp's *Allégorie de Genre,* a work that features the profiles of presidents Washington and Lincoln within the shape of the United States.[4] The deliberate ambiguity of Johnson's work mirrors the quality of optical illusion in *Allégorie de Genre.* Both Johnson and Duchamp embraced mystery, forcing their viewers to draw their own conclusions and connections. The lenses in *Duchamp with "Blue Eyes"* may refer to Duchamp's poor opinion of "retinal" art, and the shells at his lips may have to do with natural occurrences of spirals and their connection with other dimensions—a topic that intrigued both artists. In this portrait Johnson highlights those ideas of Duchamp's that he most admired and employed in his own art.

KD

1. Muffet Jones, "Selected Biographical Chronology and Exhibition History," in *Ray Johnson: Correspondences,* ed. Donna De Salvo and Catherine Gudis (Columbus, OH: Wexner Center for the Arts, 1999), 208.
2. Kate Dempsey, "Ray Johnson in Correspondence with Marcel Duchamp," MA thesis, University of Texas at Austin, 2006, 72–76.
3. Helen A. Harrison, "Ray Johnson: Shadow and Substance," in *Re-Dact: An Anthology of Art Criticism,* ed. Peter Frank (New York: Willis, Locker & Owens, 1984), 80.
4. Dempsey, "Ray Johnson in Correspondence," 73–74.

plate # **89**

Doublonnage (Marcel)
Yasumasa Morimura (born 1951)
Chromogenic print, 149.9 × 120 cm (59 × 47¼ in.), 1988
Roland and Kathleen Augustine

Yasumasa Morimura is known for appropriating the work of other artists, which he re-visualizes through the medium of photography. Using himself as the model and employing elaborate costumes and sets, he re-creates the appropriated work. In this pseudo self-portrait, Morimura casts himself, a Japanese man, as Rrose Sélavy. This act of substitution recalls Duchamp's use of a surrogate for his *Compensation Portrait* in the *First Papers* catalogue (pl. 40). However, when Morimura replaces a western guise with his own eastern face, he takes the question of gender, as constructed by Rrose Sélavy or the Ben Shahn photo, and expands it to include issues of culture and ethnicity.[1] The question of race raised by this work is accentuated by

Morimura's inclusion of two sets of differently pigmented hands. This inclusion also alludes to a ploy that Duchamp used in the photograph of Rrose Sélavy referenced here (pl. 17), in which he substituted Germaine Everling's more feminine hands for his own.[2]

AK

1. Kerstin Brandes, "Morimura/Duchamp:
Image Recycling and Parody," *Paragraph* 26
(March–July 2003): 56.
2. Schwarz, *Complete Works,* vol. 2, 487.

plate # 90

1919/1990
Carlo Maria Mariani (birthdate unknown)
Oil and graphite on canvas, 83.8 × 58.4 cm (33 × 23 in.), 1990
Carlo Maria Mariani and Carol Lane

Carlo Maria Mariani's paintings take a conceptual approach to classical art. As David Ebony writes, Mariani uses "idealized, Neo-Classical figures" to evoke "the rarefied atmosphere of antiquity" and comment not on the past but instead "address issues pertinent to contemporary art and urban living."[1] In his portrait of Duchamp, Mariani paints his subject in a fur collar, necklace, and hat like those worn by Rrose Sélavy in Man Ray's 1921 photograph for *Belle Haleine: Eau de Voilette* (pl. 15).

Despite this reference to Duchamp's gender bending, Mariani maintains Duchamp's masculine features behind the feminine props. In addition, he takes the image a step further by painting Duchamp with the upright posture and demurely folded hands of the *Mona Lisa*, to whom Duchamp added a swirling mustache and goatee in his *L.H.O.O.Q.* Like Duchamp did with the *Mona Lisa*, Mariani has also taken a pencil and expertly given his subject a trim mustache and beard, resulting in an unstable image that shuffles back and forth between Duchamp and the iconic figures of Mona Lisa and Rrose Sélavy. Mariani informs us that we can no longer see the *Mona Lisa* in the same way after Duchamp. In turn he suggests that we can no longer see Duchamp in the same way after Mariani.

AK/JWM

1. David Ebony, "Carlo Maria Mariani's Eternal Cities," *Art in America* 91 (October 2003): 111.

plate # 91

plate # 91

Deux Champs
Alice Hutchins (born 1916)
Plastic box, magnets, washers, 13 × 18.1 × 3.2 cm (5⅛ × 7⅛ × 1¼ in.),
1991/2006
Private collection

The Fluxus artist Alice Hutchins created this piece for the 1991 "After Duchamp" exhibition, curated by Jean-Jacques Lebel at Galerie 1900/2000 in Paris. Since the 1960s Hutchins has incorporated plastic boxes, magnets, and a playful engagement with language into her artistic vocabulary.[1] Hutchins has said of her interest in using magnets, "They are wonderful. There is no domination of one part.

Everything is held together by attraction."[2] Magnetism, especially its powers of attraction, figures importantly for Duchamp—most notably with the bride in his *Large Glass*.[3]

Each veiled by a layer of washers (like the mysterious Duchamp working from the shadows), two magnets hold clusters of washers in place on the work's surface. Written below them are the words "Deux Champs." Abstracted, this portrait of Duchamp is presented through the carefully constructed play on Duchamp's name, affecting a double entendre and putting into play a witty appraisal of the mysterious and magnetic presence that the absent Duchamp exerted over the thinking and practice of many artists during the decades of the 1970s and 1980s.[4]

The original piece, lost, was reconstructed in 2006.

JWM

1. Jon Hendricks, "Alice Hutchins," in *Fluxus Codex* (New York: Harry N. Abrams, 1988), 271.
2. James W. McManus, "If you want to paint elephants think of typewriters," in *Two Sisters, Alice Hutchins/Claudia Steel* (Chico, CA: 1078 Gallery, 2005), unpaginated.
3. For a more extensive consideration of the importance of magnetism in Duchamp's work, consult Henderson, *Duchamp in Context*; see "magnetism" in her indexes, 361.
4. Alice Hutchins, conversation with James W. McManus, Paris, July 14, 1997.

deux champs

plate # 92

The Enunciation
Mark Tansey (born 1949)
Oil on canvas, 213.4 × 162.6 cm (84 × 64 in.), 1992
Museum of Fine Arts, Boston; Ernest Wadsworth Longfellow Fund, the
Lorna and Robert M. Rosenberg Fund, and additional funds provided by
Bruce A. Beal, Enid L. Beal, and Robert L. Beal, Catherine and Paul
Buttenweiser, Giswold Draz, Joyce and Edward Linde, Martin Peretz,
Mrs. Myron C. Roberts, and anonymous donors

Juxtaposing the youthful figure of Marcel Duchamp with his enduring female alter ego Rrose Sélavy—depictions based on photographs by Man Ray—this multivalent portrayal of Duchamp functions as an homage, revealing Mark Tansey's assimilation of both the visual and theoretical legacy of Marcel Duchamp. The work's implicit narrative of sexual desire and frustration coyly evokes the central theme of Duchamp's *Bride Stripped Bare by Her Bachelors, Even (The Large Glass)*—a reference enhanced by the placement of Rrose behind a window, where she is rendered visible but inaccessible. The implication of Duchamp's wistful gaze at his female persona is further developed by Tansey through his placement of Duchamp's left hand, suggesting references by Duchamp throughout his career to the theme of onanism, perhaps most famously in *The Large Glass*.[1]

The conceit of Duchamp as a disappointed "bachelor" on a train in turn echoes Duchamp's 1911 self-portrait *Sad Young Man on a Train* (see pl. 38 and fig. 3.7), the poetic title of which suggests thwarted aspirations.[2] The illusionistically carved words "Marcel + Rrose," visible on the wooden bench occupied by Duchamp, both describe quite literally the encounter depicted here and bear on the title selected by Tansey: *The Enunciation*. Tansey's phrase, a pun-making reference to the appearance of the Archangel Gabriel to the Virgin Mary (who is who here?), draws attention to the double entendre embedded in "Rrose." When pronounced aloud in French, it becomes "eros." As though to emphasize the centrality of "eros" to Duchamp's work as well as the critical role played by the persona of Rrose throughout Duchamp's career, Tansey executed his canvas in a vivid shade known as "rose violet" and placed abundant roses throughout the pattern of the carpet at Duchamp's feet.[3]

ACG

1. See James W. McManus, "Rrose Sélavy: Machinist/Erotation," in *Duchamp and Eroticism,* ed. Marc Décimo (Newcastle, Eng.: Cambridge Scholars Publishing, 2007), 57–58.
2. Although Duchamp himself would later comment that "there isn't much of the young man, there isn't much of sadness, there isn't much of anything in that painting except a Cubist influence," Gabrielle Buffet-Picabia (with whom Duchamp was infatuated, despite her marriage to his friend Francis Picabia) would give the work a different nuance. As Calvin Tomkins explains, in the summer of 1912, approximately six months after the canvas was completed, Buffet-Picabia actually met Duchamp, who wished to see her, by mutual agreement on a train platform, where they spent several hours together. This covert rendezvous may have helped inspire her 1949 description of Duchamp at this period as a "sad young man in a train" possessed "of almost romantic timidity." (See Tomkins, *Duchamp,* 76 for Duchamp's quote and 111–12 for his description of the rendez-vous between Duchamp and Buffet-Picabia.) See also Gabrielle Buffet-Picabia, "Some Memories of Pre-Dada: Picabia and Duchamp (1949)," in *The Dada Painters and Poets: An Anthology,* ed. Robert Motherwell (2nd ed.; Cambridge, MA: Belknap Press of Harvard University, 1981), 256.
3. The shade is identified as "rose violet" in a wall label for the painting, preserved in the curatorial file of the Department of Contemporary Art, Museum of Fine Arts, Boston.

plate # 93

Duchamp Wanted
Sturtevant (born 1926)
Offset print on paper, 33.7 × 26 cm (13¼ × 10¼ in.), 1992
Anthony Reynolds Gallery, London

In his lecture "The Creative Act," delivered at the Houston Museum of Fine Arts in 1957, Duchamp presented a vision of the work of art as a creation of both the artist and the spectator. Refuting the notion of art as an autonomous creation, Duchamp asserted that the artist in fact has little control over how his work is received and interpreted, with the result that there is always a gap between "the unexpressed but intended and the unintentionally expressed."[1]

Sturtevant's images, which she refers to as "repetitions," occupy this gap, extending Duchamp's ideas to their logical end.[2] "The grand contradiction," Sturtevant asserts with reference to Duchamp, "is that giving up creativity made him a great creator."[3] Sturtevant launches her own interrogation of originality and identity, appropriating the work of other artists, producing images that are similar to, but not exactly the same as, the source work of art. Slight variations are essential to Sturtevant's process, for her works are created almost entirely from memory, with Sturtevant herself learning and utilizing the artist's own technical processes. *Duchamp Wanted*, a repetition of Duchamp's 1923 *Wanted: $2,000 Reward* (pl. 25), evidences a disjunction between the title and the image, for, while the title suggests that Duchamp is the one who is wanted, Sturtevant has inserted her own mug shots in place of Duchamp's. To the final sentence of the poster, which in Duchamp's version reads "Known also under name RROSE SÉLAVY," Sturtevant adds

the words "or STURTEVANT," implying that, like Duchamp, she too is guilty of the crime of impersonation, a mode of repetition. The visual impact of the black letters on a strip of white has the effect of separating Sturtevant's addition from the red text of Duchamp's poster, clearly marking the image as her own and adding an additional twist to the question of gender inversion originally introduced by Duchamp through his invocation of Rrose Sélavy. This poster, produced in 1992, after the 1969 original, extends the reach of Sturtevant's commentary on Duchamp, recalling, as it does, Duchamp's own re-creation of the 1923 version of his *Wanted: $2,000 Reward* for inclusion in the *Boîte-en-valise* (pl. 37), as well as his reclaiming of it for his *Poster within a Poster* (pl. 65), for his 1963 retrospective at the Pasadena Art Museum.[4]

Sturtevant's actions are in effect performances of Duchamp's gesture rather than copies or reproductions of his art. Her 1996 photographic collage, *Nu Descendant un Escalier*, recasts her 1968 film *Duchamp Nu Descendant un Escalier*, which itself captures, using the technique of chronophotography, the action invoked by Duchamp's infamous painting. By "repeating" her original work in the form of a still photographic image, Sturtevant enacts Duchamp's own use of similar imagery to portray himself in photographs by Eliot Elisofon (pl. 51) and George Karger (fig. 1.3). By carefully layering the collage in a steplike fashion, Sturtevant further emphasizes the work's source, Duchamp's *Nude Descending a Staircase (No. 2)* (fig. 1.2), which played a defining role in Duchamp's own self-presentation. Sturtevant uses Duchamp's work as a basis, but not a template, for her own, allowing the "unexpressed but intended and the unintentionally expressed" to become a foundation for new creations that raise questions about originality, authorship, and even the very question of what constitutes a work of art.

JEQ/ACQ

1. Marcel Duchamp, "The Creative Act" (1957), reprinted in *WMD*, 139; quoted in Tomkins, *Duchamp*, 396.
2. Sturtevant's ideas on the implication of repetition is developed in "Modes of Thought," unpublished lecture; we thank Sturtevant for sharing this manuscript with us.
3. Sturtevant, "The Reluctant Indifference of Marcel Duchamp," lecture presented May 10, 1994, at the École Régionale des Beaux-Arts, Rouen; we thank Sturtevant for sharing this manuscript with us.
4. Sturtevant's *Duchamp Wanted* is discussed by Udo Kittleman and Mario Kramer in the preface to *Sturtevant: The Brutal Truth* (Frankfurt am Main: Museum für Moderne Kunst, 2004; published by Hatje Cantz Verlag), 20; the catalogue reproduces several of Sturtevant's "repetitions" of Duchamp's work.

WANTED

$2,000 REWARD

For information leading to the arrest of George W. Welch, alias Bull, alias Pickens. etcetry, etcetry. Operated Bucket Shop in New York under name HOOKE, LYON and CINQUER Height about 5 feet 8 inches. Weight about 120 pounds. Complexion medium, eyes same. Known also under name RROSE SÉLAVY or **STURTEVANT**

"DUCHAMP WANTED"

plate # 93

Nu Descendant un Escalier
Sturtevant (born 1926)
Collage, 28.5 × 26.5 cm (11¼ × 10⅜ in.), 1996
Anthony Reynolds Gallery, London

plate # **94**

plate # 94

plate # 95

Portrait of Richard Mutt
Jonathan Santlofer (born 1946)
Hydrocal, 30.5 × 30.5 × 3.2 cm (12 × 12 × 1¼ in.),
1996–1998
Private collection

Jonathan Santlofer's images straddle the boundaries between sculpture and painting, between the conceptual and the aesthetic in art, and between artist and creation. His bas-relief portraits of Duchamp, although framed and displayed in the manner of paintings, have a distinctly sculptural quality, which highlights the nature of the images as objects. *Portrait of Richard Mutt* juxtaposes Duchamp's likeness, rendered in profile, with an image of his *Fountain,* transformed through the act of adding R. Mutt's signature from a plumbing implement to a work of art. In Santlofer's work the phrase "R. Mutt/1917" seems to function as a caption, identifying Duchamp with his earliest pseudonym. But if Santlofer's portrait captures the conceptual link between Duchamp and *Fountain,* his use of Hydrocal, a form of cement, with its bright surface, vividly emulates the physical appearance of the porcelain *Fountain.* In this manner Santlofer not only pictures Duchamp in the guise of Richard Mutt, but also draws attention to the aesthetic qualities of *Fountain.*

In *Marcel Duchamp and Rrose Sélavy,* Duchamp and his feminine alter ego fill the pictorial space, seeming to extend beyond the boundaries of the frame. Always enigmatic, Duchamp holds his finger to his lips in a gesture of silence and secrecy. Behind him, Rrose Sélavy (see pl. 14a) emerges from the background, suggesting the simultaneous existence of both Duchamp and his alter ego as aspects of his multifaceted persona. Santlofer's representations of Duchamp as intimately connected with his own creations, whether personas or works of art, underscores that the identity of the artist is bound up with, and inextricable from, that which he creates.

JEQ

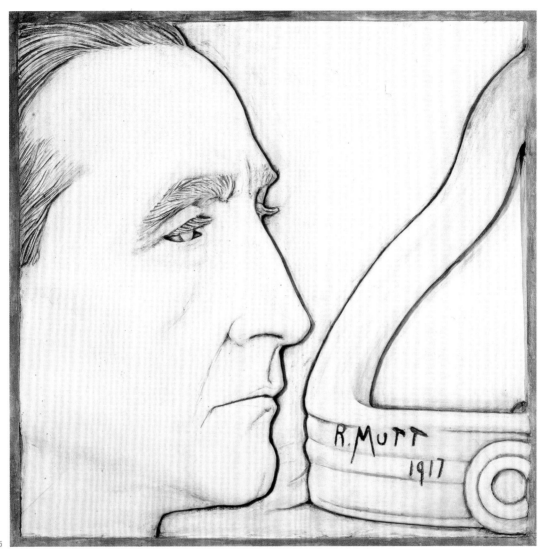

plate # 95

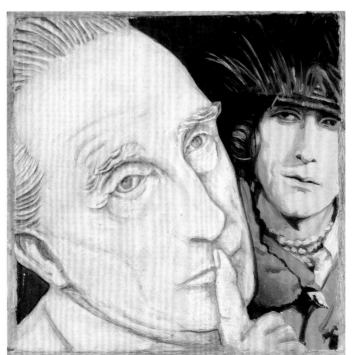

plate # 96

Portrait of Marcel Duchamp and Rrose Sélavy
Jonathan Santlofer (born 1946)
Hydrocal, 8.9 × 8.9 × 2.2 cm (3½ × 3½ × ⅞ in.), 2000
Private collection

plate # **96**

plate # 97

Fountain at the Age of 83
Douglas Vogel (born 1938)
Inkjet print and Formatt type on laid paper, 44.6 × 21.9 cm
(17⁹⁄₁₆ × 8⅝ in.), 2000–2001
Douglas Vogel and Francis M. Naumann Fine Art, New York

Douglas Vogel describes himself as from "the generation which re-discovered Marcel Duchamp in the early 1960s."[1] That interest manifested itself in his designation of a porcelain bedpan as the direct descendant of Duchamp's urinal. Vogel discovered his readymade at a flea market in upstate New York, where the form of the bedpan struck him as especially reminiscent of *Fountain*'s profile. Vogel reveals those similarities in this digitally created portrait, which he views as a bookend to the original 1917 *Fountain* as photographed by Alfred Stieglitz. Inspired by the caption "Duchamp at the age of 85," from a photograph published in *View* magazine (pl. 43), Vogel's title is a direct reference to *Fountain*'s age at the time of the creation of his readymade—eighty-three years after Duchamp unveiled *Fountain* in 1917. In this way, as Vogel says, the pairing of Stieglitz's photograph of *Fountain* and Vogel's *Fountain at the Age of 83* "complete a ready-made metaphor on man's aging."[2]

AK

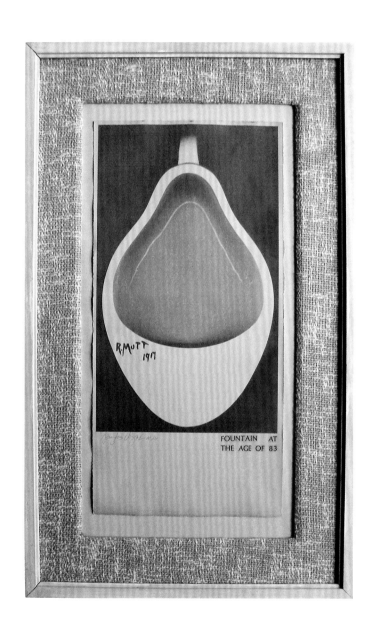

1. E-mail correspondence between the author
and Douglas Vogel, October 22, 2007.
2. Ibid.

David Hammons's *The Holy Bible: Old Testament* appears to be a leather-bound, gold-tooled Bible. Upon opening the book, however, one sees not the words of the Old Testament but Arturo Schwarz's catalogue raisonné, *The Complete Works of Marcel Duchamp*.[1] Fittingly, Hammons has appropriated a canonical work on Duchamp, using Schwarz's work as a readymade for a new creation. On one level Hammons's gesture is satirical, suggesting that the art world has elevated Duchamp to the point that his oeuvre is analogous to a holy Bible. However, *The Holy Bible* also references the compilation and transmission of information, evoking Duchamp's own efforts to document and preserve his oeuvre and also to shape his legacy. Duchamp's work with Robert Lebel for Lebel's monograph *Sur Marcel Duchamp,* his collaboration with Arturo Schwarz to replicate his readymades, and his creation of the *Boîte-en-valise,* a portable museum of his own work, demonstrate his desire to secure a place in history. Hammons's use of the Old Testament resonates with Duchamp's concerns, for it positions him as the forerunner of a new generation of artists, much the same way that the Old Testament prefigures the new.

In the late 1970s Hammons began to use discarded objects, such as bottles, bags, and chicken bones, as a way to explore contemporary social and political issues, especially those concerning African American identity and experience. *The Holy Bible,* like these early works, evidences Hammons's interest in Duchamp's concept of the readymade object. Hammons turns the artist's own concept back on him to parody the quasi-religious awe with which artists and scholars have regarded Duchamp. *The Holy Bible* captures the notion that Duchamp's work, and perhaps even the artist himself, has become a "readymade," a fate that Duchamp himself helped secure through the careful construction of his legacy.

JEQ

The Holy Bible: Old Testament
David Hammons (born 1943)
Artist's book, overall (book): 33 × 26 × 5 cm (13 × 10¼ × 1� in.), 2002
Aaron and Barbara Levine

plate # **98**

1. Hammons bound the revised, expanded paperback edition of Schwarz's *Complete Works of Marcel Duchamp* (New York: Delano Greenridge Editions, 2000).

plate # **99**

Profile vase (Duchamp), 'Collected Poems'/O'Hara, weight and back of left hand
Andrew Lord (born 1950)
Ceramic, string, epoxy, and gold leaf, 58.4 × 55.9 × 43.8 cm
(23 × 22 × 17¼ in.), 2003
Courtesy of the artist and Gladstone Gallery

Andrew Lord's profile vases can be thought of as sculptural still lifes whose ceramic components enter into a dialogue with one another. The series is centered on the vase element, which is created by two inward-facing profiles that form the negative space of a vase's contours. Lord's use of Duchamp's profile acknowledges the well-established precedent of Duchamp represented in profile, including his own 1957 *Self-Portrait in Profile* (pl. 58). The inspiration for Lord's profile vase series came from Jasper Johns's *Cups 4 Picasso*, which uses the same profile motif.[1] In addition to the vase, Lord includes a grouping of other symbolic objects in each sculpture, reusing similar elements throughout the series. For example, in this work, a book of Frank O'Hara's poetry stands as the pedestal for the vase, while a ceramic hand and weight dangle from strings, forming a counterbalance across the vase's mouth.

AK

1. Lisette Pelsers, *Andrew Lord: New Sculpture*
(Netherlands: Rijksmuseum Twenthe,
Enschede, 2003), 61.

Proposition for a Posthumous Portrait
Douglas Gordon (born 1966)
Skull, mirror, and certificate of authenticity, variable dimensions, 2004
Private collection, courtesy of Sean Kelly Gallery, New York

plate # 100

Douglas Gordon draws on a variety of representational modes and references from the history of art in his *Proposal for a Posthumous Portrait*. On one level the work can be read as a portrait of Duchamp himself. The star at the back of the cranium recalls photographs of Duchamp from 1921, picturing Duchamp with a tonsure seemingly depicting a shooting star or comet (see pls. 18, 19, 20). Gordon also draws on the *Portrait multiple de Marcel Duchamp (Five-Way Portrait of Marcel Duchamp)* from 1917 (pl. 7), in which Duchamp sits before a hinged mirror that creates the illusion of multiple sitters. By situating the skull in a corner, Gordon also seems to allude to Irving Penn's 1948 photograph of Duchamp (pl. 48), while simultaneously inverting it.[1] In a similar way, Gordon uses the mirror both as a tool to produce reflections and as a metaphor for the myriad nuances of identity. While Gordon engages with Duchamp's ideas, he also incorporates numerous references from the history of art. The skull, for example, evokes sixteenth-century Dutch *vanitas* paintings, while the spatial ambiguities and reflections bring to mind the mirror displacements of Robert Smithson.

Gordon's wide-ranging visual vocabulary, along with the various reflections and the ambiguity of the title, leave the subject of his portrait open to interpretation. The skull might also represent Gordon himself, who shares Duchamp's interests in the performative nature of identity and the ambiguity of representation. The dialectical nature of the work, however, ultimately suggests that the portrait is a conflation of several personas rather than a representation of a single subject. Gordon's "proposal" captures the complexity of creating a likeness, visualizing the tensions and ambiguities that are endemic to the genre of portraiture itself.

JEQ

1. Observation of Sean Kelly, in conversation with James W. McManus and Anne Collins Goodyear, January 18, 2008.

plate # 101

Wanted Poster
Gavin Turk (born 1967)
Silkscreen on paper, 45.4 × 29.7 cm (17⅞ × 11⅝ in.), 2006
Private collection, courtesy Sean Kelly Gallery, New York

Like Julien Levy, Richard Pettibone, Sturtevant, and Duchamp himself, Gavin Turk engages with the question of artistic identity that is at the heart of Duchamp's *Wanted: $2,000 Reward,* 1923 (pl. 25). In the place of the paired mug shot photographs that appear on these other versions of *Wanted,* Turk has inserted a single image of a figure turned in a three-quarter position. The figure wears Turk's own latex life mask. *Wanted Poster* advertises a reward of an unspecified amount for "the recovery of a mask, an alias of Gav, alias GT, etcetry, etcetry," the language a nod to Duchamp's text for his *Wanted: $2,000 Reward* of 1923. While the aliases, or personas, that Turk lists and the appearance of the life mask refer to the artist himself, the use of the mask as a device intended to conceal renders uncertain the identity of the wanted figure. The vacant eyeholes of the mask, startling against its true-to-life features, reinforce this sense of mystery.

The image in Turk's *Wanted Poster* also recalls Man Ray's photograph of a shaving-cream-covered Duchamp for the *Monte Carlo Bond* (pls. 27, 28). Visually echoing the winglike formations of Duchamp's hair in the *Monte Carlo Bond* photograph, the ambiguous protrusions of the burlap hood surrounding Turk's life mask function to further disguise and transform the figure pictured.[1] The devices of concealment and illusion that Duchamp and Turk employ recall the techniques of the actor; indeed, both have noted the similarities between the artist and the performer.[2] As Duchamp put it: "I am a regular movie actor. . . . I had absolutely no idea of becoming any Marcel Duchamp at all."[3] Turk likewise conceives of his work as performance, in which "'Gavin Turk' is Gavin Turk's pseudonym. Gavin Turk stars as himself."[4]

JEQ

1. For more on the symbolism of Duchamp's hair in the *Monte Carlo Bond,* see James W. McManus's essay in this volume, in addition to the entries in this volume on pls. 27 and 28.
2. For more on Turk's conception of artistic identity, as well as for general reflections on his work, see Turk, *Gavin Turk: Collected Works, 1989–1993* (London: Jay Jopling /White Cube, 1994).
3. Marcel Duchamp, quoted in James W. McManus's essay in this volume; from Jean-Marie Droit, "Marcel Duchamp: A Game of Chess," [1963], videocassette (Evanston, IL: Home Vision, 1987).
4. Turk, *Collected Works,* 1.

WANTED

REWARD

For information leading to the recovery of a mask, an alias
of Gav, alias GT, etcetry, etcetry. Reportedly last seen at
the Truman Brewery, Brick Lane, East London on the 5th June
Any persons with information regarding the mask's whereabouts
please contact Live Stock Market on ++44 20 8981 2388.

Gavin Turk 2006

plate # 102

Duchamp Tout Fait
Ray Beldner (born 1961)
Digital pigment print mounted on panel, 61 × 45.7 cm (24 × 18 in.), 2007
Courtesy of the artist and Catharine Clark Gallery, San Francisco

Conscious of Marcel Duchamp's penchant for shuffling identities, Ray Beldner has created a work in which Duchamp takes on ever-changing states of becoming before our eyes.[1] In this piece Beldner used computer manipulation to bring together twenty-six of the best-known portraits of Marcel Duchamp, layering transparent images to capture the essence of the artist's many faces and personas.[2] Although Beldner has appropriated Duchamp's art in other works, this piece establishes a different line of commentary about the many facets of Duchamp's identity and the way those personas resonate through time. As Beldner describes: "I purposely kept the final image light and mirror-like, to allow the viewer time to absorb the delicate details. It's a subtle photo, but if given enough time to reflect on it, one can discern many likenesses—from Rrose Sélavy to the artist at rest in front of his chessboard."[3]

AK/JWM

1. James W. McManus, interview with Ray Beldner, September 22, 2006. Beldner described his awareness of and interest in Duchamp's "Wilson-Lincoln system." (For further discussion of this "system," see Anne Collins Goodyear's and Michael R. Taylor's essays in this volume.)

2. See also Shuzo Takiguchi's *Rrose Sélavy in the Wilson-Lincoln System* in *To and From Rrose Sélavy* (pl. 83). For *Rrose Sélavy in the Wilson-Lincoln System,* Takiguchi created a lenticular double portrait that shifts between a photograph of Duchamp and the signature of Rrose Sélavy. In addition to the entry for cat. 83, the work is discussed in Anne Collins Goodyear's essay in this volume.

3. Aubrie Koenig, e-mail correspondence with Ray Beldner, October 15, 2007.

plate # **103**

Avec Ma Langue Dans Ma Joue, or With My Language in My Game
Ray Beldner (born 1961)
Wood and plaster, flocked with ground money dust, 24.9 × 15 × 5.1 cm
(9 13/16 × 5 7/8 × 2 in.), 2007
Courtesy of the artist and Catharine Clark Gallery, San Francisco

This piece is one of a series of remakes Ray Beldner has created based on Duchamp's small sculptural works. Beldner's piece was inspired by Duchamp's 1959 sculpture-drawing *With My Tongue in My Cheek* (fig. 5.4), which combined a plaster cast of Duchamp's cheek with a pencil-drawn sketch of his profile. In place of Duchamp's profile, however, Beldner has incorporated his own image. As the second part of the title suggests, Beldner inserts his tongue in his own cheek, playfully referencing Duchamp's gamesmanship with language.[1] As we have seen in other portraits gathered in this volume, artists in recent decades have continued to mine complex questions of identity previously raised by Duchamp through his own appropriation and fabrication of identities.[2] By designating himself a substitute, Beldner recalls Duchamp's own use of a surrogate in his *Compensation Portrait* for *The First Papers of Surrealism* catalogue (pl. 40). Beldner adds a further conceptual element to this series by flocking his plaster copies in ground money dust. The results, which Beldner jokes "end up looking like moldy versions of the originals," manifest his interest in Duchamp's "relationship to money and the art market," as well as paying tribute to Duchamp's sense of humor and his love of irony.[3]

AK/JWM

1. Beldner has deliberately steered clear of a literal translation of his French title into English, drawing attention to the instability of language (e-mail correspondence from Beldner to James W. McManus, September 6, 2008).
2. See, for example, the works of Richard Pettibone (pl. 72), Ray Johnson (pl. 88), Yasumasa Morimura (pl. 89), Sturtevant (pl. 93), and Gavin Turk (pl. 101).
3. E-mail correspondence between McManus and Beldner, February 9, 2007.

MARCEL DUCHAMP
CHRONOLOGY

Many excellent Duchamp biographies and chronologies are already in print, a number of which have been invaluable to this effort; these publications are included in the catalogue's bibliography. Little work, however, has been done to track developments in the depiction of Marcel Duchamp. Therefore, this chronology has the following three priorities: first, to create a historical context for the portraits included here; second, to link these works to particularly relevant aspects of the artist's life, relationships, and ideas about self-representation, especially as manifested in his alter ego, Rrose Sélavy; and third, to highlight the exhibitions, interviews, and popular publications that reached a wide public audience and served as sources for the creation and dissemination of artists' depictions of Duchamp.

Events that cannot be specifically situated within a given year are listed at the beginning of each year entry; artworks whose precise time of execution is uncertain are located at the end of the entry for the year to which they can be assigned.

Hannah W. Wong

1887

July 28: Born in Blainville, France, the fourth of six children, including three artist siblings: Gaston Duchamp, later known as Jacques Villon (1875–1963); Raymond Duchamp, later known as Raymond Duchamp-Villon (1876–1918); and Suzanne Duchamp Crotti (1889–1963)

See plate 1

1900–1909

1904
Moves to Montmartre in Paris; begins drawing satirical cartoons for humor magazines

1905
Begins one year of compulsory military service

1906
Returns to Montmartre; continues drawing for humor magazines

1909
Moves to Neuilly; begins to show in the Salon d'Autumne and the Salon des Indépendants

1910–1919

1911
Fall: Meets Francis Picabia, who probably introduces Duchamp to writings of Max Stirner

December: After trip from Paris to Rouen to visit family, completes self-portrait *Sad Young Man on a Train* (fig. 3.7 and pl. 38)

1912
March: Submits *Nude Descending a Staircase (No. 2)* (fig. 1.2) to Société des Artistes Indépendants, Paris

June 10: With Picabia, and possibly Guillaume Apollinaire, attends performance of Raymond Roussel's *Impressions d'Afrique*

July–August: Travels to Munich; begins notes and studies for *The Large Glass*. During this period, Hans Hoffmann takes portrait photograph of Duchamp (pl. 1) for Apollinaire's forthcoming *Méditations esthétiques: Les peintres cubistes*

October: Exhibits *Nude Descending a Staircase (No. 2)* in Paris at "Section d'Or" exhibition. Recalls meeting Apollinaire at this time[1]

November: American artists Arthur B. Davies, Walt Kuhn, and Walter Pach select *Nude Descending a Staircase* for exhibition in the International Exhibition of Modern Art, known as the Armory Show, which opens in New York early the following year. During their visit to the studio of Jacques Villon and Raymond Duchamp-Villon, the Americans acquire photographs of the three brothers, including *Marcel Duchamp, Raymond Duchamp-Villon, and Jacques Villon with Dog* (pl. 2)

1913
February 17: Becomes American sensation with *Nude Descending a Staircase (No. 2)* at Armory Show

1913–14
Produces first boxed edition, *Box of 1914*, a collection of notes on *La Mariée mise à nu par ses célibataires même (The Bride Stripped Bare by Her Bachelors, Even [The Large Glass])*

1915
June 15: Arrives in New York to much media fanfare; soon meets future patrons Louise and Walter Arensberg, as well as a large circle of artists and poets who would give shape to New York Dada

Late November–December: Establishes studio in Lincoln Arcade building. Teaches French as means of income

1916
April: Discusses idea of "ready-made" publicly for the first time in an interview for the April 4 *Evening World* article, "Big, Shiny Shovel Is the Most Beautiful Thing He Has Ever Seen." *Portrait de Marcel Duchamp sur mésure* by Jean Crotti (1915, pl. 3) is shown at Montross Gallery, New York City. Drawings related to portrait later surface (pls. 4, 5)

Fall: Begins giving French lessons to Carrie, Ettie, and Florine Stettheimer; attends Florine's fall solo show at Knoedler Gallery

Mid-October: Moves to 33 West 67th Street, in same building as Arensbergs. They will pay his rent in exchange for *The Large Glass*

December: Through the Stettheimers, meets Henri-Pierre Roché, who would become a close friend. Meets Katherine S. Dreier, a director and benefactor of Society of Independent Artists

1917
April: Submits readymade, *Fountain*, consisting of an overturned urinal, to Society of Independent Artists' exhibition under the pseudonym R. Mutt. It is rejected

April–June: Coedits Dada publications *The Blind Man* (nos. 1 and 2) and *Rongwrong* with Roché and Beatrice Wood

June 21: Photo postcard taken of *Marcel Duchamp, Francis Picabia, and Beatrice Wood at the Broadway Photo Shop, New York City* (pl. 6). That same day, he sits for photo postcard *Five-Way Portrait of Marcel Duchamp* (pl. 7)

October or November: Francis Picabia likely produces *Sheet of Studies Including a Portrait of Marcel Duchamp* (pl. 8)

—*Marcel Duchamp* by Edward Steichen (pl. 9)

1918
On commission from Dreier, creates *Tu m'* (fig. 5.3). Considers this, his last major painting, a "form of résumé"[2]

August 14: Leaves New York with Yvonne Chastel for nine-month stay in Buenos Aires

—*Abstract Portrait of Marcel Duchamp* by Katherine Sophie Dreier (pl. 10)

1919
Early spring: Receives "powerful treatment" for hair loss from Chastel while in Argentina; the tonsure haircut he received at this time is documented in a photograph (pl. 11)

Summer: Departs from Buenos Aires (June 22) and arrives in Paris at the end of July. Establishes contact with the Dada group there and creates *L.H.O.O.Q.*

1920

January 6: Returns to New York

April 29: Founds Société Anonyme, Inc., in New York with Man Ray and Dreier

—Persona of Rose (later Rrose) Sélavy appears as conceptual, but not yet visual, entity

c. 1920

—*Marcel Duchamp* by Joseph Stella (pl. 12); Charles Sheeler photographs *Baroness Elsa's Portrait of Marcel Duchamp* (pl. 13)

1921

Early: First photographed as Rose Sélavy by Man Ray

Before April: Man Ray photographs Rose Sélavy again (pl. 14a). Photograph is incorporated into a label for *Belle Haleine: Eau de Voilette* (pl. 15)

April: Photograph of *Belle Haleine: Eau de Voilette* appears on cover of a journal launched by Man Ray and Duchamp, *New York Dada* (pl. 16)

June: Leaves for Paris. Remains until January 1922

July 10: "Rose" published as "Rrose" in Picabia's *Le Pilhaou-Thibaou*

Late summer: Man Ray (?) photographs Duchamp's close-cropped tonsure with the star-comet (pls. 18, 19).[3] The inscription "Voici Rrose Sélavy," in Duchamp's handwriting beneath one of the views of his tonsure (pl. 20), documents the close relationship between this haircut and the development of Rrose Sélavy[4]

Early fall: Sits as Rrose Sélavy for Man Ray, who captures various poses while in Paris (including pl. 17)[5]

October: Picabia's painting *L'oeil cacodylate* goes on view in the Salon d'Automne. Duchamp has signed the work with a pun on Picabia's name and has added a second *r* in Rrose: "en 6 qu'habilla rrose Sélavy"[6]

1922

January 28: Departs France for New York to continue work on *The Large Glass*

December 1: André Breton's journal, *Littérature*, publishes Robert Desnos's series of punning poems dedicated to "telepathic" correspondence with Rrose Sélavy, along with Breton's essay in praise of Duchamp

—Gertrude Stein writes "Next: Life and Letters of Marcel Duchamp," a prose portrait of the artist[7]

1923

Early: Alfred Stieglitz makes two portrait photographs of Marcel Duchamp, one from the side and one from the front (pls. 23 and 24). Their similarity to mug shots is reinforced by Duchamp's *Wanted: $2,000 Reward* (see pl. 25)[8]

February 10: Sails for Europe, where he remains until 1942, except for three brief visits to the United States (1926–27, 1933–34, and 1936)

Mid-July: Returns to Paris. Eventually begins romantic relationship with Mary Reynolds

October 5: Release of Ettie Stettheimer's semiautobiographical *Love Days*, which includes a thinly veiled literary portrait of Duchamp

—*Marcel Duchamp* by Florine Stettheimer (pl. 22); Man Ray creates *Cela Vit*, a now-lost painted portrait of Duchamp with a rose and the words "Cela Vit" in bottom right corner. The painting is later etched by Man Ray (pl. 21)

1924

October: The cover of Francis Picabia's journal *391* is illustrated with *Portrait of Rrose Sélavy* (pl. 26), fashioned from an appropriated image of the boxer Georges Carpentier

November 1: Issues *Monte Carlo Bond* (pl. 27), which features Man Ray's photograph taken that year of Duchamp's head and face lathered in shaving cream (pl. 28)

December: Appears in René Clair's film *Entr'acte* playing chess with Man Ray. Is also in third act of *Cinésketch*, playing Adam in brief tableaux imitating Lucas Cranach's famous image of Adam and Eve.

1926

April 27: Sits for Antoine Pevsner for a portrait commissioned by Dreier

August 30: Screens *Anémic Cinéma* (1925–26), made in collaboration with Man Ray and Marc Allégret. Last frame ends with the words "copyright by" and Rrose Sélavy's signature and fingerprint

October 13: Sails to New York to organize a Constantin Brancusi exhibition at Brummer Gallery

November 19–January 1, 1927: *The Large Glass* shown publicly for the first time in the International Exhibition of Modern Art, sponsored by the Société Anonyme, Brooklyn Museum, New York

1927

February 27: Sails back to Paris, where he resides for the next sixteen years

June 7: Marries Lydie Sarazin-Lavassor, the twenty-four-year-old daughter of an automotive manufacturer. The couple divorces by January 1928

1930

—*Profile Portrait of Marcel Duchamp* by Man Ray (pl. 29)

1933

October: Returns to America to install Brancusi exhibition at Brummer Gallery (November 17, 1933–January 13, 1934). Probably meets Joseph Cornell during this time. Returns to Paris on January 20, 1934

1934

September: Publishes boxed edition of *La Mariée mise à nu par ses célibataires même (The Bride Stripped Bare by Her Bachelors, Even [The Green Box])*

December 5: André Breton's important essay on Duchamp, "Lighthouse of the Bride," published in the Parisian journal *Minotaure*

1936

March 7: "Cubism and Abstract Art," organized by Alfred Barr, opens at Museum of Modern Art, New York, including five works by Duchamp

April 14: Gabrielle Buffet's article on Duchamp, "Cœurs volants," appears in *Cahiers d'Art*; later republished in translation as "Magic Circles" in a special issue of *View* devoted to Duchamp (see March 1945)

May 25: Travels to United States to gather images for his *Boîte-en-valise*

May 27: At Katherine Dreier's home in West Redding, Connecticut, begins task of repairing *The Large Glass*, which he then installs in her library

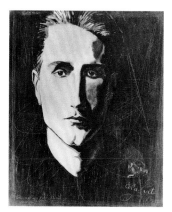

See plate 21

July 31–August 1: Sits for portrait by Daniel MacMorris at the artist's request. Results in two studies by MacMorris (pls. 30, 32) and the final painted portrait in 1937 (pl. 34)

August: Crosses country by train to visit the Arensbergs in Hollywood, California, where he has his works in their collection photographed for the *Boîte-en-valise,* which Walter Arensberg will later describe as "a new kind of autobiography" with which the artist had "become the puppeteer of [his] past"[9]

September 7: Returns to France

December: *Anémic Cinéma* is shown at Julien Levy Gallery, New York

December 7: "Fantastic Art, Dada, Surrealism," organized by Barr, opens at Museum of Modern Art, with eleven works by Duchamp

c. 1936: Man Ray creates photograph (pl. 35) combining Hoffmann's portrait of Duchamp (pl. 1) with image of Duchamp's *Glider*

1937

February 5–27: First solo exhibition presented by Arts Club of Chicago. Levy writes catalogue preface

May: Frederick Kiesler publishes article on *The Large Glass* in "Design-Correlation" series, *Architectural Record,* with photographs by Berenice Abbott

—*Mary Reynolds and Marcel Duchamp,* possibly by Costa Achilopulu (pl. 36)

1938

January 17: Exposition internationale du surréalisme opens in Paris. Duchamp contributes female mannequin representing Rrose Sélavy (fig. 4.3)

1939

January: Presents Museum of Modern Art with copy of *Monte Carlo Bond* (pl. 27), his first work in a public collection

April 19: *Rrose Sélavy,* an anthology of Duchamp's modified printed readymades, published in Paris by GLM

1941

January 1: Announces appearance of his boxed edition, *by or of Marcel Duchamp or Rrose Sélavy [Boîte-en-valise]* (see pl. 37)[10]

July: Peggy Guggenheim transports materials for fifty of Duchamp's *Boîtes-en-valise* from Marseilles to New York

1942

Early spring: André Gomès photographs Duchamp at the Villa Air-Bel in Marseilles, the base of an organization to help war refugees (pl. 39)

May 14: Sails from Marseilles to United States. In New York, associates with surrealist artists and writers

September 7: *Time* magazine publishes "Artist Descending to America," discussing Duchamp's escape from occupied France and including a photo of the artist

October 14–November 7: With Breton, organizes "First Papers of Surrealism" exhibition at Whitelaw Reid Mansion, New York. With help of a few other artists, weaves a mile of string throughout the rooms. John D. Schiff and Arnold Newman photograph the installation, with the latter creating a portrait of Duchamp's features overlaid with string from the maze (pl. 41). For exhibition catalogue, suggests artists use found pictures as "compensation portraits" of themselves and appropriates Ben Shahn's Depression-era photograph of female "rehabilitation client" to represent himself (pl. 40)[11]

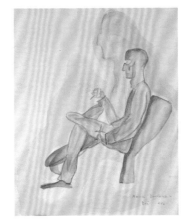

See plate 46

1943

Probably early in the year: Meets artist Maria Martins, wife of a Brazilian ambassador as well as the inspiration for the figure in *Étant donnés.* The two would remain in contact until about 1951

1944

Appears with his *Rotoreliefs* in Hans Richter's film, *Dreams That Money Can Buy*

1945

March: *View* magazine publishes issue devoted solely to Duchamp (pl. 42a and b), which includes *Marcel Duchamp at the Age of Eighty-Five* (pl. 43). Variant image, without glasses (pl. 44), reveals the care Duchamp took to create the illusion of old age

March 13–April 11: Whitney Museum's "European Artists in America" includes Duchamp's *Allégorie de genre,* possible precursor to his profile self-portrait (pls. 57, 58)

April 19–26: *Marcel Duchamp at the Age of Eighty-Five* (pl. 43) included in window display designed by Duchamp, Breton, and Roberto Matta at Brentano's, New York

c. 1945: Meets Ettore Salvatore, who creates life mask of Duchamp (pl. 45), from which a series of casts are made during the early 1960s

1946

May 1: Sails for France

July: Breton organizes "Tracts et Papillions Surréalistes" exhibition installed in the front window of La Hune bookstore in Paris (fig. 1.4); Duchamp's *Boîte-en-valise* and photographic portraits of him by Man Ray and Carl Van Vechten feature prominently

—*Marcel Duchamp* by Beatrice Wood (pl. 46)

1947

January 13: Settles permanently in New York

July 7: Exposition internationale du surréalisme, organized by Duchamp and Breton, opens in Paris

November 8: Duchamp poses for portrait by Frederick Kiesler (pl. 47)

1948

—*Marcel Duchamp* by Irving Penn (pl. 48)

1949

April: Participates in "Western Round Table on Modern Art" at San Francisco Museum of Art. *Nude Descending a Staircase (No. 2)* is on view in a related exhibition. Duchamp then travels to Los Angeles to visit Walter and Louise Arensberg. While there, he meets Katharine Kuh, a curator of modern painting and sculpture at the Art Institute of Chicago, and visits with Man Ray and William Copley

October 20: "Twentieth-Century Art from the Louise and Walter Arensberg Collection," which includes thirty works by Duchamp, opens at Art Institute of Chicago

1950

September 25: *Fountain* (represented by a substitute) shown in public for the first time at the Sidney Janis Gallery's "Challenge and Defy" exhibition

September 30: Mary Reynolds dies in Paris. Duchamp is with her

December 28: Duchamp, who has been named by the Arensbergs a trustee of their Francis Bacon Foundation, joins in their decision to present the Philadelphia Museum of Art with their collection of his work

c. 1950

—*FBI Wanted Notice* by Julien Levy (pl. 49)

1951

Fall: Renews acquaintance with Alexina (Teeny) Matisse. They move into a New York apartment soon afterward, where they reside until 1959

—*Portrait of Marcel* by William Copley (pl. 50)

1952

February 25: "Duchamp Frères et Soeur" opens at Rose Fried Gallery, New York

March 29: Katherine Dreier dies; Duchamp, one of the executors of her will, begins disbursement of her collection

April: *Life* magazine publishes an article on Duchamp, "Dada's Daddy" (pl. 51)

1953

April 15: "Dada: 1916–1923," organized by Duchamp, opens at Sidney Janis Gallery, New York

October: Duchamp receives his sister Suzanne's etching of him (pl. 53)

November 25: Louise Arensberg dies

—*Portrait No. 29 (Double Exposure: Full Face and Profile)* by Victor Obsatz (pl. 54); *Marcel Duchamp* by Jacques Villon (pl. 52)

1954

January 16: Marries Teeny Matisse; becomes stepfather to Jacqueline, Paul, and Peter Matisse

January 29: Walter Arensberg dies. Duchamp serves as executor of estate

October 15: Louise and Walter Arensberg permanent exhibition opens at the Philadelphia Museum of Art. Duchamp assists with installation

1955

December 30: Becomes a naturalized U.S. citizen

c. 1955

—*Marcel Duchamp in Blond Wig* by Man Ray (pl. 55)

1956

January: NBC television broadcasts Duchamp's interview with James Johnson Sweeney, filmed at the Philadelphia Museum of Art, in its "Wisdom Series"

1957

February 19: "Jacques Villon, Raymond Duchamp-Villon, Marcel Duchamp," organized by Sweeney, opens at Guggenheim Museum, New York

February 25: By this time, Duchamp has completed 130 (later 137) versions of *Self-Portrait in Profile* (pl. 58) for the deluxe editions of Robert Lebel's 1959 monograph on Duchamp (pl. 62).[12] These were done using his *Template for Self-Portrait in Profile* (pl. 57)

April: Gives the talk "The Creative Act" at the meeting of the American Federation of Arts in Houston, Texas

—*Marcel Duchamp* by John D. Schiff (pl. 56)

1958

December: Arnold Rosenberg creates series of photographic portraits of Duchamp, including *Duchamp at Chess Board* (pl. 60) and *Marcel Duchamp Double Exposure* (pl. 61)

—*Marcel Duchamp* by Richard Avedon (pl. 59)

1959

April 6: Exhibition opens at the Sidney Janis Gallery in honor of Robert Lebel's *Sur Marcel Duchamp* (pl. 62). English translation by George Heard Hamilton would appear in early November. Along with *Self-Portrait in Profile* (pl. 58), deluxe edition included another new work, *Eau & gaz à tous les étages*

Summer: Conducts further experiments with self-portraiture, including *Torture-morte* (fig. 5.5) and *With My Tongue in My Cheek* (fig. 5.4)

October 1: Publication of *Marchand du Sel, écrits de Marcel Duchamp,* compiled by Michel Sanouillet

1960

January 29–February 1: Window display in honor of Lebel's monograph at Bamberger's Department Store, New Jersey (fig. 5.7)

December 16: George Heard Hamilton publishes first full English translation of *The Green Box* in London, titled *The Bride Stripped Bare by Her Bachelors, Even,* with typographic arrangement by Richard Hamilton. Jasper Johns reviews book[13]

1961

October 2: Museum of Modern Art's "Art of Assemblage" exhibition opens. Duchamp gives lecture, "A propos of Readymades," at exhibition symposium. Marvin Lazarus later takes photographs of Duchamp viewing the show (see pls. 63, 64)

—*Boîte—Series D* by Marcel Duchamp (pl. 37) assembled by Jackie Matisse Monnier

1962

June 26: BBC television program *Monitor* broadcasts interviews from 1961 between Duchamp and Katharine Kuh and Richard Hamilton

1963

February 16: Attends opening of "Armory Show—50th Anniversary Exhibition" at Munson-Williams-Proctor Institute, Utica, New York

April: Ulf Linde curates Duchamp retrospective at Galerie Buren, Stockholm

October 8–November 3: Designs invitation, poster, and catalogue cover for his first major retrospective exhibition, "by or of Marcel Duchamp or Rrose Sélavy," at Pasadena Art Museum. Exhibition poster, *Poster within a Poster* (pl. 65), reproduces *Wanted: $2,000 Reward* (1923) (pl. 25)

November 24: Gives lecture, "Apropos of Myself," City Art Museum of St. Louis

See plate 50

1964

June 5: In collaboration with Duchamp, Arturo Schwarz opens "Homage to Marcel Duchamp" at Galleria Schwarz in Milan. The exhibition features the newly editioned readymades, documented in *Hommage à Marcel Duchamp Ready-Mades, etc. (1913–1964)*

—*Marcel Duchamp Looking at Hat Rack* by Ugo Mulas (pl. 68); *M.D.* by Jasper Johns (pl. 66)

1965

Refuses to sign protest against Gilles Aillaud, Antonio Recalcati, and Eduardo Arroyo for their painting series depicting his fictitious murder, *Live and Let Die, or the Tragic End of Marcel Duchamp,* shown at Galerie Creuze, Paris

January 13: "Not Seen and/or Less Seen of/by Marcel Duchamp/Rrose Selavy, 1904–64," opens at Cordier & Ekstrom, New York City, and travels to five museums across the country

—*Duchamp Emerging from Curtains* by Ugo Mulas (pl. 69)

1966

February 7: Opening of Cordier & Ekstrom's "Hommage à Caïssa," exhibition benefiting Marcel Duchamp Fund of the American Chess Foundation. At the opening, Andy Warhol films *Screen Test: Marcel Duchamp* (pl. 70), while Nat Finkelstein photographs Warhol (pl. 71)

June 18: First major European retrospective, "The Almost Complete Works of Marcel Duchamp," organized by Richard Hamilton, opens at Tate Gallery, London

July: Special issue of *Art and Artists* (London) devoted to Duchamp. Cover is *Hommage à Marcel Duchamp* by Man Ray

—*Ferus Poster* (pl. 72) and *Katherine Dreier's Living Room* (pl. 73) by Richard Pettibone

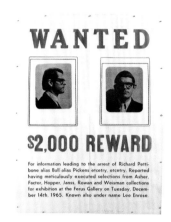

See plate 72

c. 1966

—*Portrait of Marcel Duchamp: Nine Malic Moulds and Cast Shadows* by Arnold Newman (pl. 74)

1967

Publication of important extended interviews by Pierre Cabanne, *Entretiens avec Marcel Duchamp,* in Paris. English translation by Ron Padgett published in New York, 1971

Publication in Paris of monograph by Octavio Paz, *Marcel Duchamp ou le château de la pureté.* Spanish deluxe boxed version published under the title *Marcel Duchamp* in Mexico a year later

February 14: "A l'infinitif" exhibition at Cordier & Ekstrom coincides with translation into English and publication of *A l'infinitif* (also known as *The White Box*), a collection of previously unpublished notes written from 1912 to 1920

—Brian O'Doherty completes sixteen-part portrait of Duchamp based on his electrocardiogram, including *Portrait of Marcel Duchamp: Mounted Cardiogram 4/4/66* (pl. 75); *Portrait of Marcel Duchamp, 3 leads* (pl. 76); and *Study for the Second Portrait of Marcel Duchamp, lead 1, mounting increments* (pl. 77)

1968

July (?): Lewis Jacobs films Duchamp for *Marcel Duchamp in His Own Words*

October 2: Duchamp dies quietly of heart failure. He is widely memorialized, including in an obituary published in the October 11 issue of *Life* (pl. 85)

—*Marcel and Teeny Duchamp* by Henri Cartier-Bresson (pl. 78); *Portrait of Marcel Duchamp* by Mel Bochner (pl. 81); *Account of a Dream about Marcel Duchamp* by Joseph Cornell (pl. 84); *Marcel Duchamp* by Richard Hamilton (pl. 80); *Star (Duchamp with Star Haircut)* by Ray Johnson (pl. 82); *Triple Exposure of Duchamp Smoking a Cigar* by John D. Schiff (pl. 79); *To and From Rrose Sélavy* by Shuzo Takiguchi, with prints by Jasper Johns, Jean Tinguely, and Shusaku Arakawa, and a version of Duchamp's *Self-Portrait in Profile* dedicated to Takiguchi (pl. 83)

1969

Publication of Arturo Schwarz's *The Complete Works of Marcel Duchamp* and his *Notes and Projects for the Large Glass*

July 7: Duchamp's secret work, *Étant donnés: 1. la chute d'eau, 2. le gaz d'éclairage,* installed at the Philadelphia Museum of Art, opens to the public

—Featured in summer issue of *Art in America*

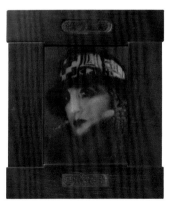

See plate 86

1971

March 19: "Marcel Duchamp, Grafica e Ready-made" opens at Galleria Civica d'Arte Moderna, Ferrara, Italy

November 6–9: Symposium on Duchamp organized by Barbara Rose and Moira Roth at University of California at Irvine

—*Fragment—According to What—Hinged Canvas* by Jasper Johns (pl. 67)

1972

Exhibitions dedicated to Duchamp open, including "Marcel Duchamp: Drawings, Etchings for *The Large Glass,* Readymades" at Israel Museum, Jerusalem (March) and "Marcel Duchamp, 66 Creative Years at the Galleria Schwarz," Milan (December). Publication of John Golding's monograph, *Marcel Duchamp: The Bride Stripped Bare by Her Bachelors, Even,* and Lebel's expanded edition of *Marcel Duchamp* with a new chapter on *Étant donnés*

1973

September 22: Duchamp retrospective, organized by Anne d'Harnoncourt and Kynaston McShine, opens at Philadelphia Museum of Art

1976

—*Portrait of Rrose Sélavy* by Thomas Chimes (pl. 86)

1977

January 31: "L'Oeuvre de Marcel Duchamp," curated by Jean Clair, opens at Musée National d'Art Moderne (Centre Georges Pompidou), Paris

1980

Marcel Duchamp, Notes (deluxe edition), arranged and translated by Paul Matisse, with preface by Pontus Hulten, published for Musée National d'Art Moderne (Centre Georges Pompidou), Paris

1984

—*A Room in Connecticut* by Red Grooms (pl. 87)

1987

October 1: "Apropos of Marcel Duchamp, 1887/1987,"opens at Philadelphia Museum of Art in honor of the one-hundredth anniversary of Duchamp's birth

—*Untitled (Duchamp with "Blue Eyes")* by Ray Johnson (pl. 88)

1988

Doublonnage (Marcel) by Yasumasa Morimura (pl. 89)

See plate 78

1990

Joseph and Robert Cornell Memorial Foundation donates Joseph Cornell's *Duchamp Dossier* to Philadelphia Museum of Art

December 7: "Marcel Duchamp, 1887–1968" exhibition opens at Shoshana Wayne Gallery, Santa Monica

—*1919/1990 (Portrait of Duchamp)* by Carlo Maria Mariani (pl. 90)

1991

September 15: "Marcel Duchamp" opens at Galerie Ronny van de Velde, Antwerp

1991–2006

—*Deux Champs* by Alice Hutchins (pl. 91)

1992

—*The Enunciation* by Mark Tansey (pl. 92)

—*Duchamp Wanted* by Sturtevant (pl. 93)

1993

April 3: "Marcel Duchamp: Work and Life," organized by Pontus Hulten, Jennifer Gough-Cooper, and Jacques Caumont, opens at Palazzo Grassi, Venice

1996

Calvin Tomkins publishes his widely read *Duchamp: A Biography*

—*Nu Descendant un Escalier* by Sturtevant (pl. 94)

1996–98

—*Portrait of Richard Mutt* by Jonathan Santlofer (pl. 95)

1998

October 8: "Joseph Cornell/Marcel Duchamp . . . In," organized by Anne d'Harnoncourt, Walter Hopps, and Ecke Bonk, opens at Philadelphia Museum of Art

1999

October: "Marcel Duchamp: The Art of Making Art in the Age of Mechanical Reproduction" (Achim Moeller Fine Art) and "Apropos of Marcel: Making Art After Marcel Duchamp in the Age of Mechanical Reproduction" (Curt Marcus Gallery), both organized by Francis M. Naumann, open in New York

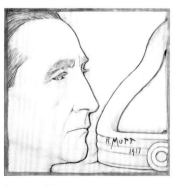

See plate 95

2000

—*Portrait of Marcel Duchamp and Rrose Sélavy* by Jonathan Santlofer (pl. 96); *Fountain at the Age of 83* by Douglas Vogel (pl. 97)

2002

—*The Holy Bible: Old Testament* by David Hammons (pl. 98)

2003

January 24: "Debating American Modernism. Stieglitz, Duchamp, and the New York Avant-Garde," organized by Debra Bricker Balken, opens at Georgia O'Keeffe Museum, Santa Fe

—*Profile Vase (Duchamp) . . .* by Andrew Lord (pl. 99)

2004

—*Proposition for a Posthumous Portrait* by Douglas Gordon (pl. 100)

2005

November 28: "Marcel Duchamp and Rrose Sélavy," organized by Marc Décimo, opens at Musée des Beaux-Arts, Orleans, France

2006

—*Wanted Poster* by Gavin Turk (pl. 101)

2007

—*Duchamp Tout Fait* (pl. 102) and *Avec Ma Langue Dans Ma Joue . . .* (pl. 103) by Ray Beldner

2008

February 21: "Duchamp, Man Ray, Picabia," organized by Jennifer Mundy, opens at Tate Modern, London

April 25: "Marcel Duchamp Redux," organized by Gloria Williams Sander, opens at Norton Simon Museum, Pasadena, California

July 15: "Marcel Duchamp: A work that is not a work of art," organized by Elana Filipovic, opens at Museo de Arte Moderna, São Paulo, Brazil

2009

March 27: "Inventing Marcel Duchamp: The Dynamics of Portraiture" opens at National Portrait Gallery, Smithsonian Institution

July 7: "Marcel Duchamp: *Étant donnés*" opens at Philadelphia Museum of Art

Notes

1. As Calvin Tomkins points out, the precise date of Duchamp's meeting of Guillaume Apollinaire is uncertain. Although Duchamp repeatedly asserted in interviews that he did not meet Apollinaire until October 1912, following his return from Munich, he also had a recollection of attending a performance of *Impressions d'Afrique* with both him and Picabia in June 1912. See Tomkins, *Duchamp*, 90–91, 473.

2. Duchamp, quoted in Tomkins, *Duchamp*, 202.

3. Dating these photographs and determining where they were taken and by whom has been the subject of considerable scholarly attention. Dates given have fluctuated between 1919 and 1921. Arturo Schwarz, based on a later notation by Duchamp, dates Man Ray's photograph of Duchamp with his "comet" tonsure to 1919. Recently, a series of five photographs of Duchamp with this haircut, published in "Portfolio: Photographs of or about Marcel Duchamp," *Étant donné Marcel Duchamp* 7 (2006): 222–24, figs. 8–12, bear the date 1921. For the original 1921 dating by Anne d'Harnoncourt and Kynaston McShine, see "Chronology," in d'Harnoncourt and McShine, *Marcel Duchamp*, 18. For Schwarz's explanation of his 1919 dating, see Schwarz, *Complete Works*, vol. 2, 673. Recent discoveries make it possible to date the photographs between August 9 and September 17, 1921. See James W. McManus's essay in this volume, n. 100.

4. See James W. McManus's essay in this volume for more on this interrelationship.

5. Scholarship provides a variety of dates for this object. This date reflects Schwarz, *Complete Works*, fig. 393.

6. This incident is likely the origin of the double *r*. In a letter to Katharine Kuh, Duchamp explained, "The 'a' of 'habilla' gave me the idea to continue punning: arose (the verb 'arroser' takes two r's); and then I thought very clever to begin a word, a name with 2 Rs—like the 2 ls in Lloyd." For more, see entry for March 24,

1949, in Jennifer Gough-Cooper and Jacques Caumont, "Ephemerides on and about Marcel Duchamp and Rrose Sélavy, 1887–1968, in *Marcel Duchamp: Work and Life*, ed. Pontus Hulten (Cambridge, MA: MIT Press, 1993).

7. Gertrude Stein, *Geography and Plays* (1922; New York: Something Else Press, 1968).

8. Ecke Bonk makes the connection between Stieglitz's photographs and those included on the *Wanted* poster. See Bonk, "Ready made rectifié: 'WANTED/$2,000 REWARD,'" in *Marcel Duchamp, The Portable Museum: The Making of the Boîte-en-valise, de ou par Marcel Duchamp ou Rrose Sélavy, Inventory of an Edition*, trans. David Britt (1986; London: Thames & Hudson, 1989), pl. 56, 243. However, visual analysis of photographs of the lost 1923 original does not support his assertion that the pictures on the poster were actually by Stieglitz. I am grateful to Sarah Greenough for her input on this question.

9. Tomkins, *Duchamp*, 316.

10. For a detailed discussion of the contents of the boxes and an overview of the seven series, see Bonk, *Duchamp, The Portable Museum*; on the titling convention, see ibid., 257.

11. The source photograph is identified in David Hopkins, "The Politics of Equivocation: Sherrie Levine, Duchamp's 'Compensation Portrait,' and Surrealism," *Oxford Art Journal* 26, no. 1 (2003): 56. See also the catalogue entry (pl. 40) on this portrait.

12. Scholars traditionally date these objects to 1958; however, Paul Franklin's recent discussion of the publication of Lebel's monograph includes correspondence between Duchamp and Arnold Fawcus that demonstrates the first edition of the torn *Self-Portrait in Profile* was complete by this date. See Franklin, "1959: Headline, Duchamp," *Étant donné Marcel Duchamp* 7 (2006): 146.

13. See Jasper Johns, "Duchamp," *Scrap* no. 2 (December 23, 1960): 4.

Selected Bibliography

Marcel Duchamp in His Own Words

"A Complete Reversal of Art Opinions by Marcel Duchamp, Iconoclast."
Arts and Decoration (New York) 5, no. 2 (September 1915): 428.

Duchamp, Marcel. "The Nude Descending-a-Staircase Man Surveys Us."
New York Tribune, September 12, 1915.

———. *The Bride Stripped Bare by Her Bachelors, Even.* Edited by Richard
Hamilton. Translated by George Heard Hamilton. London: Percy Lund,
Humphries, 1960.

———. *Salt Seller: The Writings of Marcel Duchamp.* Edited by Michel Sanouillet
and Elmer Peterson. New York: Oxford University Press, 1973.

———. *Marcel Duchamp, Notes.* Edited and translated by Paul Matisse. Boston:
G. K. Hall, 1983.

———. *in the infinitive: a typotranslation by Richard Hamilton and Ecke Bonk
of Marcel Duchamp's White Box.* Translated by Jackie Matisse, Richard
Hamilton, and Ecke Bonk. Paris: Succession Marcel Duchamp, 1999.

"The European Art-Invasion." *Literary Digest*, November 27, 1915, 1224–27.

Hahn, Otto. "Passport No. G255300." *Art and Artists* 1, no. 4 (July 1966): 10.

[Heap, Jane.] "The Monte Carlo Bond." *Little Review* 10, no. 2 (Fall–Winter
1924–25): 117–22.

"Marcel Duchamp Visits New York." *Vanity Fair*, September 1915.

Roberts, Francis. "'I Propose to Strain the Laws of Physics': Interview with
Marcel Duchamp [1963]." *ARTnews* 67, no. 8 (December 1968): 63.

Seitz, William. "What's Happened to Art? An Interview with Marcel Duchamp
on Present Consequences of New York's 1913 Armory Show." *Vogue*,
February 15, 1963, 112.

Siegel, Jeanne. "Some Late Thoughts of Marcel Duchamp, from an Interview
with Jeanne Siegel." *Arts Magazine* 43, no. 3 (December 1968–January
1969): 21–22.

Sweeney, James Johnson. "Eleven Europeans in America: Marcel Duchamp."
Museum of Modern Art Bulletin 13, nos. 4–5 (1946): 21.

Secondary Sources

Ades, Dawn. "Duchamp's Masquerades." In *The Portrait in Photography*. Edited
by Graham Clarke, 94–114. London: Reaktion, 1992.

Balkin, Debra Bricker. *Debating American Modernism: Stieglitz, Duchamp, and
the New York Avant-Garde.* New York: American Association of Arts in
association with Distributed Art Publishers, 2003.

Baruchello, Gianfranco, and Henry Martin. *Why Duchamp? An Essay on Aes-
thetic Impact.* New Paltz, NY: Documentext, 1985.

Bonk, Ecke. *Marcel Duchamp, The Portable Museum: The Making of the Boîte-en-
valise, de ou par Marcel Duchamp ou Rrose Sélavy, Inventory of an Edition.*
Translated by David Britt. London: Thames & Hudson, 1989.

Breton, André. *First Papers of Surrealism.* New York: Coordinating Council
of French Relief Societies, 1942.

Buffet-Picabia, Gabrielle. "Some Memories of Pre-Dada: Picabia and
Duchamp." Reprinted in *The Dada Painters and Poets: An Anthology.*
Edited by Robert Motherwell, 255–67. 2nd ed. Cambridge, MA:
Belknap Press of Harvard University, 1981.

Cabanne, Pierre. *Dialogues with Marcel Duchamp.* Translated by Ron Padgett.
1967. Reprint, New York: Viking, 1971.

Camfield, William A. *Marcel Duchamp: Fountain.* Houston: Menil Collection,
1989.

Clair, Jean. *Duchamp et la photographie.* Paris: Éditions du Chêne, 1977.

———. *Sur Duchamp et la fin de l'art.* Paris: Éditions Gallimard, 2005.

Clearwater, Bonnie, ed. *West Coast Duchamp.* Miami Beach, FL: Grassfield
Press, 1991.

Corn, Wanda. *The Great American Thing: Modern Art and National Identity,
1915–1935.* Berkeley: University of California Press, 1999.

Décimo, Marc, ed. *Marcel Duchamp and Eroticism.* Newcastle, Eng.: Cambridge
Scholars Press, 2007.

De Duve, Thierry, ed. *The Definitively Unfinished Marcel Duchamp.* Cambridge,
MA: MIT Press, 1991.

———. *Pictorial Nominalism: On Marcel Duchamp's Passage from Painting to the
Readymade.* Translated by D. Polan. Minneapolis: University of Minne-
sota Press, 1991.

Demos, T. J. *The Exiles of Marcel Duchamp.* Cambridge, MA: MIT Press, 2007.

D'Harnoncourt, Anne, and Kynaston McShine, eds. *Marcel Duchamp.* New York
and Philadelphia: Museum of Modern Art and Philadelphia Museum of
Art, 1973.

D'Harnoncourt, Anne, and Walter Hopps. "*Étant donnés: 1. la chute d'eau, 2. le
gaz d'éclairage:* Reflections on a New Work by Marcel Duchamp." *Philadel-
phia Museum of Art Bulletin* 64, nos. 299–300 (April–September 1969).

Dickerman, Leah, ed., *Dada: Zurich, Berlin, Hannover, Cologne, New York, Paris.*
Washington, DC: National Gallery of Art, 2005.

Golding, John. *Marcel Duchamp: The Bride Stripped Bare by Her Bachelors, Even.*
New York: Viking, 1973.

Henderson, Linda Dalrymple. *The Fourth Dimension and Non-Euclidean Geometry
in Modern Art.* Princeton, NJ: Princeton University Press, 1983.

———. *Duchamp in Context: Science and Technology in the Large Glass and Related
Works.* Princeton, NJ: Princeton University Press, 1998.

Herbert, Robert L., Eleanor S. Apter, and Elise K. Kenney, eds. *The Société
Anonyme and the Dreier Bequest at Yale University: A Catalogue Raisonné.*
New Haven, CT: Yale University Press, 1984.

Hopkins, David. *Marcel Duchamp and Max Ernst: The Bride Shared.* New York:
Oxford University Press, 1998.

Hopps, Walter, Ulf Linde, and Arturo Schwarz. *Marcel Duchamp: Ready-Mades,
etc., 1913–1964.* Milan: Galleria Schwarz, 1964.

Hulten, Pontus, ed. *Marcel Duchamp: Work and Life.* Cambridge, MA: MIT Press,
1993.

Iles, Chrissie. "Marcel Duchamp, Man Ray and the Desiring Machine." In
Marcel Duchamp Man Ray: 50 Years of Alchemy, 19–47. New York: Sean
Kelly Gallery, 2004.

Janis, Carroll. "Marcel Duchamp Curates Dada." *Art in America* 94, no. 6
(June–July 2006): 152.

Jones, Amelia. *Postmodernism and the En-gendering of Marcel Duchamp.*
Cambridge: Cambridge University Press, 1994.

Joselit, David. "Marcel Duchamp's *Monte Carlo Bond* Machine." *October* 59
(Winter 1992): 8–26.

———. *Infinite Regress: Marcel Duchamp, 1910–1941.* Cambridge, MA: MIT Press,
1998.

Judovitz, Dalia. *Unpacking Duchamp: Art in Transit*. Berkeley: University of California Press, 1995.

Kachur, Lewis. *Displaying the Marvelous: Marcel Duchamp, Salvador Dalí, and Surrealist Exhibition*. Cambridge, MA: MIT Press, 2001.

Kuenzli, Rudolf E., and Francis M. Naumann, eds. *Marcel Duchamp: Artist of the Century*. Cambridge, MA: MIT Press, 1989.

Kuh, Katharine. "Marcel Duchamp." In *The Artist's Voice: Talks with Seventeen Modern Artists*, 81–93. 1962. Reprint, New York: Da Capo, 2000.

Krauss, Rosalind E. *The Originality of the Avant-Garde and Other Modernist Myths*. Cambridge, MA: MIT Press, 1985.

Lebel, Robert. *Marcel Duchamp*. Translated by George Heard Hamilton. New York: Grove Press, 1959. Originally published as *Sur Marcel Duchamp*. Paris: Trianon Press, 1959.

Leiris, Michel. "The Arts and Sciences of Marcel Duchamp." *Fontaine* (Paris) 7, no. 54 (Summer 1946).

Leja, Michael. *Looking Askance: Skepticism and American Art from Eakins to Duchamp*. Berkeley: University of California Press, 2004.

Linde, Ulf. *Marcel Duchamp, Interviews und Statements*. Stuttgart: Edition Cantz, 1992.

Lyotard, Jean-François. *DUCHAMP'S TRANS/Formers*. Translated by I. McLeod. Venice, CA: Lapis Press, 1990. Originally published as *Les transformateurs Duchamp*. Paris: Éditions Galilée, 1977.

Marquis, Alice Goldfarb. *Marcel Duchamp: The Bachelor Stripped Bare, a Biography*. Boston: MFA Publications, 2002.

Masheck, Joseph, ed. *Marcel Duchamp in Perspective*. Englewood Cliffs, NJ: Prentice-Hall, 1974.

McEvilley, Thomas. *The Triumph of Anti-Art: Conceptual and Performance Art in the Formation of Post-Modernism*. Kingston, NY: Documentext, 2005.

McManus, James W. "Trucage photographique et déplacement de l'objet: À propos d'une photographie de Marcel Duchamp prise devant un miroir à charnières (1917)." *Les Cahiers du Musée national d'art moderne* 92 (Summer 2005): 94–111.

Mileaf, Janine. "Boxes, Books, and the *Boîte-en-valise*." In *A Transatlantic Avant-Garde*. Edited by Sophie Levy, 163–72. Chicago and Giverny: Terra Museum of American Art, 2003.

Moffitt, John F. *Alchemist of the Avant-Garde: The Case of Marcel Duchamp*. Albany, NY: State University of New York Press, 2001.

Molesworth, Helen. "Rrose Selavy Goes Shopping." In *The Dada Seminars*. Edited by Leah Dickerman and Matthew S. Witkovsky, 173–89. Washington, DC: Center for Advanced Study in the Visual Arts at the National Gallery of Art, 2005.

Motherwell, Robert ed. *The Dada Painters and Poets: An Anthology*. 2nd ed. Cambridge, MA: Belknap Press of Harvard University Press, 1989.

Mundy, Jennifer. *Marcel Duchamp, Francis Picabia, and Man Ray*. London: Tate Gallery, 2008.

Naumann, Francis M. *New York Dada, 1915–23*. New York: Harry N. Abrams, 1994.

———. *Making Mischief: Dada Invades New York*. New York: Whitney Museum of American Art, 1996.

———. *Marcel Duchamp: The Art of Making Art in the Age of Mechanical Reproduction*. Ghent: Ludion Press; New York: distributed by Harry N. Abrams, 1999.

Naumann, Francis M., and Hector Obalk, eds. *Affectionately, Marcel: The Selected Correspondence of Marcel Duchamp*. Translated by Jill Taylor. Ghent: Ludion Press, 2000.

Nodelman, Sheldon. "The Decollation of Saint Marcel." *Art in America* 94 (October 2006): 107–19.

Paz, Octavio. *Marcel Duchamp: Appearance Stripped Bare*. Translated by Rachel Phillips and Donald Gardner. New York: Viking, 1978.

Reff, Theodore. "Duchamp & Leonardo: L.H.O.O.Q.-Alikes." *Art in America* 65 (January–February 1977): 87.

Roth, Moira. "Marcel Duchamp in America: A Self Ready-Made." In *Difference/Indifference: Musings on Postmodernism, Marcel Duchamp and John Cage*, 17–30. Amsterdam: G + B Arts International, 1998.

Sargeant, Winthrop. "Dada's Daddy." *Life* (April 28, 1952), 100–111.

Sawelson-Gorse, Naomi, ed. *Women in Dada: Essays on Sex, Gender, and Identity*. Cambridge, MA: MIT Press, 1998.

Schwarz, Arturo. *The Complete Works of Marcel Duchamp*. 3rd rev. ed. New York: Delano Greenridge Editions, 1997.

Seigel, Jerrold. *The Private Worlds of Marcel Duchamp: Desire, Liberation, and the Self in Modern Culture*. Berkeley: University of California Press, 1995.

Spector, Jack J. "Freud and Duchamp: The Mona Lisa 'Exposed.'" *Artforum* 6, no. 8 (April 1968): 56.

Takiguchi, Shuzo. "Toward Rrose Sélavy: A Marginal Note to To and From Rrose Sélavy." Preface to *To and From Rrose Sélavy*. Tokyo: Rrose Sélavy, 1968.

Tashjian, Dickran. "Vous pour moi?" In *Mirror Images/Women, Surrealism, and Self-Representation*, 36–65. Cambridge, MA: MIT Press, 1998.

Temkin, Ann, Anne d'Harnoncourt, et al. *Joseph Cornell/Marcel Duchamp . . . in Resonance*. Houston and Philadelphia: Menil Collection and Philadelphia Museum of Art, 1998.

Tomkins, Calvin. *Duchamp: A Biography*. New York: Henry Holt, 1996.

View: The Modern Magazine. Marcel Duchamp Number, ser. 5, no. 1 (March 1945).

Wohl, Helmut. "Marcel Duchamp in Newark." *The Burlington Magazine* 145, no. 1198 (January 2003): 36–39.

Zapperi, Giovanna. "Marcel Duchamp's Tonsure: Towards an Alternative Masculinity." *Oxford Art Journal* 30, no. 2 (August 13, 2007): 291–303.

Acknowledgments

As with all scholarly projects—particularly one that combines exhibiting a diverse range of outstanding works of art with the rigors of producing a catalogue with new research provided by a superb team of contributors—ours has benefited from the input, advice, and support of numerous colleagues, institutions, friends, and family members. Our rethinking of Marcel Duchamp's use of and contributions to the field of portraiture has, of necessity, progressed down paths both familiar and untried, and our efforts to negotiate these byways has time and time again been eased by the many individuals and institutions we wish to acknowledge here. We are grateful for the guidance, the enthusiasm, the generosity, the insight, and the patience that has enabled us to preserve our sense of excitement and pleasure in realizing this exhibition and publication.

Our first thanks belongs to the institutions that lent their support to this undertaking at the outset. The Smithsonian Institution has provided important backing. We thank former Under Secretary of Art Ned Rifkin for his encouragement and assistance. We acknowledge with immense gratitude the generous support of a two-year Smithsonian Scholarly Studies grant that enabled us to undertake the research and to assemble the contributors who have made this project possible. We thank Catherine B. Harris and Bruce W. Morrison at the Office of Research Training and Services for administering this grant. We appreciate the invaluable feedback we received from Wanda Corn and anonymous reviewers. We wish to offer special thanks to Julie Heath at the Lunder Conservation Center for the encouragement and program funds she provided to support conservation research in connection with the exhibition.

We are grateful for the generous contributions of many colleagues at the National Portrait Gallery (NPG). We thank Director Martin E. Sullivan and Deputy Director Carolyn Kinder Carr for their ongoing support. Marc Pachter, now director emeritus, provided invaluable enthusiasm in launching this project. In the Department of Exhibitions, we thank Beverly Cox for her unflagging energy and assistance in overseeing the complex logistical demands of coordinating all aspects of the exhibition. Special thanks goes to Kristin Smith for her energy, persistence, and good humor in coordinating exhibition loans and organizing photographic coverage for the catalogue. We thank Molly Grimsley for her hard work in bringing to Washington the many important loans on which our project has relied. Amy Baskette has earned our immense gratitude for her cheerful and astute assistance in managing many administrative details of this project. For making available, both for the exhibition and the publication, objects from NPG's own collection, we thank Wendy Wick Reaves, Ann Shumard, Frank H. Goodyear III, Rosemary Fallon, Ed Myers, Lizanne Garrett, and Mark Gulezian. The exhibition was beautifully designed and installed by Nello Marconi, Al Elkins, and the Design and Production Department staff, and we thank them, along with Todd Gardner, Mark Planisek, and Dale Hunt. For their assistance in planning educational programming for the exhibition, we thank Rebecca Kasemeyer and Ian Cooke. For facilitating the exhibition's electronic components, we thank Linda Thrift, Deborah Sisum, Benjamin Bloom, and Sue Garton. Bethany Bentley has worked tirelessly to promote the exhibition. For their energy and enthusiasm for the exhibition and for marshalling the resources necessary to support it, we thank Sherri Weil, Preuit Rauser, Charlotte Gaither, and Julia Hahn. This catalogue would not be possible without the sharp eye, encouragement, and unflagging energy of NPG's head of publications, Dru Dowdy, to whom we owe a special debt of gratitude.

Several other bureaus within the Smithsonian have also made invaluable contributions to this exhibition. For their generosity in making available numerous collections at the Archives of American Art, we owe a special thanks to Susan Cary, Wendy Hurlock Baker, and Marisa Bourgoin. At the Hirshhorn Museum and Sculpture Garden, we thank Aimee Soubier and Lee Aks for their generous assistance. We also thank Cecilia Chin at the National Portrait Gallery/American Art Library for her invaluable support, as well as Rebecca Pfordresher, assistant director of Foundation Relations, and Desiree Smith in the Office of Sponsored Projects for their enthusiastic assistance with NPG's fundraising for this exhibition and catalogue.

We are also grateful to numerous supporters at California State University, Chico. Scott McNall, former provost, and Catherine Sullivan Sturgeon, curator at the Janet Turner Print Museum, offered invaluable enthusiasm and support. Wendy Diamond at the Meriam Library provided important assistance with research. Jeff Teeter, Instructional Media Center, and Tom

Patton, Department of Art and History, photographed works borrowed from local collections. The students in James McManus's Dada/Surrealism seminar (fall 2007) and the Duchamp seminar (spring 2008) served as a sounding board for this project.

In addition to our home institutions, a number of other museums and libraries have offered extraordinary assistance and support. This show would not be possible without the wide-ranging expertise and goodwill we encountered at the Philadelphia Museum of Art. We are grateful for Anne d'Harnoncourt's early encouragement; her presence at the time of this project's completion is greatly missed. Archivist Susan Anderson repeatedly went beyond the call of duty in helping us ferret out key objects and pieces of information. We thank her for her incredible generosity in providing access to the archives's unparalleled collection of material on Duchamp. In the Department of Prints, Drawings, and Photographs, Innis Shoemaker, Shelley Langsdale, and Kate Ware have been generous in sharing their collections and expertise. We offer a special thanks to conservator Scott Homolka for helping us with research on objects of particular interest. We are indebted to Michael R. Taylor, who not only contributed his expertise to our catalogue but offered generous counsel, advice, and support for this project throughout its development. At the Museum of Modern Art in New York, we have benefited immensely from the generosity of several colleagues. In the Department of Drawings, Kathy Curry tirelessly facilitated research on key objects. Paper conservator Scott Gerson worked without hesitation to reinstall Frederick Kiesler's drawing of Marcel Duchamp in its proper frame and contributed his expertise on other works. Adrian Sudhalter, in the Department of Painting and Sculpture, has been a great partner in our research into Jean Crotti. For invaluable assistance with other research, we also thank Jeanne Brun, Maureen Carey, William A. Camfield, Dickran Tashjian, Richard Field, Sarah Greenough, Quentin Bajac, Sylvie Lorant, Florence Willer-Perrard, Marco Rosin, and Mary Saunders. And for early encouragement, we thank Linda Dalrymple Henderson and Richard Shiff.

We are grateful for the incredible generosity shown by numerous individuals in support of our efforts. We wish to especially thank Jacqueline Matisse Monnier for sharing her insights and her collection; Sean Kelly, whose enthusiasm and support for our exhibition aided in making a number of important works available; and Francis M. Naumann, who brought his vast knowledge and passion for Duchamp to our undertaking. Naumann's research and persistence led to the rediscovery of Daniel Mac-Morris's 1937 *Marcel Duchamp,* and we thank him for enabling us to exhibit this important work for the first time in more than seven decades. David Fleiss offered wonderful enthusiasm and alerted us to a number of intriguing portraits of Duchamp. Frances Beatty has provided invaluable encouragement and generous access to key works of art.

We have benefited tremendously from the opportunity to speak with a number of artists who portrayed Duchamp. We thank Mel Bochner, Sturtevant, Andrew Lord, Ray Beldner, and Bethan Huws. For their ongoing assistance and stalwart support at every stage of this undertaking, we offer heartfelt thanks to Brian O'Doherty and Barbara Novak, and also to Douglas Vogel.

This groundbreaking catalogue owes a great deal to the new research undertaken by the essayists who have contributed to it. We thank Janine Mileaf, Francis Naumann, and Michael Taylor for their hard work and new scholarship.

We have each been extraordinarily fortunate in the intellectual acumen and diligence of the research assistants who have facilitated every aspect of this project. For their enthusiasm and dedication we thank Caroline Dickson, Charlotte Gaither, Aubrie Koenig, Jennifer E. Quick, Molly Sciaretta, and Hannah Wong.

No show can happen without the support of patrons of the arts. We wish to acknowledge with deep thanks the financial support provided by the Henry Luce Foundation, the Florence Gould Foundation, Ella Foshay, Mr. and Mrs. Aaron M. Levine, and Mary McMorris and Leonard Santoro.

Finally, we are each grateful for the ongoing support of our families and, in particular, our spouses, Frank H. Goodyear III and Lani McManus. Although the measure of our debt and gratitude cannot be sufficiently expressed through words, we wish to acknowledge how much we owe them. Thank you for everything.

This catalogue is dedicated to the memory of Marcel Duchamp, and to Jacqueline Matisse Monnier, who does so much to keep that memory alive.

ANNE COLLINS GOODYEAR AND JAMES W. MCMANUS

Index

Photographers and Copyrights

Published in conjunction with the exhibition "Inventing Marcel Duchamp: The Dynamics of Portraiture," at the National Portrait Gallery, March 27– August 2, 2009.

Support provided by the Henry Luce Foundation, the Florence Gould Foundation, Ella Foshay, and Aaron and Barbara Levine.

Library of Congress Cataloging-in-Publication Data

 Inventing Marcel Duchamp : the dynamics of portraiture / edited by Anne Collins Goodyear and James W. McManus ; with additional essays by Janine A. Mileaf . . . [et al.] ; foreword by Martin E. Sullivan.

 p. cm.

 Published in conjunction with an exhibition held at the National Portrait Gallery, Smithsonian Institution, Washington, D.C., Mar. 27, 2009– Aug. 2, 2009.

 Includes bibliographical references and index.

 ISBN 978-0-262-01300-0 (hardcover : alk. paper)

 1. Duchamp, Marcel, 1887–1968—Portraits—Exhibitions. I. Goodyear, Anne Collins. II. McManus, James W., 1942– III. Mileaf, Janine A. IV. National Portrait Gallery (Smithsonian Institution). V. Title: Dynamics of portraiture.

N6853.D8A4 2009

709.2—dc22 2008047497

Published by the National Portrait Gallery, Smithsonian Institution
 http://www.npg.si.edu/

Copublished by the MIT Press
Massachusetts Institute of Technology, Cambridge, Massachusetts
 http://mitpress.mit.edu

Image details:
Front cover: John D. Schiff, *Marcel Duchamp* (pl. 56)
Back cover: Marcel Duchamp, *View* (back cover) (pl. 42b)
Endsheets: Marcel Duchamp, *Self-Portrait in Profile* (pl. 58)
Pages 10–11: Shuzo Takiguchi, *To and From Rrose Sélavy* (pl. 83)
Pages 13, 23, 41, 59, 81–82, and 101: Hans Hoffmann, *Portrait of Marcel Duchamp* (pl. 1)
Page 127: Man Ray, *Portrait of Marcel Duchamp Overlaid with a Photogram of the Glissière* (pl. 35)

Project Director: Dru Dowdy
Editor: John Pierce
Designer: Jeff Wincapaw
Proofreader: Amy Smith Bell
Indexer: Candace Hyatt
Typesetter: Marissa Meyer
Color management by iocolor, Seattle
Produced by Marquand Books, Inc., Seattle
 http://www.marquand.com
Printed and bound in China by Regent Publishing Services, Ltd.